FLORAL STYLE

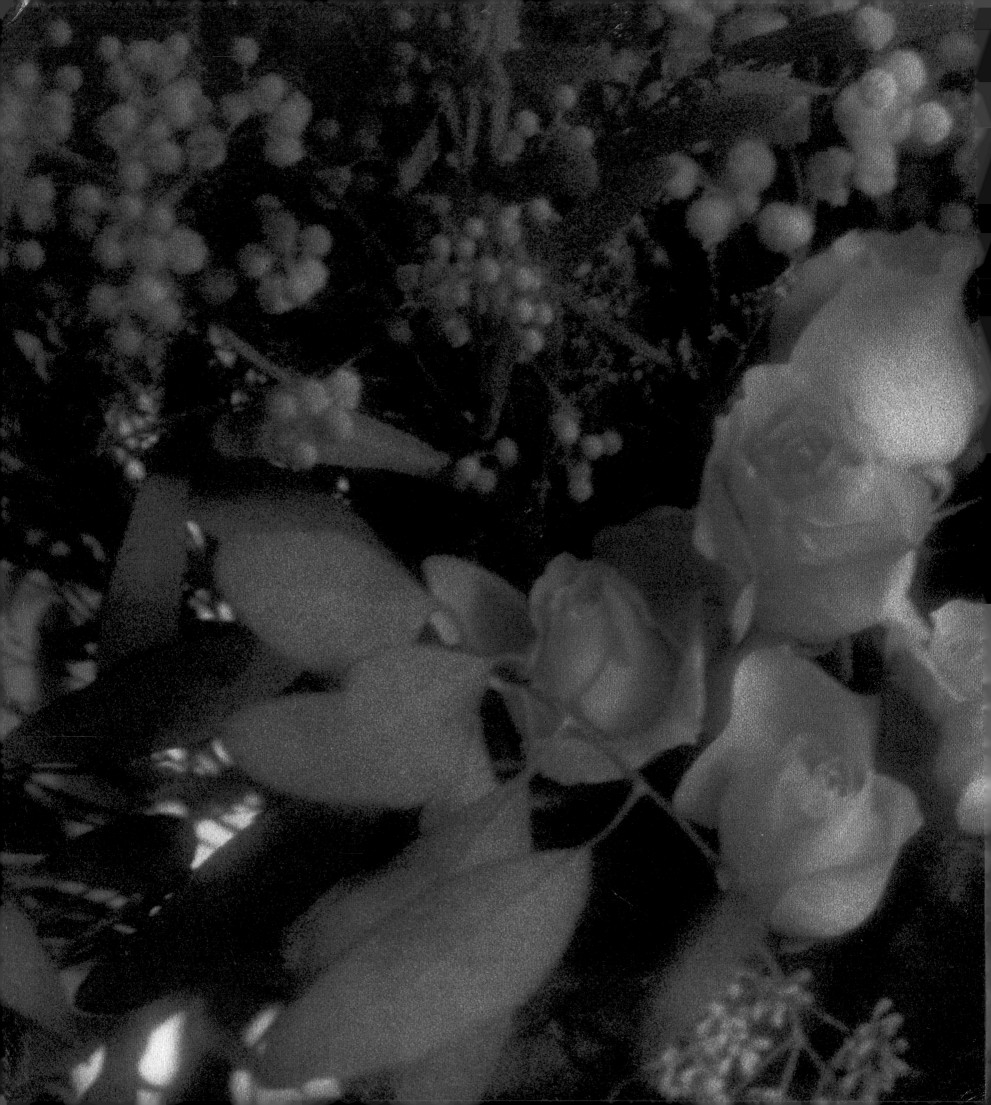

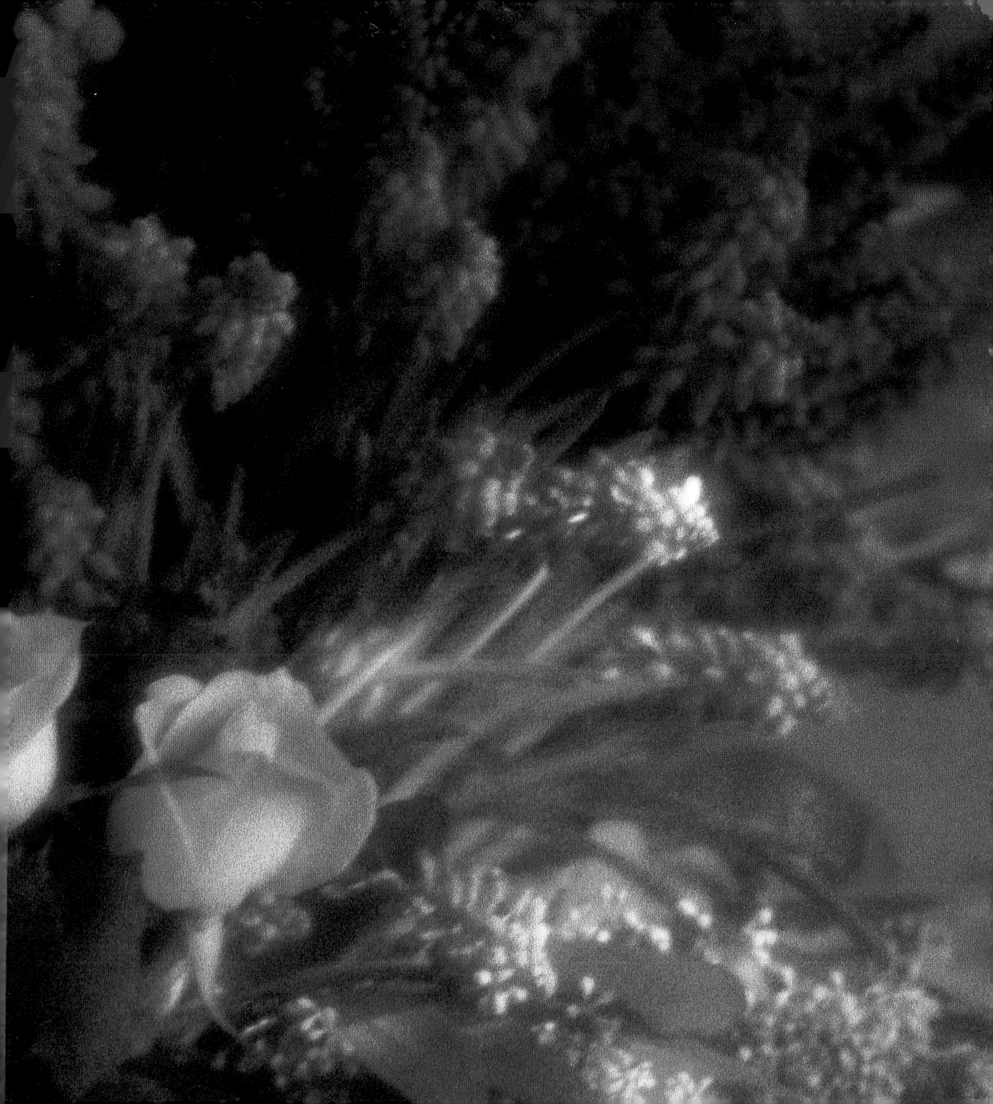

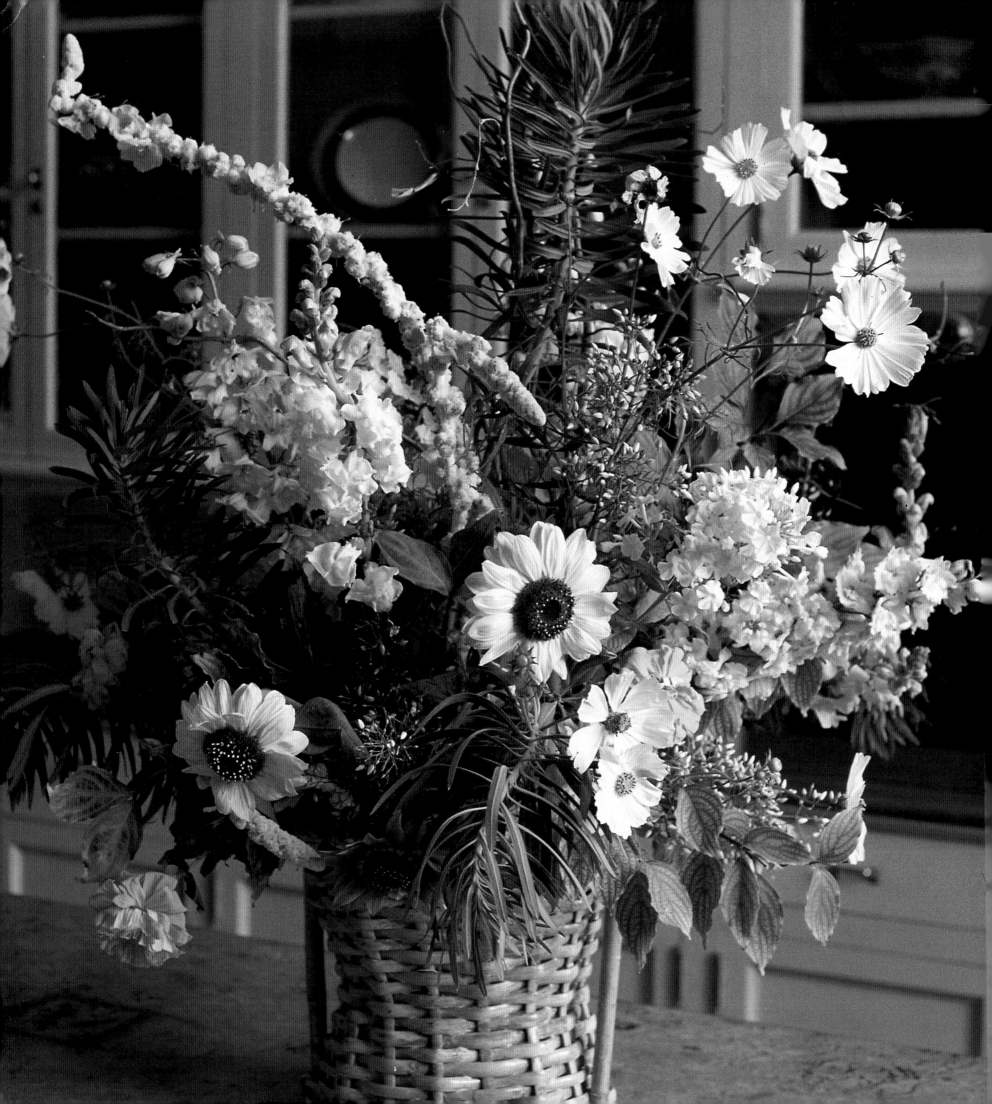

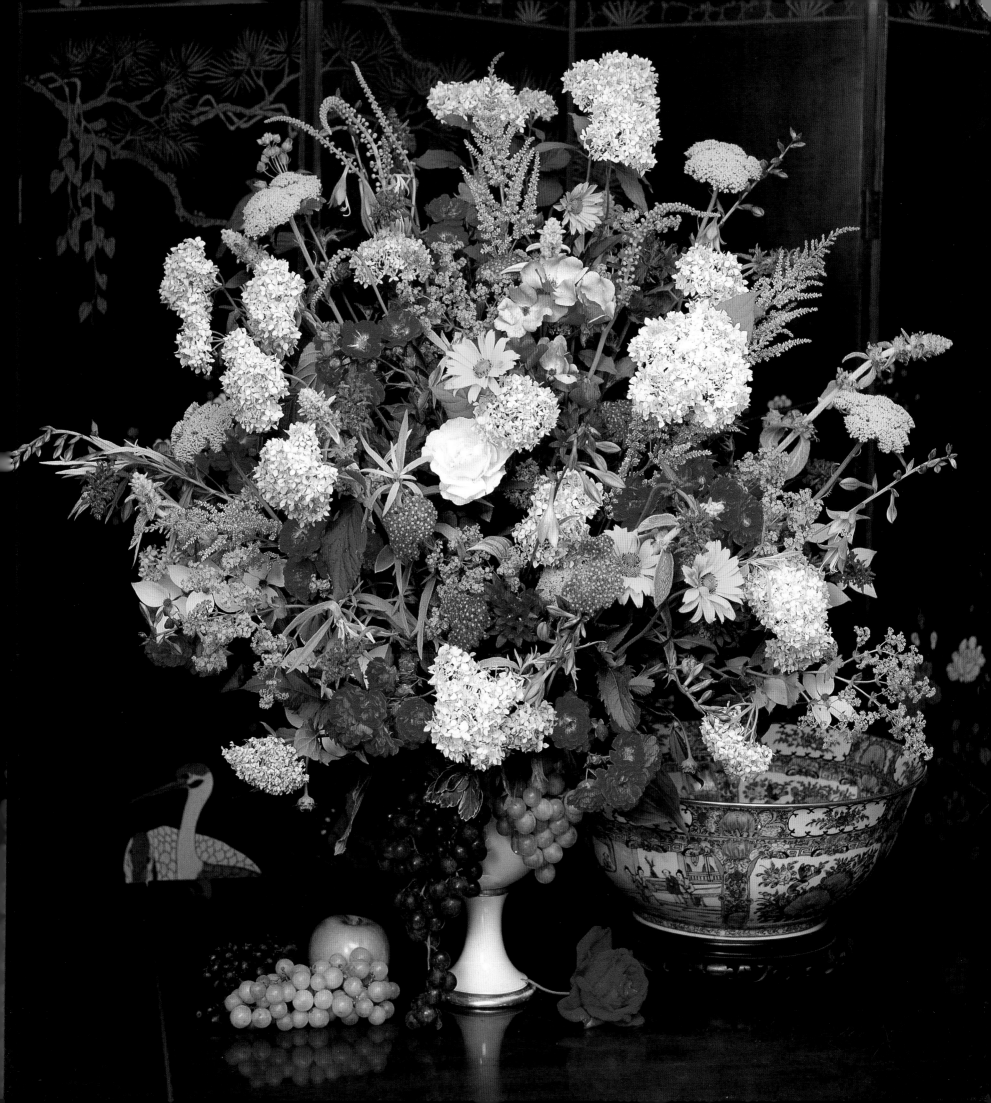

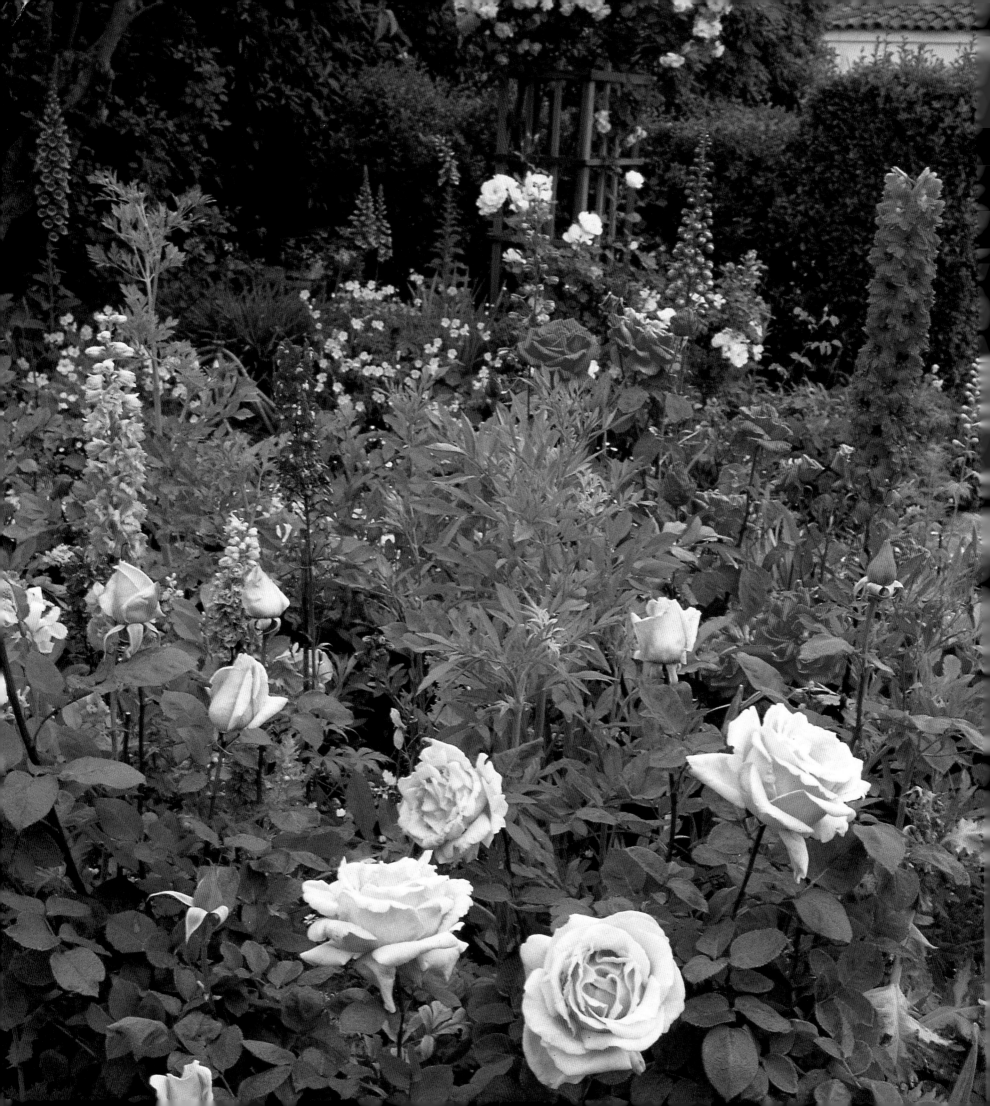

FLORAL STYLE

Vena Lefferts with John Kelsey

Photo Research by Kathy Farrell-Kingsley

HUGH LAUTER LEVIN ASSOCIATES, INC.

Copyright © 1996
Hugh Lauter Levin Associates, Inc.

Art/Editorial director: Leslie C. Carola

Cover and book design: Kathleen Herlihy-Paoli, Inkstone Design

Copy editor: Deborah Zindell

Printed in Hong Kong

ISBN: 0-88363-056-7

"The Infinite has written its name on the heavens in shining stars,
and on the earth in tender flowers."

—JEAN PAUL RICHTER

(Pages 2-3) Masses of flowers grouped by species recreate the garden itself. Such an expression of floral style may seem simple, but it requires sophisticated understanding to resist the urge to "arrange" the colors in a floral mass. The garden-style arrangement features pink roses, blue muscari, bicolor dendrobium orchids, acacia, seeded eucalyptus, and heather. Flowers by Vena Lefferts. Photo by Maureen DeFries.

(Page 4) Yellow and white flowers with a variety of greenery in a soft-hued woven basket make a perfect marriage, an exquisitely simple floral statement. Adding more color, or greenery would only confuse the picture and dilute this sparkling expression of country simplicity. Photo by Peter Margonelli.

(Page 5) A rich arrangement of flowers straight from the garden, spilling out of a faience compote, evokes an Old Master painting, a Renaissance portrait of exuberant life. The flowers include deep pink spray roses, lady's mantle, yarrow, pink astilbe, heliopsis, lamb's ears, hydrangea, campanula, and hosta. Flowers by Vena Lefferts. Photo © Fine Gardening magazine.

(Pages 6-7) This cheerful monochromatic arrangement of little yellow flowers in a big yellow vase became modern and sophisticated when the designer swept it asymmetrically to one side. The flowers are oncidium orchids. Photo by Peter Hōgg.

(Page 8) Warm sunlight, bright colors, and natural shapes and textures —a true garden of delight and the source for flower lovers' passion. Photo by Jerry Pavia.

(Page 9) Green stems under water contrast cheerfully with bright spring flowers. Photo by Peter Hōgg.

(Opposite) Background flowers of tulips, hydrangeas, and statice. Photo by Marshall Lefferts.

CONTENTS

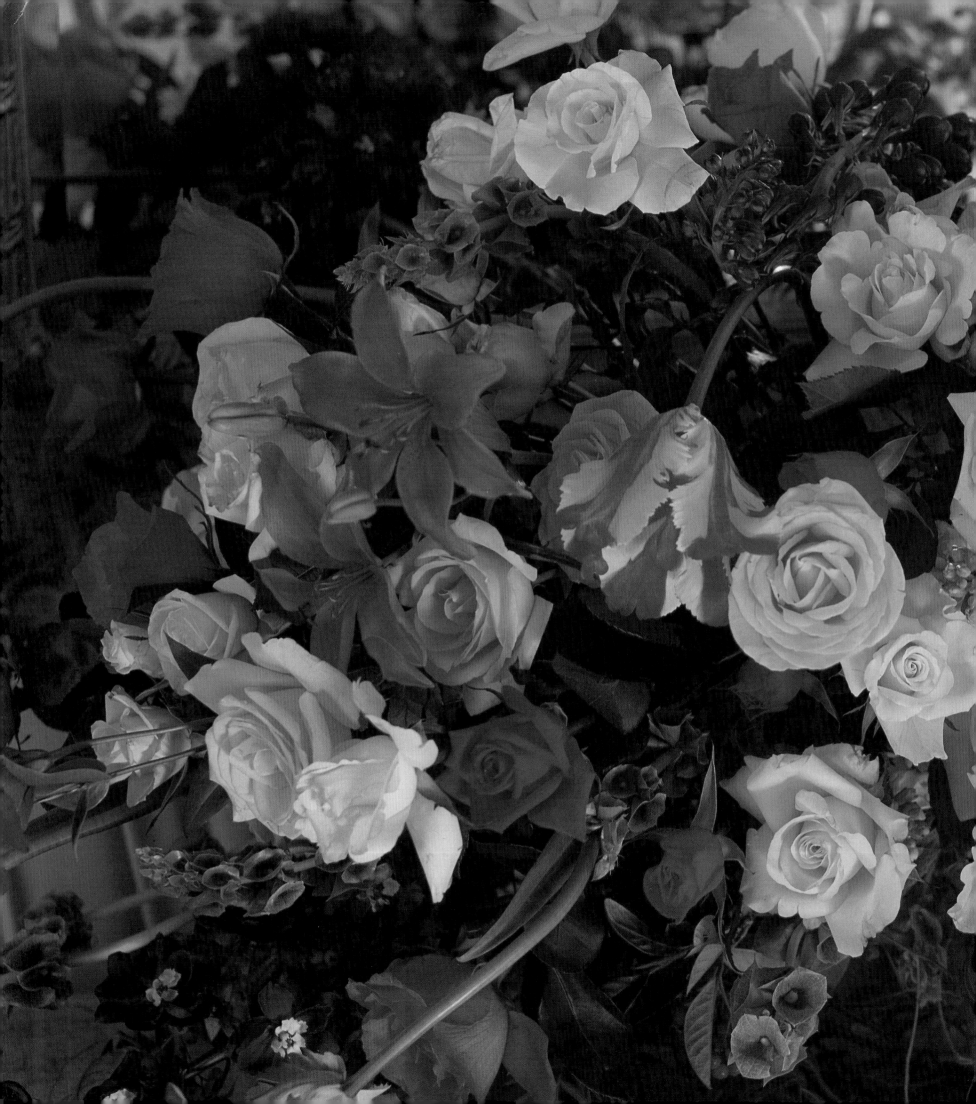

INTRODUCTION:
A SENSE
OF
FLORAL STYLE

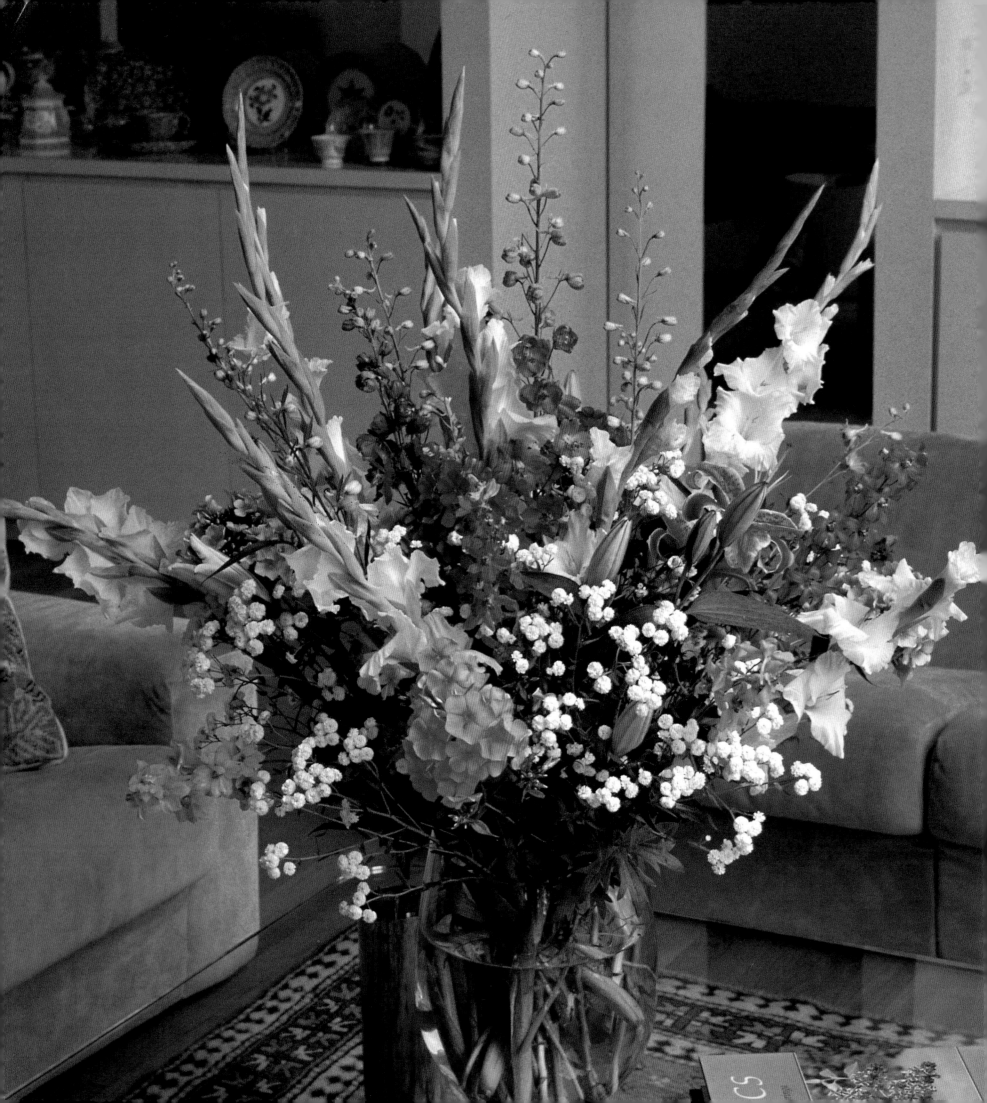

*F*lowers engage our senses, evoke strong feelings in our hearts, and connect our spirit with the natural world in a pure, profound way. We see their beauty, smell the fragrance, touch the delicate blossoms. Then the flower wilts, withers, and is gone. Their ephemeral nature makes the gift of flowers all the more precious. We sense our own divinity and our own mortality in the company of flowers.

People love to work with flowers because of their dual nature: they are transcendent, but they are also very real. Everyone has favorite memories of walking through a garden or field, surrounded by exquisite beauty, and choosing flowers to bring to a friend, or to take home to place in a vase. Do you remember being in an overgrown cutting garden, ever in your life? Flowers face-high on all sides, soft sunlight, buzz of insects. The blossoms press into the pathway, you turn around, petals and leaves brushing your skin, your perception of reality takes a shift, the moment is truly rapturous. Then it's back to earth, cut some flowers, and leave the garden.

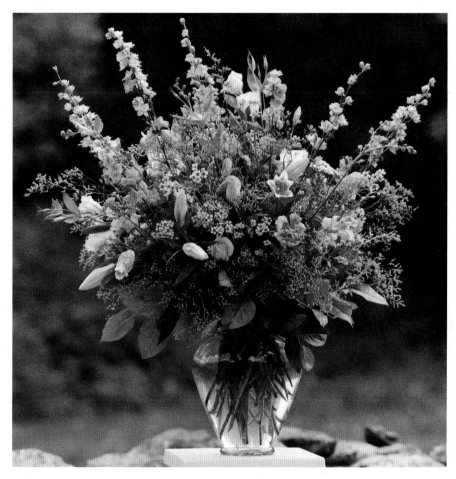

(Previous spread) Whose heart would not be lifted by this vibrant profusion of flowers? These lavish gifts from the earth extend an eager welcome of hope and joy to all who come near. The arrangement includes Champagne roses, anemones, lilies, cattleya orchids, Rothschild vanda orchids, and gilded lemon leaf. Flowers by Sylvia Tidwell. Photo by Grey Crawford.

(Opposite) The delicacy of this elegant spray of white gladiolus, pink phlox, hybrid delphinium, lilies, and button chrysanthemums evokes feelings of gratitude for such gifts from the natural world. Photo by Peter Margonelli.

(Right) Radiant spikes of pink larkspur burst forth from this charming arrangement of lilies, roses, limonium, lisianthus, and waxflowers. The clear glass ginger jar, an essential accessory for the floral stylist, gives shape to the arrangement without jangling its subtle palette of colors. Flowers by Vena Lefferts. Photo by Maureen DeFries.

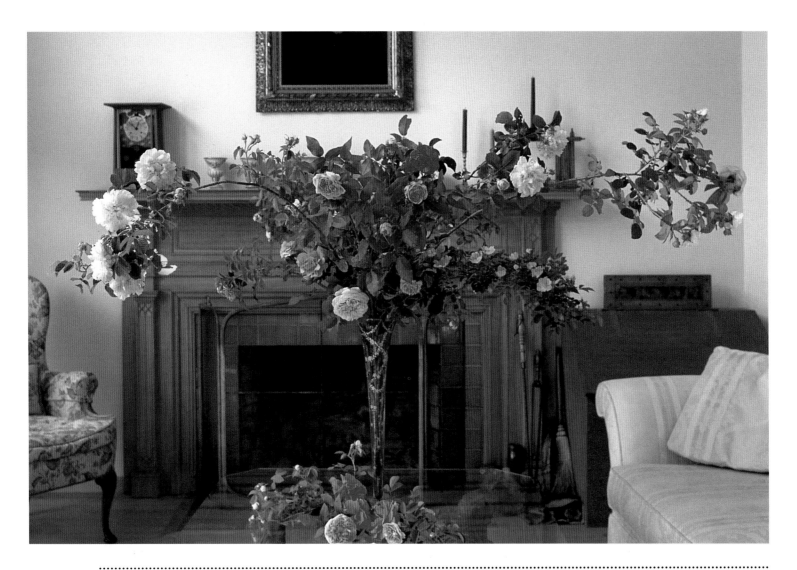

Climbing rose branches reach far into the room from a tall glass vase, softening the traditional decor and inviting guests to sit and linger. Photo by Peter Margonelli.

Floral design is one art form that people understand, appreciate, and value. A beautiful arrangement brings joy and meaning into people's lives. A floral gift is appropriate for any occasion, and always welcome.

Most beginning designers have an innocent and spontaneous approach to creating an arrangement. They make wonderfully loose arrangements without being drawn to a predefined shape or line, a refreshing contrast to the work of a practiced, and possibly more reserved, eye. In fact, professional designers often achieve design liberation by relaxing the "rules," by stretching traditions, and by abandoning habits.

Don't be afraid that you don't know how to begin, or that you aren't sure what looks best. Trust your own instincts. When an arrangement pleases you, it will please other people as well.

If you are confident of your ability to design a traditional mounded centerpiece with carnations and baby's breath, try designing a contemporary floral arrangement with tropical exotics, or creating a large arrangement with unusual varieties of flowers or using an unusual container. The

sheer adventure of trying something new is what will stretch your creativity. Try to begin with all of the innocence of a child who knows nothing, then try again—you can use the same flowers— with all of the intellectual aspects of design in mind. See which approach you prefer. It might depend on how you're feeling today. In a group, if ten different people use the same materials to make an arrangement, they will create ten different results.

You begin to interpret the flowers when you choose which ones to cut or buy. These decisions go beyond choosing fresh stems with blooms of the right color. If you know who the arrangement is for, what is the occasion, and where it will be placed, you know the context of the arrangement. You have a place in that context, so your feelings about the recipient can direct you to the most appropriate flowers.

Just as often, you may buy a gorgeous bouquet on impulse, then wonder what to do with it. One good response is to find a vase and place the flowers on the dining room table or the kitchen counter, or anywhere else it will give you pleasure. Another is to present them to a friend, just because. Floral gestures like these resonate through the fabric of daily life.

The process of conditioning the flowers not only prepares them for the longest possible vase life, it also puts you into close contact with your material. The plan of the arrangement thus begins to form, somewhere below the level of conscious thought, before the placement of a single flower. With experience, you become able to bring this aspect of style into focus. You can see the arrangement in the bunches of cut flowers. You know without thinking about it what kind of container will work best.

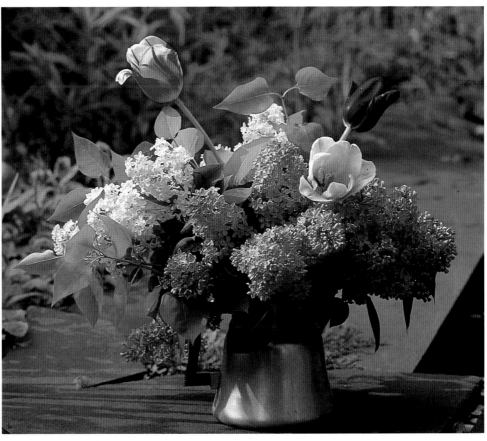

Floral style begins with gathering fresh flowers from the garden and arranging them loosely in a simple container. Flowers and photos by Gloria Nero.

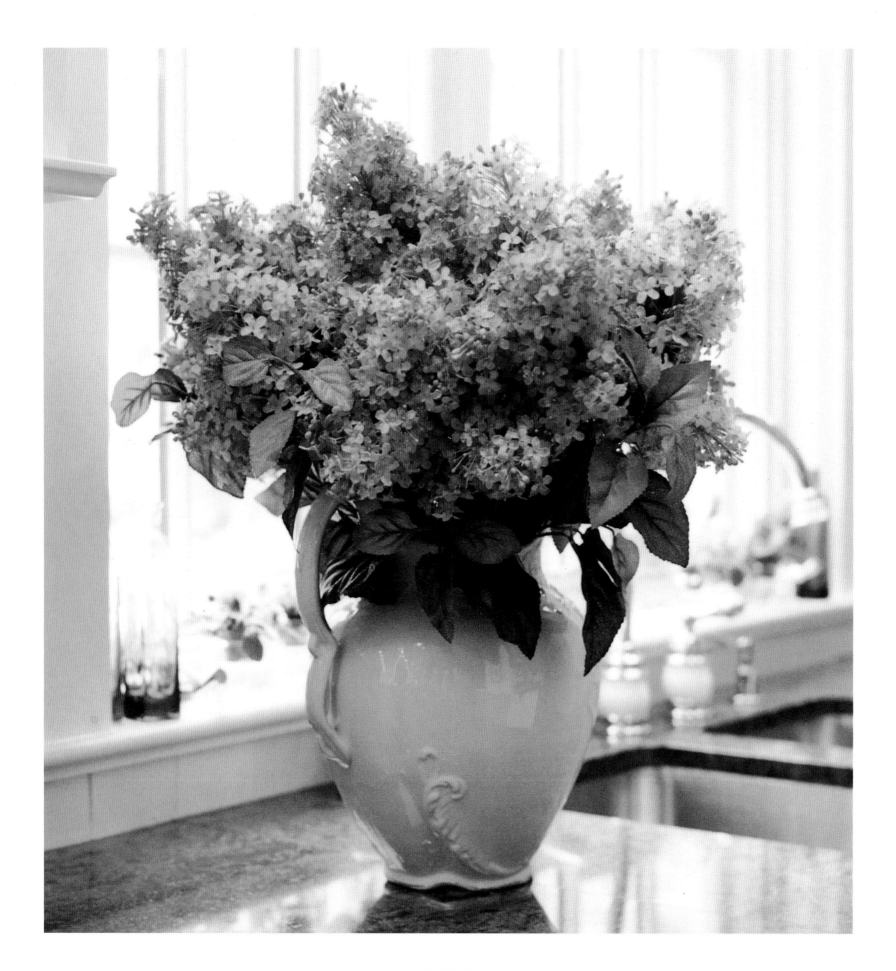

Arranging the flowers in the container can be an analytical process, or an emotional one, or an experience that intertwines both thought and feelings. It's very helpful to study the elements of design and to learn how these ideas about form, line, and color apply to flowers. However, whenever you are not sure how to proceed, always go with what feels best to you.

When you arrange flowers for your family and your friends, you have a luxury that professional designers cannot afford. You can take all of the flowers out of the vase and start over. You can hunt up a better vase, and give the arrangement a different shape. You can go back to the garden or the market for more snapdragons, or for roses of yet another hue, or for the expensive, out-of-season tulips you resisted in the first place. You can experiment and play.

You may choose to hire a professional floral designer for some special occasion needs, or even for casual everyday arrangements, but even then you need to be able to express what you want. The more information the designer has the better the finished result. Informal, casual arrangements can be kept simple enough to grace your home every day. A varied selection of cut flowers and foliage will enhance your environment and your life in inexplicable ways. Flowers on the dining table or breakfast nook brighten mealtimes, and you can fuss with them whenever you like.

When you begin to work with the flowers, your eyes delight in the lovely colors and shapes, you feel their softness on your skin, you smell and taste their fragrance. And you respond to their beauty, intellectually and emotionally. Now you trim the stems and arrange them to make the most

of the beauty that you sense. You interpret the flowers in the choices you make—and what you do is always different from what anyone else would do. This is your own sense of floral style. This book can help you gain access to it, and may inspire you to express it. Your deepening relationship with the flowers can forever change your life.

..

(Opposite) The kitchen comes to life by the simple addition of a bouquet of faux lilacs in an antique pitcher of white porcelain. Silk flowers by Anita Widder. Photo by Maripat Goodwin.

..

(Right) A spray of limonium and a single stem of white chrysanthemums complete this composition of subtly colored papers, green bamboo, and rich braid. Flowers by Meiko Kurbota. Photo by T. Tanaka.

SMILE!

When you see exquisite wedding bouquets, or a magical centerpiece, take a picture for your own floral album. You can learn a lot by photographing favorite arrangements. Having an album of favorite floral arrangements also helps to define your own floral style when you meet with a professional designer.

You'll also find it interesting to take a series of photographs of a floral experiment. If you are trying several arrangement ideas with a selection of flowers, snap each idea as it takes shape. With Polaroid cameras, or today's quick processing, you can see the pictures while the "final" arrangement is still fresh in the vase. Looking at the flowers and the photos together probably will give you a new idea to try.

Your album of flower photographs will become an increasingly useful reference. You'll be able to watch your taste and technical skill grow. And you'll have a place to begin when friends ask your advice about flowers for their parties.

Like a fresh breeze, this loose bouquet of yellow French tulips brings the joy of springtime into the room. Photo by Elizabeth Heyert.

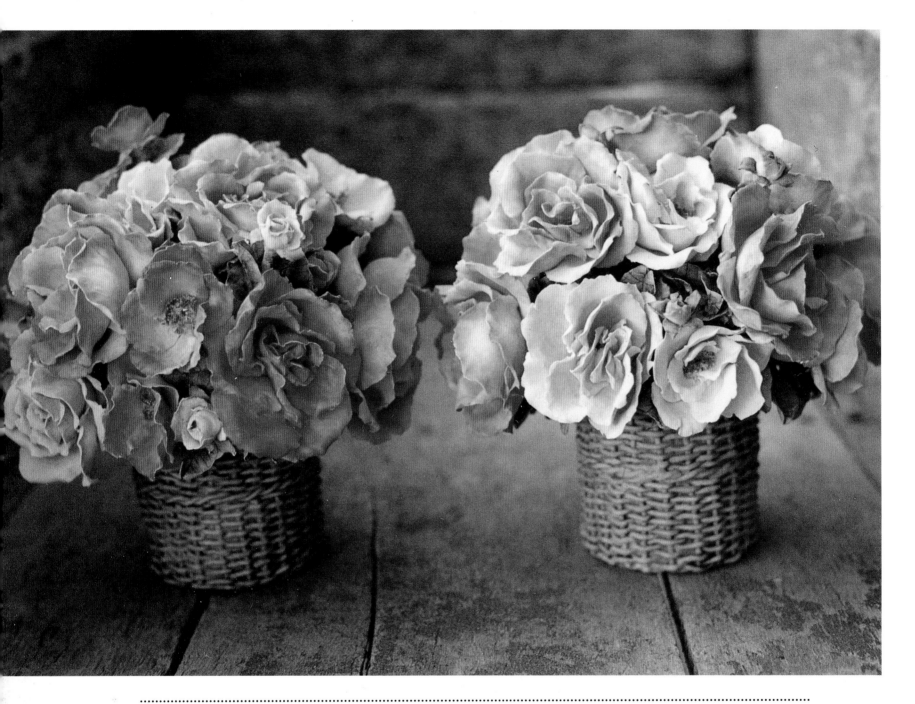

(Above) *Flowers inspire artists to extend their creative powers, here to mimic garden roses in colorful porcelain. Ceramic flowers and photo by Clare Potter.*

(Opposite) *The floral designer has carefully orchestrated the colors, species, and overall shape of this formal arrangement of Queen Anne's lace, roses, snapdragons, green lady's mantle, and gypsophilia. The exuberance of the arrangement complements the room's fine antiques and period detailing. Photo by Maria Ferrari.*

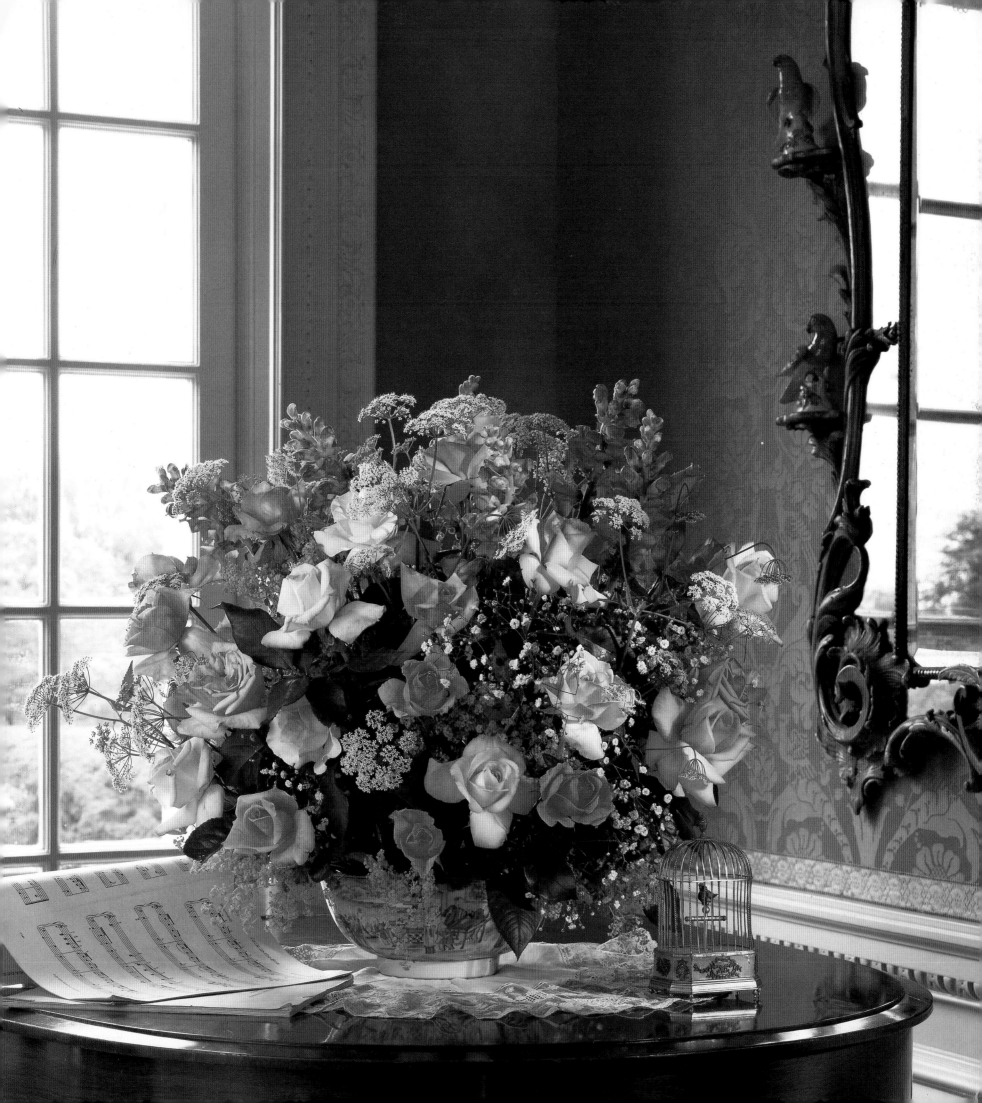

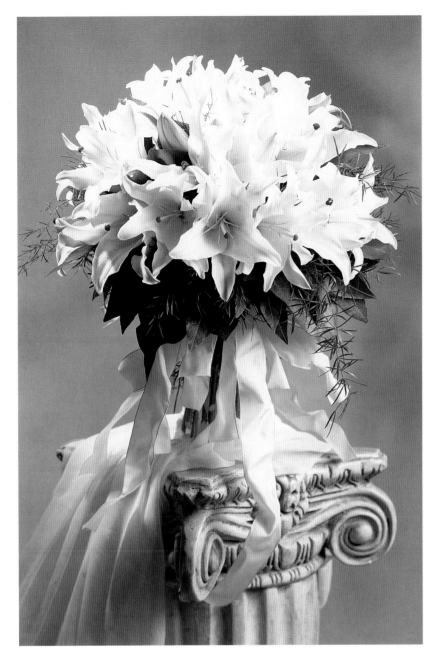
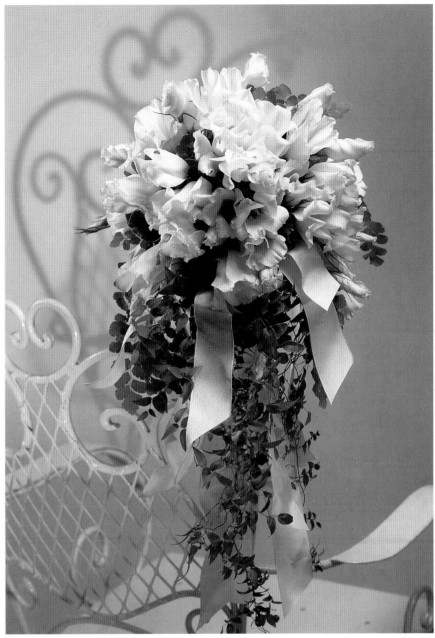

(Above, left and right) Exquisite bouquets of lisianthus and of white lilies complete the bridal ensembles on the special day. No wedding would be complete without a profusion of flowers, which symbolize the community's heartfelt wishes for prosperity and good fortune for the happy couple as they begin their life together. Photos by Irene Chang.

(Opposite) The guests who attended this wedding will remember the opulent wedding bower and lavishly arrayed tables for a long time. Flowers by Sylvia Tidwell. Photo by Grey Crawford.

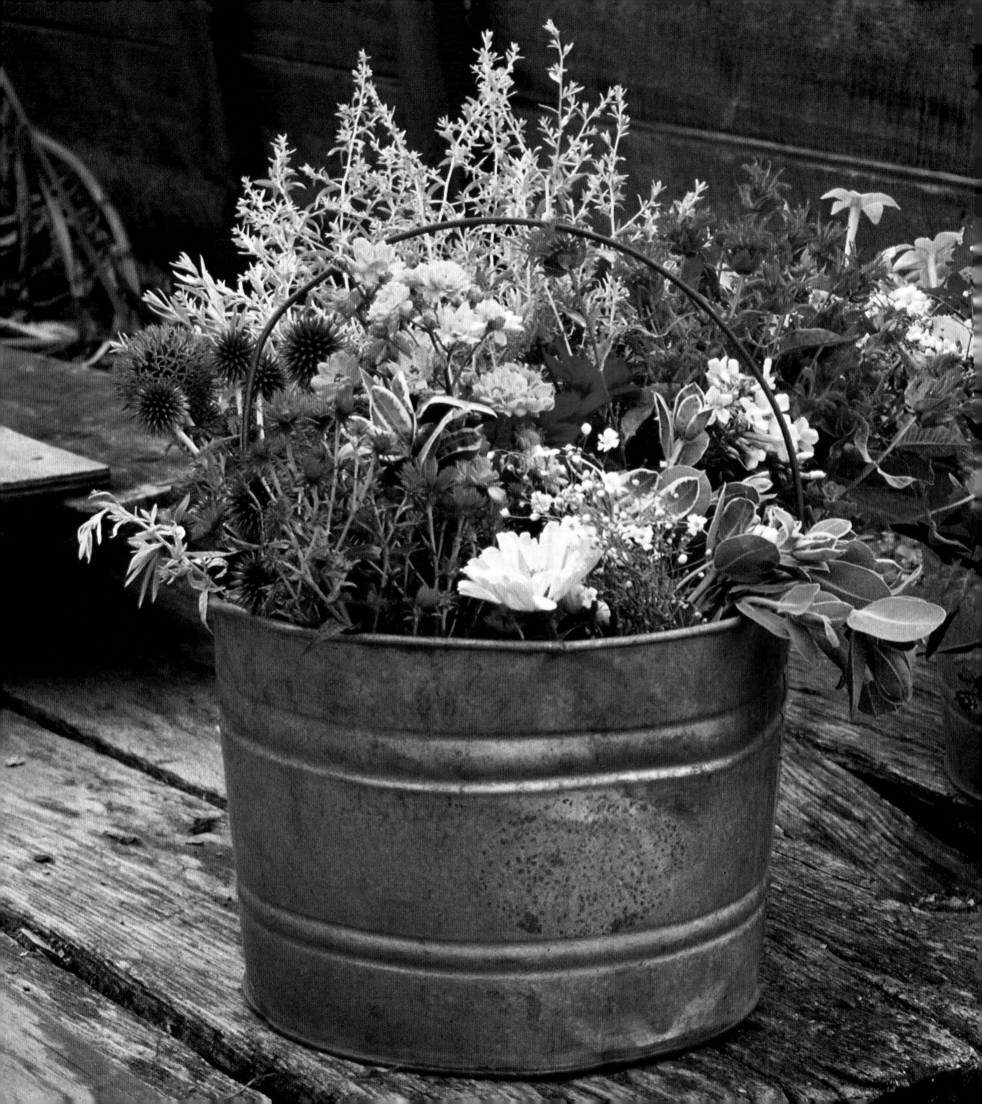

PREPARING AND CONDITIONING FLOWERS

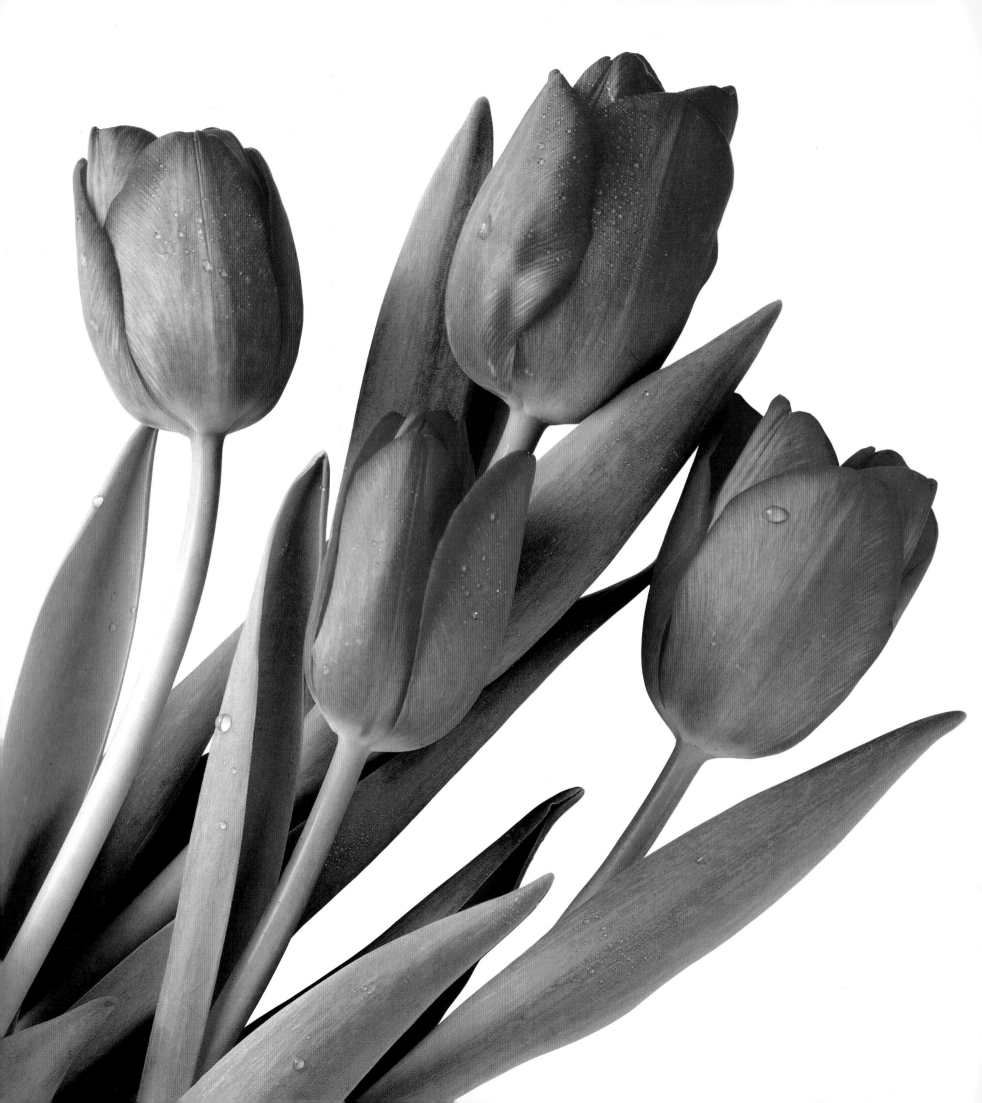

Choosing the right flowers for an arrangement is always an adventure. You may know what you want, but you can't know what you will find at the market or in the garden. And while you might not find what you thought you wanted, you can always be receptive to the flowers that actually are available to you. In this way you will receive the delight that comes from creative improvisation.

Although intensely pleasurable, preparing flowers also is hard physical work. You must heft heavy buckets of water, you make a mess of the work space, and preparation always takes a lot longer than the actual arranging. But, like digging the soil in preparation for gardening, like wedging the clay or scrubbing the vegetables, preparing the flowers also prepares you to express your own sense of floral style.

(Opposite) The simple perfection of fresh-cut tulips glistening with water droplets reflects the beauty and fragility of our natural world. Photo by Maria Ferrari.

(Below) Luscious blooms streak across the fields in Gilroy, California. Photo by Peter Margonelli.

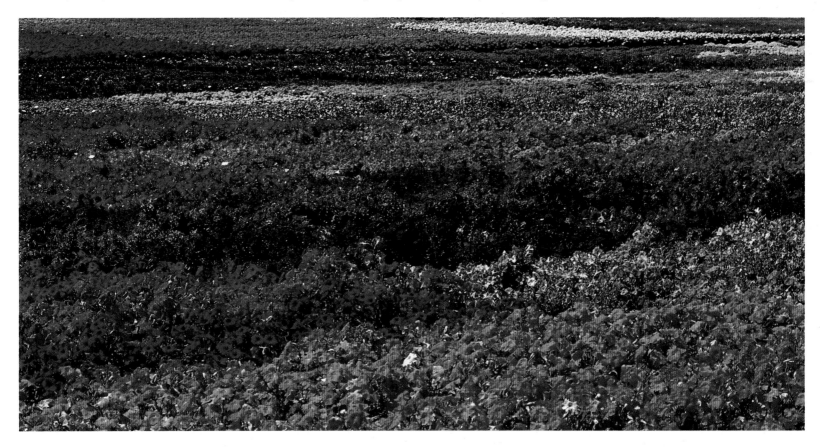

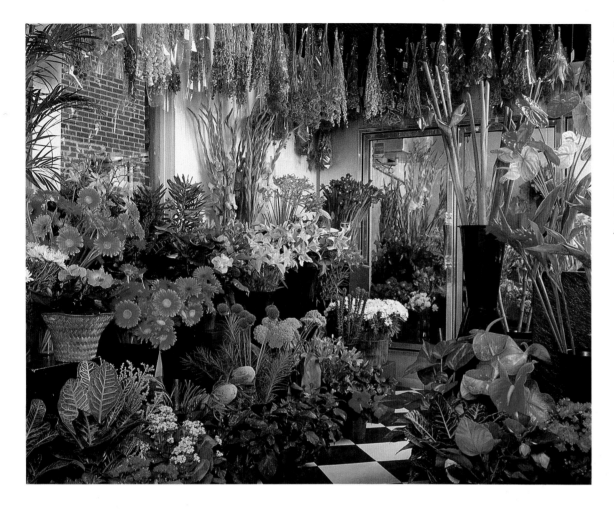

A profusion of colorful flowers, from bright gerbera daisies to elegant irises, anthuriums, red ginger, and birds of paradise, fill the aisles of this dramatic flower shop—truly a floral arranger's paradise. Bunches of soft-hued dried flowers hang from the ceiling. Photo: The Stockhouse Inc./ Joe Robbins.

Preparing the flowers is a craft not unlike preparing ingredients for cooking. You wash and trim and sort, to put your materials into the best possible condition for arrangement and presentation. You also feed the buds and blossoms, awakening them and refreshing them. The conditioning process extends vase life, sustaining the pleasure your flowers will give to you, your family, and your friends.

SETTING UP YOUR WORK AREA

Before you can work with the flowers, you may need to organize your work space. You will need a large, clear work surface. A workbench, table, or kitchen island with good lighting is perfect. The ideal environment is cool, free of clutter, and near a water source. You can always work in the kitchen, but consider the basement or the garage, as long as it isn't too dark and dank. If the floor of your work area is concrete, tile, or stone, you might cushion it with a rubber mat or a scrap of carpet. You could be standing and working there for an hour or more, and nothing is more distracting than tired, aching feet.

You'll also invite an aching back, if your work station is not at a comfortable height. Invert a plastic bucket on the tabletop, and place a plastic lazy Susan on it. Choose a bucket that brings

the arrangement up to the level of your elbows when you're standing. The turntable lets you work on all sides at once.

Preparing the flowers creates a lot of leafy debris, which should go back to the earth by way of the compost pile. Put a cardboard carton underneath the worktable, or a large plastic bucket alongside it, and you can clean up as you go along.

People commonly skimp on cleanliness when conditioning flowers, which is a serious mistake. The flowers are sensitive organisms. You want to keep them alive and vibrant even though they are separated from their roots in the earth. Their cut stems are open wounds, susceptible to bacterial infection and fungal invasion. Scrub all of your conditioning buckets and your tools with hot soapy water and a dash of bleach, and rinse them thoroughly with clear water. A casual rinse is not enough. Your flowers will repay you by staying with you.

CHOOSING FRESH FLOWERS

Choosing the flowers for an arrangement can be both exciting and daunting. It involves all of the senses as well as your creative intelligence. There are so many flowers from which to choose, you must find someplace to begin, while also remaining open to what's available in the garden or marketplace.

Begin by thinking about the context of the arrangement, what is the occasion,

A hard-to-overlook source of fresh flowers is any one of the many sidewalk flower stands on city streets. Passersby on a street in Paris often can't resist the heady perfume and colorful charm of these buckets of fresh flowers. Devaney Stock Photos.

ESSENTIAL TOOLS
AND SUPPLIES

• Good quality clippers or pruning shears. These are called secateurs (pronounced sek-a-'tirs) by the British, and are listed this way in many garden catalogues. The Felco women's size 6 secateurs fit small hands, but if you can find a local dealer, try other sizes and styles too. Reserve your good secateurs for flowers only.

• A second pair of pruning shears for cutting twigs and woody stems.

• A pruning saw for cutting branches.

• A paring knife or a sharp little pocket knife for trimming and splitting stems.

• A long, sharp knife for cutting floral foam.

• Gardening gloves for stripping rose foliage and handling prickly evergreens.

• Plastic buckets, galvanized metal or enamel coated pails, glass bowls, and other conditioning containers of varying heights and volumes. You can't have too many clean buckets.

• A long-spouted watering can.

• A spray mister.

• Granulated sugar and liquid bleach, for making your own conditioning water, or a commercial conditioning additive such as Floralife.

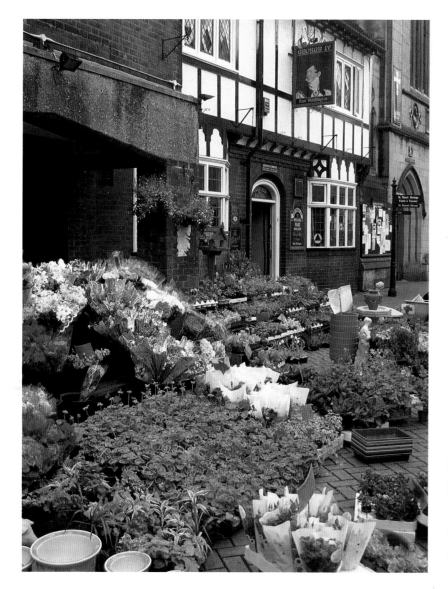

Street markets everywhere feature fresh flowers and potted plants, and it's fun to become knowledgeable about what's locally available at different seasons of the year. Photo by Phyllis Keal/Unicorn Stock Photo.

who is it for, where will it go, how big it should be. Choosing a container in advance will help you focus your choices. You may have a design idea you wish to develop, or a color scheme you want to follow. Consider the number of flowers you need. The availability of specific flowers will depend on where you live, on the time of year, on how much time you can give to shopping, and on how much money you wish to spend. The flower arranger must simultaneously be producer, director, stage designer, and prop manager.

The usual sources for flowers include florists' shops, supermarkets, corner grocery stores, farmers' markets, roadside stands, greenhouses, mail-order catalogues, and your own or a friend's garden. It's always summer somewhere on Earth, and flowers increasingly are being grown in greenhouses. Because foreign and domestic markets ship fresh flowers daily, many varieties are available year-round from florists and markets.

Even when you are not looking for flowers to buy, it's fun to window-shop in floral shops. You learn what is or is not readily available in your area, and also which flowers may be special ordered. It has become easy to order fresh flowers or floral arrangements from mail-order catalogues, so don't ignore them as a source of fresh flowers. You needn't keep the arrangements themselves. You can rearrange the flowers into your own containers and designs once you have them at home. And don't forget potted plants. It's sometimes cheaper to buy a plant and to harvest its flowers or foliage for your arrangements.

Ah, but the flowers are so beautiful that you want them all. Nevertheless, you must resist being seduced, and take the time to inspect cut flowers for freshness. Although proper refrigeration helps keep them fresh, most commercial flowers are at least three days, and perhaps five days or even longer, away from the plant. Look for sturdy stems, perky green foliage, and flowers in bud or just beginning to unfurl and to reveal their mature colors. Immature flowers—flowers not yet fully bloomed—will last longer in the finished arrangement, and you will have the added pleasure of

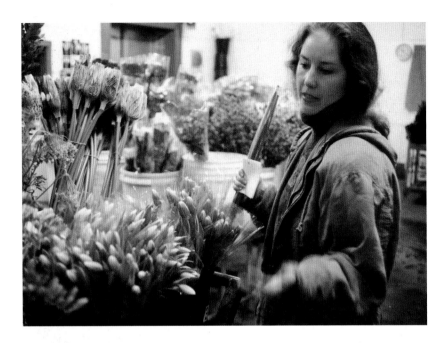

(Left) Flowers at the wholesale market may rest in boxes and plastic tubs instead of in pretty containers, but they'll also be fresher. Photo by John Kelsey.

(Below and opposite) Few things are as much fun as cutting summer flowers. Gather garden flowers in the cool part of the day, not in the noon sun. If possible, put the stems directly into water. Photos by Maureen DeFries.

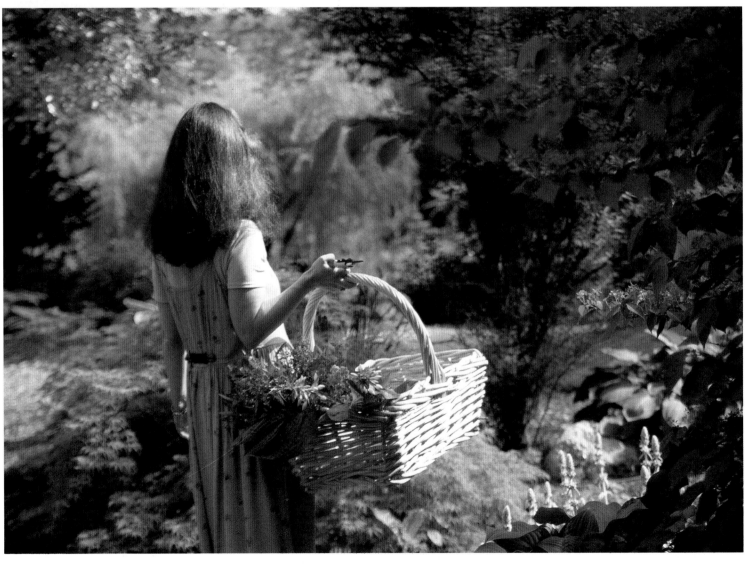

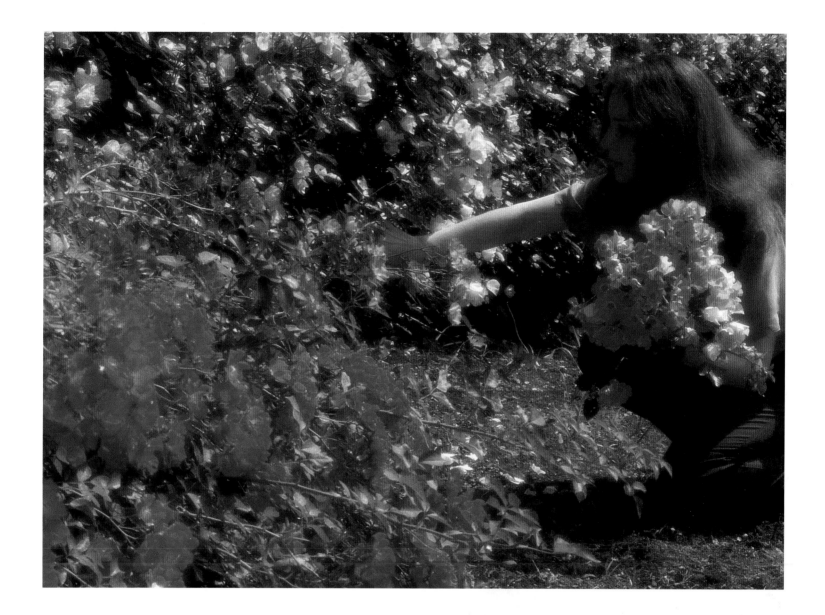

watching them unfold. Flowers cut after they have fully bloomed will soon wilt. Avoid yellowing foliage, foliage with dead brown edges, and any plant that looks bruised or crushed. Flowers that look a little tired generally will revive when you condition them, as long as they don't show damaged tissue.

Gathering fresh flowers from the garden is among life's richest pleasures. Flowers you grow yourself often are larger and hardier, and they have more individuality, more personality. And, of course, they carry a more personal message. The best time to pick is either early in the morning or in the evening, when the sun is low and the stems are full of water. Strong sunlight during the heat of the day causes the water reserves in the stems to be at their lowest. Flowers cut then will wilt quickly and will not respond as well to conditioning. You can pick flowers any time on an overcast or foggy day, because the flower stems and leaves soak up and retain moisture from the air.

When you head out to the garden, it's best to carry a bucket of warm water with you. If that's too awkward, take a shallow basket or an empty bucket. Cut the flower stems on the diagonal with

a sharp blade, and if you are carrying water, immerse the stems. Stand the flowers gently and loosely into your bucket, or lay them gently in your basket, and place them in the shade. Don't crowd them or you will crush the delicate petals. Never tear the stems; tearing will make them more susceptible to quick deterioration.

The one essential piece of equipment is the best possible shears, or secateurs, you can buy. Never use scissors to cut your flowers because scissors will compact the stem. Treat your good secateurs the same way you would treat your good sewing scissors. Don't use them for anything else, and don't let children borrow them.

If you like the look of wildflowers in your arrangements it is best to grow them from seed in your own garden, and not to try collecting them from fields on other people's property. Not only do you risk breaking the law by picking flowers that may have been classified as endangered species and are therefore protected under state or federal law, you'll also be trespassing.

Unlike commercial flowers, garden flowers and wildflowers are likely to harbor insects. They'll be at home on your deck or picnic table. But you might not want them dropping onto the dinner rolls at your formal party. Take the time to look for these uninvited guests when you cut and condition the flowers, and shoo them away. Drop worms and beetles into your compost box so they can return to their world. As a last resort, you might have to spray with insecticide.

Whether you purchase the flowers or pick them yourself, it's a good idea to choose flowers that have similar or compatible vase life. If you plan to enjoy the arrangement in your own home, you will be able to remove the flowers as they wilt and die. But if an arrangement is going where it is not likely to receive much care, such as to a hospital room, you should choose flowers of similar longevity. The flower glossary—One Hundred Favorite Flowers—includes information about vase life.

(Left) Wild branches and vines, such as this colorful bittersweet, can be gathered at any time of year. Photo by John Kelsey.

(Opposite) Ice water slows down ripening and, once the blooms are at their peak, will help keep each flower at its most beautiful. Many professional flower arrangers have a walk-in refrigerator or cold room, but ice cubes can be just as effective. Photos by Maureen DeFries.

CONDITIONING FLOWERS

Water conducts the life force and without it flowers will quickly perish. The purpose of conditioning the flowers is to infuse them with fresh water and to retard the loss of moisture from the cut stems. Once you bring your flowers home be sure to keep them out of direct sun and cool drafts. Handle the flowers with care so as not to damage their heads, stems, or foliage, and make sure they are never crowded.

Cut flowers should be kept cool until you are ready to condition them. The refrigerator is cool and dark, like the night, so the flowers go to sleep. However, you must not refrigerate cut flowers alongside fruit, because fruit emits a chemical signal that tells the flowers their job is done, causing them to wilt more quickly. As an alternative to finding refrigerator space, you can cool flowers in buckets with ice cubes around their wrapped stems.

Flowers purchased from a reputable florist's shop will have already been conditioned, but the stems will have begun to seal over and you should recut them when you get home. Always recut flower stems at an angle and under water. This prevents the intake of air, which could block the absorption of water and hasten wilt and decay.

To condition flowers, follow these steps:

1. Fill a deep bowl or a sink with warm water, to a depth of about six inches. Also prepare buckets of warm water with a conditioning agent to feed the flowers and retard the growth of bacteria and fungus. You can add a tablespoon of sugar and a few drops of bleach to each gallon of water, or you can add Floralife, a packaged additive available from florists' shops. Sugar and bleach leaves the water looking clearer.

2. Remove from the stems all foliage and thorns that would be below the water line of your vase or container. Not only is this plant material visually distracting in a clear vase, but rotting

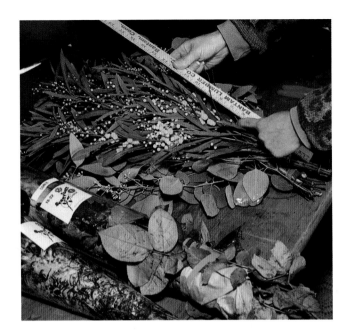 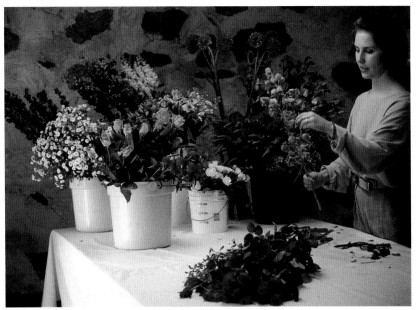

Conditioning the flowers can take as long as actually arranging them. It's important to have enough buckets, to avoid crushing the fragile blooms. (Left) Photo by John Kelsey. (Right) Photo by Maureen DeFries.

leaves will encourage the growth of fungi and bacteria, which will cloud the water, create an unpleasant smell, and hasten the deterioration of the blooms.

3. Immerse the stems in warm water (about 110 degrees Fahrenheit) while you clip them at a 45-degree angle with very sharp pruning shears, secateurs, or a paring knife. This ensures that water, not oxygen, is taken up quickly by the stems. The angled cut prevents the stems from lying flat against the bottom of the vase, which could block the intake of water.

4. Transfer the cut stems immediately to a prepared bucket of warm water with conditioning agent. The water should cover half to two-thirds of the stem length, and the flower itself should peek over the rim of the bucket. Stems of similar size that have been treated in the same manner should be placed in buckets together. This is why you need a variety of buckets.

5. Allow flowers and foliage to sit in the conditioning buckets from two to eight hours, or overnight in a cool, dark area. If you will not be designing your arrangements for a day or two, add ice cubes to the water to retard aging and simulate refrigeration. If you have a refrigerator large enough to hold the buckets, by all means store them there overnight. The ideal temperature for holding most flowers is 36 to 40 degrees Fahrenheit; tropical flowers, however, should be held at 45 to 50 degrees.

Straighten bent flower stems by rolling four to six of them in newspaper, tying the roll with raffia or twine, and placing them in conditioned water overnight.

For woody-stemmed flowers and foliage (such as apple blossoms or flowering quince), peel away the last few inches of bark or hard stem. Then crush the end with a wooden mallet or with a

hammer wrapped in cloth, or else vertically split the stem several times with a sharp blade.

For flowers with stems that are firm on the outside but contain soft interior fibers (such as chrysanthemums, liatris, hydrangeas, and roses), dip stems into a pot of very hot water for a minute or two, or pour hot water from a kettle over the stems that you have placed in a glass bowl or metal bucket. Quickly place the flowers into a bucket of cold water for half an hour to complete the process. Then transfer the cut flowers to warm or cool conditioned water. The 180-degree water forces air to escape from the stems and allows fresh water to replace it. Be sure to protect leaves and blooms from heat by rolling them loosely in newspaper, leaving only the bottom three to four inches of stems exposed.

For flowers that exude a milky sap (such as euphorbia, poppies, and ranunculus), singe the stem ends over a flame (a candle or match) before immersing in water. This seals the cut end and keeps the plant from losing its sap.

For flowers with hollow stems (such as amaryllis, delphinium, and dahlias), turn the flowers upside down, fill the stems with tepid water and plug the ends with a cotton ball or other absorbent material. Pierce the stems lightly just below the flower head to allow any trapped air to escape, then immediately stand the flowers upright in tepid water.

Flowers sometimes wilt unexpectedly despite your best efforts to condition them. Before you abandon them, try to revive them. Recut the stems and place them in five to ten inches of hot water for half an hour. Or try submerging the flowers, heads and all, in cool (not cold) water for a few hours, or even overnight.

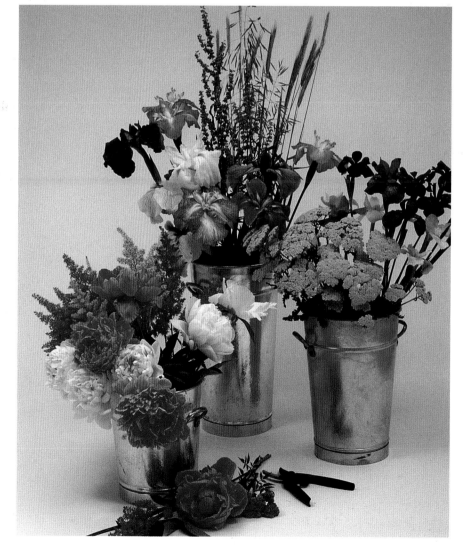

Conditioning buckets should be tall enough to immerse the stems in water, while leaving the blossoms above the rim. Measuring the stems at the outset helps organize the buckets and containers. Photo by Michael Dodge/White Flower Farm.

CONDITIONED
AND UNCONDITIONED ROSES

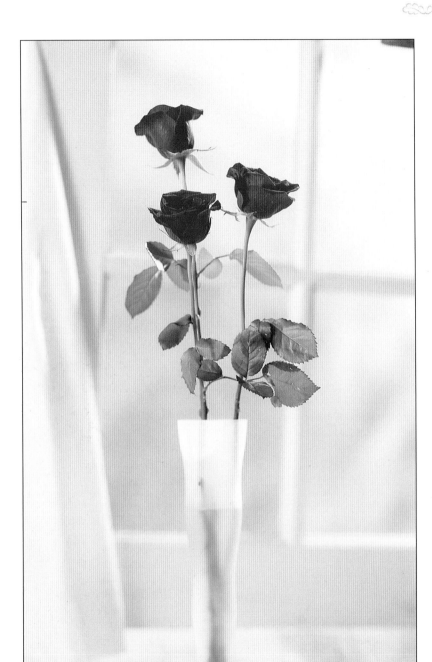
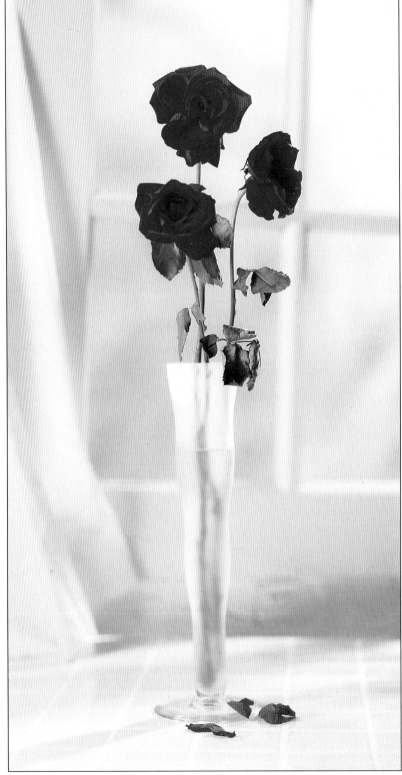

Proper conditioning keeps flowers at their peak of loveliness, and slows down their aging process. The three conditioned roses in the flute glass (opposite) remain attractive for several days, while the four unconditioned roses in the drinking glass (below) wilt and wither. Photos by Irene Chang.

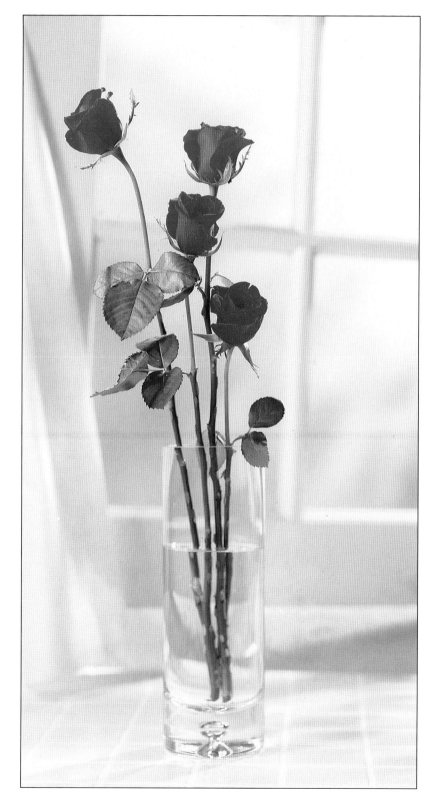

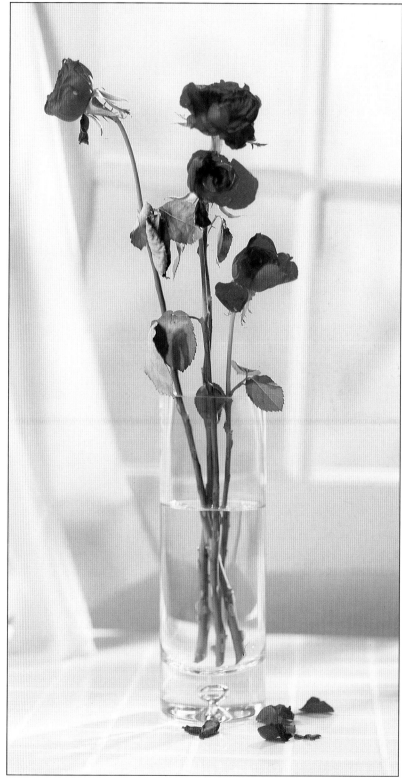

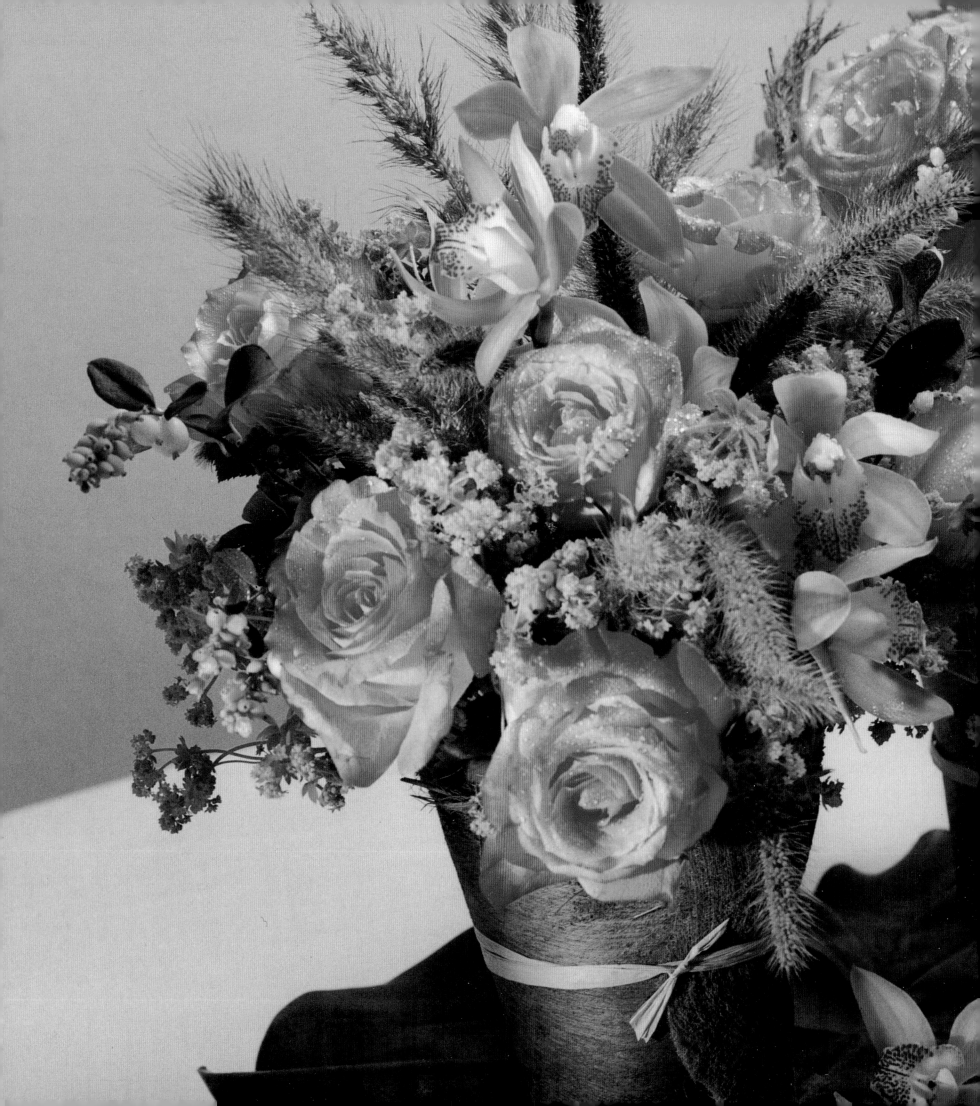

SELECTING THE CONTAINER

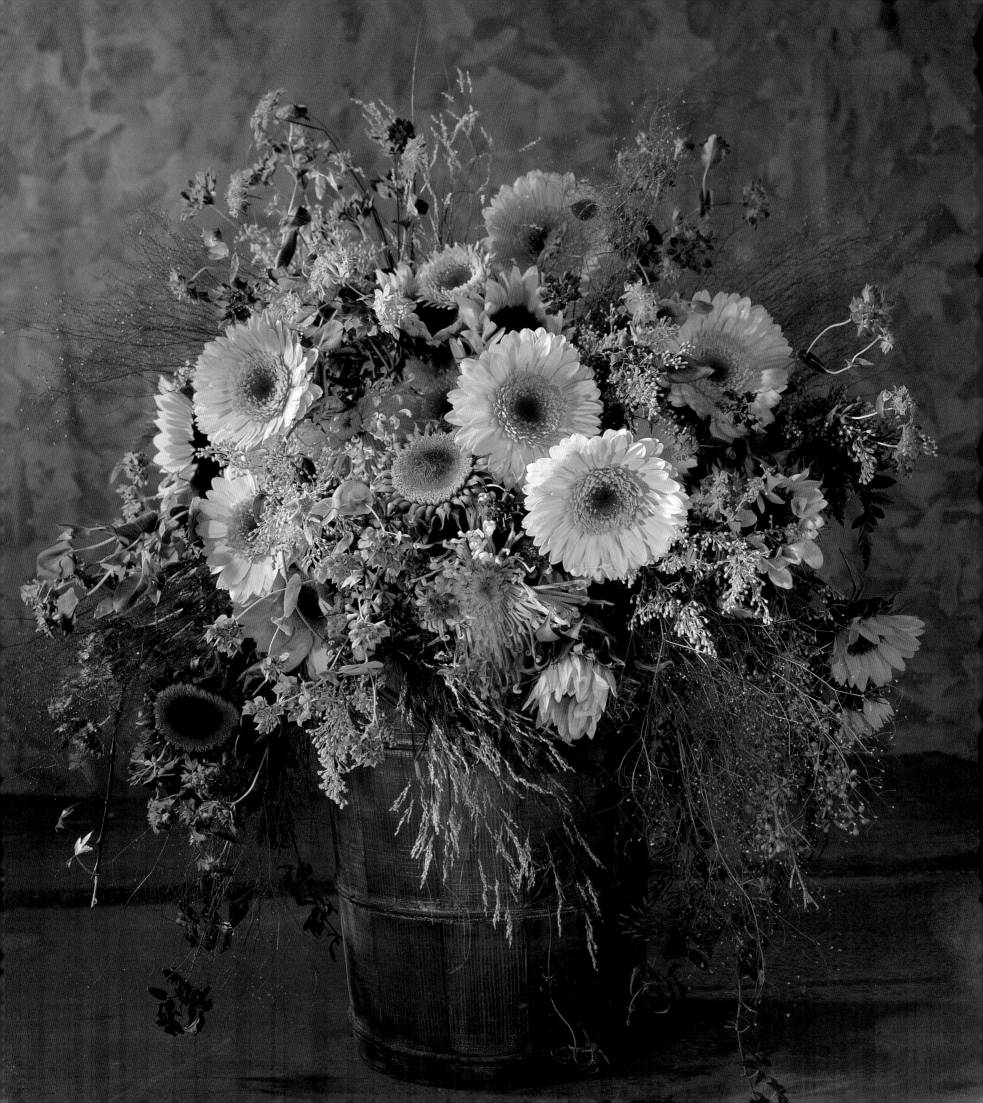

*T*he container is the foundation of the arrangement, the brick and mortar that gives it shape and support. It holds the flowers, lifts them, and presents them. From the point of view of the flowers, the container is a life raft, a capsule of watery sustenance in an arid environment. But to the flower stylist, the container plays the opening phrase in the melody of the arrangement. Your choice of container not only unlocks possibilities for your design, it also excludes possibilities. In this way the container begins to define your own sense of style.

Which comes first, the container, the flowers, or the theme of the arrangement? The answer is, it all depends and it doesn't matter, as long as these elements work harmoniously together. If you're making a gift arrangement to take to someone's home, you'll probably shop for a container you know will fit their decor, then design your arrangement to suit it. But if you're decorating your own dinner party, you'll probably rummage among the containers you already have, looking for the right one, or at least, one that will do.

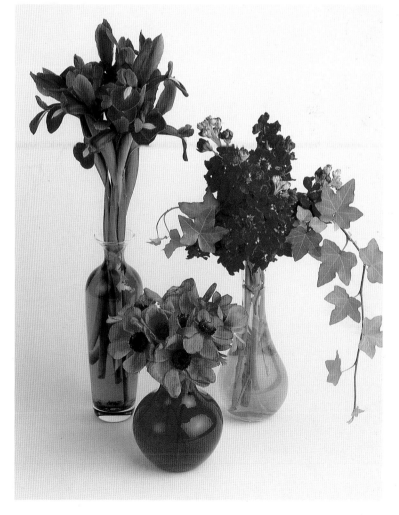

...

(Previous spread) Ordinary flower pots become artfully mysterious containers when they are wrapped with cocoa fiber and tied with raffia. The rustic fiber contrasts with the formality of soft, romantic-colored roses, orchids, and lady's mantle. A single monstera leaf, with scattered orchid blooms, completes the composition. Flowers by Elizabeth Ryan. Photo by Z. Livnat.

...

(Opposite) Sometimes the container can barely contain the flowers, as here with this exuberant display of colorful mums. Photo by Sidney Cooper.

...

(Right) Water dyed in adjacent colors plays against the blossoms and simulates the look of richly colored glass. The glass allows the shadow of the flower stems to remain part of the arrangement. Flowers by Stephen Smith for Florists' Review.

You don't get far into flower arranging without collecting containers you just know you will use, sooner or later. Some floral designers are passionate in the pursuit of the unusual, humorous, quirky, dramatic, or rare, and they scour flea markets, garage sales, consignment shops, and junk yards. Think too about found objects, such as a log from the woodpile, a slab of cut stone, or a hollowed-out vegetable or fruit. You'll soon find that almost anything can be made into a container for flowers. There are just three requirements:

- The container has to hold water. But a bottle, a plastic liner, a coffee can, a Tupperware insert, can always fix that.
- The container has to give structure to the arrangement.
- The container should work harmoniously with the flowers you have in mind, with the occasion and its setting, and with your own sense of style.

The container helps organize the design. Some containers, like Chinese ginger jars, provide structure on their own, because of their shape and the size of the opening. Other containers need the assistance of a frog, or a grid of floral tape. But even a flat plate will work, once you secure a block of floral foam to it.

There is meaning in the juxtaposition of flowers and container. A ceramic pitcher of daisies conveys one message, but three or five daisies in a frog says something else. Many people would be afraid to put a rustic basket of chrysanthemums on a formal dinner table with fine china and crystal—but someone with an adventurous spirit could make it work.

Casual occasions and settings call for low-key containers. Copper cookware, a watering can, or an earthenware pitcher contains a simple design for an everyday occasion. Old-fashioned pastel-hued roses are divine in soft, color-washed porcelain. They're equally charming in hand-blown vases of watercolored glass. A loose, country garden bouquet will be as much at home in a woven basket edged with green moss as in a bright ceramic jug.

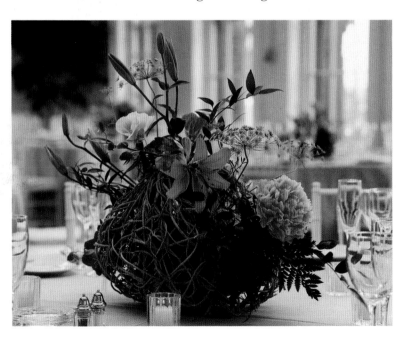

Formal, dressy occasions require refined containers, like gilded china, crystal, or silver. A formal arrangement need not be large. A small crystal bowl floating a single petite rose still makes an elegant statement.

Stylized designs, often inspired by the Japanese art of ikebana, are miniature dramas in which the container shares center-stage with a few carefully chosen flowers and stalks. A contemporary vase, sleek and dark, might call for three perfect lilies, or a studied composition of blue iris. A conch or nautilus shell, containing a single hibiscus flower and bedded in a shallow tray of sand, adds an evocative touch to breakfast by the sea.

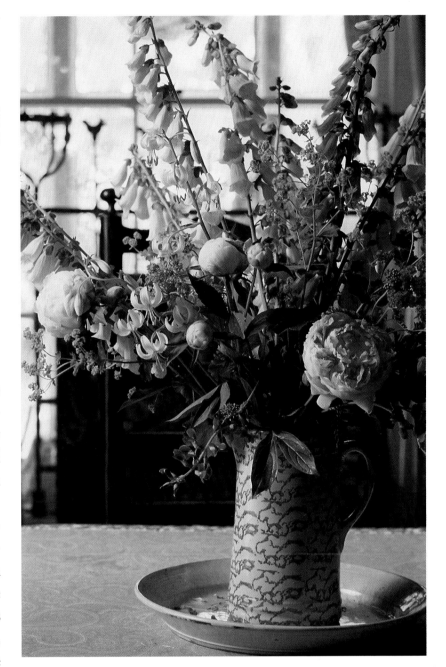

(Opposite) A basket of tangled vines conceals a small container of life-giving water. The rustic basket contrasts pleasantly with the few splendid blooms of peony, godetia, lily, dendrobium, and dill. Photo by Christine Newman.

(Right) The soft floral pattern on the ceramic jug is repeated in a varied form in the soft range of colors in the flowers and in the soft, spontaneous arrangement. Photo by Peter Margonelli.

CHOOSING A CONTAINER

GLASS. Clear glass containers can help convey the mood of the flowers by getting out of their way. Glass doesn't add a new color, and its form becomes indistinct behind the strong, green pattern of stems seen through the water.

Stems in water add depth to an arrangement. They appear to bend and mold themselves to the curves inside the glass. They can seem other-worldly, because you aren't quite sure where their shimmering, refracted images really are. You try to locate the stems by touch, but you can't—they are shielded behind the glass and water. The stems can become an austere counterpoint to the intense colors, intricate details, and touchable softness of the blooms themselves.

Clear glass ginger jars, which come in all sizes, are perfect for casual flower arrangements. But so are glass cylinders, cubes, bubble bowls, and fishbowls. Handfuls of colored or clear glass marbles add sparkle and light reflection in a vase or dish. They also support the stems and hold them in place. You can use pebbles, coins, shells, wood chunks, beach sand, or mosses in the same way as marbles, or try filling the space with crumpled cellophane, which almost disappears from view.

If you are not meticulous about removing all foliage from below the water line, the water will turn green and smell foul. Soft leaves under water invite spoilage, which your flowers won't like, and neither will you. This is true in any container, but uniquely visible through clear glass.

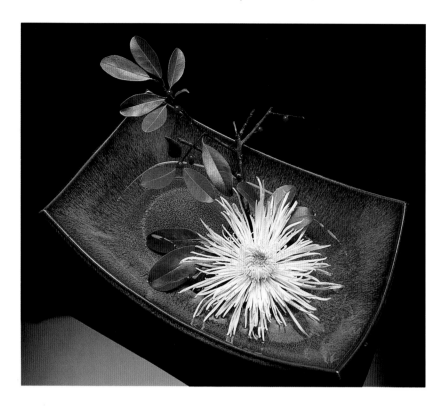

PORCELAIN. Glazed porcelain holds water like glass, but its opacity conceals the stems and removes them from the visual composition. Instead, it contributes its own color and shape. From a style point of view, porcelain and opaque glass are equivalent materials because the form and color of the container, and any image or raised motif, contribute to the floral design, but also can be a challenge to design around. While vases of white porcelain or of soft colors can retreat from the floral arrangement, strong colors could compete with the flowers themselves. They may need to be balanced by a monochromatic composition in an agreeable hue, or by a mass of blooms.

EARTHENWARE. The soft orange-brown of unglazed pottery—terra cotta—is the perfect complement to the greens of leaves and stems. It doesn't compete with the blooms. It looks simple and unpretentious, natural and earthy. It requires some sort of liner, as do cracked antique ceramic vases and bowls. Often you can put a glass jar or vase inside the pottery container, adding the color and form of one to the clean practicality of the other. If the jar peeks out, cover it with sheet moss.

BASKETS AND BOXES. Like earthenware, baskets and wooden boxes speak of the hearth and the country. They are plant material, so their colors correspond to those of still-living plants. Wooden boxes make a sturdy, masculine base for massive and dense arrangements. Baskets often have handles, so basket arrangements are easy to move and to present. Basketry and boxes in all shapes and sizes can be waterproofed by covering the inside with thick sheets of plastic garbage-bag material, or by finding a nonporous container (even a mixing bowl or a small bucket) to form a lining.

METAL. Silver is elegant and refined, but it can also be showy and bright. Patinated copper and cast iron speak of quality and permanence. Urns of burnished bronze and tarnished brass feel warm and venerable; they will not compete with the flowers the way shiny silver might. Floral preservatives may cause pitting in silver, brass, bronze, and copper, so vases of these metals also are best protected with a liner.

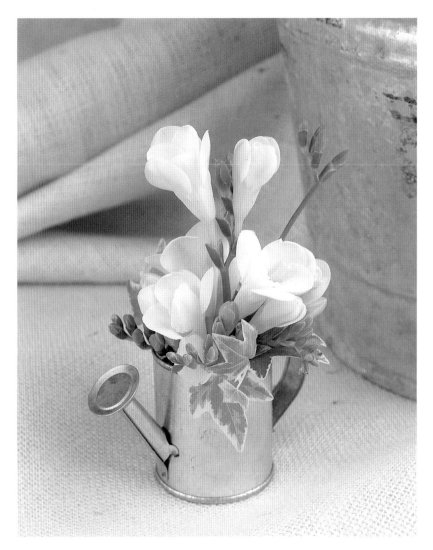

A tiny watering can makes a playful home for a bouquet of freesia and miniature ivy. Photo by Stephen Smith for Florists' Review.

FOUND OBJECTS. Once you distinguish between the container you see and the inner liner that holds the water, you'll find no limits to what you can creatively adapt. The world is full of unusual containers for floral designs. A section of iron pipe, the empty rusted hub of a carriage wheel, an abandoned birdcage, weathered metal milk cans, once lined, can all be filled with unruly vines, twigs and branches, and field and garden flowers resplendent with seasonal color. Unusual containers might include items of clothing, such as slippers or hats. A scarf looks fresh tied around a vase or jar for added intrigue and interest. A paper bag, printed cardboard box, or a painted drawer, if suited to your design concept, can make a very original statement of style.

SUPPORTING AND ANCHORING THE FLOWERS

The container supports the flowers and helps them stay where you put them. The form of the container, and the size and shape of its mouth, together determine the types of designs which might work best in it. A narrow opening holds only a few stems, but it keeps them in place. A wide-mouthed pitcher or vase can hold many stems, but they tend to flop around in disarray, at least until you add enough to fill the opening. The designer is not entirely at the mercy of the container's geometry because we have floral tape, metal frogs, wire mesh, glass marbles, stones, and floral foam for separating and retaining the stems. But the simplest structure, and often the best, is the classic method borrowed from the Japanese designers: cut branches and stems with crotches, crossed and wedged against one another in the vase, create a matrix in which other stems can lodge. The grid of crossed stems divides the vase opening, helping you distribute the flowers as you compose the arrangement.

Shallow dishes, edged trays, platters, and low bowls provide very little access to water, and insufficient-to-no stem support. A pin-holder, frog, or kenzan secures the stems, but the arrangement is limited by the necessity to balance the weight of the flowers against the weight of the holder. Stability can be added by temporarily securing the holder to the dish with florist's clay or "Sure-Stik," a very sticky waterproof gum. Instead of a frog, you can use a small block of sculpted floral foam, but it will also need to be anchored in place and then covered with moss.

Large urns also pose special problems. If they're full of water they're nearly impossible to move, they're not always watertight, and they're usually even bigger than you thought. Always set a smaller container inside a large urn. Mound foam together to build the inner container up to the height you want, and anchor it in place with florist's tape.

Floral foam, presoaked and dripping water, is the perfect material for extending your design opportunities. It can be shaped and stacked. Different densities are available; the thickness and fragility of stems and their ability to take up water determine which density of foam to use. Floral foam is essential to some designs because it allows you to position flower stems precisely. Huge open-mouthed concrete urns filled to overflowing with tall weighty stems, a glorious reception display towering over a base of narrow Plexiglas tubes, a basket smothered under a profusion of snapdragons and roses, all such arrangements rely on floral foam, not only to supply water, but also to provide a strong, coherent foundation.

Floral tape is excellent for constructing a grid over the mouth of a vase to separate the individual stems. The tape is available in white, clear, and green, but if not hidden by draped foliage, even the green tape will need to be covered by moss, raffia, or ribbon. Some designers make a framework by crumpling wire mesh into the opening of the vase, but the wire can scratch the vase, and it's unnecessarily harsh on the stems, too. Support problems generally can be solved with interlaced stems of greenery, or with blocks of foam.

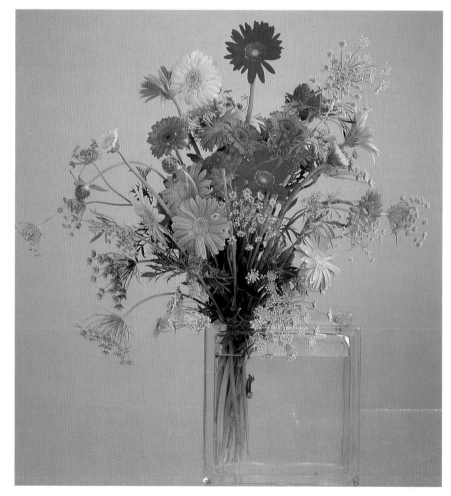

A simple strip of floral tape traps the hand-tied bouquet at one end of the glass block, adding a contemporary asymmetry to an otherwise simple arrangement of gerbera daisies and Queen Anne's lace. Photo by Stephen Smith for Florists' Review.

COLLECTING
AND
CREATING CONTAINERS

Taking the time and effort to collect unique containers, and even to design and commission an original or handmade collectible, will make your floral arrangements stand out from the rest. Even when not in use, a pleasing hand-crafted container or fine vessel can be an important and distinctive sculptural accessory, whether alone or clustered with similar pieces. Potters, ceramists, glass blowers, woodworkers, and metalsmiths are all artists with an affinity for living and organic materials, so the vessels they create are likely to harmonize with floral styles.

It's also rewarding to create your own unique containers, starting with a glass or plastic jar or vase. You can paint the outside of glass and plastic any color you like, using artist's acrylics or regular enamels. Put a stick in the mouth of the jar or glass so you can hold it upside down without getting your fingers in the paint. Alternatively, you can cover the outside surface with double-stick tape, as a base for a collage of paper or foil, fabric scraps, pressed and dried leaves, or bark. Fragile surfaces can be protected with a coating of lacquer or varnish, in a matte finish or a shiny one. Leaves, grasses, mosses, or other live materials make a very unusual surface treatment and will look fresh without any finish coat.

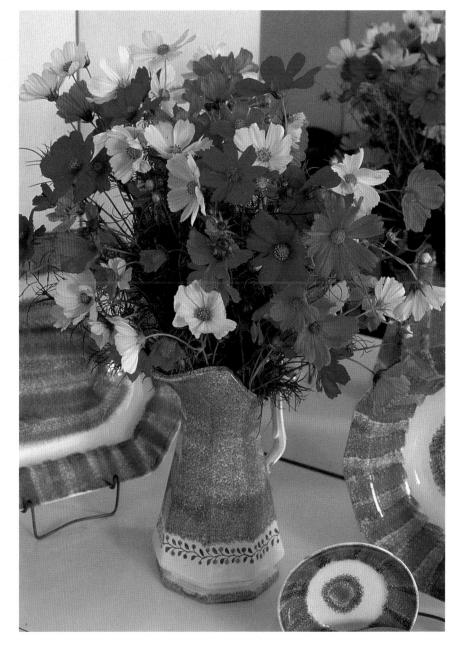

...

Simple country flowers show at perfect ease in a simple container. The height and shape of the container should work with the height of the flower stems. Soft colors and natural shades, or white, will complement all floral hues without competing for attention. These hand-painted ceramic dishes have the same soft palette of colors as the bouquet of cosmos. Photo by Peter Margonelli.

CONTAINERS FOR
DRIED AND FAUX FLOWERS

Choosing a container for a dried or silk arrangement follows the same considerations as for fresh ones, except the container does not have to hold water. This is why preserved flowers present ever so many more options for arranging. Water is not only unnecessary, but moisture is an enemy of dried flowers, entering the cells of the petals and turning them brown. The best way to preserve the color and shape of dried flowers is to spray them with a sealant, or to place them in an airtight glass dome or shadow box. The sentimental significance of flowers that you dried following a wedding or christening far outweighs any diminution of beauty, loss of color or of perfect shape, that they may suffer as they age.

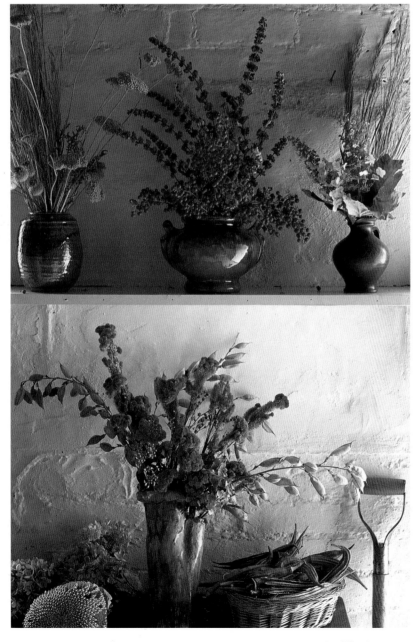

A collection of soft-hued dried flower arrangements grace these rough-hewn shelves. Photo by Peter Margonelli.

ESSENTIAL MATERIALS

- Floral foam, for supporting flowers in virtually any container, comes in two grades, instant and standard. Instant is softer and holds more water; you can poke a tulip into it. Standard can support heavy branches. Soak the foam in water for about ten minutes, until it's completely saturated. Cut with a sharp kitchen knife.
- Floral tape, a green cloth-based adhesive tape for anchoring floral foam in containers and for building grids that separate stems in vases. Floral tape stays put even when wet.
- Stem-wrap, a soft, stretchy tape for attaching stems to picks, wrapping bouquets, and boutonnieres, and generally hiding wires and other support materials.
- Floral clay, or "Sure-Stik," a sticky waterproof substance for anchoring frogs in vessels.
- Floral wire, for making branches and stems into garlands and wreaths, and for attaching flowers, cones, or plastic fruit. Look for the kind that's covered with soft green chenille, or use green plastic-covered twist-ties.
- White Styrofoam forms, for making wreaths and topiaries. White Styrofoam is softer and easier to use than either green-painted Styrofoam or bundled straw.
- Wooden picks, small wooden sticks with a length of wire attached to one end, for anchoring stems and soft stalks. Avoid metal picks; the sharp edges can cut you.
- Spray sealant, for keeping moisture out of the dried flowers.

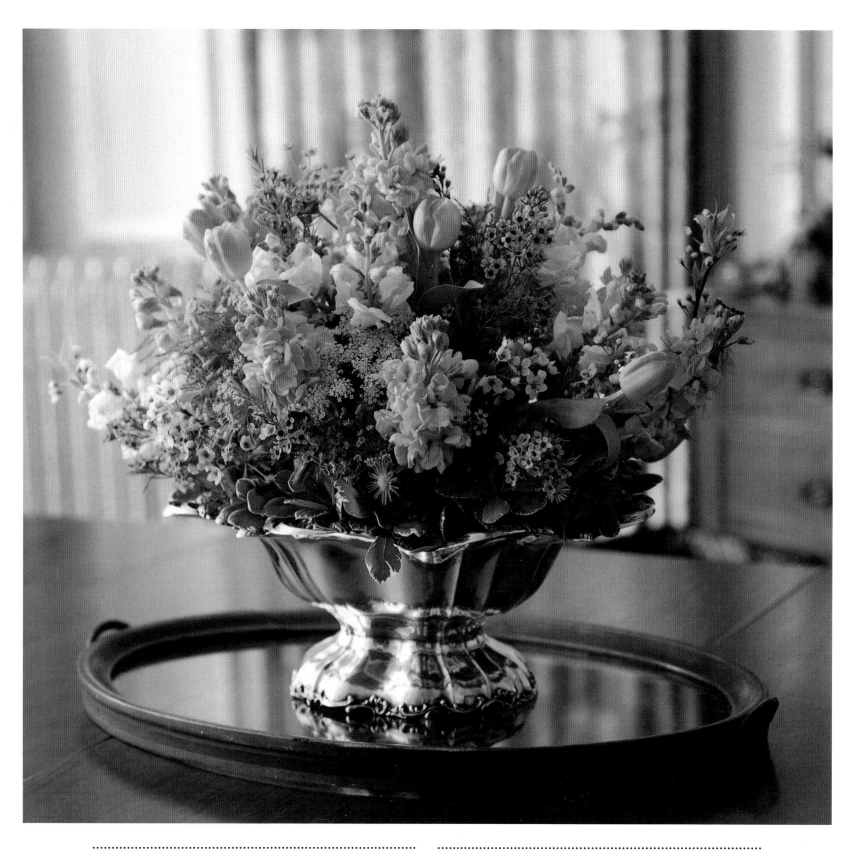

(Above) A silver compote lends a formal air to this mass arrangement of pink tulips, blush stock, waxflowers, and asters. The shape of the container echoes the shape of the arrangement. Photo by Maripat Goodwin.

(Opposite) The silver pitcher reflects its dark surroundings and drops from view, leaving center-stage to the blowzy orange poppies. Photo by Georgia Sheron.

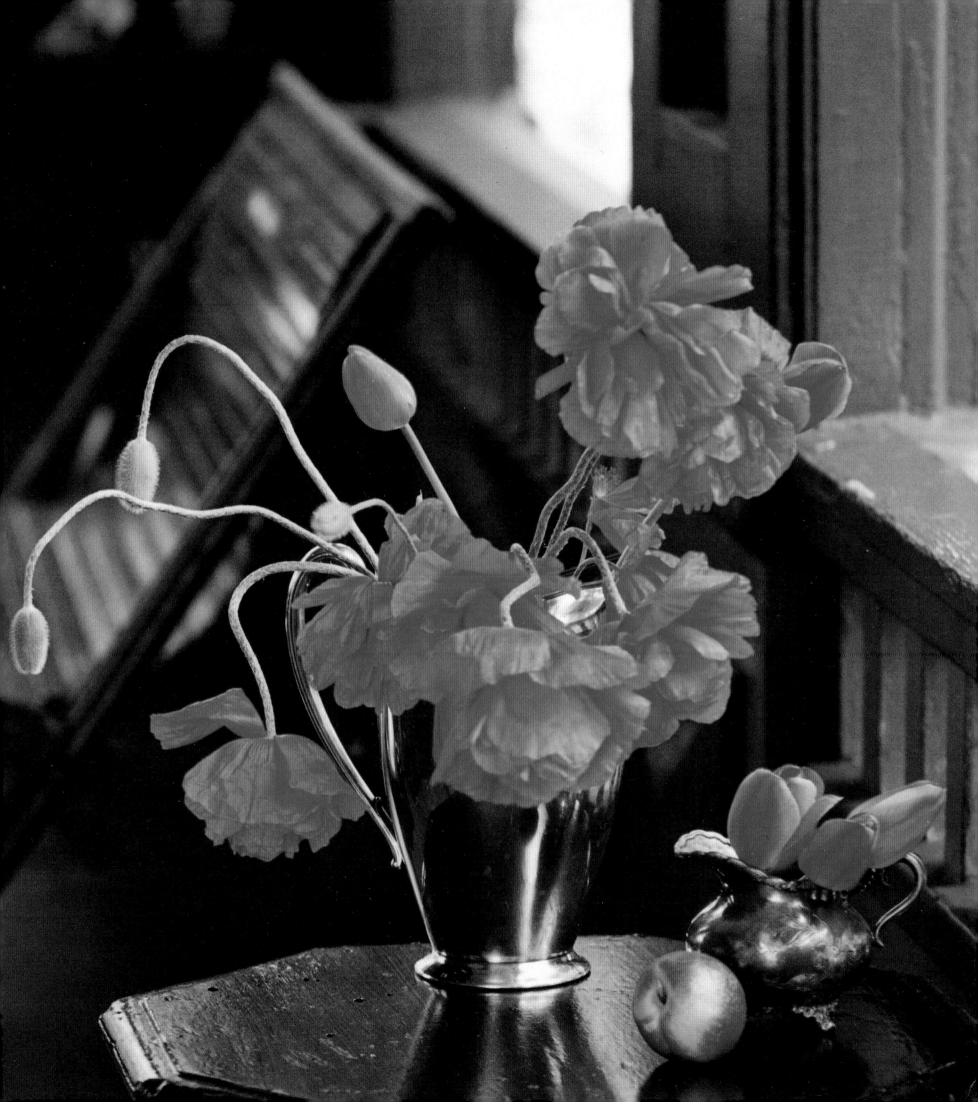

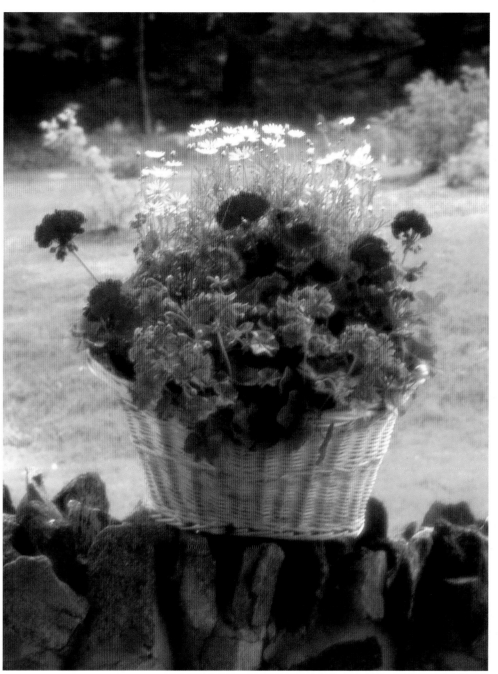

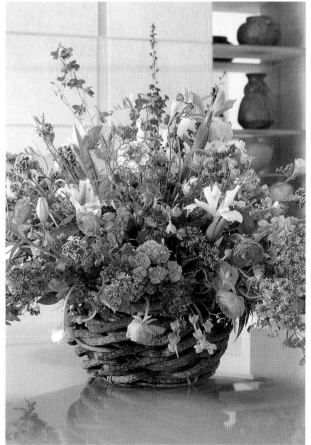

(Above) The charming mixture of iris, lily, leptospermum, lilac, freesia, rose, and dianthus complements the country basket. Photo by Phyllis Keenan.

(Left, top and bottom) Baskets harmonize with most species of flowers, though they must have a water container and a block of floral foam. These arrangements are all well-suited to their rustic containers. (Top) Flowers and photo by Vena Lefferts. (Bottom) Devaney Stock Photos.

(Opposite) The natural world supplies its own container for this profusion of stargazer lilies, liatris, lavender delphinium, and gypsophilia. Flowers and photo by Susan Groves.

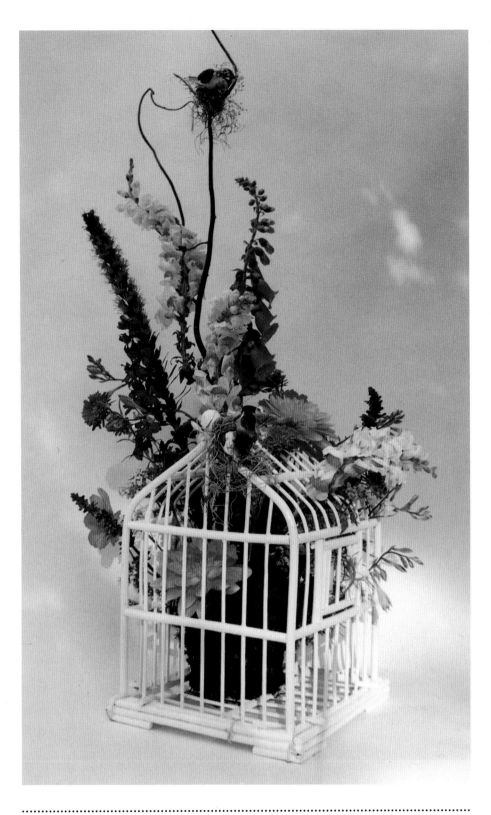

..

(Above) Flowers, reaching for the light, escape the confines of the vacated birdcage. Flowers and photo by Kasha Furman.

..

(Opposite) A gold compote sparkles over gilded votive candleholders, creating a festive foundation for this holiday arrangement of multicolored roses, blue anemones, and green pine boughs. Flowers by Elizabeth Ryan. Photo by Z. Livnat.

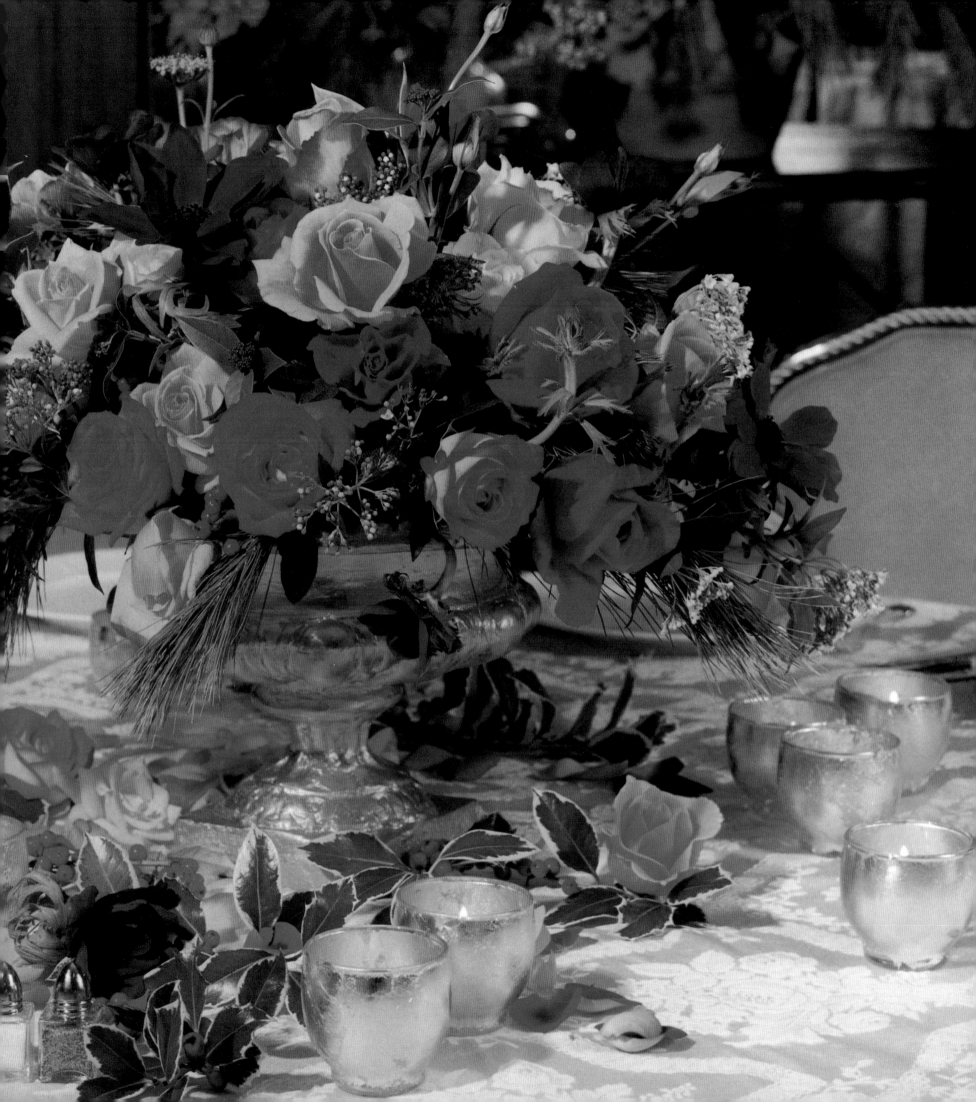

(Opposite, top) To create a long mound of flowers, choose a long container. This white ceramic box holds asters, sweet peas, roses, and primula supported by a trimmed-to-fit portion of Oasis floral foam. Photo by Stephen Smith for Florists' Review.

(Opposite, bottom) A hidden grid of floral tape laced across the mouth of this wide bowl keeps the blossoms in place. The arrangement includes scabiosa, kalanchoe, bouvardia, and heliopsis, placed closely together and ringed with foliage to conceal the tape mechanics. Photo by Stephen Smith for Florists' Review.

(Below) A block of floral foam inside the container supports the stems of these irises and tulips. Like the spring sunshine, light plays off the polished brass container. Flowers and photo by Kasha Furman.

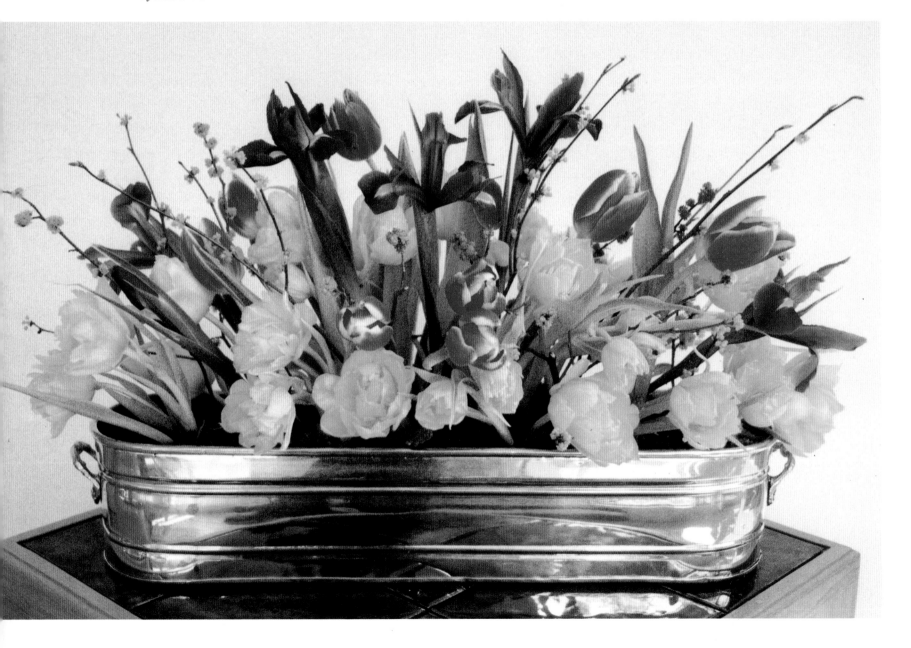

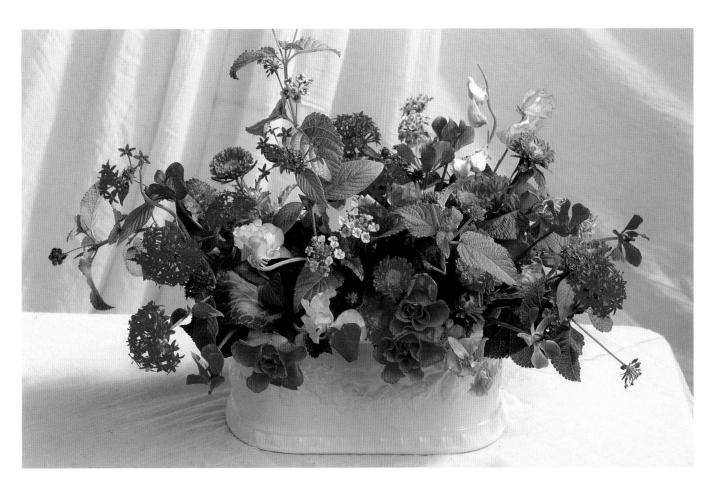

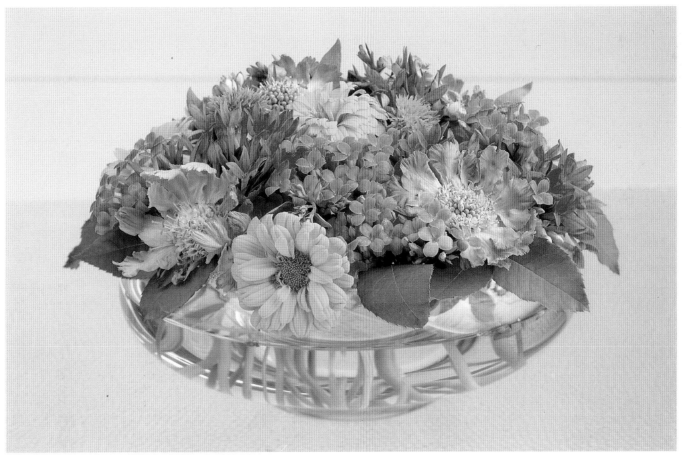

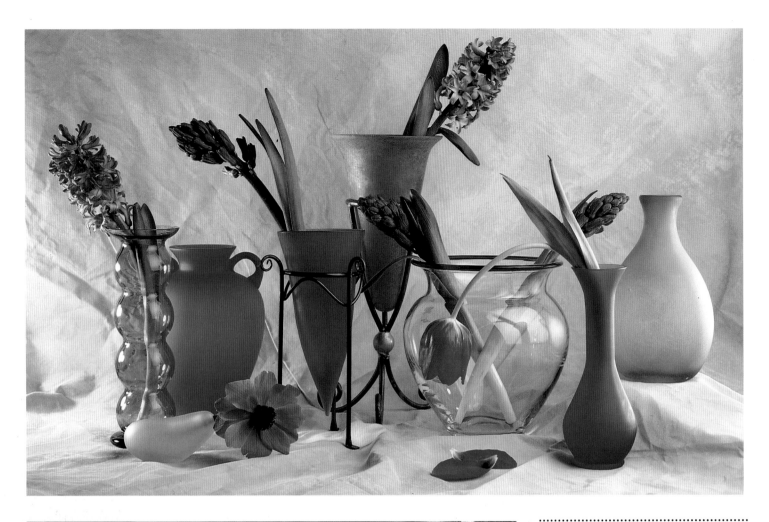

(Above) The combination of harmonious colors of clear and frosted glass makes these containers work so well together. Photo by Zeva Oelbaum.

(Left) A sheer silk scarf transforms a simple container of purple dendrobium orchids. Photo by Georgia Sheron.

(Opposite) A clear glass bowl may need some mechanical help to hold the flowers in place. Clear glass marbles position these colorful garden roses. Photo by Peter Hōgg.

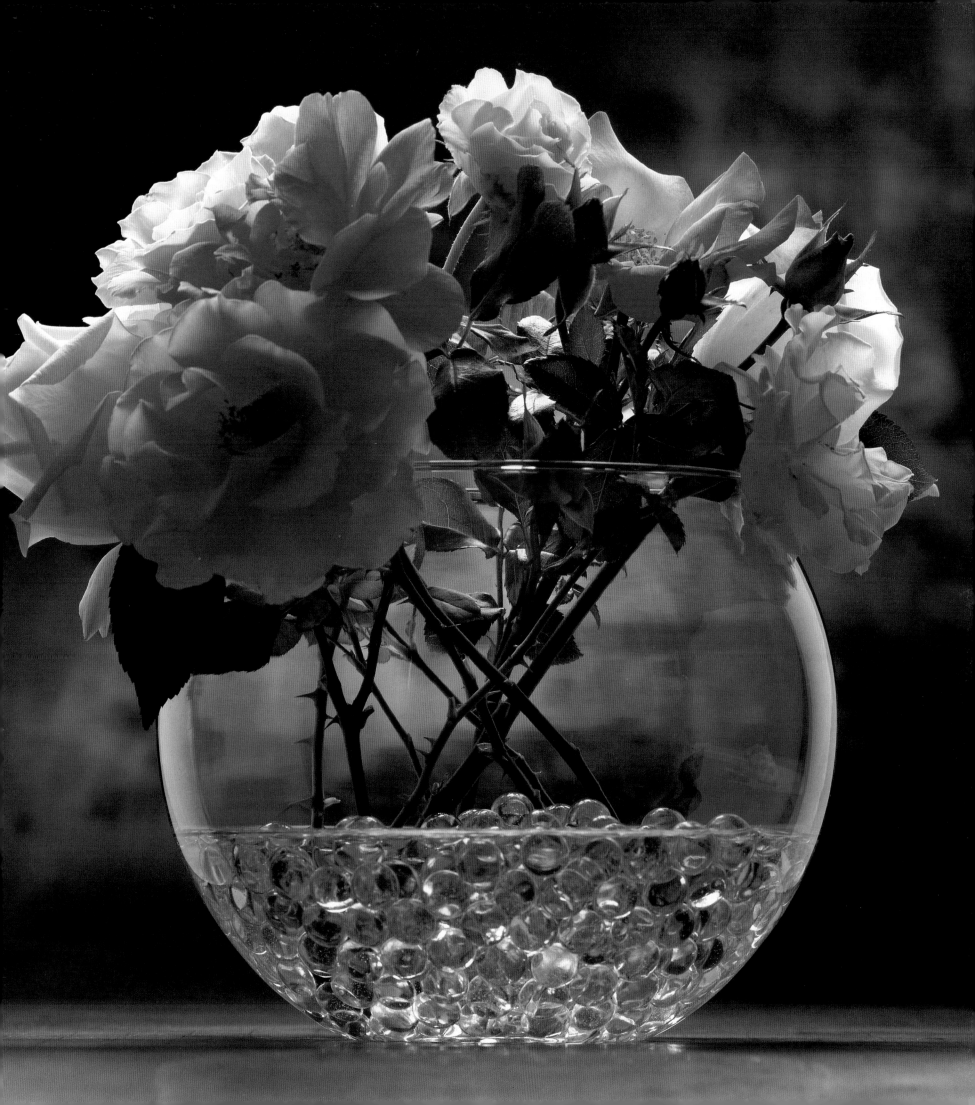

(Right, top) Tall gladiolus fan outward from a tall glass vase. It's difficult to improve on the pure simplicity of this traditional combination. Photo by Grey Crawford.

(Opposite) Sinuous sprays of crocosmia play off the wiggly shape of the vase, whose deep cobalt color complements the rich red-orange blossoms. Photo by Grey Crawford.

(Right, bottom) Tropical foliage echoes the shape of the blue glass vase, creating a suitable foundation for the tall sprays of monkey grass and the two white anthurium blossoms. Photo by Grey Crawford.

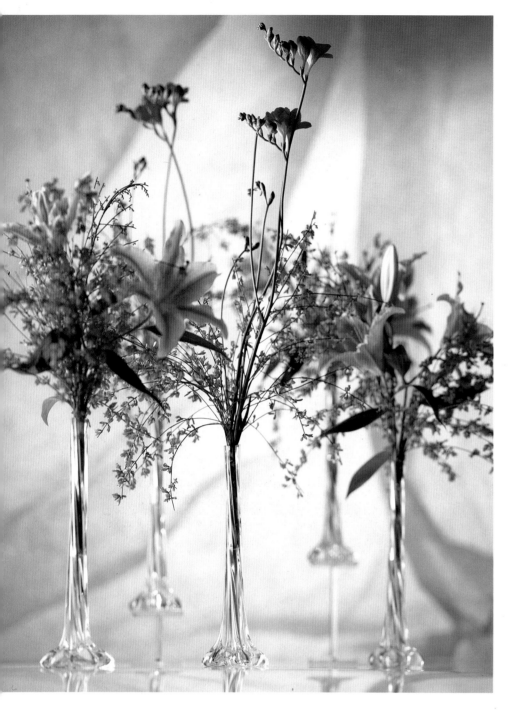

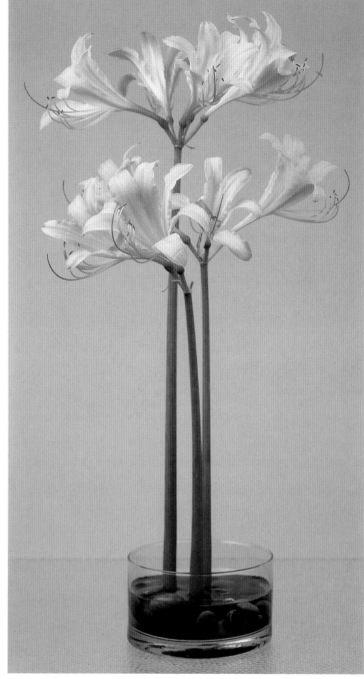

(Above, left) A cluster of pencil-thin bud vases makes an ethereal arrangement of pink lilies, freesia, and genista. Photo by Peter Hōgg.

(Above, right) Three short nails glued to the bottom of this shallow glass container support three long-stemmed lily stalks. A handful of river rocks hides any trace of the mechanics. Photo by Stephen Smith for Florists' Review.

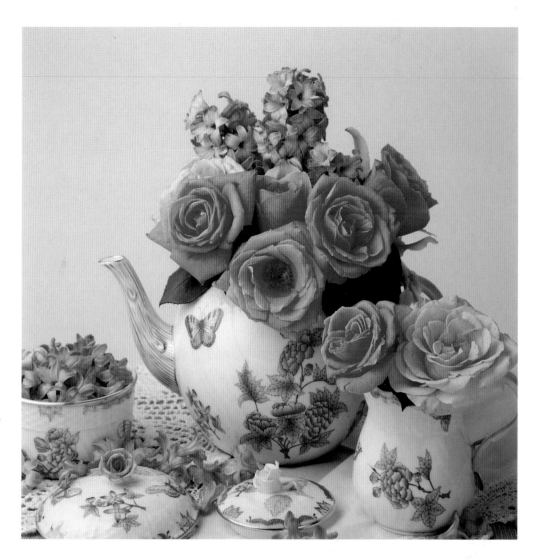

The flowers are virtually the same, but the china teapots are quite different. Each arrangement consists of container together with flowers, and changing either element changes the feeling and tone of the composition. Photos by Stephen Smith for Florists' Review.

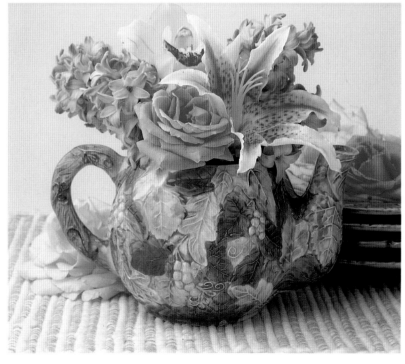

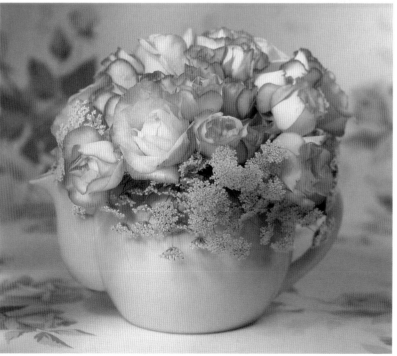

(Left) Mixed dahlias sit prettily in a pebbled glass vase. Photo by Eliot Wadsworth/White Flower Farm.

(Below, left and right) A low water level in a tall glass container creates the illusion that the container is low, and the tall flower stems seem to have no visible support. Photos by Peter Hōgg.

(Opposite) This unusual container lifts and presents a spreading mass of lilies, goldenrod, eremurus, and heliconia. Flowers by Ginger Lind for Preston Flower Market. Photo by Jeff Covington.

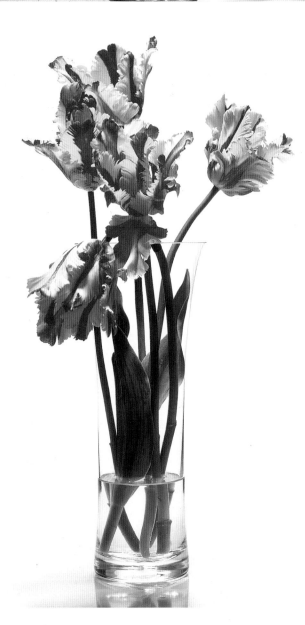

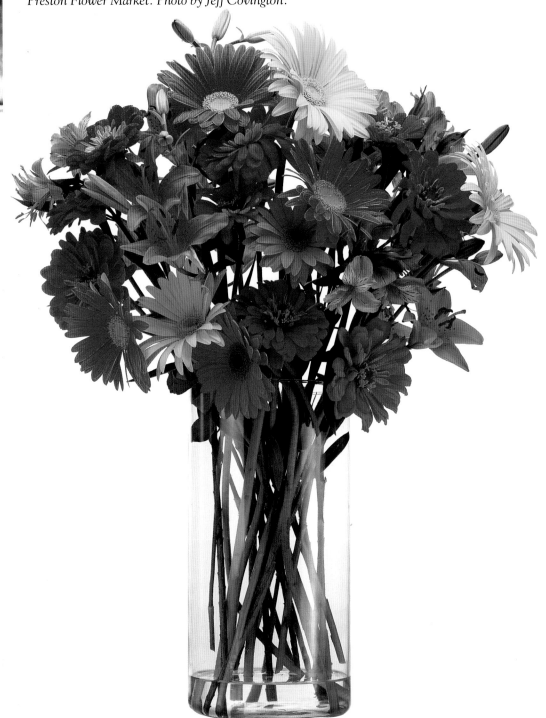

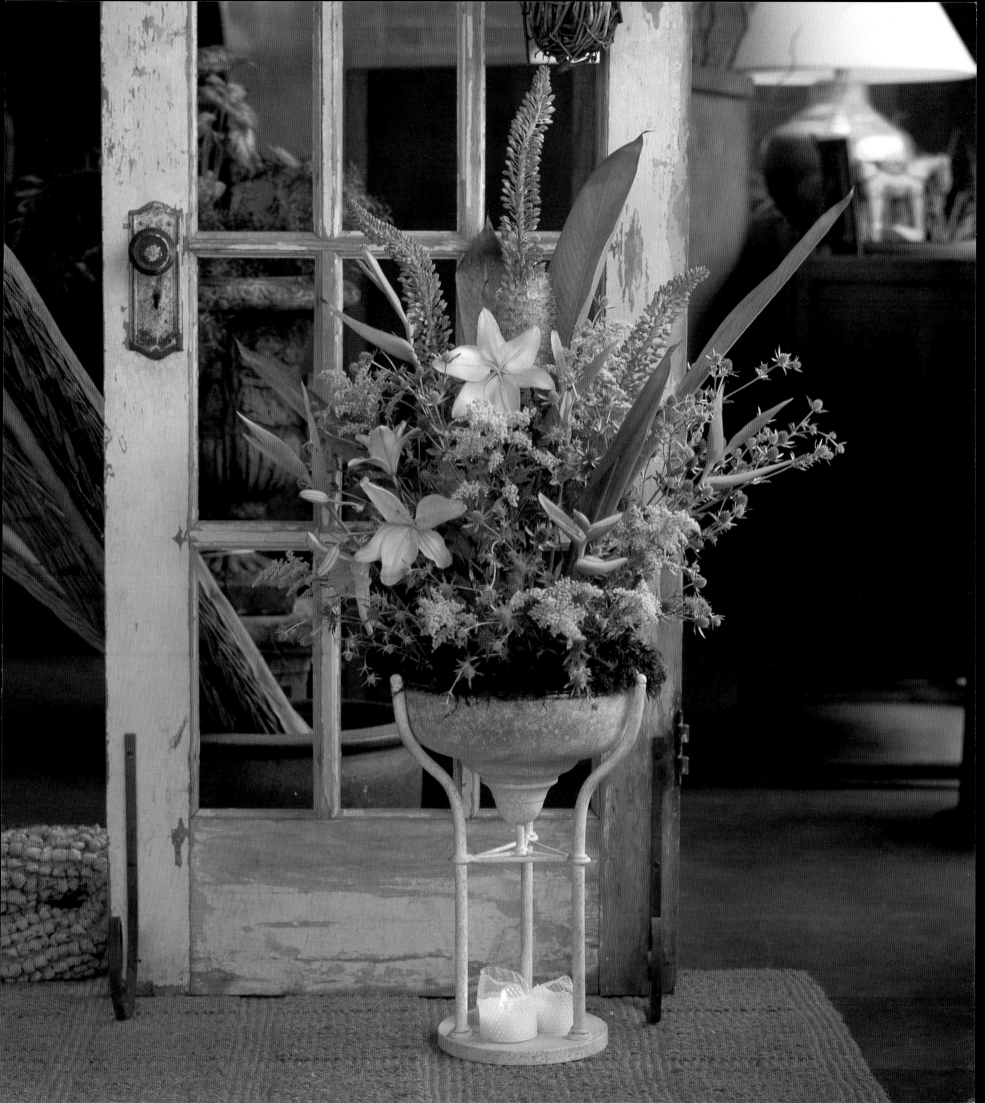

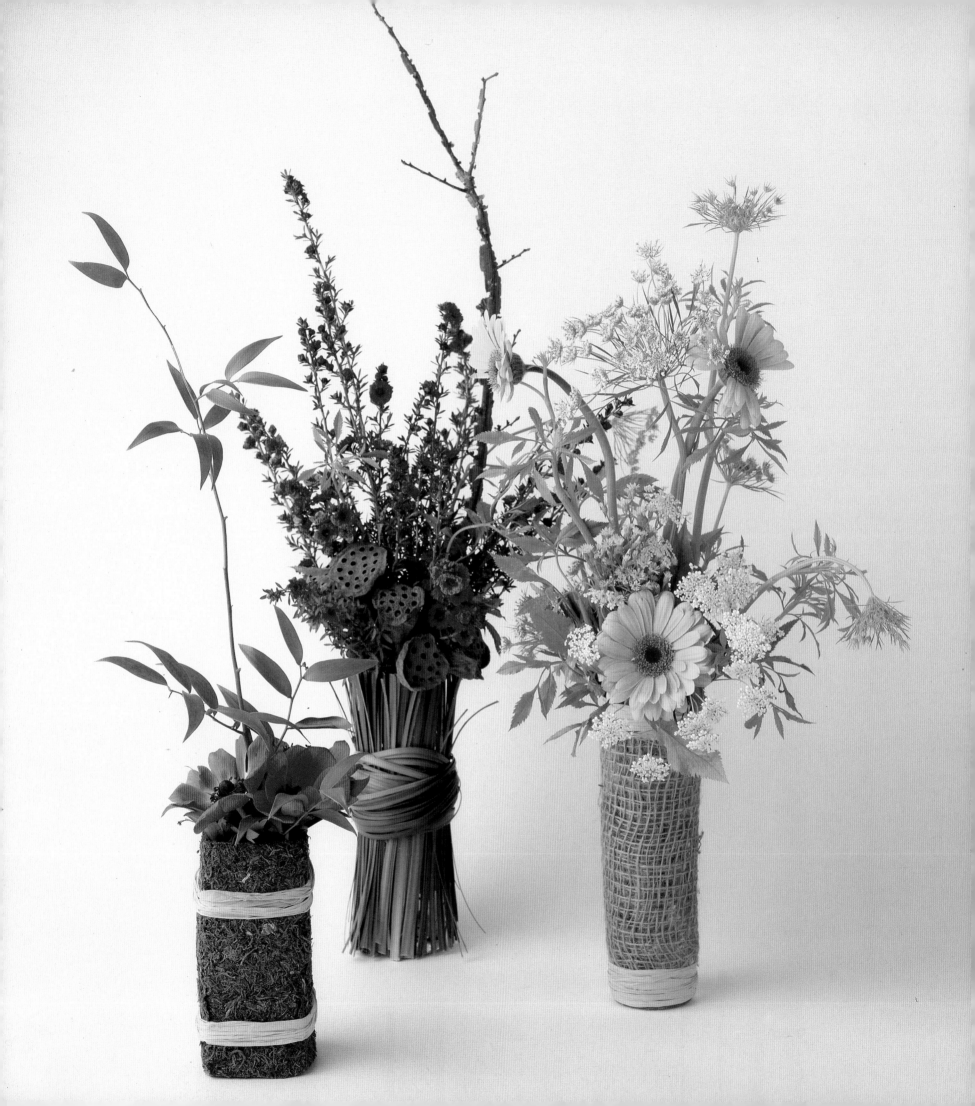

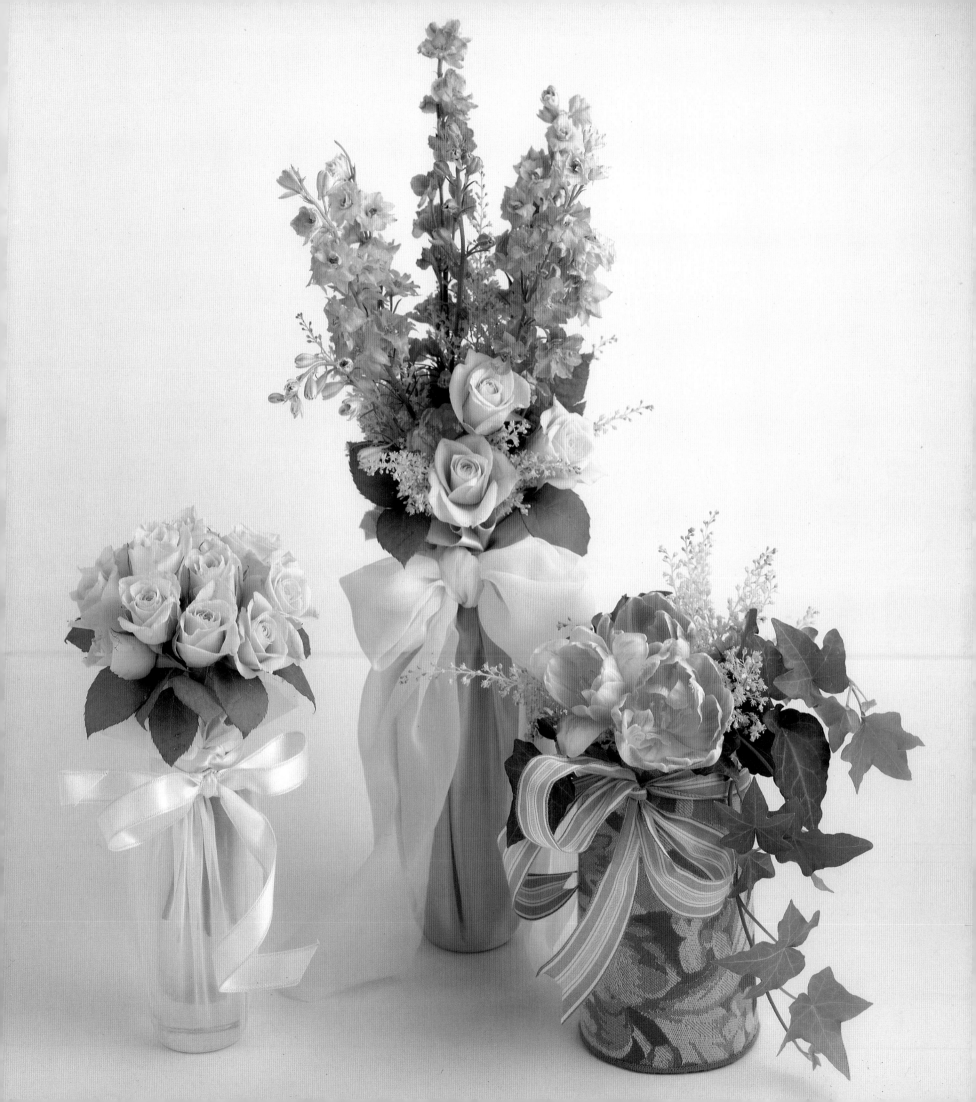

(Previous pages) Virtually anything can be wrapped around a simple jar, to create a customized container. Ties of raffia complement the earthy wrappings (left), while satin and chiffon ribbons add a romantic note to the fabric wrappings (right). In each case, the designer's goal is a harmonious composition. Photos by Stephen Smith for Florists' Review.

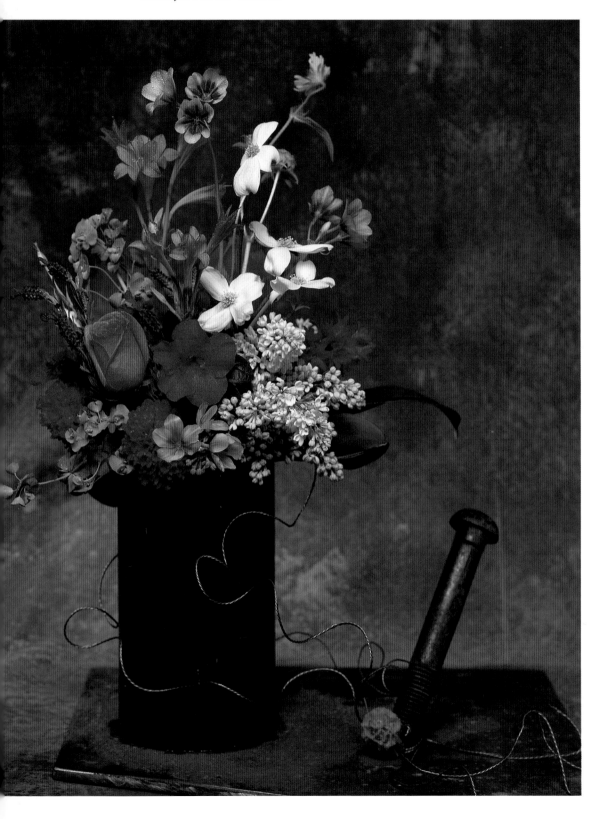

(Left) The dark base and container add a dramatic, earthy feeling to this sky-reaching arrangement. Flowers by Fabrice. Photo by Z. Livnat.

(Below) This small arrangement makes a strong, elegant statement. Photo by Peter Fink/Picture That.

(Right) Long, loose stems of foxglove, roses, and lady's mantle draped from an unused Panama fan bring a carefree feeling in to this garden room. Photo by Peter Margonelli.

(Below) The ceramic crock gives a country flavor to this arrangement of mixed sunflowers. Devaney Stock Photos.

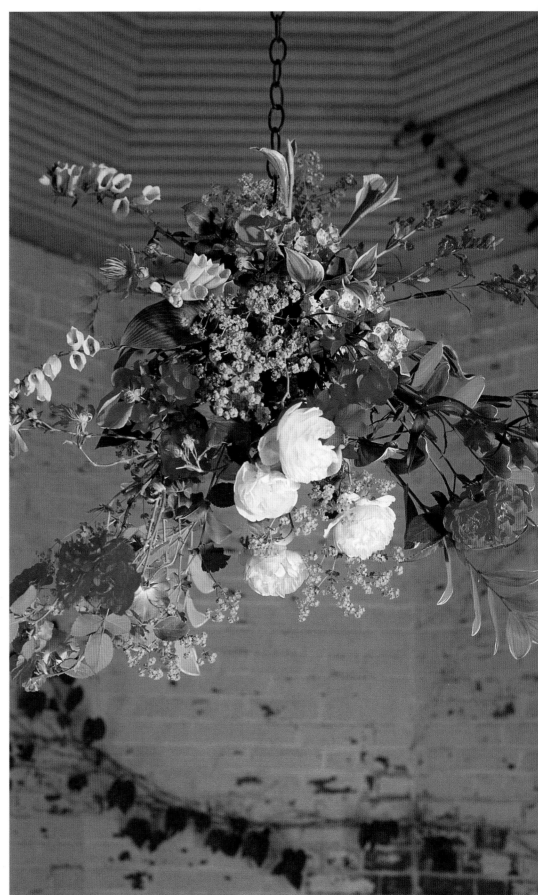

Almost anything can be a container for flowers provided there is enough room inside for water to feed the flowers. Sometimes just a saucer's worth of water will do. Flowers by Marlo. Photo by Emily Miller.

Handpainted pottery and fresh garden flowers are the perfect match in a patio setting. Flowers and photo by Gloria Nero.

(Right) A wrap of green moss tied with a raffia bow creates a suitable container for Queen Anne's lace, lavender waxflowers, blue statice, hosta, snapdragons, yarrow, and purple loosestrife. Flowers and photo by Kasha Furman.

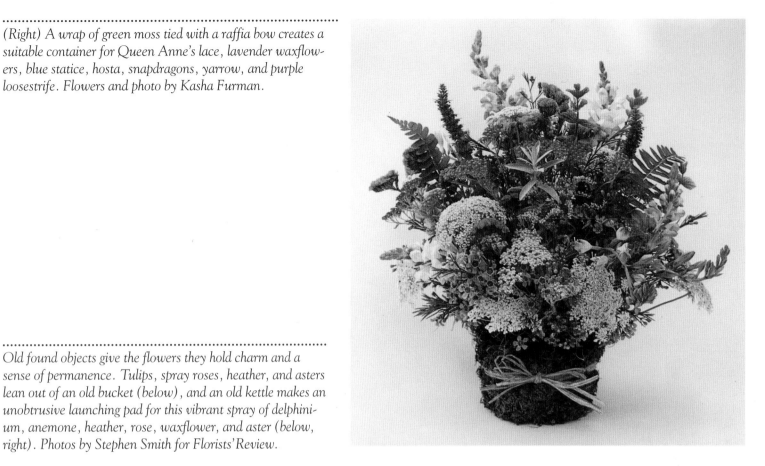

Old found objects give the flowers they hold charm and a sense of permanence. Tulips, spray roses, heather, and asters lean out of an old bucket (below), and an old kettle makes an unobtrusive launching pad for this vibrant spray of delphinium, anemone, heather, rose, waxflower, and aster (below, right). Photos by Stephen Smith for Florists' Review.

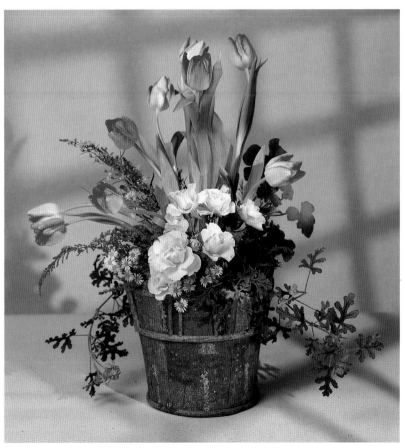

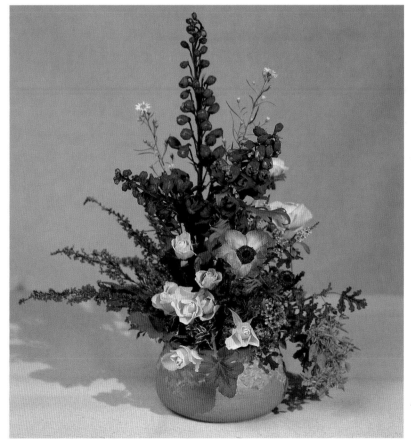

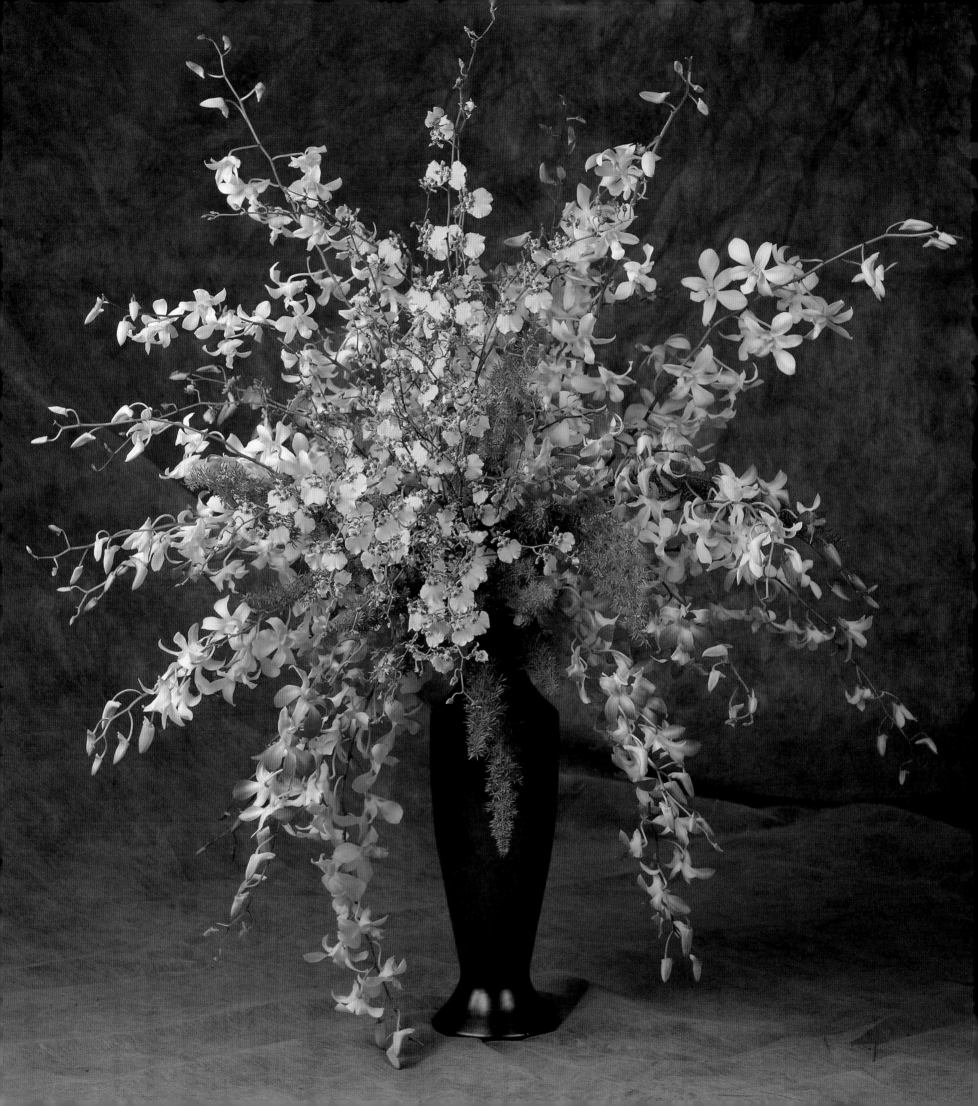

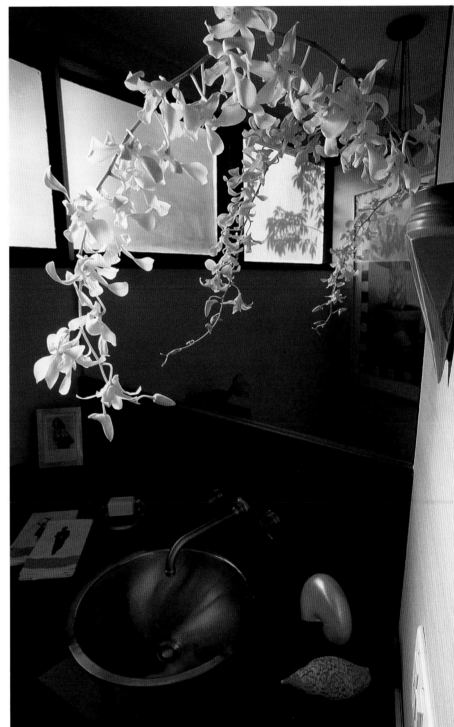

(Opposite) A dramatic display of spray orchids fans out around the tall vase. Photo by Stephen Smith for Florists' Review.

(Right) A wall sconce provides the perfect support for these gracefully arching branches of orchids. Photo by Grey Crawford.

(Below) A stark bowl of flowers makes a dramatic statement on a conference room table. Photo by Grey Crawford.

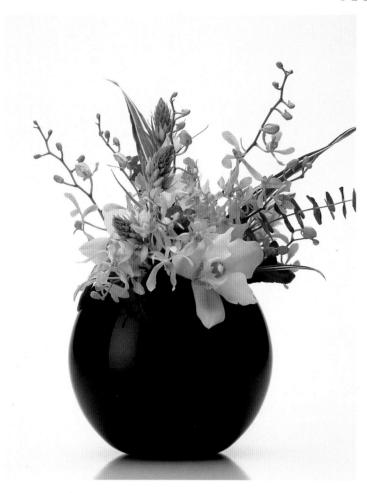

The shape of the container helps generate the shape of the arrangement. Even with similar flowers and controlled colors, different shaped containers will lead to different arrangements. The shape of the container's neck has the biggest effect on the shape of the arrangement. The proportional relationship between the height of the container and the height of the flowers also has a lot to do with the ultimate effect of the composition. Photos by Peter Hōgg.

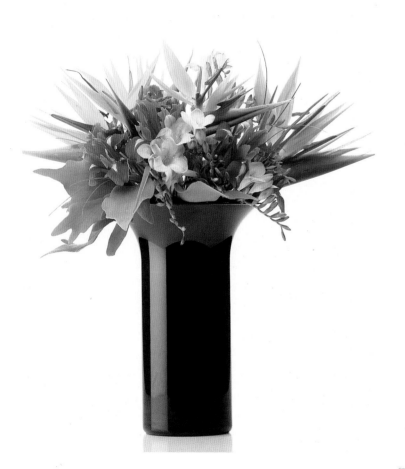

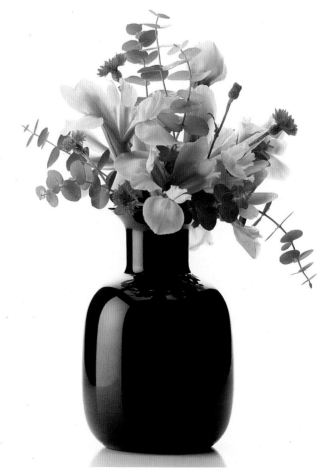

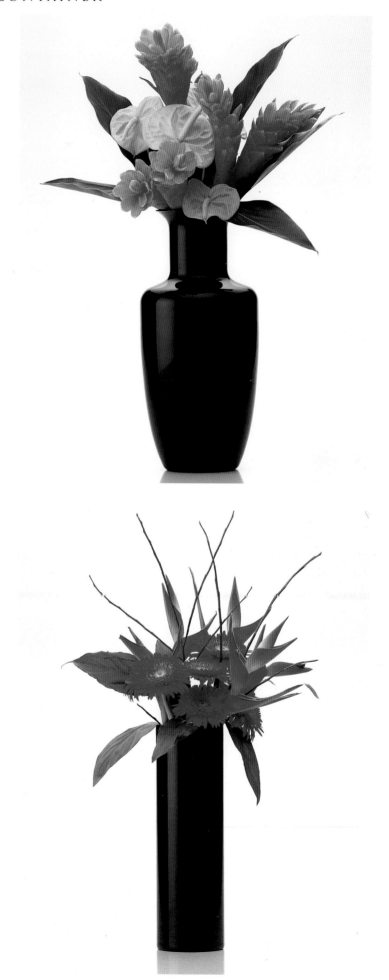

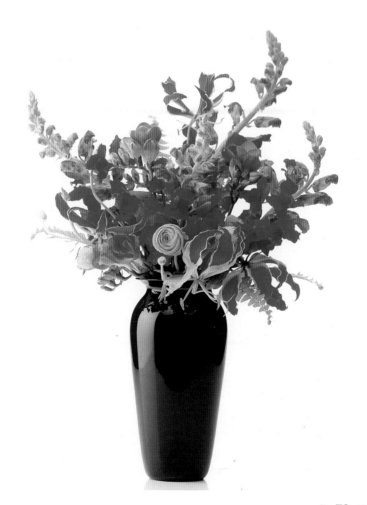

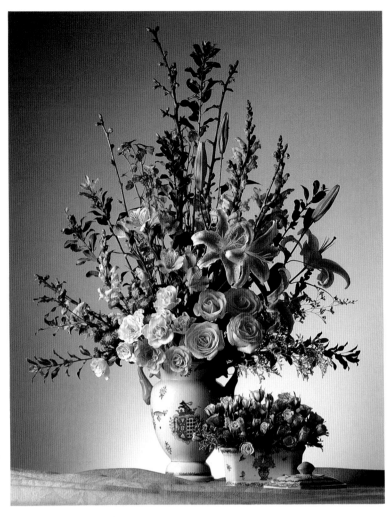

Evoking nostalgic images of gentler days, these striking arrangements in Chinese porcelain—one large, one small—contain stargazer lilies, Osiana roses, delphiniums, snapdragons, asters, apple blossoms, Carola alstroemeria, and limonium. Photo by Peter Hōgg.

(Below) Country-like arrangements of fabulous pastel flowers delight the eye. Slightly formal white porcelain containers (below right) or unusual glass vases provide a pleasing presentation. Photos by Peter Margonelli.

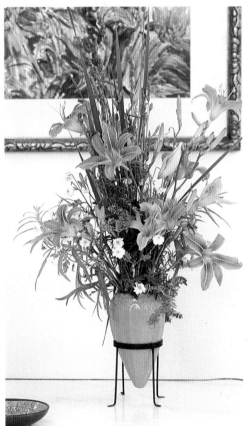

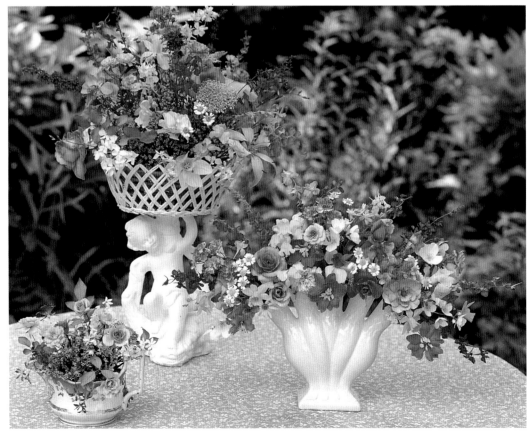

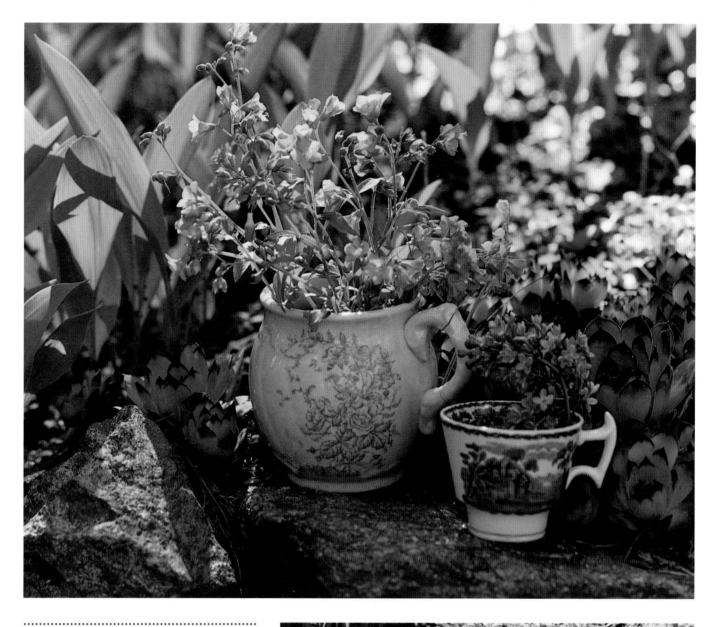

(Above) Two antique ceramic cups present delicious sprays of delphinium and lilac. It's always fun to put real flowers in a floral-painted china container. Photo by Georgia Sheron.

(Right) With spring flowers, there's no such thing as a bad glass vase. A cluster of vases creates a different presence than a mass arrangement, even with about the same floral mass. Photo by Georgia Sheron.

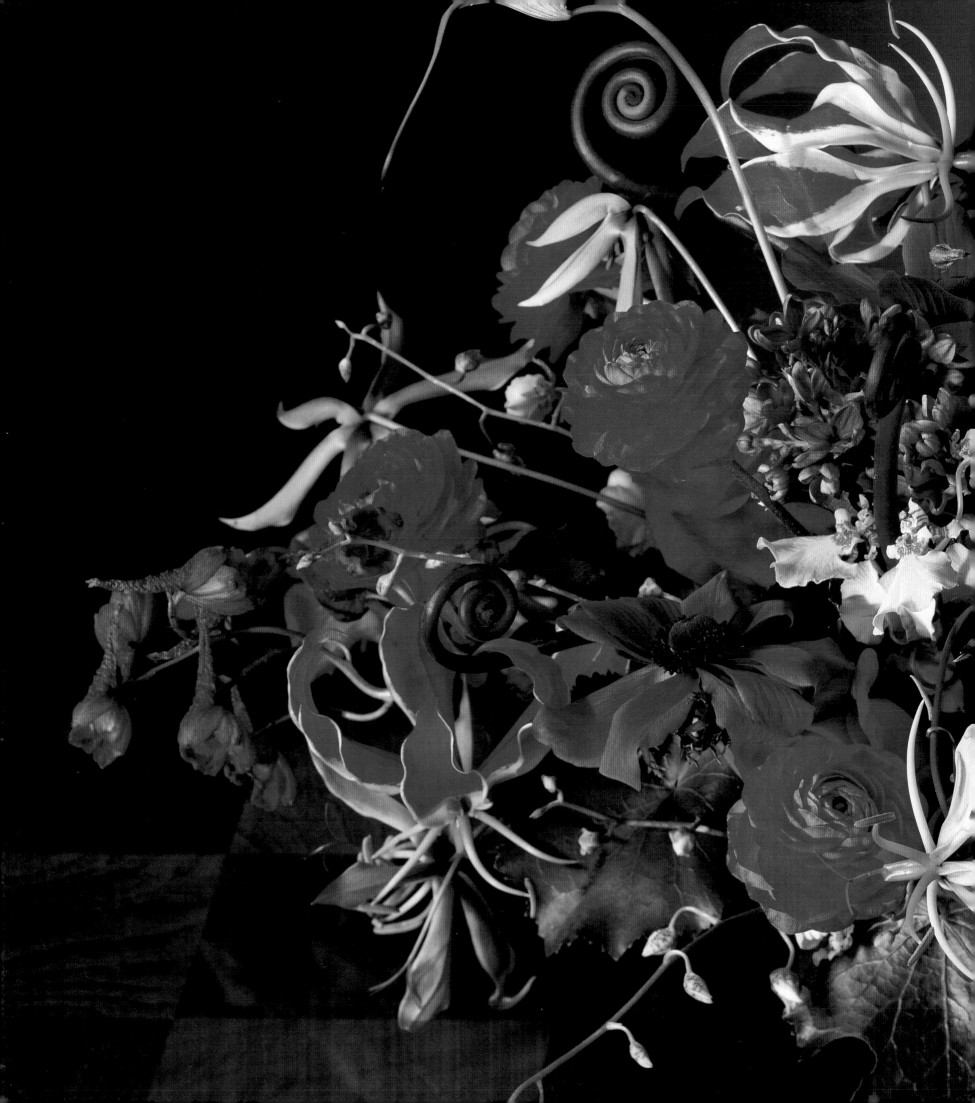

DESIGNING THE ARRANGEMENT

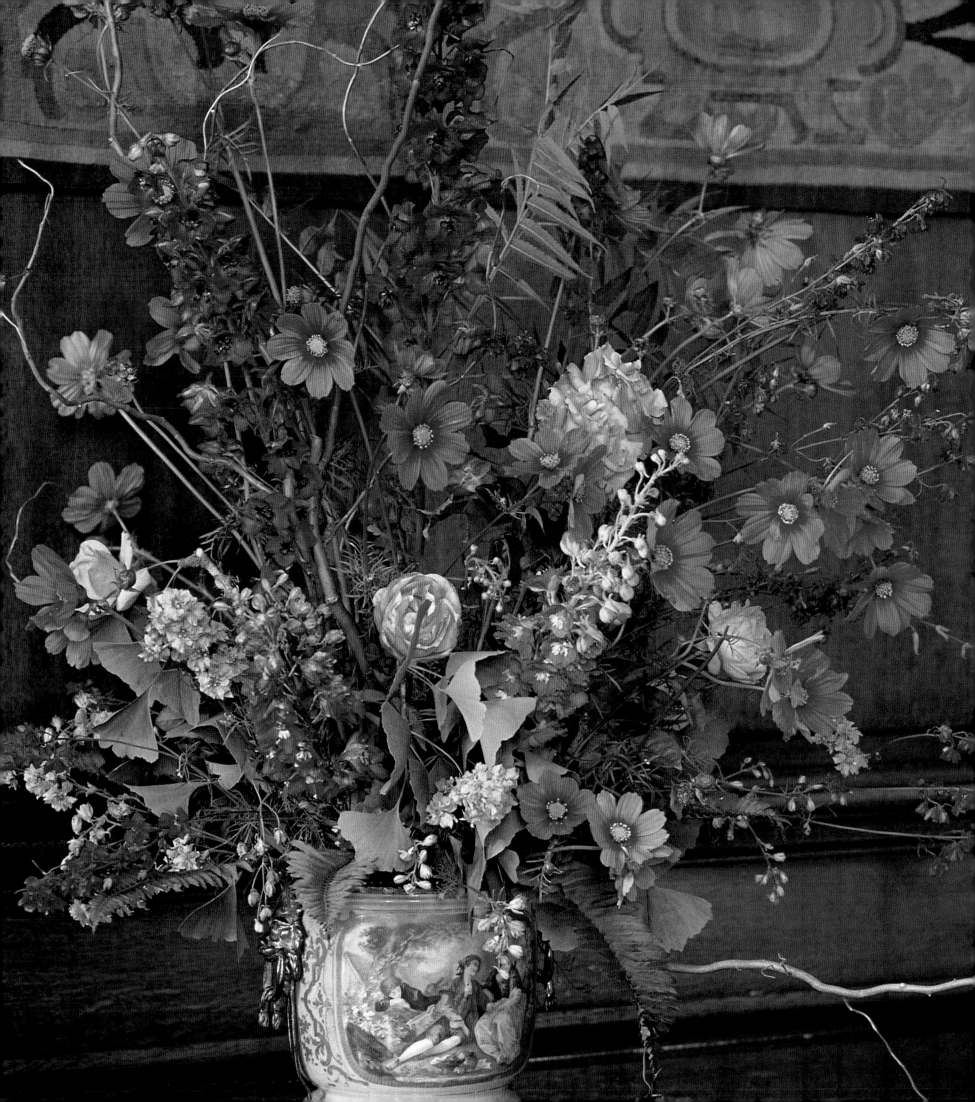

Today, most people arrange flowers in an informal or casual style. Informal arrangements generally require fewer flowers, less mechanics, and less time to create than more formal, elaborate arrangements. Flowers are cut in varying heights and allowed to fall loosely to the edge of the container, leaving space between the blooms. Clusters of the same types of blossoms, such as a mixture of garden roses, are cut in different lengths so they will gracefully open alongside one another. Foliage can be ferns or leaves picked from the garden or from plantings around the house, or unusual greenery can be purchased to achieve the "just-picked" look. Whatever the setting, an informal style evokes an informal, casual feeling with less rigidity and less stress: the elements of a life of ease.

(Previous spread) The exotic shapes, forms, and textures of these glorious flowers dazzle the eye with an explosion of color. Flowers by Sandra Parks. Photo by Kan Photography.

(Opposite) A harmonious arrangement results from the artful contrast of a formal container with an informal arrangement of cosmos, delphinium, and curly willow. Photo by Peter Margonelli.

(Right) Flowers clustered tightly together in a compact ball make a mass arrangement. In this example, a hand-tied gift bouquet of roses, Queen Anne's lace, sweet peas, lilies, statice, Russian olive blossoms, French tulips, and waxflowers. Flowers by Fabrice. Photo by Z. Livnat.

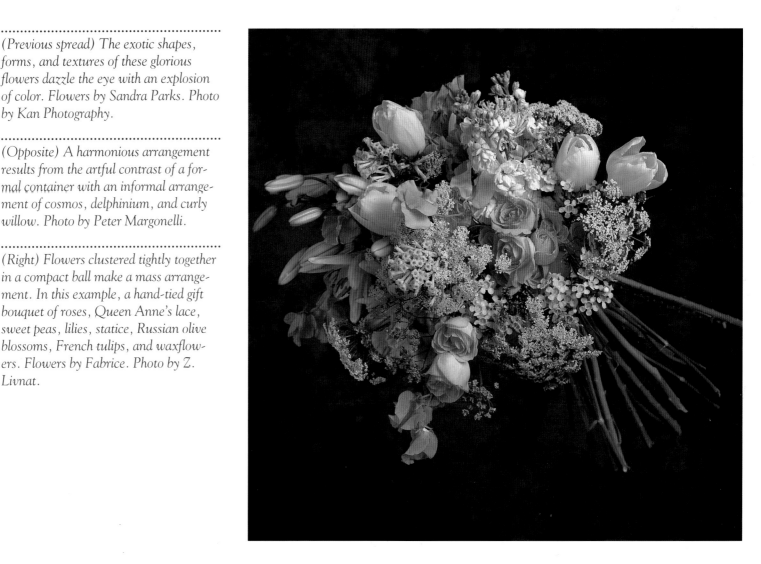

Formal arrangements are generally designed for formal occasions, often for period rooms or halls. Weddings, religious ceremonies, christenings, coronations, high teas, and grand balls all are occasions for formal floral designs. Sometimes designers of formal arrangements are inspired by the magnificent displays in paintings by the Dutch and Flemish Masters of the 16th and 17th centuries, or by the sculpted topiary forms seen in Roman frescoes. Formal arrangements often are large, but whatever their scale they exhibit both presence and abundance.

Stylized arrangements owe much to the Japanese art of ikebana, in which three or more carefully chosen flowers, a small amount of background foliage, and an elegant container all work together to create a miniature world of balance and harmony. To those trained in ikebana, the arrangement symbolizes the heavens, the earth, and the place of man in the cosmos. Like other Japanese arts, the elegant purity of ikebana has inspired modern designers, and we can borrow its exquisite logic without immersing ourselves in philosophy. A stylized arrangement asserts a thoughtful, created presence—nothing is accidental here, nothing is out of place.

Some people seem to be born with the intuitive ability to design, while others develop the ability through observation, study, and experimentation. Learning how to design is learning how to see the natural world, and how to select, or edit, elements of it. Though learned as any other skill, with time the ability to design becomes intuitive. The way to learn about design is to observe nature, for it is the ever-present example of perfect design, changing daily, seasonally, yearly. By actively looking and seeing, you can become aware of nature's abundant diversity of shapes, textures, and colors, the dynamic combinations seemingly random and yet always harmonious and complementary to one another.

Opening up to your own creative style is simple, yet perhaps it is also the most difficult thing. Sit quietly wherever you are, by the window or in the garden, and pay attention to nature and to how you're feeling. Creativity springs from silent attention.

..

The predominant red-orange color of this complex Old Masters-inspired arrangement comes from the roses, dahlias, oranges, strawberries, radishes, and nectarines. The other colors— purple grapes and lisianthus, green asparagus and foliage, yellow lemons and galax-wrapped votive candles—create a rich backdrop. Flowers by Elizabeth Ryan. Photo by Z. Livnat.

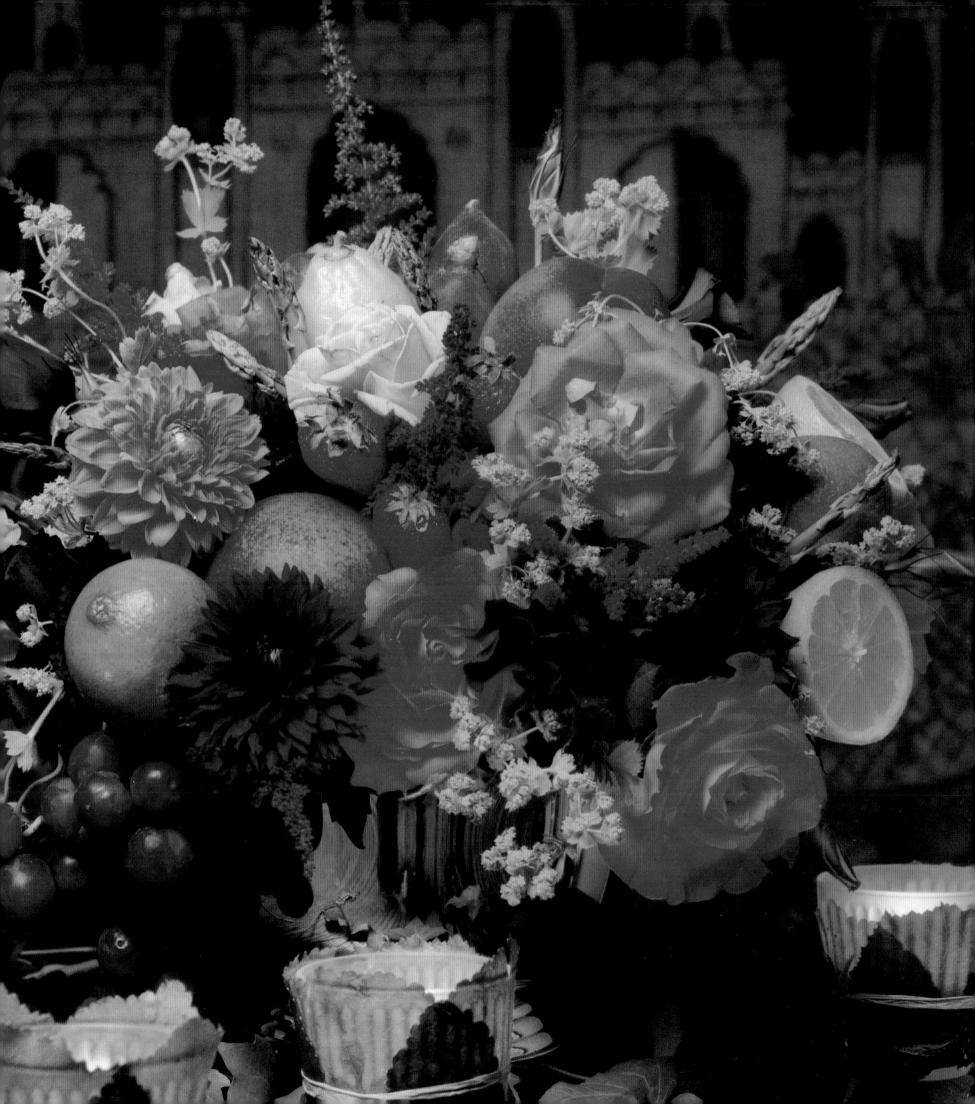

CONTEXT IS EVERYTHING

Every arrangement has a time and a place, and a reason for coming into being. This is its context. Context is a complex concept that embraces both the setting where the floral arrangement will reside, as well as the occasion for making an arrangement. The context determines whether the arrangement is casual, formal, or stylized. It also defines, and perhaps limits, your color choices, the scale of the arrangement, and many other aspects of the design. Furthermore, if a bouquet will be presented as a gift, the personal style and environment of the recipient also become part of the context.

The background of the room forms the backdrop for your arrangement, and florals are most successful when they are styled in keeping with the character of the room. Formal rooms call for formal arrangements, casual rooms for casual ones. The container and such accents as ribbons and

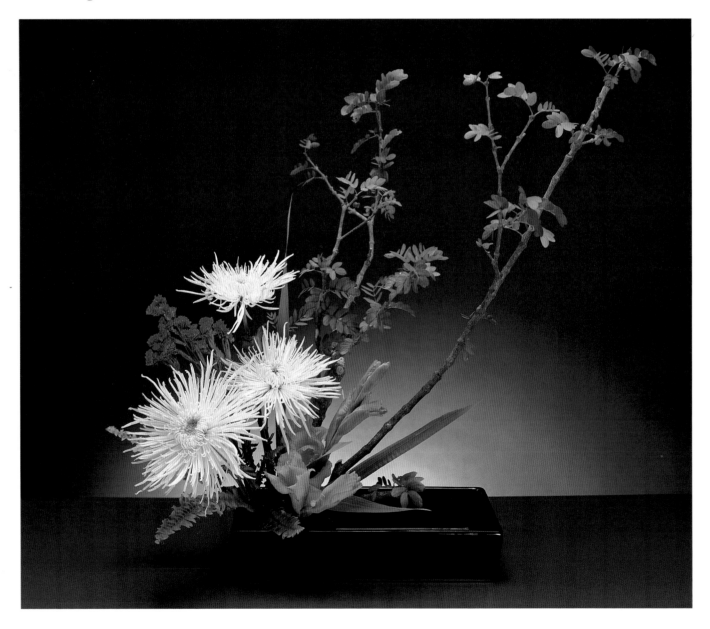

(Opposite) Three spider chrysanthemums shine like yellow stars at the heart of this stylized arrangement, where the container—a dark ceramic slab—virtually drops from view. Here the designer has edited the plant material to suit the needs of the composition: the hot pink flowers are gladiolus trimmed from their long stalks. The sweeping branches are mimosa. Flowers by Meiko Kurbota. Photo by T. Tanaka.

(Right) Not afraid to experiment, the designer of this arrangement houses the flowers inside a bell-shaped clear glass vase. The underwater blooms shimmer in a whole new way. Like a lens, the water refracts and concentrates the light. The arrangement includes a stargazer lily, Scotch broom, red roses, euphorbia, and locust pods. Flowers by Sandra Clothier. Photo by Robert Mertens.

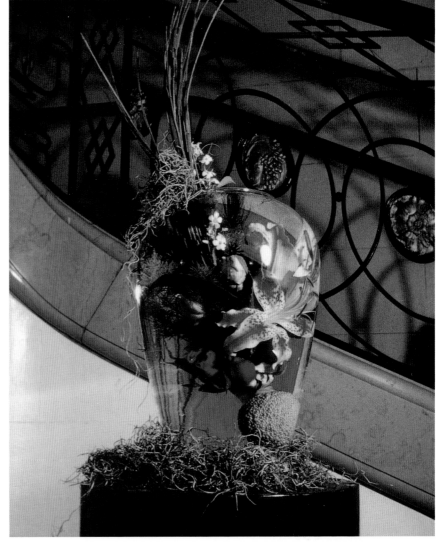

wrappings help connect the arrangement to its setting and unify the total composition. Strong prints or busy stripes and plaids will be complemented best by an unfussy arrangement, possibly a group of the same color flowers in a simple container. Conversely, a stark room with white or ecru walls will be enhanced by a dramatic arrangement with pure lines or forms and strong color.

Scaled to the size of the room, the floral design will look right in its place. A few stems of iris in a small vase might be lost in a large formal dining room, but will look appropriate in a breakfast nook or powder room. A massive arrangement would overpower an intimate guest room, but would be perfect in an expansive living room or a two-story entrance foyer. You can err more easily by trying to include a large, formal arrangement in a small space than by incorporating a small arrangement in a large space. A small arrangement can make a vast space less imposing, more intimate, and draw one's focus to a particular area. And besides, sometimes it's fun to be playful and unexpected.

As an artist paints a canvas, the floral designer creates a three-dimensional vignette: visually delightful, tactile, and fragrant, a small masterpiece for the moment. Within the context of the design, floral artists work with the same elements as all other artists. These elements include color, texture, and fragrance, which are inherent in the flowers themselves; form, line, and space, which designers impose by how they manage the floral material; proportion, rhythm, and balance, which designers juggle as they compose the arrangement. Any one of these elements can become the dominant aspect of an arrangement, or even the inspiration for it.

..
(Left) An asymmetric sweep of yellow oncidium orchids enhances the trompe l'oeil illusion of this sophisticated entry hall. In a complex context such as this, the floral accent is best kept simple and direct. Photo by Elizabeth Heyert.
..
(Opposite) Purple agapanthus in a clear glass vase complement the yellow walls of this pleasant dining room. The simple lines of the single-species arrangement echo the elegantly sparse decor of the room. Photo by Grey Crawford.

COLOR. Color impacts us emotionally as well as visually. Color sets the mood of the arrangement and makes a statement without saying a word.

The time to consider color is when you are shopping for the flowers. The color of the arrangement may be dictated by the occasion—Valentine's day or a pink wedding—or by the color of the container, or the decor of the recipient. Just as often, the color palette comes from your intuitive sense of context, of what the arrangement is for and what the recipient might like. As you choose the flowers, hold the bunches next to one another to see whether the colors harmonize or clash. Pay attention to your inner voice: it will let you know if you are about to make a poor choice. Each choice affects the next one, and it may also affect choices you thought you'd already made. Creating your palette is exciting and fun. You'll probably go back and forth between choices several times before you finalize your choice of flowers.

Warm hues of red, yellow, and orange can soothe, brighten, or irritate; cool hues of blue, purple, and green can be relaxing, or sometimes somber or depressing. Tints of pink, lavender, and creamy butter-yellow may evoke a cheerful feeling, whereas tones, or shades, may be melancholy and dark. Shades can also seem rich and inviting, or earthy and understated, all depending on their context. Response to color is as individual as personality, and the key is to experiment with color combinations.

Different types of color harmony create different effects. A monochromatic color scheme can use one hue mostly, though sometimes as numerous shades and tints, in the form of a single floral species or in several species of flowers. Analogous color harmony is created by combining a hue with the colors adjacent to it, for example, red with red-orange and red-violet. Complementary colors create contrast and excitement with cool/warm combinations such as blue with orange, green with red,

purple with yellow. White and near white flowers are almost always appropriate; white flowers in a white or pastel room are always divine. Versatile whites and greens mix easily with other flowers, creating contrast and lightness, and neutralizing what might otherwise be a too-strong mix of colors.

Nature composes harmonious seasonal palettes. Fresh purple, blue, yellow, and white flowers welcome spring. Crocus blossoms push through the warming soil, and daffodils, perky and fragrant, defy the return of winter. Masses of daffodils placed in a colorful Delft pitcher, a lined terra cotta

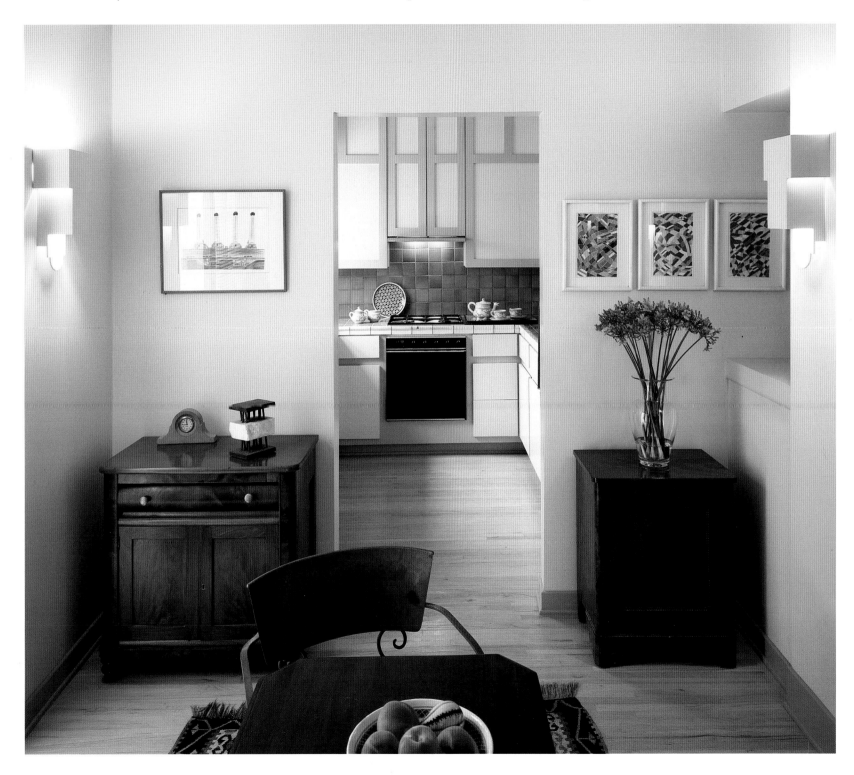

pot, or a clear glass vase, bring the brightness of the season into the house. Summer welcomes the full range of primary and pastel colors, and cutting gardens abound with annual and perennial blooms. The fall hues of gold, orange, and red are complemented by the purple of asters and various bright and rich shades of changing foliage. Winter brings red, white, and evergreen, and we mix their many shades with the soft browns of nuts and the warm hues of fruit.

Flowers are all about natural color, and there are no bad colors in nature, though some combinations aren't entirely harmonious together. Jarring combinations arise from vast differences in value or color saturation. I might hesitate to put hot pink next to pale yellow, even though that very combination of colors might appear between the petals and stamens of a single blossom. But you might not be jarred by such a combination. Color is such a subjective judgment, and someone else may be able to take a combination one person doesn't like and infuse it with real style. You must be guided by the colors that feel right and make sense to you.

TEXTURE. Both flowers and leaves have texture, which speaks to us through our sense of touch as well as through our eyes. Smooth, rough, leathery, prickly, feathery, soft, crinkly, glossy: we have too few words for the universe of textures and surface qualities we can sense. The textures of plants

contrast with, or complement, the manufactured textures of containers: light-absorbing organic surfaces against smooth, glassy ones that reflect the light. Using similar textures creates a flow, a certain sense of visual harmony, while mixing textures can stimulate visual excitement. Texture makes a subtle counterpoint to color.

SCENT. Fragrance is the design element that's unique to the florist's art. It is complex, subtle, and important, because the sense of smell is extraordinarily evocative. A waft of scent can bring forth richly complex memories of times and people, and can inspire the recollection of lost moments. A bouquet of Grandmother's favorite gardenias can

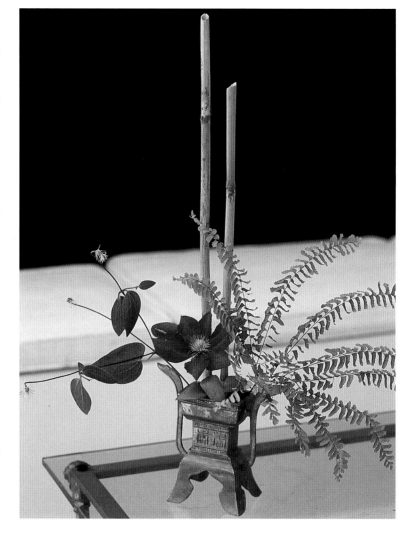

A few carefully chosen blossoms set in the precisely right container and in the precisely right spot makes a floral statement that is at least as strong as a massive basket spilling over with flowers. Photo by Peter Margonelli.

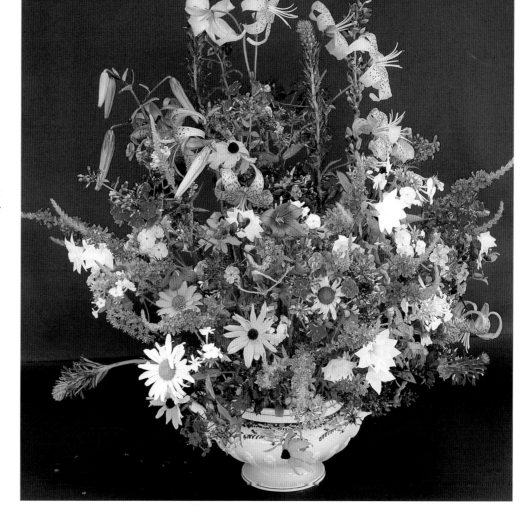

The star shapes of the yellow lilies, the flat circles of the black-eyed Susans, and the spikes of loosestrife create rich color, texture, and a deep surface. Photo by Peter Fink/Picture That.

move a person to tears or at least a moment of nostalgia, because of the way scent can trigger deep memories.

If you want to work with fragrance, remember that garden-grown flowers usually are more fragrant than commercial flowers. And as memories rise unbidden, so do pollen allergies. The most fragrant flowers are also the ones most liable to trigger sneezing.

FORM. Every arrangement has a shape or form, and so do the individual flowers and leaves. Mass arrangements have a silhouette that's close to solid, and that makes a basic shape: triangle or pyramid, circle or sphere, square or cube. The container you choose may suggest the form of an arrangement. The form may also be inspired by the setting: a long buffet table calls for a long arrangement, a tight corner for a compact one.

A bouquet can be densely packed or loose and airy, and the designer has considerable freedom to choose the shape. But if you ignore the shape of your arrangement, it's liable to end up with no shape: a formless mass with bits sticking out every which way. When you find yourself looking at a floral blob, choose a shape to impose upon it. You'll find you can bring the unruly stems into line once you make a decision about what the shape is going to be.

Look too at the shapes of the flowers themselves. There are globes and trumpets, stars, flat wheels and spikes, simple forms and complex ones, single flowers, massed heads with many petals, and sprays. The shapes of the blossoms may suggest the shape of the overall arrangement, or they may be notes that complement or contrast with the larger form.

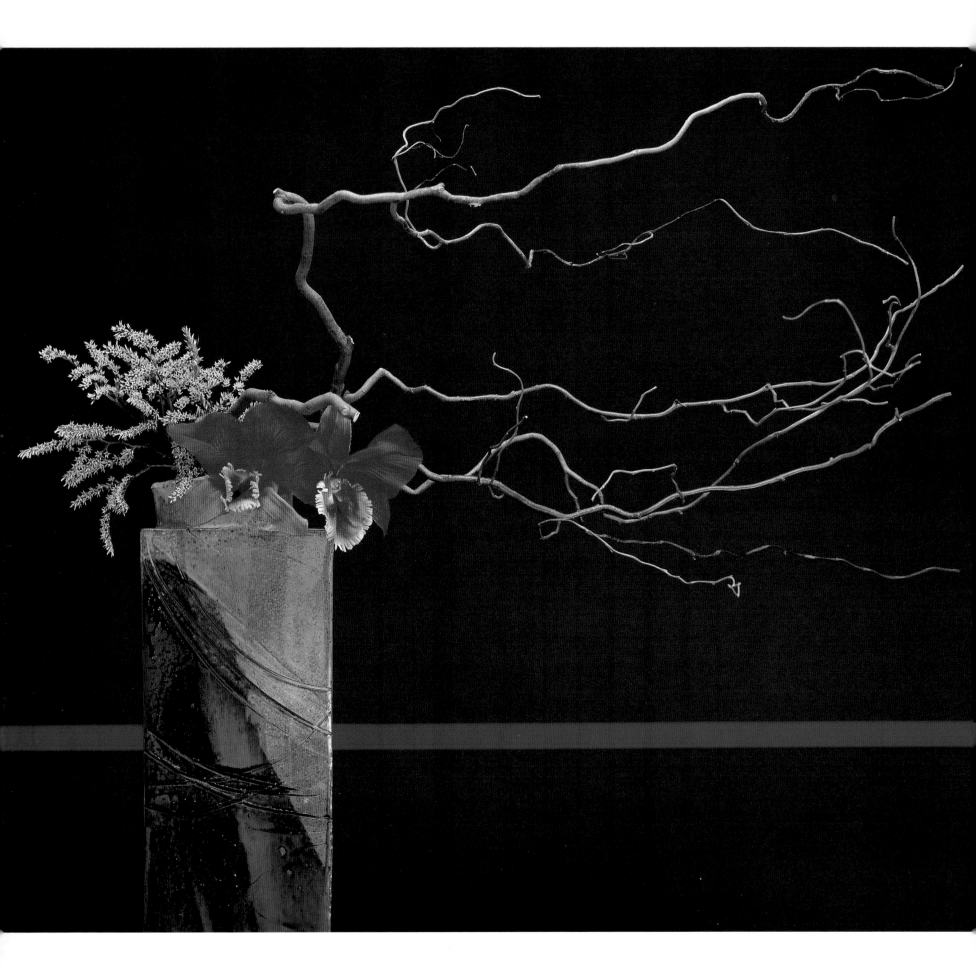

LINE. Branches, long spiky flowers, and blade-thin leaves make lines. The lines of flowers and plants are not perfectly straight and uniform. Floral material often curves and reaches. The designer can use floral lines to lead the eye, to establish a direction, and to echo the shape of a strongly vertical or horizontal container. Arrangements that emphasize lines have a contemporary feeling. Working with lines can lead you to a simple statement made with a few dramatic flowers and the perfect container.

SPACE. The space around an arrangement defines its shape and connects it to the room. We move through this space as we appreciate and enjoy the flowers. The space around each flower emphasizes its particular presence, charm, and importance in the design. Closely configured, with little space to breathe, flowers become indistinct masses of textures, shapes, and colors, which may be the effect you want. However, complex and dramatic flowers need space or their spirit will be crushed and lost. You don't have to use all the flowers you have gathered or purchased in a single arrangement. You can always make more than one arrangement.

RHYTHM. The regular repetition of a visual element produces rhythm. An accent flower such as a large dahlia or chrysanthemum can be spaced rhythmically against a background of dark green foliage. A bunch of daffodils can form a rhythmic palisade by being lined up in pin-holders across a flat dish. The rhythm of flowers is not as precise as the rhythm of music. One half-note is always the same as another half-note, but one peony is not exactly the same as another peony. Rhythm is a design element you can use to unify an arrangement, though it's not often the inspiration for one.

BALANCE. An arrangement needs visual balance as well as physical stability. The weight of the mechanics in the container and the mass of flowers must be gravitationally sound and centered, and they must also seem to be so. Top-heavy flowers like amaryllis or proteas need a strong base to balance their weight. Light, airy flowers can float on

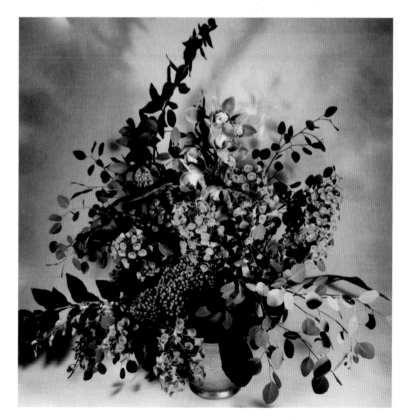

(Opposite) Life, death, earth, air, and fire—all the elements are represented in this stylized arrangement of willow branches, orchids, and statice, poised in a dramatic raku vase. Flowers by Meiko Kurbota. Photo by T. Tanaka.

(Right) By choosing flowers, berries, and foliage in various shades of green, the designer emphasizes textures and shapes instead of floral colors. The monochromatic arrangement includes euphorbia, cymbidium orchids, and flat eucalyptus. Flowers by Sandra Clothier. Photo by Robert Mertens.

top of a design or around its the edges. This is a more balanced approach than placing them at the bottom, under a cloud of larger flowers.

An arrangement has symmetrical balance when it has a center with similar types and sizes of flowers on either side. Traditional design styles achieve balance with symmetry.

Asymmetrical balance, though more challenging, can add excitement and interest. Most Chinese and Japanese arrangements are examples of asymmetry in floral design. A large bloom, such as a lily or anthurium, placed near the center of an imagined axis can be balanced with several smaller blooms on long stems, or with a mass of twigs. The arrangement has balance even though it doesn't mirror the same flowers across a center line. An asymmetrical arrangement might not have a central line, it might express a direction instead.

PROPORTION. As you scale the arrangement to its setting, so you keep the size of the floral mass in proportion with the container. The rule of thumb is, flower height not less than one-third taller or more than two-thirds taller than the vase. As you balance colors, sizes, and shapes within your composition, lights with darks and flowers against foliage, you'll begin to sense the correct proportions of the various elements. Keep the elements in balance, until you have a good reason to allow one aspect to dominate. A good arrangement does not overwhelm its container or setting. As you gain experience, your sense of balance and proportion will become more intuitive and natural for you. You won't have to think about it.

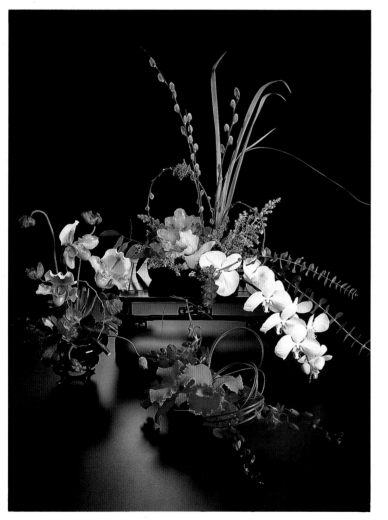

...
(Left) A theatrical grouping of three dark containers of exotic orchids with poppies, eucalyptus, and pussy willow makes a polished contemporary statement. Flowers by Sandra Parks. Photo by Kan Photography.

...
(Opposite) Spiky leaves of snakeplant give outward motion to this loose, fan-shaped arrangement of roses, cosmos, phlox, and larkspur. Photo by Peter Margonelli.

...
(Overleaf) The just-picked look of these coral-pink and ivory hybrid tea "Secret" roses is perfect for today's popular informal style. The combination of single buds and blossoms in various stages of maturing provides an appealing texture in a mass arrangement that beautifully echoes the size and shape of its container. Photo by Irene Chang.

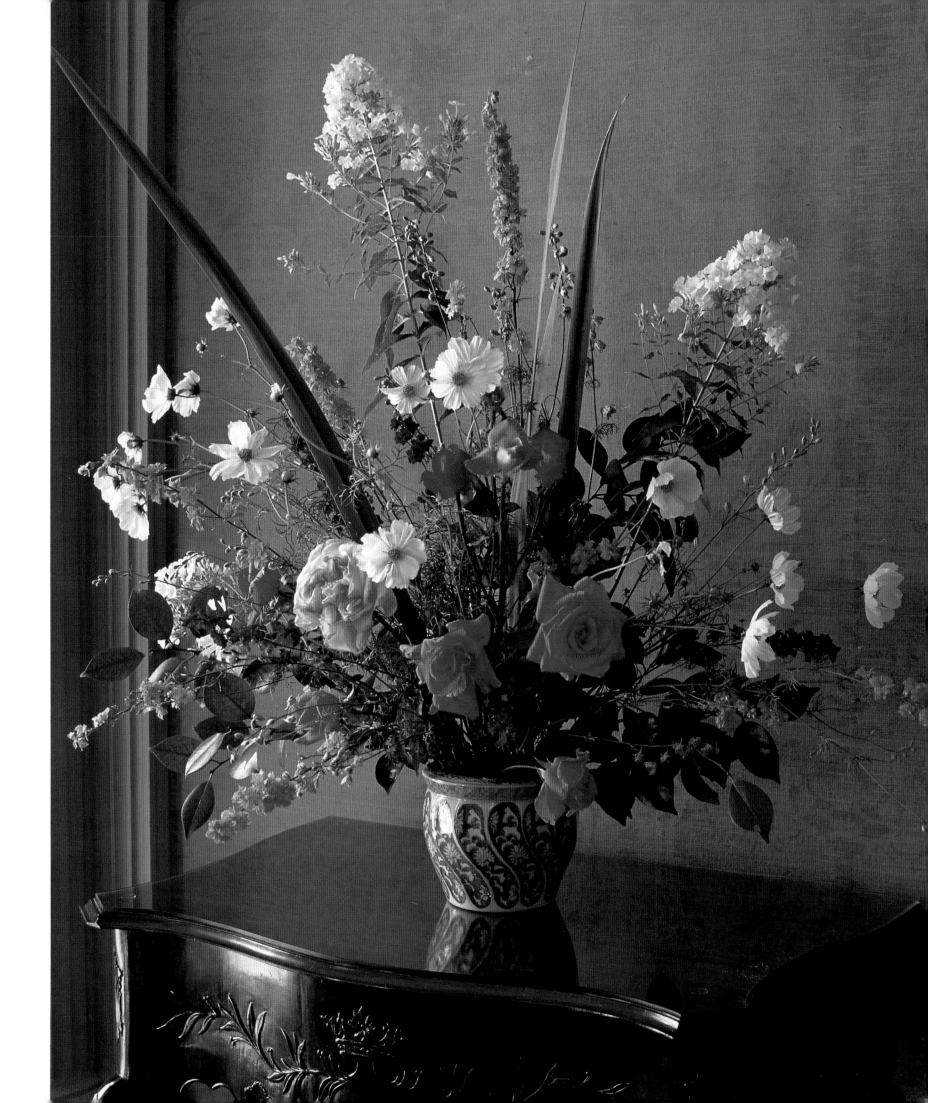

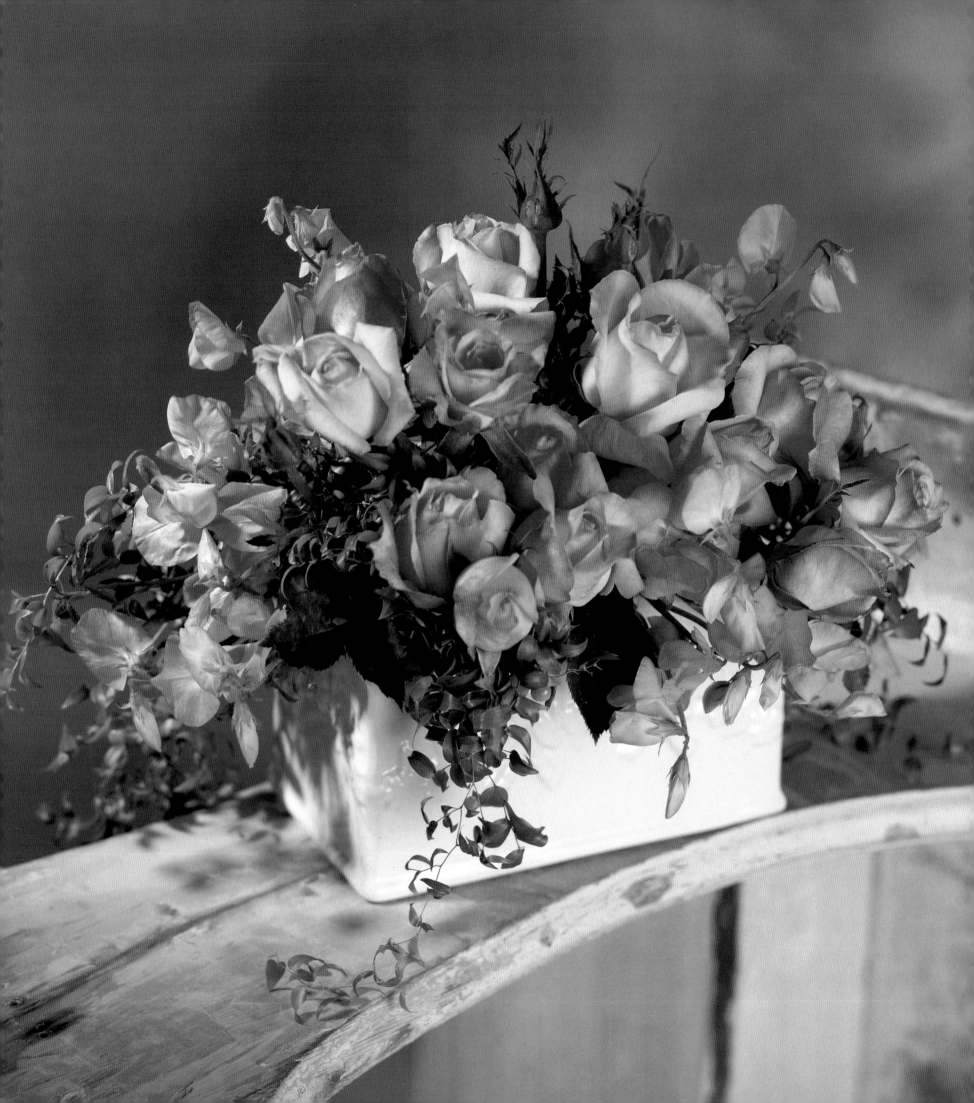

MORE MORE
SAME SAME

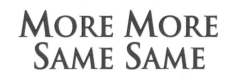

Making centerpieces that match is not the same as making identical center-pieces. These three arrangements are not the same, even though their charming rhythm would happily unite the guests at three tables.

The lively feeling of same-yet-different begins with the designer's use of the same kinds of flowers and foliage, divided about equally. This gives the floral masses and colors a consistent weight and presence. The key, however, is the designer's creative ability to make the most of the strong sweep of the ferns. The arrangements have been styled with a rhythmic gesture and accent, without getting hung up on pointless consistency.

Making several small arrangements is a good way to avoid the problem of the overwhelming centerpiece. You may want to make a strong floral statement at your dinner party, but you also want your guests to enjoy one another without craning around a vast hedge of flowers. A trio of similar arrangements pushed together makes a strong statement. When it's time to sit down, make space for the guests by separating the vases into a line or a triangle. You can even take one or two of the vases off the table.

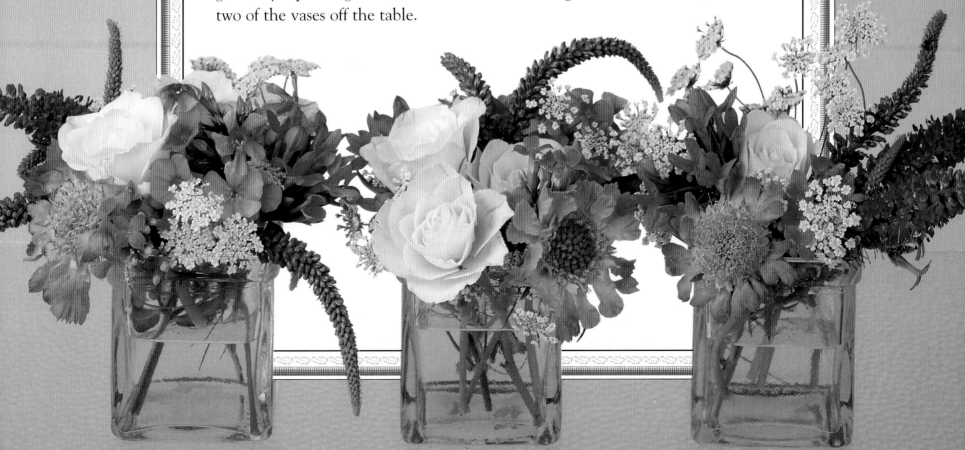

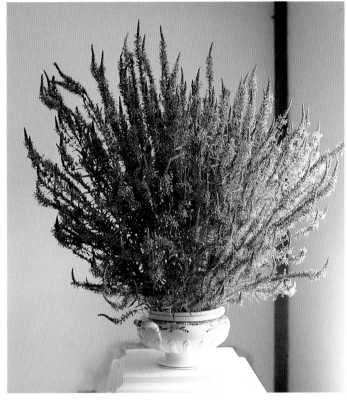

(Opposite) *Porcelina roses, lisianthus, hydrangea, and Queen Anne's lace festoon a tall candelabra, creating the scene for a golden wedding anniversary. Flowers by Elizabeth Ryan. Photo by Z. Livnat.*

(Left) *Purple loosestrife fans upward from a wide vase, a rhythmic and bold gesture in a single color. Photo by Peter Fink/Picture That.*

(Below, left) *Like the moon over the darkened earth, a globe of white Casablanca lilies appears to hover over the black sphere of the clay pot. The bamboo sticks physically and visually balance the arrangement. Photo by Sidney Cooper.*

(Below) *Calla lilies, white lilac, roses, French tulips, and freesia play a symphony in white and green. The clear glass ball defines the globular shape of the composition, and brings the flower stems into the color scheme. Flowers by Sandra Parks. Photo by Kan Photography.*

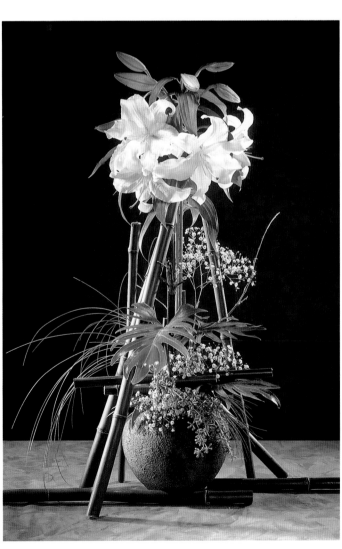

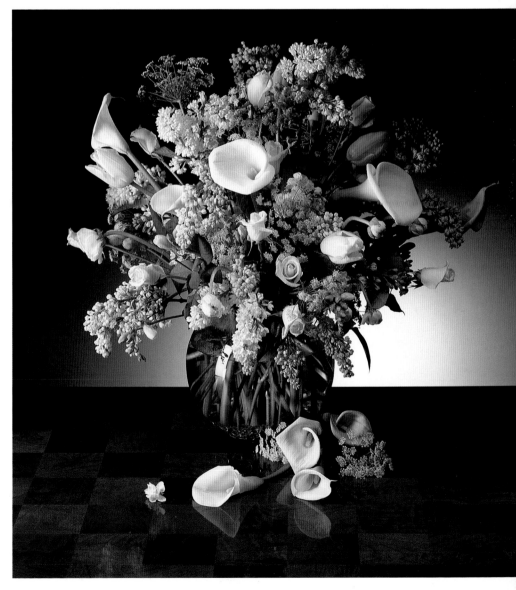

THE PROCESS OF ARRANGING

With the context in mind and the occasion at hand, the flowers chosen and conditioned, the vase washed and sparkling, finally it's time to actually create the arrangement. When you condition your flowers, keep each kind of flower together. Survey all of your material and consider the lengths of the stems. A full and balanced arrangement has short stems, medium-length stems, and tall stems. These are relative terms; the proportions of the container relative to the tallest plant material determines the potential height of your arrangement. If you want it taller, you'll have to find some longer stems to work with, or else extend the stems with water-picks or with floral tape and wire, or even with floral foam. Now, with a clean dry vase at hand, add a block of moistened floral foam, and anchor it to the liner or vase with crisscrossed floral tape. The floral foam can rise above the level of the container if you are creating a tall arrangement. Prepare a gallon of warm water containing a tablespoon of sugar and a few drops of bleach. Fill the vase with it, and place a bowl of warm water close at hand.

Begin with sturdy stems and/or foliage. Use them as they are, or cut into shorter stems to add dimension to the arrangement. If you are using floral foam anchor each stem on the foam. If not, crisscross the stems to create a structure, a gridwork of sorts. Make sure the stems interlace. This is the foundation of your arrangement.

Reserve large flower masses—peonies, chrysanthemums, hydrangea—for late in the arrange-

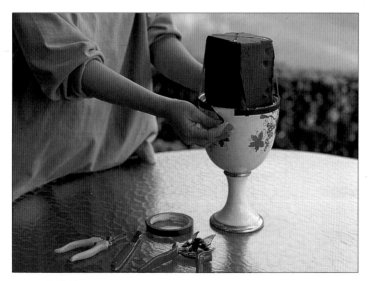

ment. Build the backdrop first. Quickly work through each kind of flower. Use the grid of stems to distribute the flowers throughout the arrangement, placing all of the hydrangeas before starting on the daisies or whatever's next.

With the mass of the arrangement beginning to form, decide whether you will give it any particular shape. Flowers spilling out of a container naturally suggest a soft mound, or a sphere. They can be organized into a triangle, or a square, and the form can take on direction, becoming asymmetrical. Long stems define the shape and find its edges. Small flowers and sprays of florets develop the shape and give it dimension. Large flowers and spots of intense color punctuate the composition. The flowers with fragile petals, like roses and poppies, go in last.

Once you can see the whole arrangement, go back over it, trimming and rearranging the flowers so the composition becomes balanced and harmonious. Adjust the heights and the elevations, and make sure all of the mechanics of tape and foam are covered. Sometimes you may remove some flowers, perhaps they were the wrong shape or the wrong color. They'll go into another arrangement, or into a vase by themselves.

Turn the arrangement around, look at it from across the room. Look for holes, not necessarily to fill them, but to decide. Does it need anything else? What do you have for an accent, a piece of ribbon, a little ornament, a few long feathers, some moss? The arrangement is done when it feels right. You can make a casual arrangement too tidy; you just have to know when to stop.

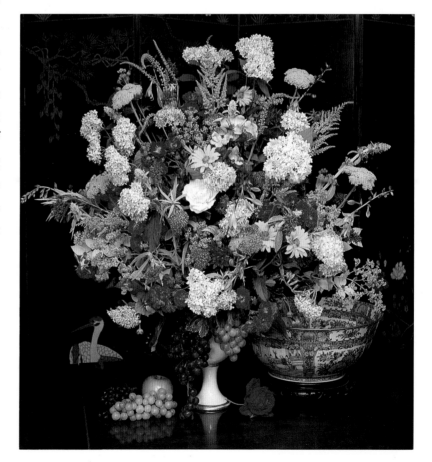

Shape, color, and proportion. Here are five deceptively complex arrangements, each involving several species of flowers in close, but not identical, colors. These vase arrangements show how the thoughtful designer can take charge of the floral material, decide on a theme for the arrangement, and follow through with clarity and style. Adding color dye to the vase water is an ingenious, inexpensive way to create an unusual effect. All photos by Peter Hōgg.

CREATING A ROMANTIC CENTERPIECE

⟨∾ ∾⟩

This delicate and romantic arrangement of old-fashioned pink rambling roses accented with lavender and lamb's ears is a lovely centerpiece. Less than thirteen inches high, guests can see over it easily to converse with diners on the other side of the table. See finished arrangement on facing page.

• Place a frog or metal pin-holder in the clean, dry vase.

• Recut the roses on a diagonal, under water.

• Wrap each rose stem, from flower to end, with floral wire.

• Press the base of each stem onto the frog spikes and gently bend the stems over the edges of the container.

• Fill in with lamb's ear and lavender stems cut just a little longer than the roses. Different lengths and textures are what give the arrangement depth, so create dimension by clipping stems and trimming leaves.

This arrangement will stay fresh for several days, especially if you refresh it with cool water every few days.

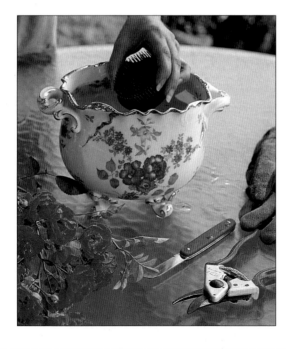 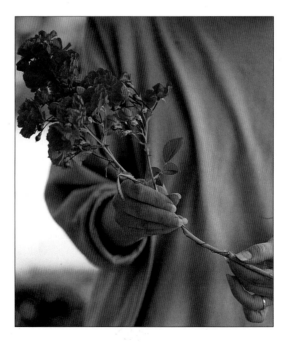

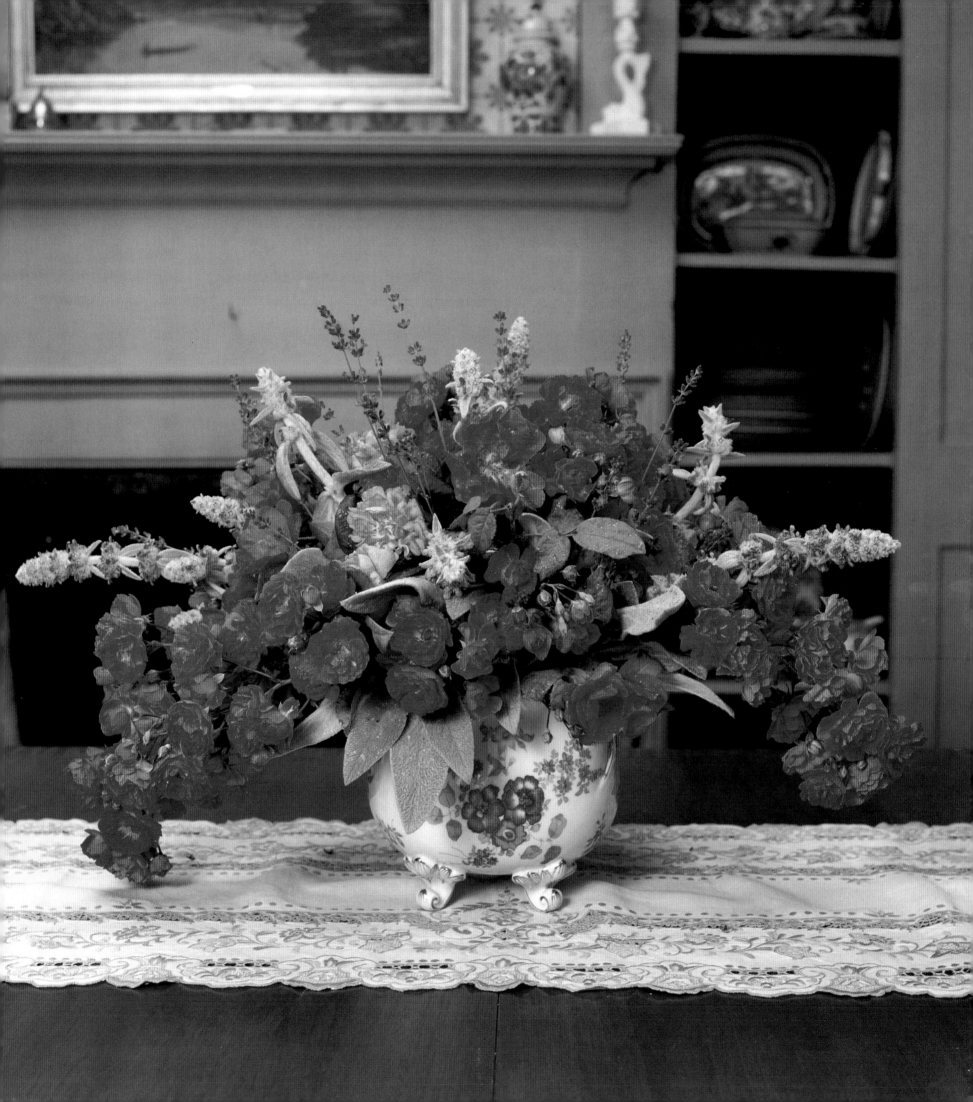

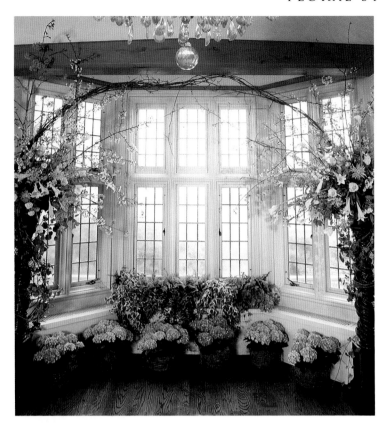

(Left) A wedding bower is created using the natural shape and light of the floor-to-ceiling glass alcove to define its boundaries. Devaney Stock Photos.

(Below) A family of terra cotta pots provides the base for the family of roses, from Osianas to spray roses. Topiary-like Italian pitosporum stand sentinel. Photo by Peter Hōgg.

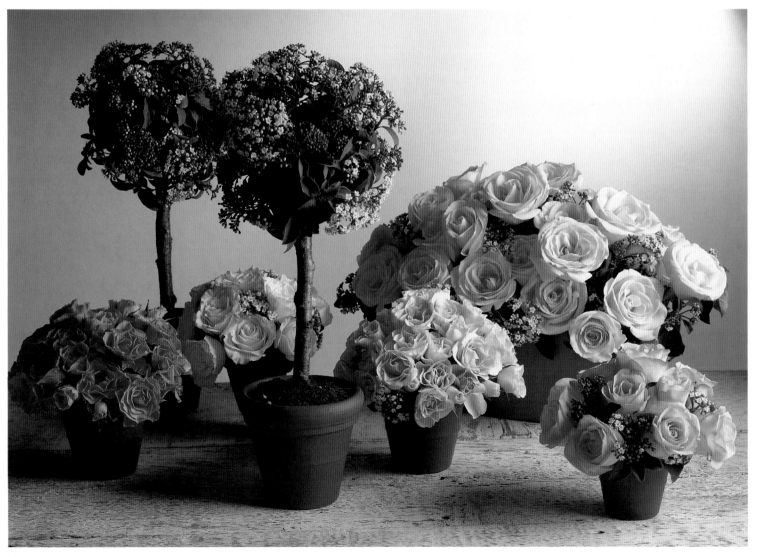

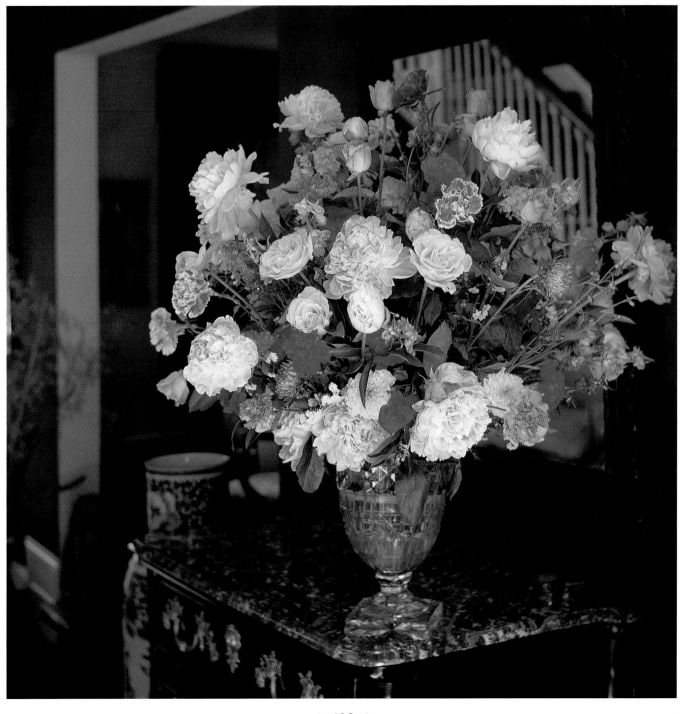

Although they share the same rounded shape, these arrangements express quite different styles. The yellow tulips and narcissus at right are blossoms with deep cups, which interrupt the smooth surface of the mound. The peonies, roses, and carnations in the cut crystal vase, below, are all smooth, ball-shaped flowers, closely reflecting the overall shape of their arrangement. Photos: Picture That.

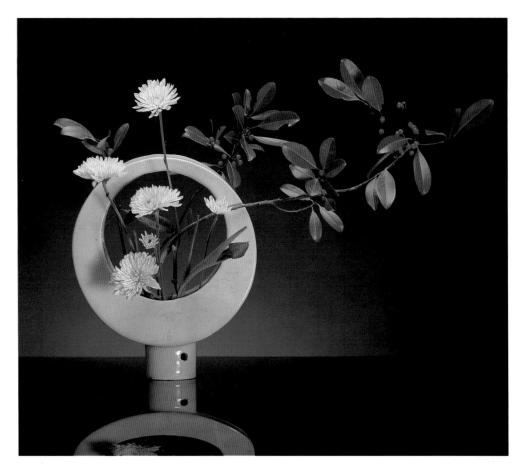

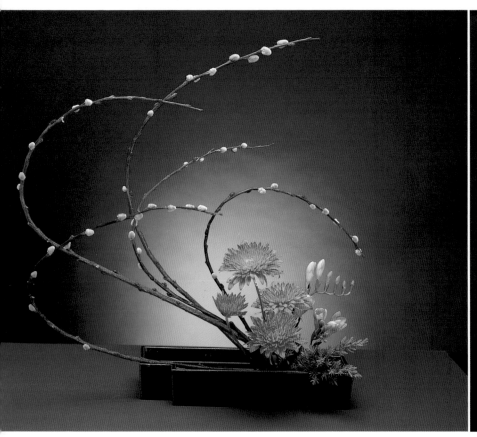

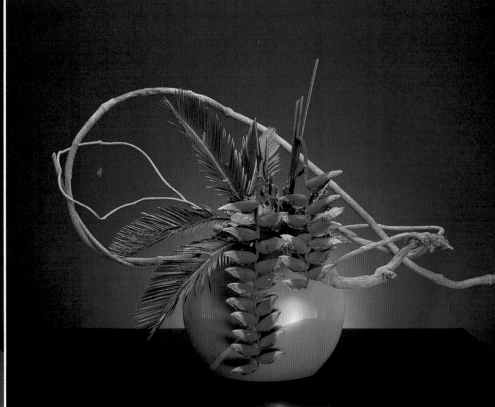

The Japanese art of ikebana inspires stylized arrangements of strong lines and shapes with a few well-chosen flowers. The arrangement of the blossoms, and the gesture of the stalks and branches, can be interpreted visually or symbolically, that is, as compositions of line, form, and color, or as metaphors for the relationships between people and the cosmos. Flowers by Meiko Kurbota. Photos by T. Tanaka.

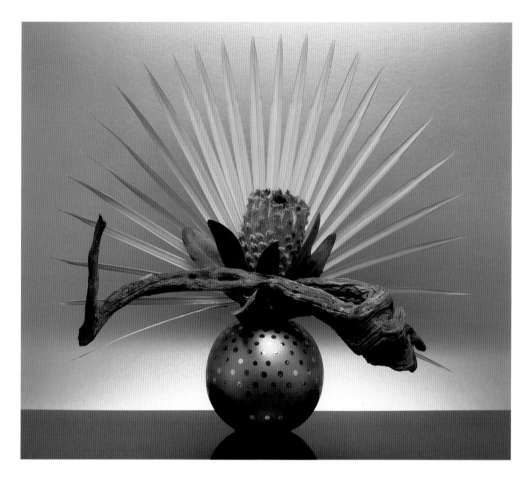

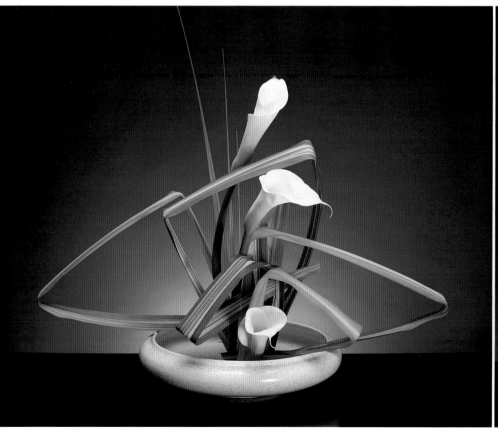

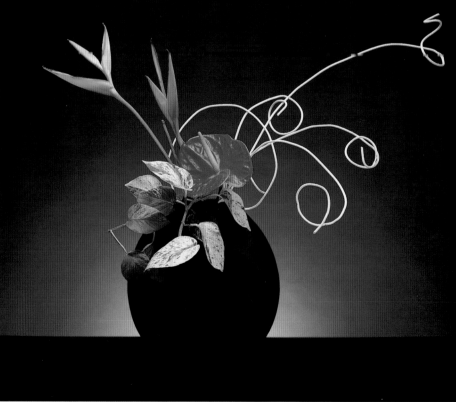

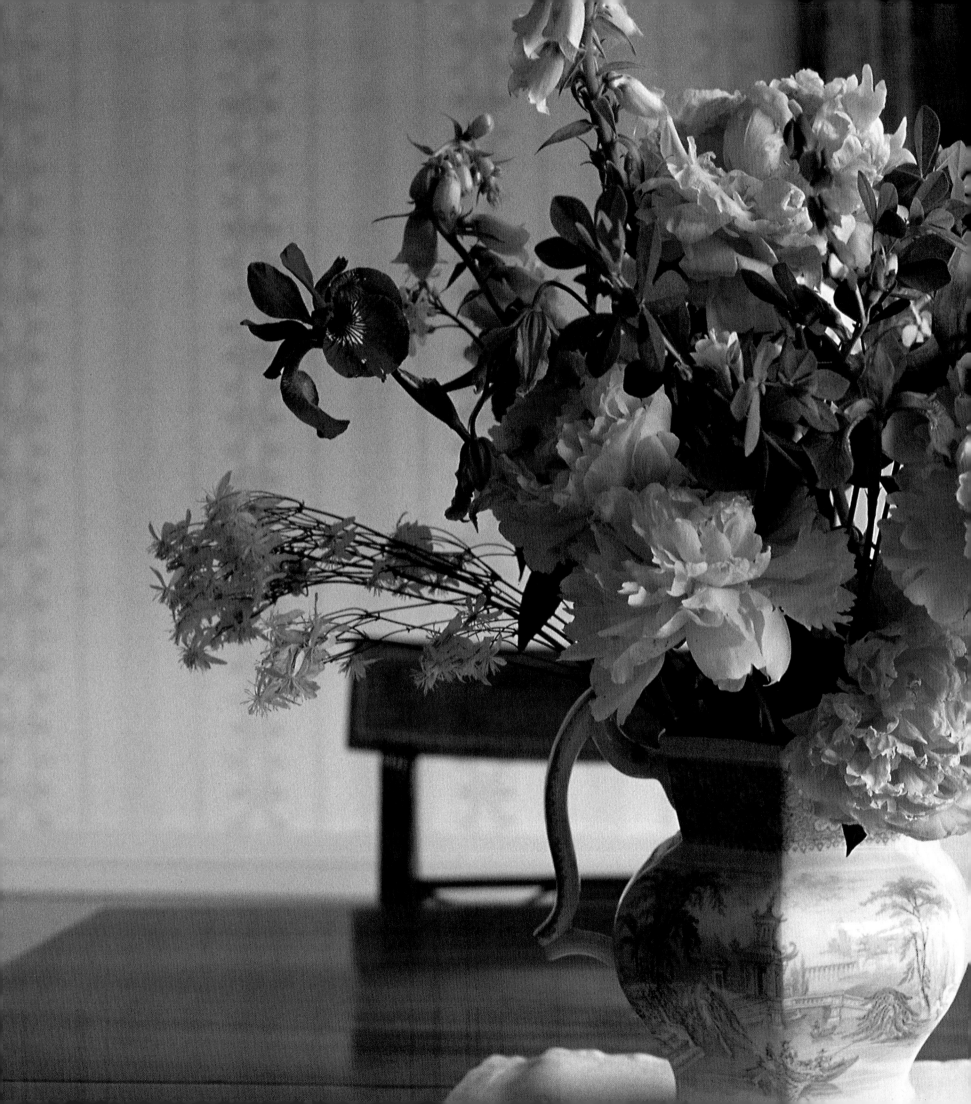

FLOWERS
FOR
EVERYDAY

F lowers instantly change the mood in any room. When people enter a room and see the flowers they respond to them immediately. Flowers extend your greeting and your welcome to family and friends.

Our joyful response to flowers isn't simply a matter of personal inclination. We respond to them because of what they actually are: the reproductive organs, the sexual parts, of plants. They resonate with vibrant energy. They bring life into our homes.

It has been said that although we could live without flowers, most of us would not choose to do so. Flowers remind us of our place on Earth. They speak to us of the sun and of the seasons of the year.

(Previous spread) A casual arrangement of fresh flowers is always appropriate and needs no special occasion. This bouquet includes foxglove, powder-pink peonies, and iris in a square Chinese pitcher. Photo by Peter Margonelli.

(Opposite) It's time for lunch in this warm country kitchen, and a wooden box of fresh flowers invites family and friends to gather around. The flowers include yellow solidaster, pale blue delphinium, lavender waxflowers, anemones, and Monte Casino asters. Photo by Elizabeth Heyert.

(Right) A pitcher of lilacs and white freesia, and a plate of pansies—the flowers flow across the table and into the salad of field greens, enlivening both the setting and the meal itself. Photo by Georgia Sheron.

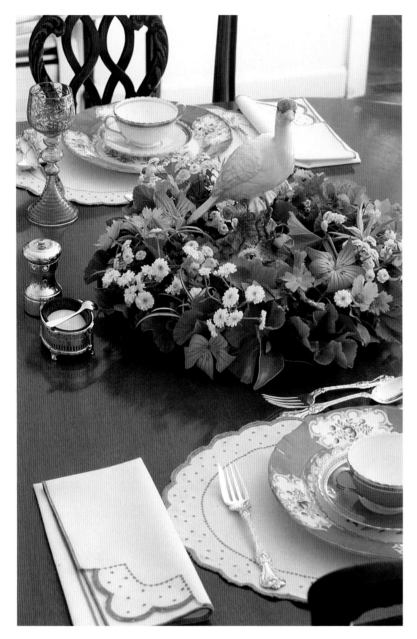

A well-conceived plan for decorating a dining room with fresh flowers is beautifully executed with complementary arrangements. On this page, the low centerpiece of summery blossoms provides an elegant focal point for a beautifully presented luncheon. Photo by Peter Margonelli.

When people see flowers, they often ask, what is the occasion? There doesn't need to be any occasion, it's enough to be together. Every day is a good day for having flowers in the home, where you live, where you spend your time. And there really aren't any inappropriate locations for flowers, either.

IN THE ENTRY. When you see cut flowers in a window or an entry foyer, you know someone is living in this house. The flowers greet you and welcome you. A pot of anemones or geraniums can lead you from the driveway or garden. You can hang a simple wreath of garden flowers, placed into a moistened ring of floral foam, on the door. A bunch of wheat or fresh-cut flowers and grasses, tied with raffia or a burlap ribbon and hanging at the entrance—simple and lovely.

IN THE DINING ROOM. Flowers in the dining room make your guests feel special, participants in an occasion. Your centerpiece echoes the season, accentuates your decor, or creates a party theme. Though a centerpiece is the first thing to attend to, there's no reason to stop at just one arrangement. Consider a second vase or basket on the sideboard, or on a pedestal in the corner of the room.

Arrangements for the dining room tend to be formal, dressed up for the party and on their best behavior. If your decor is traditional, you'll want to select a container that complements your furniture and accessories. It may be an antique vase, or crystal, or gold-filled porcelain, or even a serving dish from the dinner set. Chinese ginger jars go well with Chippendale and Queen Anne furniture styles. Rookwood pottery was made for Arts and Crafts furniture, whereas Art Deco furniture styles call for cut crystal, frosted glass, and silver. Modern decor is simple and understated, complemented by stylized arrangements of a few well-chosen flowers in a sophisticated container.

Not all dining room arrangements have to be formal, however. Country decor generally calls

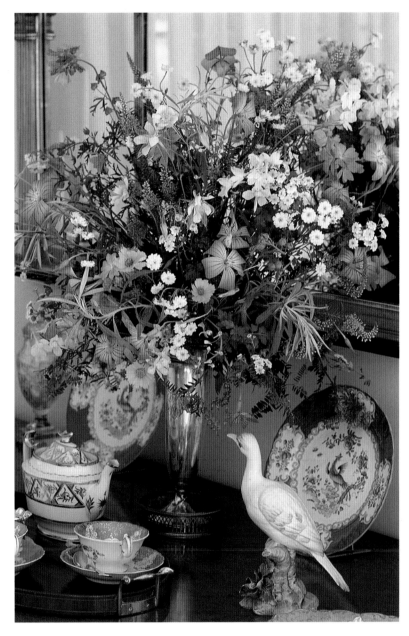

for simple, unstudied arrangements and casual centerpieces. And there are informal occasions in the most formal room—a few friends over for lunch, for example, or a family dinner. You might enjoy the contrast of a Mason jar full of wildflowers on your antique mahogany table. You can please yourself and your guests.

The old rule of centerpieces says you must not make the arrangement higher than about thirteen inches, or so high that guests can't see one another over it. Be aware of the potential difficulty, but don't feel inhibited by this restriction. If the arrangement is too tall, you can always move it from the table to the sideboard or buffet, or to a small end table brought into the dining room for just this purpose. You can keep flowers on the table by setting each place with a small vase containing a single bloom.

Buffet arrangements are altogether different. They don't occupy the center of the table, and no one has to see over them, so they can be large. With multiple containers, you can create a mound of flowers running from one end of the buffet table to the other, a rich and luscious backdrop to the dishes and platters of food. Just be sure the flowers and foliage don't dangle into the gazpacho, nor interfere with access to it.

IN THE LIVING ROOM. Flowers are the colorful accents that complete your living room decor and make your statement of style. Let your favorite furniture, paintings, and objets d'art inspire your palette of colors. Plan your flowers to work with the focal points of the room, usually the fireplace and mantel, cocktail table, or perhaps the windows. When your living room sports decorative mirrors, you can use them to visually double the size of flower arrangements. Pick up the detailing of the mirror's frame in the container, if you can, though you won't go wrong if you deliberately choose a contrasting style instead.

Floral arrangements often function as bridges between spaces, colors, and forms. An urn of dahlias—red, magenta, and pink—links the soft upholstery of your favorite sofa with the faded colors in your Persian carpet. An earthenware crock spilling an informal arrangement onto the windowsill connects the inside of the room with the garden outside, or perhaps it blocks the view of parked cars or children's play equipment. A sleek piano loses its severity when it supports a dramatic arrangement of blooms in a fabulous old container. It's difficult to make a mistake with flowers in the living room, unless you become intimidated and hide them from view. Bring your flowers forward so your family and guests can see them and enjoy them.

IN THE KITCHEN. Flowers bring color and life to your work and to the food you prepare. Kitchens these days are convivial places where guests gather while the cook prepares the meal. The kitchen is a casual place, so casual arrangements are most appropriate, as are earthenware pots of greens and herbs. Kitchen arrangements need not be large nor complicated—a mug of marigolds on the windowsill, or a colorful crock full of cosmos, may be all you need. Observing how a flower mixes colors might even inspire you to compose more colorful meals. Flowers in the kitchen can even help you scrub through a sink full of pots and pans.

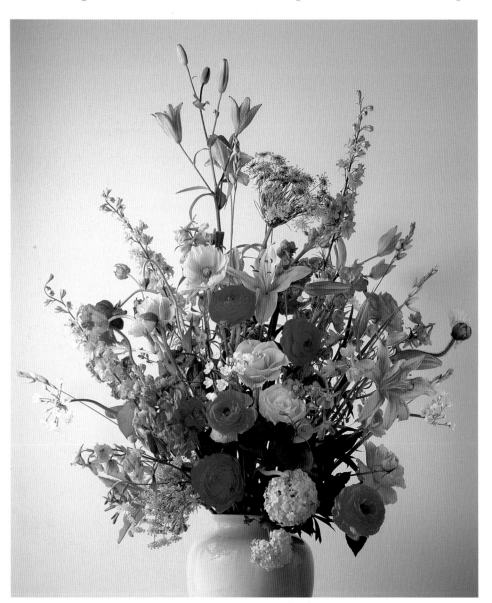

IN THE BEDROOM. We retire to the bedroom to regenerate ourselves, and a serene bouquet can soothe and revitalize the frazzled spirit. Make the guest room a sanctuary of welcome by placing a pretty white porcelain

(Left) A profusion of summer blooms—including ranunculus, lilies, Queen Anne's lace, and roses—reach gracefully out of this classic white porcelain ginger jar. Photo by Maria Ferrari.

(Opposite) The outdoors comes indoors in the guise of chive flowers, lady's mantle, and lavender, all fresh from the garden, to bring a lift to any kitchen. Photo by Peter Margonelli.

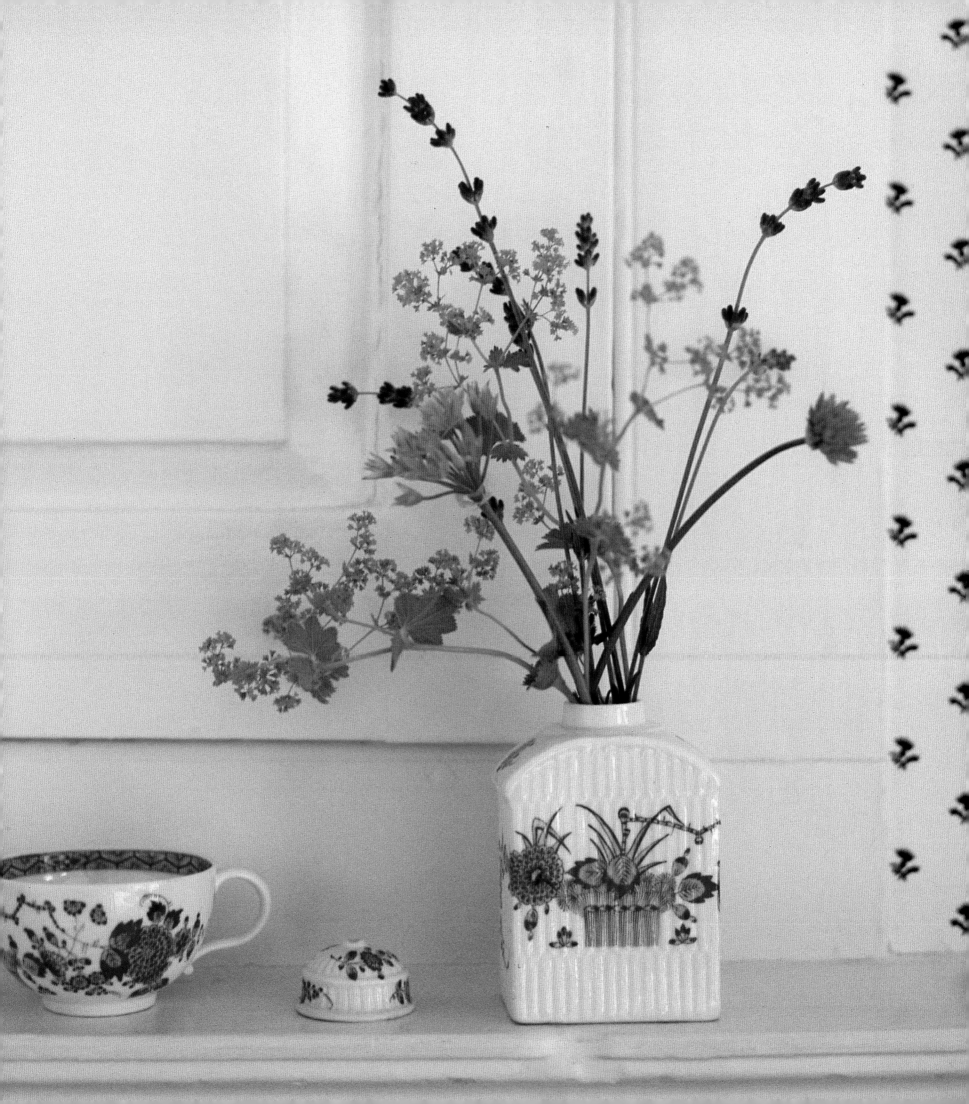

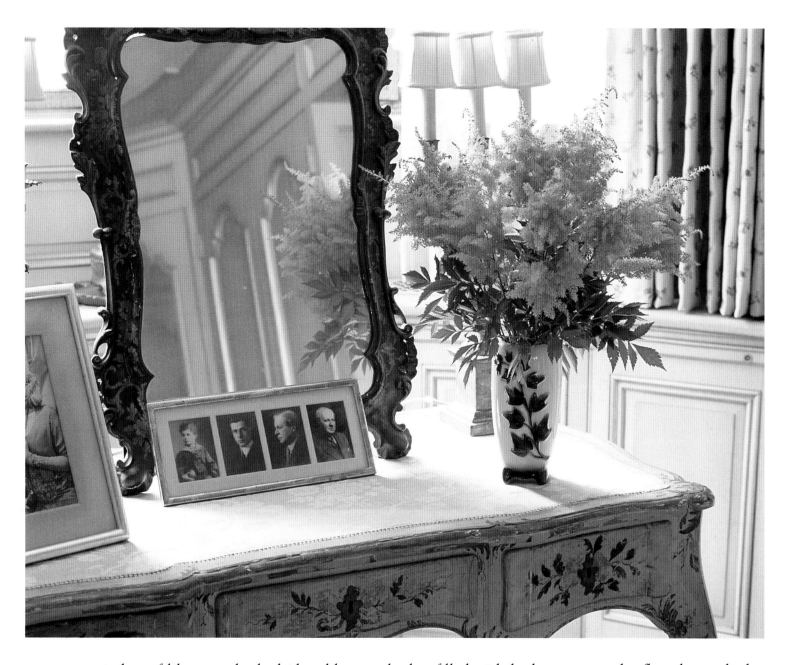

pitcher of lilacs on the bedside table, or a basket filled with hydrangeas on the floor beneath the window. And of course, nothing could be more romantic than a slender vase of roses on the dressing table. Bedroom arrangements may be kept simple—a single species of flowers, perhaps, or a monochromatic arrangement—but mixed arrangements are equally inviting.

IN THE BATHROOM. You come face to face with your self in the bathroom, and flowers can give you the lift you might need. Choose flowers that won't mind radical swings in temperature and humidity: chrysanthemums, narcissus, lilacs, hyacinth, tulips. Trailing ferns and spider plants not only cope well with extreme conditions, but also contribute to purifying the air. Bathroom tile and mirrors are hard and smooth, so you can work with that, choosing glass or colorful ceramic containers, or you can play with contrasts by choosing containers made from baskets, driftwood,

seashells. However, avoid dried flowers and dried potpourri in the bathroom since they will absorb moisture and perhaps odor as well.

IN THE WORKPLACE. The artist's barn or loft studio comes alive with an inside window box "planted" with fresh-cut long-lasting asters, achillea, miniature iris, and coreopsis. The professional's waiting room loses its austere, apprehensive quality when there is a vase of sunflowers on the table. For optical health the most diligent office worker must look up from the computer screen— you can't spend all your time in cyberspace. Even if you don't have a window on the outside world, you can always have a container of fresh flowers. They will freshen the air as they lift your spirits, bringing bright life to the neutral drabness of a commercial color scheme.

ON THE PATIO. Don't neglect the possibilities offered by cut flowers in outdoor living spaces. Just because you can see the garden from your patio doesn't mean you can't also have a vase on the table, or an urn alongside you on the deck. You can mix containers of cut flowers with planters of greenery or of blooms. Informal containers made from found objects usually work in outdoor spaces—old washtubs, wheel

(Opposite) Flowers in the bedroom create a restful atmosphere. Simple, monochromatic arrangements of one or two species contribute to the peaceful ambiance. Photo by Peter Margonelli.

(Right) Seafoam statice in a galvanized bucket shoots a spot of rich color into this spartan bathroom. Photo by Grey Crawford.

These flowers create a bridge between the terrace and the trees, uniting the outdoor and indoor spaces. The lavish arrangement includes blue iris, feverfew, Queen Anne's lace, pale blue delphinium, astilbe, and deep red-purple stock. Flowers and photo by Kasha Furman.

hubs, cement blocks, whatever strikes your sense of adventure. The verandah looks perfectly natural with a milk-pail full of ornamental grasses or native hydrangeas and oak leaves. Nor is scale an issue—it's difficult to overwhelm an outdoor living space with an arrangement, so the only limit is your energy and your access to suitable floral material.

FLORAL THEMES

Today, flowers come to us from all over the world, which provides another thematic approach to creating unique arrangements. For example, you might design an arrangement to accompany ethnic cuisine. A special guest would be honored by an arrangement based on the flowers of his ancestral homeland. And you can evoke another time by studying the floral paintings of that era in order to reproduce those arrangements. Finding the precise materials can sometimes be a challenge,

Blue delphiniums, yellow snapdragons, blue and yellow pottery, blue sky, yellow chair. Time for a relaxing cup of coffee in the garden. Photo by Elizabeth Heyert.

but what matters is the spirit of the style, not its letter.

The ancient Egyptians floated water lilies in low bowls and enhanced their homes with lotus blossoms in ceramic vases decorated with floral motifs. The people of classical Greece and imperial Rome used flowers lavishly, especially in celebrations, and would sometimes carpet the floor of a banquet hall with fragrant rose blooms and petals. Their festivals were replete with garlands and head-wreaths, and their interiors favored fresh as well as dried flower topiaries.

Renaissance times brought a horticultural golden age and the beginning of the formal bouquet. New and rare botanical species of flowers and plants were propagated by skilled gardeners, and many specimens were exported and imported, much to the delight of wealthy connoisseurs. As a leading trading nation and a nation of gardeners, the Dutch were at the forefront of this floral explosion, as you can see in their magnificent floral paintings. Today these incredible arrangements can be duplicated with multicolored striped tulips, double primroses, camellias, peonies, crown imperial, hybrid delphinium, morning glories, lilies, and old-fashioned roses.

In the nineteenth century, the Victorians of England and America introduced many newly collected plants and flowers fetched from Africa, South America, and China. They were passionate in their love of flowers and they hybridized old favorites to create new varieties—fancy striped, wonderfully fragrant, multipetalled, or more divinely colored. It was in Victorian times that arranging flowers became a popular hobby for women, who displayed their talents at grand parties. Overflowing urns and romantic, flower-filled rooms were very much a part of Victorian life.

Meanwhile, the Impressionist painters—Cézanne, Van Gogh, Degas, Monet, and others—showed us a new way to see light and color. Soft, magical, and ephemeral, their floral impressions recreated the effect and mood of the flowers, as opposed to the detailed realism of the Old Masters. About the same time, the Art Nouveau designers returned to nature to find the antidote to industrial uniformity. They focused on the sensuous lines of tendrils, stems, foliage, blooms, and buds in flowing depictions of lilies, vines, and climbing roses.

Softer floral colors of pinks, mauves, lavenders, and purples, and a softer, less restrained attitude toward arranging flowers was exemplary of floral design in the 1930s and 1940s. Lilac, wisteria, iris, delphiniums, larkspur, and roses, mixed and placed in a translucent pearlized ceramic vase, evoke those times. To recreate the 1950's popular style, think of bawdy, vibrant, hot, and even clashing colors in strongly shaped and brightly colored ceramic vases. The 1960s brought eclecticism alive as styles loosened and "flower power" brought a focus to the singular beauty, simplicity, and peacefulness of flowers.

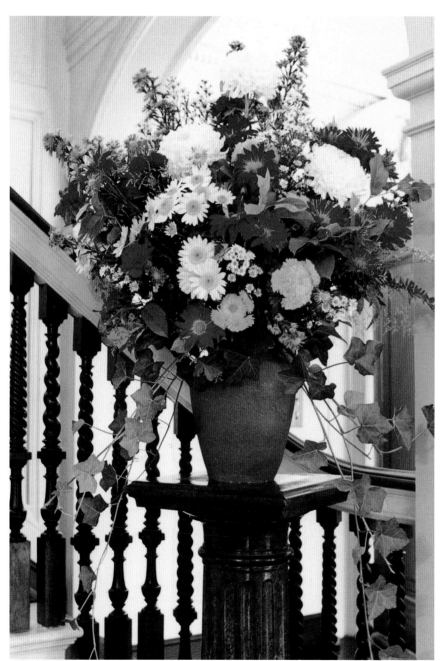

Now, late in the twentieth century, post-modernism gives us access to all historical styles, to reproduce or reinterpret as we wish. Meanwhile, minimalism is once again popular, under the powerful influence of Oriental design ideas. Think of simple shapes, containers with one type of flower in a group, bowls of seed pods and twigs massed together. A clear and simple statement can speak as eloquently as an overflowing vase.

(Left) Fall flowers—chrysanthemums and asters in a Portuguese urn—catch the sunlight in the hallway. Flowers and photo by Kasha Furman.

(Opposite) A blue cylinder containing birds of paradise becomes the focal point of this richly colored Arts-and-Crafts style sitting room. Photo by Grey Crawford.

SEASONAL OUTBURSTS

Flowers bring nature into our homes and connect us with the earth, so an arrangement that reflects the season of the year is always appropriate. When we force narcissus to bloom during January, or buy imported tulips and daffodils, we're treating ourselves to a glimpse of the springtime to come. We're heartened, we can make it through the cold. When we spy the first crocus, or bring a branch of cherry blossoms into the house, we know that springtime has arrived. The bountiful profusion of spring and summer flowers is at hand. When we bring the last of the summer flowers in from the garden, we know it's time to close down for autumn and winter. We don't have to think about these changes, we feel them in our hearts and in our bones.

For seasonal inspiration, consider China's Buddhist priests, who developed simple yet sophisticated floral designs containing just one species of flower in reflection of each season: for spring, the flowering peach tree blossoms or peonies; for summer, the lotus flower and leaf; for autumn, the long-lasting chrysanthemum; and for winter, the fragrant paper-white narcissus with evergreen pine branches. Today, you don't have to be quite so formal about it, you can work with the flowers and plants that are locally available in each season of the year.

SPRING. A spray of blossoms from a fruit tree occurs only once a year: peach, apple, cherry, quince. Blink, and the blossoms are gone. Often they are too fragile and transitory for commercial handing, which is why you usually don't see them in florists' arrangements. But these same qualities make them precious when you are arranging for family and friends. As early as the end of January, you can bring in branches from dogwood, forsythia, magnolia, flowering quince. They'll bloom if you put them in hot water in a warm part of the house, though you must change the water and clip the stems every three days. Branches pruned from flowering trees make a statement, albeit a fleeting one, that transcends the hustle and bustle of daily life. Stop, these flowers say. Take a moment off and consider beauty. You won't see this again soon, not for a whole year.

Tulips, daffodils, hyacinths, and narcissus are the traditional bulb flowers of spring. Their appearance in the garden is always welcome, and like the flowering branches, you can force them indoors. First you must keep them cold for a few weeks to simulate winter, then simply water them and warm their feet. Everyone loves a cut-glass vase of daffodils or a decanter of tulips, but you can also make a rhythmic vertical arrangement using foam or a pin-holder in a shallow dish. Imagine your dish is the garden, and space the flower stalks and leaves the way they would grow outdoors.

SUMMER. The problem in summer, if it can be called a problem, is choosing which flowers to bring indoors, from the profusion in the market and garden. Life offers few experiences richer than an hour in a cutting garden, surrounded by peonies, zinnias, cosmos, snapdragons, delphiniums, and of course, the roses. Cut all you can carry, for tomorrow there will be as many more. Have flowers throughout the house, for this is their season of glory.

AUTUMN. The traditional autumn flowers are asters, daisies, and chrysanthemums, but in many parts of the country they are overwhelmed by the amazing reds, oranges, and golds of the leaves. You can use branches of autumn-colored leaves the same way you would use stems of flowers, as the mass of an arrangement, or as the accent motif. However, when you bring them indoors as individual branches, you may be surprised by the way the colors soften. Autumn leaves require sunlight to really sparkle.

WINTER. The holiday season dominates winter arrangements, but before the holiday season and after it, we long for a touch of green inside the house. Bring in evergreen branches from the needle-bearing trees—fir, pine, cedar, and spruce—as well as from broad-leaved evergreens such as box, mountain laurel, and rhododendron. Even in the snowy Northeast, there's always a spot of color in the landscape, in the form of such winter berries as bittersweet. You can always add color and interest to an evergreen wreath or vase arrangement with cut flowers from the florist's shop, with special ornaments, with gay ribbons, and with rich fruits and nuts.

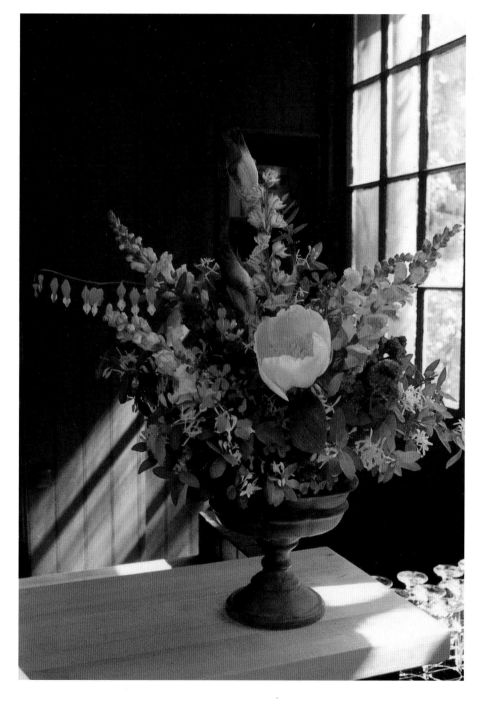

Spring flowers—bleeding hearts, snapdragons, honeysuckle, larkspur, peonies, and statice—sift the soft light from a country window. Flowers and photo by Kasha Furman.

FORMAL AND INFORMAL FLOWERS, CONTAINERS, AND ACCESSORIES

❧

These lists will help you sort flowers, containers, and accessories into formal and informal styles. But what is really appropriate depends on the context, and above all on the sense of style you bring to the design. Trust your inner sense. If it works for you, it probably will work for other people too.

FORMAL

CONTAINERS

Cut or etched crystal
Polished metals: silver, gold, brass, bronze
Epergne stand
China and porcelain bowls, compotier
Classical shaped urns on pedestals
Cloisonné or intricately designed vases
Refined topiary shapes

ACCESSORIES

Lace, satin, velvet, taffeta ribbons
Rich sumptuous tapestries and fabrics
Fine, heavily embroidered or lace linens
Silken tassels and cording, gold balls

FLOWERS

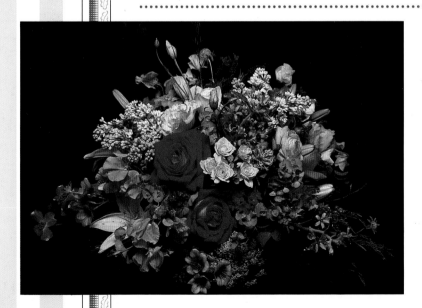

Casablanca lily, Lilium longiflorum
Dendrobium orchid
Cherry blossoms
Gardenia, camellia
Hybrid delphinium
English roses, long-stemmed roses
Dahlia
Stephanotis
Scabiosa
French tulips
Foxgloves
Calla lily

Star of Bethlehem
Bearded iris
Sweet peas
Viburnum
Lisianthus
Foxtail lily
Snapdragon
Peony
Gypsophilia

INFORMAL

CONTAINERS

Wooden tubs, trugs, bowls
Distressed metals with patina; copper, pewter
Chunky colorful ceramic
Glass jars, handblown organic glass
Simple terra cotta, earthenware pots
Hand-built pottery
Carved-out vegetables and fruit
Basketry

ACCESSORIES

Raffia, burlap, twine, rope
Plaids or bright, brash colorful tablecloths
Simply decorated cotton runner or cloth
Loose mosses, twigs, bamboo

FLOWERS

Chrysanthemums and pom pons
Tropical flowers; heliconia, bird of paradise
Forsythia branches
Sunflower
Gladioli
Climbing rose, wild rose
Zinnia
Grape hyacinth
Coreopsis
Standard carnation
Wildflowers
Gerbera daisy
Day lily
Geranium
Iris
Yarrow
Hydrangeas

Poppies
Queen Anne's lace
Aster
Thistle

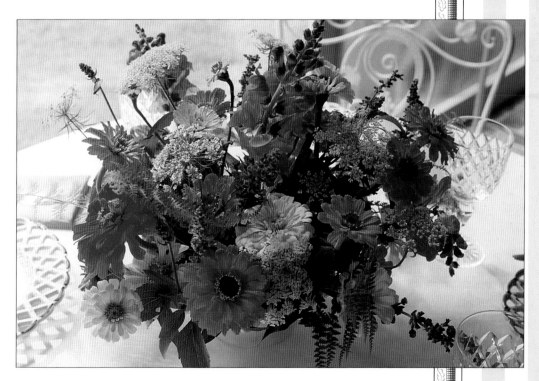

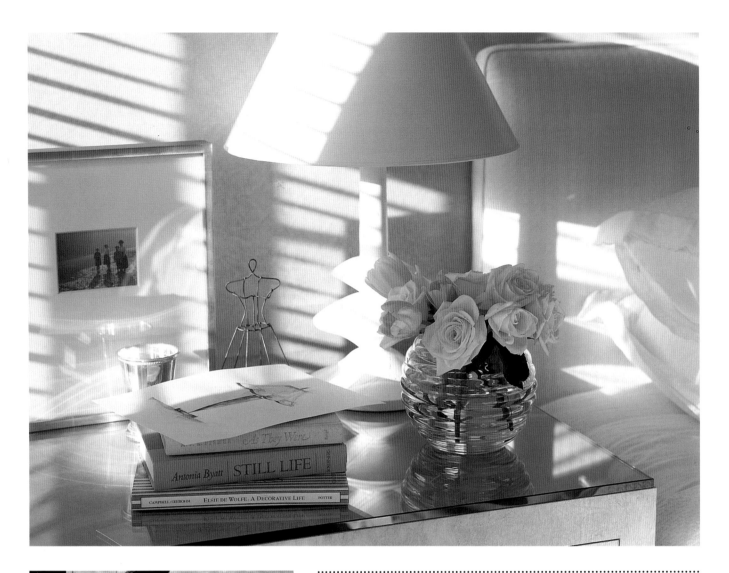

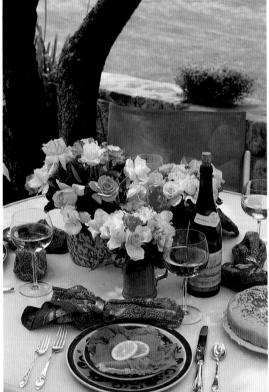

(Above) *This guest room feels like home, because the hostess has placed a welcoming bouquet of roses and tulips on the bedside table. Photo by Grey Crawford.*

(Left) *Several small vases of freshly picked garden roses grace the table for an elegantly informal lunch on the terrace. Photo by Peter Margonelli.*

(Opposite) *A simple arrangement of pink hydrangea in a clear glass globe completes the table setting for a delightful lunch. A clear and powerful floral statement does not need to be elaborate or expensive. Photo by Grey Crawford.*

The window box is partly flower arrangement and partly a bit of garden brought almost inside the house. It's a chance to make an arrangement that changes as the flowers unfold. (Left) Colorful primula peek over a curtain of vinca. Photo by Jim Schwabel/New England Stock Photo. (Below, left) Bountiful blossoms fall out of a hidden window box below. Photo by Maureen De Fries. (Below) Bright petunias and nasturtiums break the severity of louvered shutters. Photo by Michael Shedlock/New England Stock Photo.

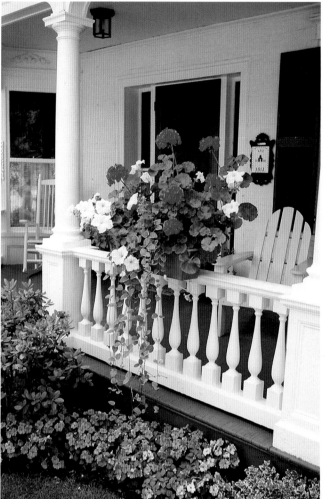

Any little flat spot is a good place for a container of flowers. These friendly boxes contain petunias, geraniums, and lobelia. (Above) Photo by John and Diane Harper/New England Stock Photo. (Above, right) Photo by Howard Karger/New England Stock Photo. (Right) Photo by Jim Schwabel/New England Stock Photo.

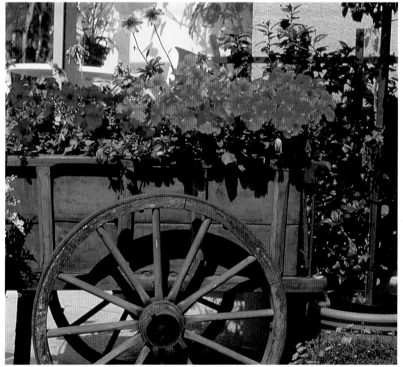

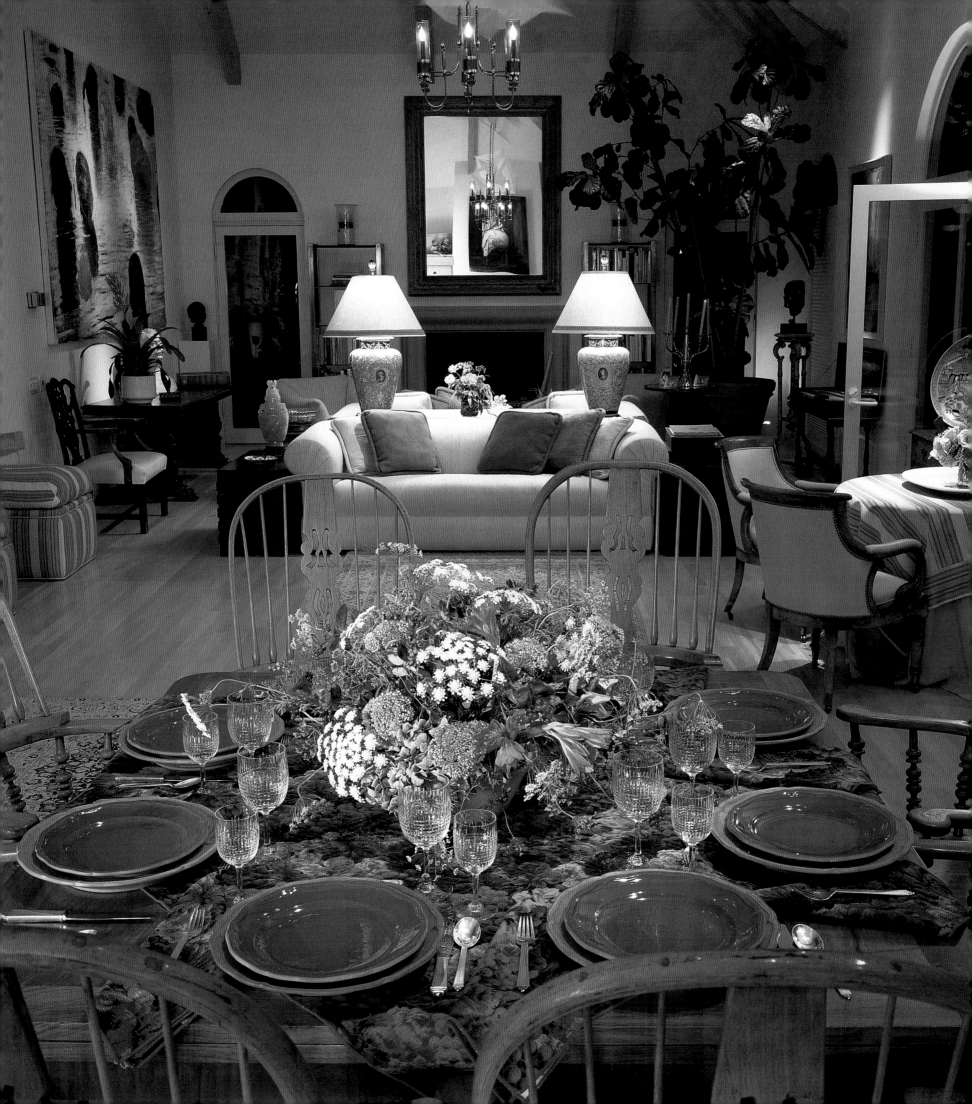

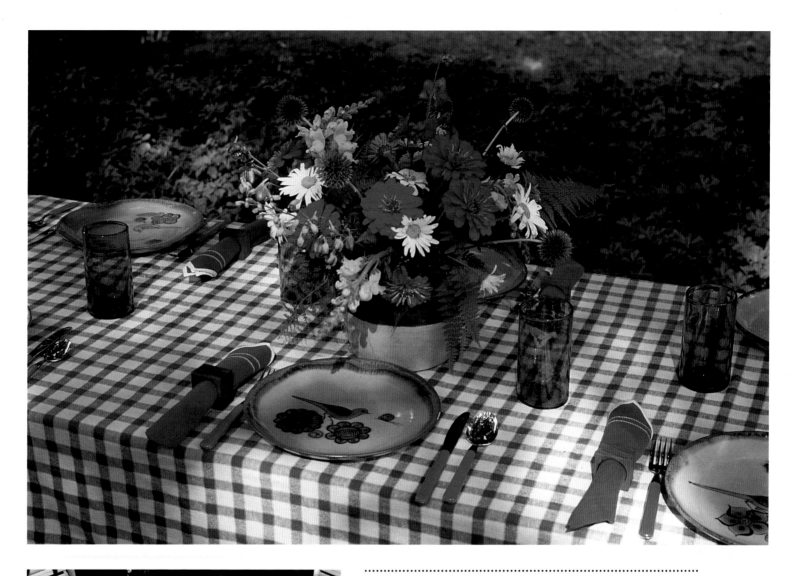

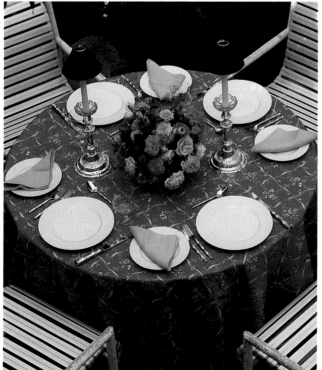

(Opposite) Casually stylish tables set for casual meals are inviting anywhere—inside or out. Photo by Grey Crawford.

(Above) A tablecloth, linen napkins, and attractive place settings elevate a patio lunch or dinner—with the essential assistance of bowls of fresh flowers. The flowers include marguerite daisies, zinnias, delphinium, globe thistle, and physostegia. Photo by Peter Margonelli.

(Left) A patio supper complete with candles and flowers is a civilized oasis in the middle of the city. Devaney Stock Photos.

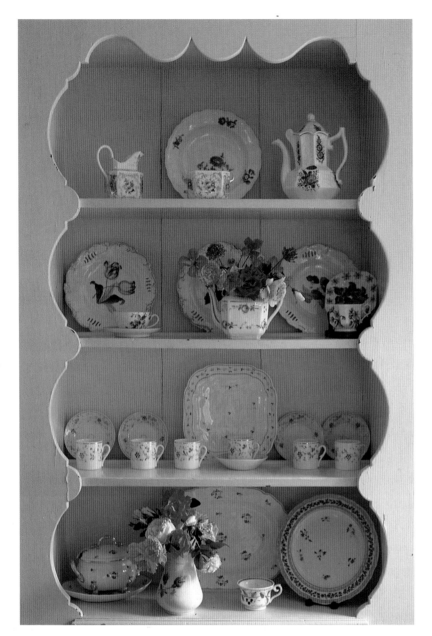

Flowers add color and visual interest to any still-life arrangement of objects, whether casual, as in the cheerful bathroom (left), or delightfully natural, as these roses that lighten up an old-fashioned, summer-drenched china cupboard (top, left), or the tumbler of roses that accent a sleek bathroom (top, right). (Left) Devaney Stock Photos. (Top, left) Photo by Peter Margonelli. (Top, right) Photo by Grey Crawford.

(Opposite) The shape and texture of this arrangement echo the shape and texture of its ceramic container. The flowers include sunflowers, lilies, asters, foxglove, and purple lisianthus. Photo by Grey Crawford.

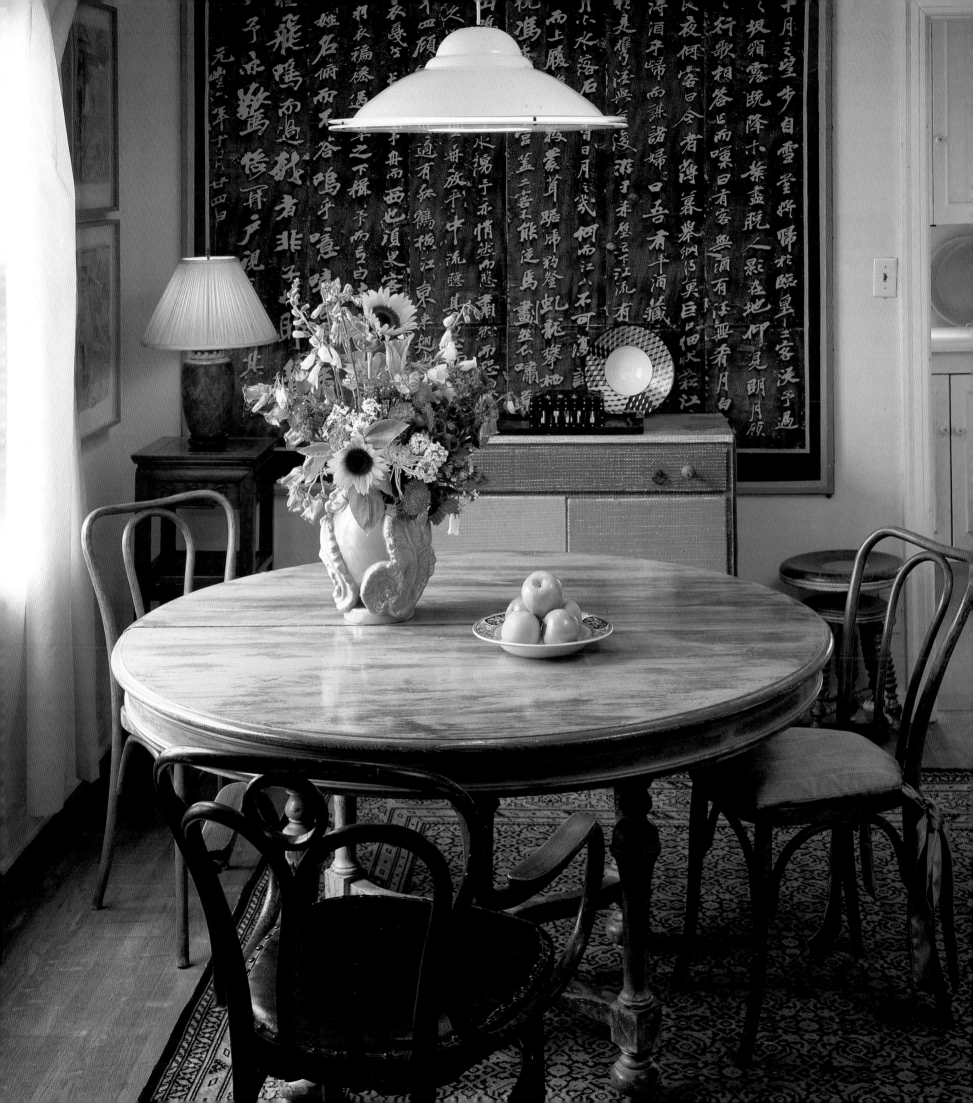

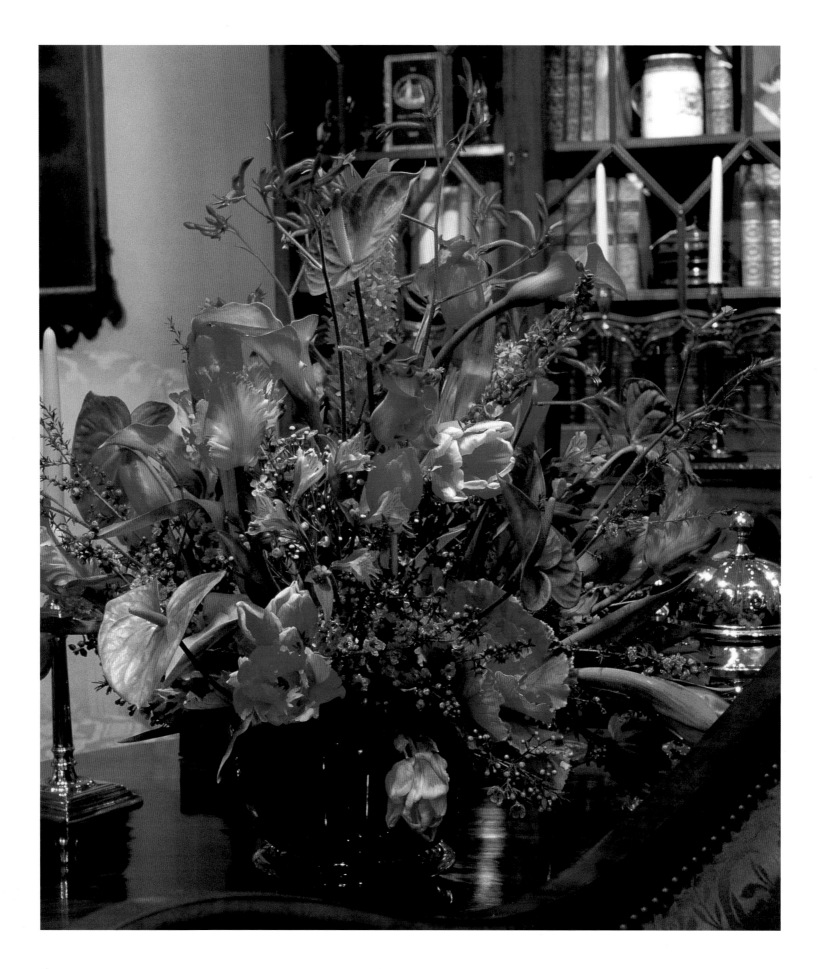

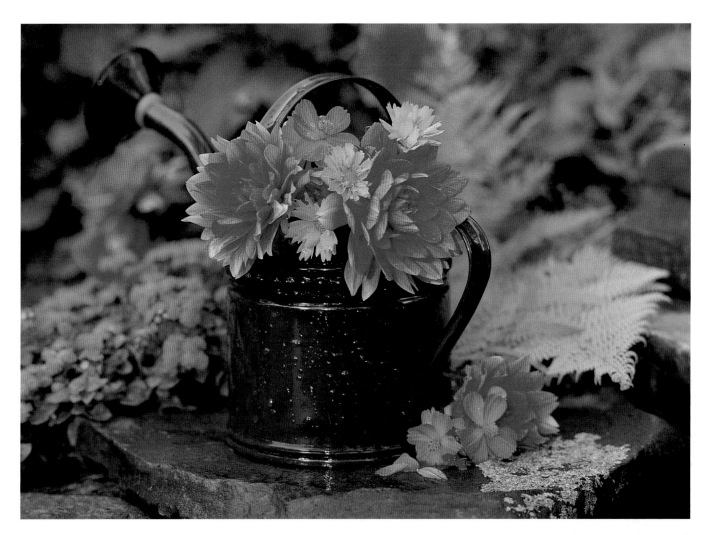

(Above) Vivid coreopsis, dahlias, and ageratum contrast brightly with a black enameled watering can. Photo by Michael Giannaccio/New England Stock Photo.

(Right) Colorful cosmos, veronica, asters, stock, and roses tumble from a compote on a glass table in a sunny living room. Flowers by Vena Lefferts. Photo by Maureen DeFries.

(Opposite) The deep colors of tulips, calla lilies, and crocosmia anchor this arrangement in the library. Devaney Stock Photos.

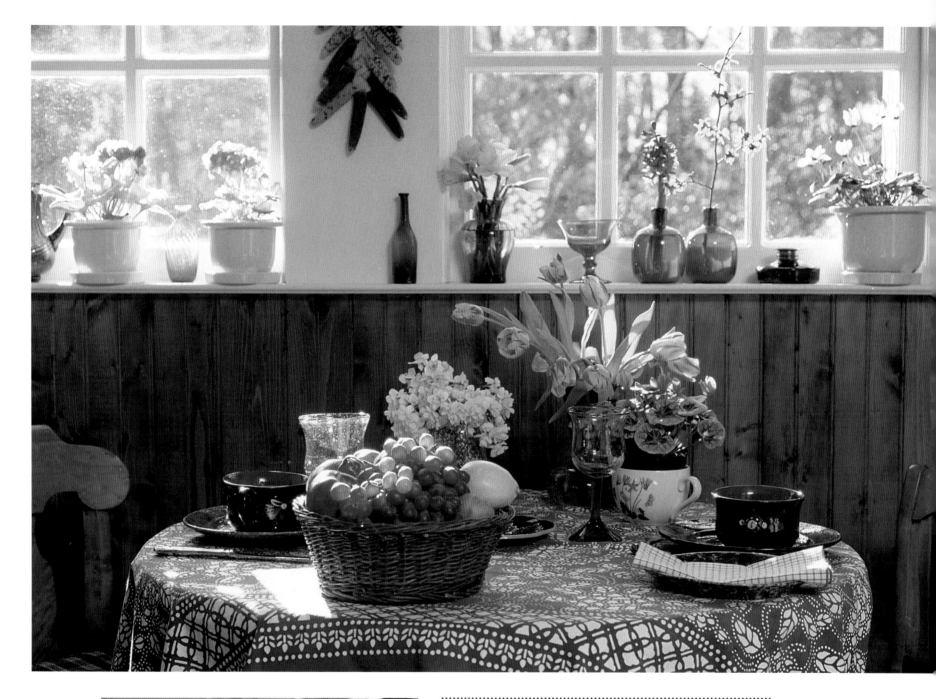

(Above) A floral centerpiece is an essential backdrop for casual dining with family and friends. Smaller bouquets on side tables and ledges extend the welcome throughout the room. *Devaney Stock Photos.*

(Left) A simple paper ribbon completes the lush bouquet of peonies in white, pink, and red, with just a touch of yellow. *Flowers and photo by Kasha Furman.*

(Above) A riotous profusion of the palest ivory-yellow roses brings a cottage-garden feeling to this refreshing summer afternoon iced-tea break. An equally perfect counterpoint is achieved by these white roses with a formal coffee service (right). Photos by Elizabeth Heyert.

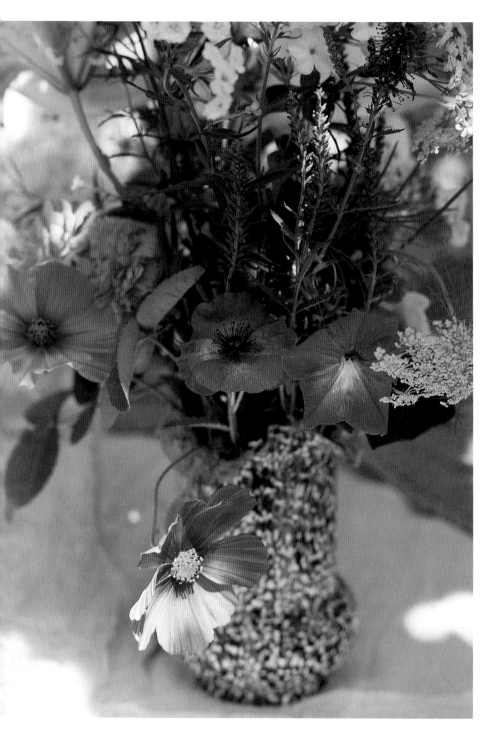

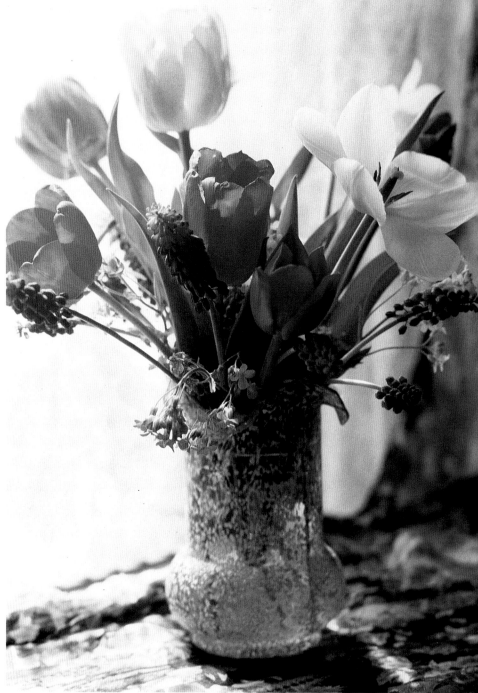

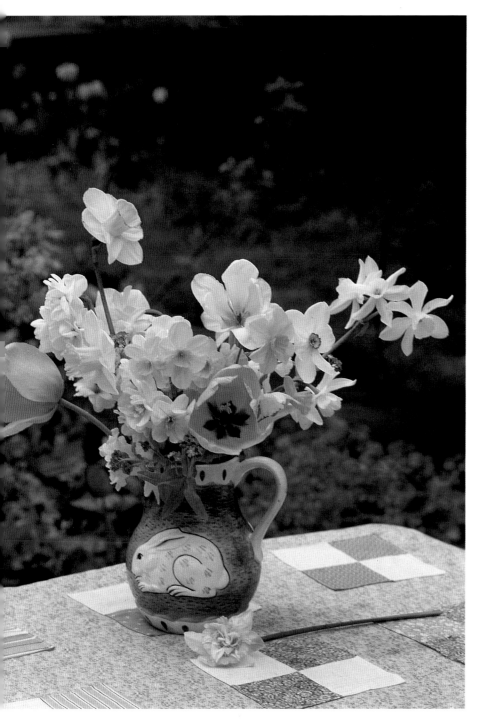

Simple eye-catching arrangements of fresh garden flowers, like these, can bring life and color into every corner of the home, reminding us of our affinity for the natural world. Flowers and photos by Gloria Nero.

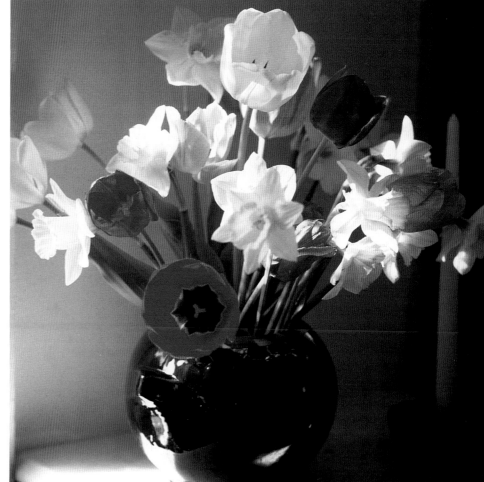

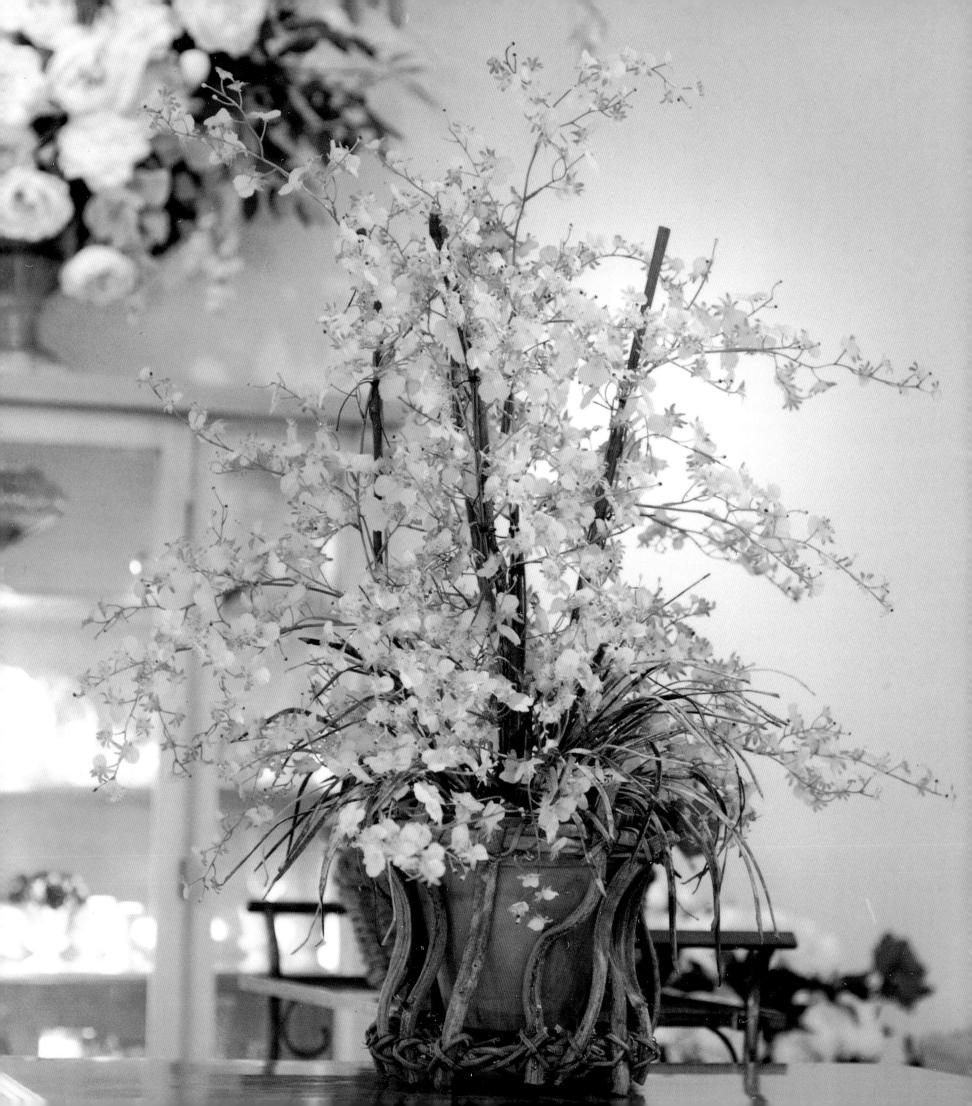

(Opposite) A natural-looking mass arrangement of silk cymbidium orchids in a rustic container is wonderfully inviting any day of the year, year after year. This room will never be without the visual interest of flowers. Silk flowers by Anita Widder. Photo by Maripat Goodwin.

(Right, top and bottom) Daisies, rudbeckia, and petunias put color into the arid Southwestern landscape. Photos by Peter Margonelli.

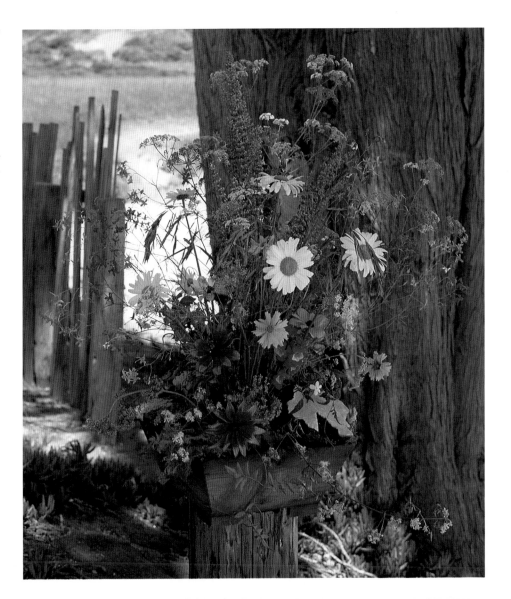

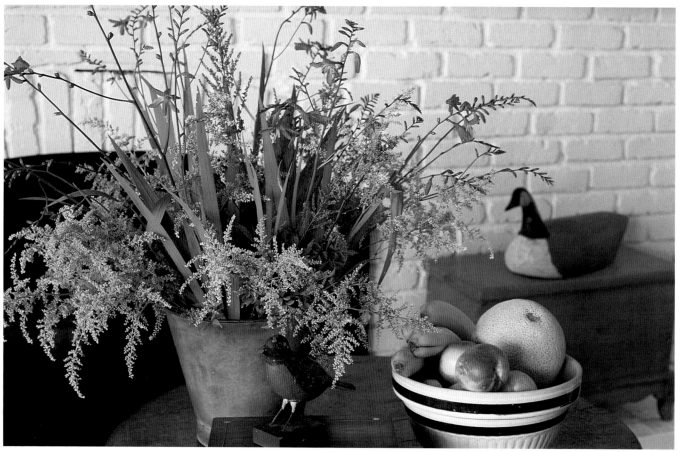

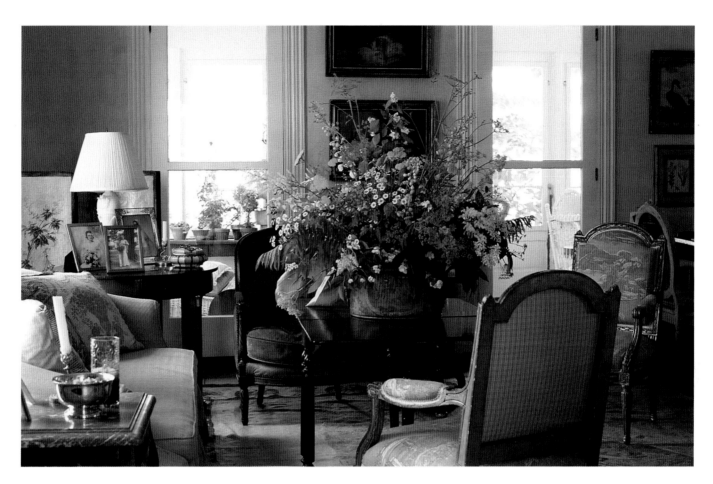

..

(Above and right) Wherever family and friends prefer to sit and talk is the right place for floral expressions. Animated people engaged with one another will be the bright spots in these friendly rooms. Photos by Peter Margonelli.

..

(Opposite, top) A white painted trug brought this profusion of lavender straight from the garden to the dining room table. Muted floral colors speak softly and harmoniously with the predominantly white decor (opposite, bottom). Photos by Peter Margonelli.

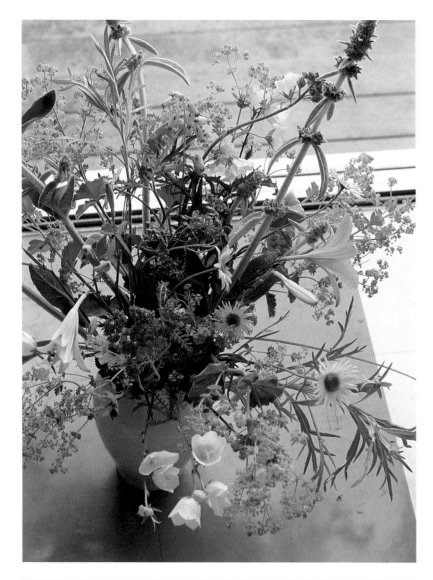

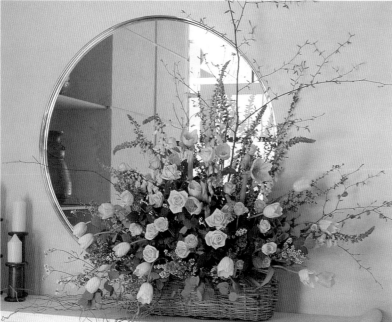

(Left) An ethereal arrangement of summer flowers echoes the air and light of a sunny room. Photo by Peter Margonelli.

(Left, bottom) A delicate arrangement of pink roses, tulips, foxglove, and lilac brings high spring into the entry foyer. Devaney Stock Photos.

(Below) A luscious autumn flower arrangement includes chrysanthemums, Peruvian lilies, delphiniums, New Zealand flax, and Laura lilies. Devaney Stock Photos.

(Opposite) A novel basket of painted wood makes a friendly home for a colorful bouquet of pansies. Photo by Peter Margonelli.

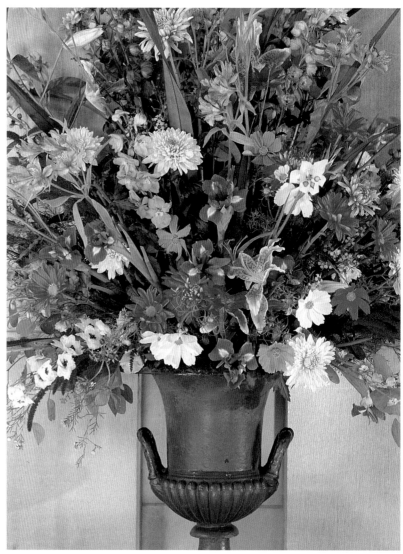

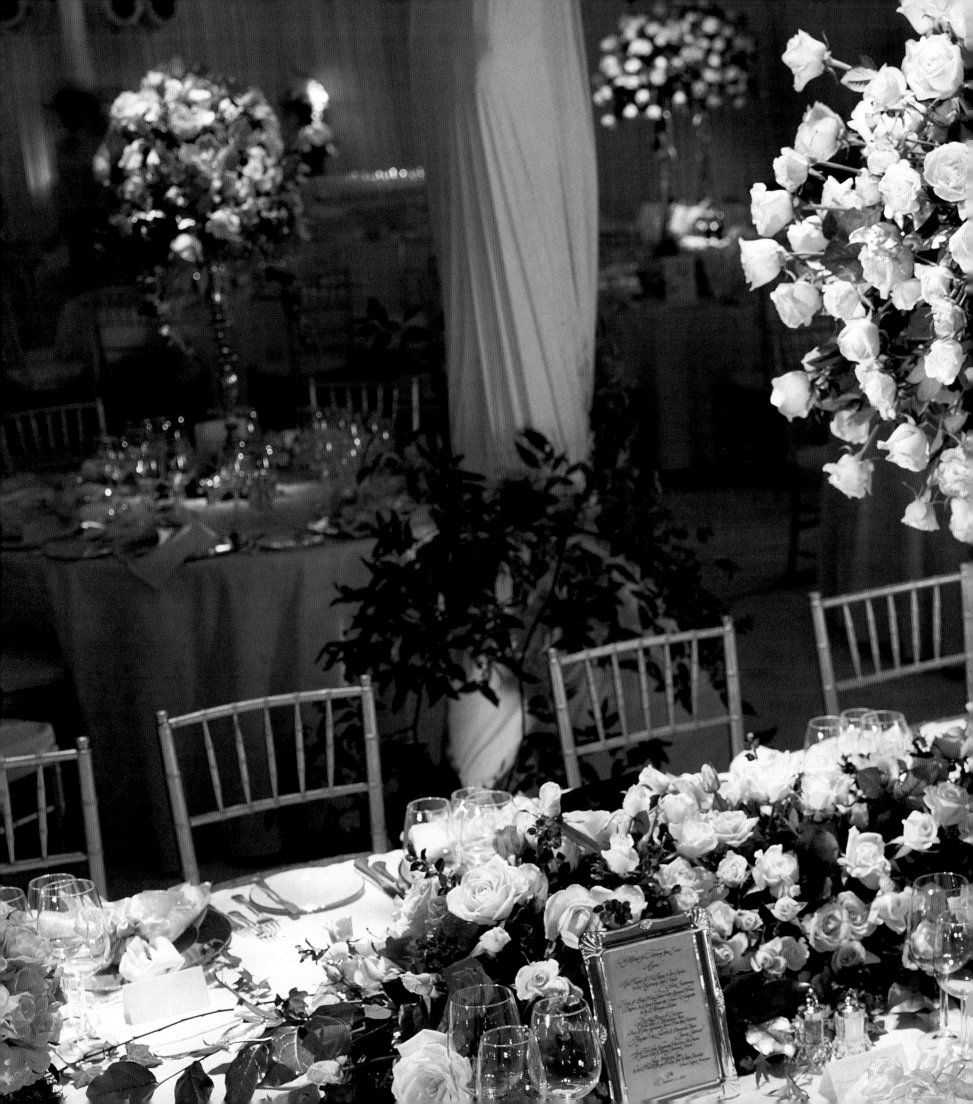

FLOWERS
FOR
SPECIAL
OCCASIONS

*F*lowers are one of the ways people tell each other about the importance and the meaning of special events and occasions. The mere presence of flowers signifies that this event is no ordinary occurrence. It is the single rose handed to the college graduate as she receives her diploma, the armful of roses given to the prima ballerina on opening night, the hundreds of roses thrown to the victorious matador. It is a tribute, an emphatic accolade about struggle and triumph, expressed in the language of flowers.

The important celebrations and passages in our lives actually require the presence of flowers. They make the specialness of the event clear to the participants as well as to the spectators and to the world at large. The obvious example is the wedding, for most people the floral extravaganza of a lifetime. But we also mark christenings, birthdays, and wedding anniversaries with flowers, and finally, we mark the passage that is death.

(Previous spread) A runner of Jacaranda and Champagne roses, laced with ivy and gilded lemon leaf, graces the head table at this elegant wedding. Flowers by Sylvia Tidwell. Photo by Grey Crawford.

(Opposite) Containers made of clear glass almost disappear from view, revealing the flower stems, refracted through the water, making them part of the visual composition. Though a springtime flower, tulips are perfect at any time of year. Photo by Elizabeth Heyert.

(Right) A swag of Casablanca lilies, limonium, gypsophilia, and white larkspur, on a lush background of springeri fern and leatherleaf, welcomes arriving guests. Photo by William Yarrington for Georgia Sheron.

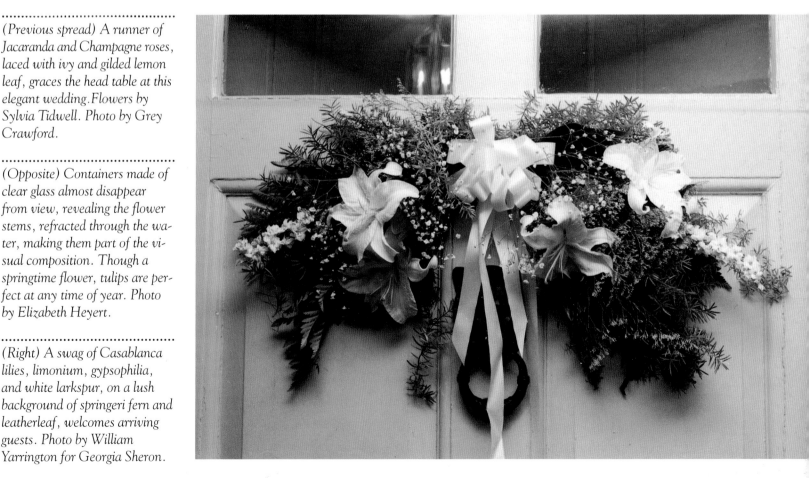

Exuberant floral arrangements also enliven all of the meaningful celebrations in our annual calendar. What would the holiday season be without greens brought into the house? Valentine's Day without roses, Easter without daffodils and tulips, Mother's Day without festive flowers, the Fourth of July parade without anything red and white, Thanksgiving without an abundance of fruits, veg-bles, and berries? Our major holidays are the peak expressions of the seasons of the year, and we celebrate them with the flowers of their time. With the addition of an arrangement of fresh flowers an ordinary event becomes a very special occasion.

NEW YEAR'S DAY falls shortly after the winter solstice and grants us all a new beginning and a fresh new time, along with the release of baggage from the past. The color of New Year's Day is the white of rebirth and renewal. White flowers evoke a feeling of clarity, and they encourage reflection upon the opportunity implicit in the transition to a new year.

VALENTINE'S DAY is the pure and simple red rose of true love. A hopelessly romantic and adventurous Valentine might suggest a more complex message with the gift of a small bouquet of significantly meaningful flowers and herbs, or a "tussie mussie" as it was called in the seventeenth century. Iris is for "a message," lilac for "the first emotions of love," white camellia for "perfect love-liness," lily of the valley for "the return of happiness," ivy for "fidelity," mimosa means "secret love," and a red tulip is "a declaration of love." A note to explain the meaning of each featured flower, written inside a handmade card, is certain to charm that special someone.

EASTER, MAY DAY, and the vernal equinox all arrive with the soft and rich pastels of the early seasonal flowers. The crocus, jonquils, and tulips break ground with their tender but determined green shoots. Lilies longiflorum are fragrant and long lasting, potted or cut, a favorite for Christian churches as altar flowers for the Easter ceremony. An Easter picnic, centered around an egg hunt, is always cheerful and bright with tulips, iris, and other bulb flowers in baskets or colorful ceramic pitchers and pots. And even at the millennium, the truly light-of-heart still can spend May Day dancing, with floral garlands in their hair. Feasting and flowers celebrate the fullness of spring.

MOTHER'S DAY, though a recent addition to the calendar, has become a significant time to honor your mother with a gift of flowers. A lovely bouquet of fresh-cut mixed flowers, or a dozen red roses in a box or vase, is a fitting tribute to her special place in your life. Father's Day can also be a great time to surprise Dad at the office or at home with the delivery of flowers and a note expressing your love.

THE FOURTH OF JULY, with flags flying, fireworks displays, casual attire and attitudes, inspires loose colorful garden arrangements that strike a patriotic note. Drape picnic tables with stars-and-stripes fabric topped with fresh white cotton squares. Red dianthus, standard carnations, alstroeme-rias, zinnias, and other red flowers will add vibrancy to the whites of fragrant freesia, stock, phlox,

The natural beauty of sand dunes and a carefree bouquet of white lilac, allium, yellow euphorbia, and pink and red bouvardia offer a delightfully stylish invitation to a special summer picnic. Photo by Elizabeth Heyert.

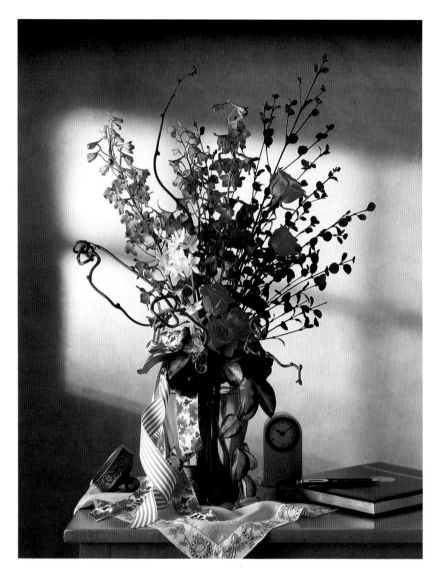

Flowers in patriotic colors, accented by flag-bunting ribbon, make a hearty Fourth of July arrangement. Photo by Maria Ferrari.

or lilies. Add the crowning glory to your Independence Day floral centerpiece with blue iris, bachelor's buttons, and blue statice.

THANKSGIVING is the major autumn holiday, but a bounteous harvest calls for a floral acknowledgment any time during the autumn months. You've got your pick of the local crops from farm stands, and richly colored flowers from gardens, fields, and floral shops, for decoration and display. Hosting a Thanksgiving gathering of family and friends is a wonderful way to share your own personal "harvesting" and to heap abundant goodness on a banquet table.

Thanksgiving is the perfect opportunity to mix luscious fruits and vegetables with dried and fresh-cut flowers. Combine unusual materials, mosses and twigs, and rustic containers, to create an earthy display. Shocks of wheat tied with raffia braids will stand tall on the sideboard. Ropes and burlap bind stalks of corn to a lamppost or porch column. Floral designs of this season build on the rich colors of autumn leaves: the dark purples of monkshood and lisianthus, the russets and bronzes of chrysanthemums, the golden tones of yarrow and solidago, the oranges of Chinese lanterns, lilies, and bittersweet berries, the gentle reds of rose hips, leucadendron, euphorbia, and anemones.

CHRISTMAS means a glorious mixture of long-lasting and deliciously fragrant evergreen boughs with cones, nuts, and fruits at the center of the traditional celebration. Add glossy, dark-green magnolia leaves and ivy trails to create a lush textural background for natural objects and glass or paper decorations. Red amaryllis, poinsettias, carnations, and roses will complement the green foliage and bring cheer to the dreary, bleary months of winter. Hand-crafted baskets, antique or heirloom ornaments, velvet, paper, or plaid ribbons on tree boughs all conjure nostalgic visions of Christmas in the country. Gild the edges of cones, dip nuts in gold paint, twine gold lamé ribbon through gar-

lands and around wreaths, and the ordinary becomes the extraordinary, glowing in candlelight with golden bright highlights.

Nontraditional floral Christmas decorations can be an exciting departure from the expected. Consider white flowers: long-lived lilies, white poinsettias, amaryllis, Stars of Bethlehem, or hellebores coupled with blue spruce, blue-berried juniper, and dried blue hydrangeas. Highlight your arrangement with white- or silver-sprayed birch branches, and snow-dipped or silver-tipped spruce cones.

Decorating for Christmas in the desert or on the balmy coast can be a challenge and adventure without the evergreen surroundings and cold snowy weather that other parts of the country enjoy. A grouping of miniature cactus in a low terra cotta dish, surrounded by strands of tiny red

Black lacquer cubes formally present unusual arrangements of wheat grass and lavender, tied with organza ribbon. Photo by Peter Margonelli.

(Opposite) Dried red berries and flowers transform a wintertime mantelpiece. Tall red candles complete the picture. Photo by Peter Hōgg.

(Above) Flowers and fabrics in rich hues of red and gold create a festive atmosphere for this New Year's Eve ball. The large sideboard arrangement at right features the colorful star-shapes of lilies, set against radiating branches of pussy willow. Flowers and photo by Lamsback Floral Decorators.

chili pepper lights and covered with fluffy faux snow, makes for a humorous centerpiece. The saguaro cactus wrapped in electric multicolored lights becomes a celestial sentry in the desert night. An equally fanciful approach for Christmas at the sandy shores might be to sprinkle miniature palm trees with "snow." You could complete the funky picture with startled pink flamingos perched one-legged in deep faux snow, surrounded by pink poinsettias and pastel-hued glass balls.

BIRTHDAYS AND ANNIVERSARIES are private holidays, and as floral occasions they often can be approached in a free-spirited way. Whether for an adult or a child, a birthday party celebrates the individual. You can style the flowers to suit the age, interests, and tastes of the celebrant. For children's birthday parties, you can be as whimsical as you like, using offbeat containers (soda cans, toy trucks) and inexpensive blossoms in strong colors. For an adult, make an arrangement with his or her birth flower. For a wedding anniversary, it's totally charming to recreate the bridal bouquet or the altar flowers in a vase arrangement.

Other personal holidays suitable for marking with flowers include graduation from high school or college, the first day on a new job, a housewarming. Christenings and Bar Mitzvahs are special times that require fresh flowers not only at the ceremony itself, but also in the home.

THE WEDDING

An abundance of fragrant and magnificently colored flowers spill over the edge of an antique ceramic urn, garlands of roses climb the banister and arch gracefully over the entrance, flower-filled crystal vases and silver candelabra bedeck the tables. The flowers create a visual ecstasy and set the stage for a perfect wedding, the event of a lifetime.

Months of planning and preparation culminate in this day of celebration. The unfolding of the events is carefully orchestrated and all the participants have detailed instructions and schedules to follow. In the background, the floral designer has much creative work to do in the few days preceding a large wedding, and it all must be done on time.

The task of arranging wedding flowers is large and complex. Whether you have taken on the challenge yourself, or are working with a floral professional, you should write the plan on paper: what's at the entrance, how to decorate the ceremony, how many centerpieces for the reception, what the bride desires for her bouquet, the corsages and boutonnieres for the wedding party, all of it, right down to bud vases for the ladies' room. Visit the wedding site—church, temple, home, or garden—and the reception site in order to measure, count, list, and plan all of the floral arrangements required, and to map out all the different kinds of flowers to buy.

Which flowers to use depends on the season of the year and on the wishes of the bride. Most people prefer local, seasonal flowers, not only for sentimental reasons, but also for economy. Weddings often have color themes, and it's nice to unify all of the arrangements by carrying one species of flower throughout. A white bouquet complements and harmonizes with the wedding gown, and thus does not distract attention away from the bride herself. Though most brides choose roses for the bouquet, this is her day and she shall have whatever she desires, traditionally as a gift from her fiancé.

..

An archway of greenery creates a handsome and intimate wedding bower within an over-sized hotel ballroom. The pine boughs have been arranged to draw attention to the celebrants. The large pine cones convey a traditional meaning of good wishes for long life together. Flowers by Elizabeth Ryan. Photo by Z. Livnat.

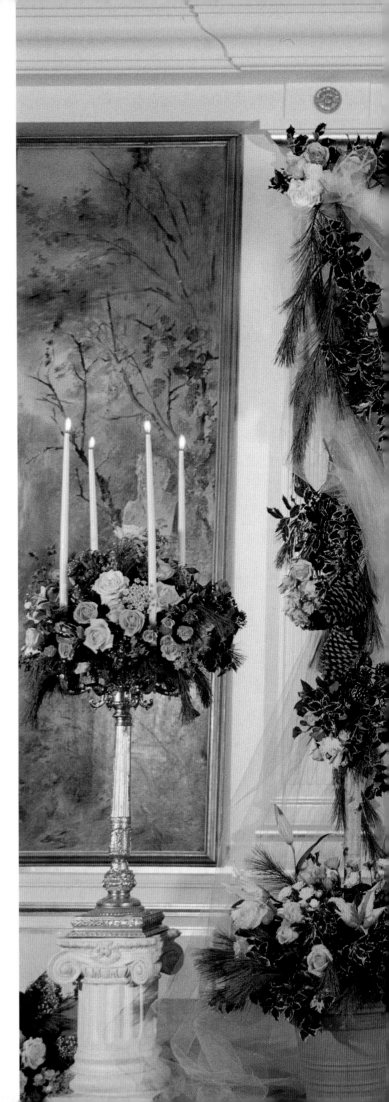

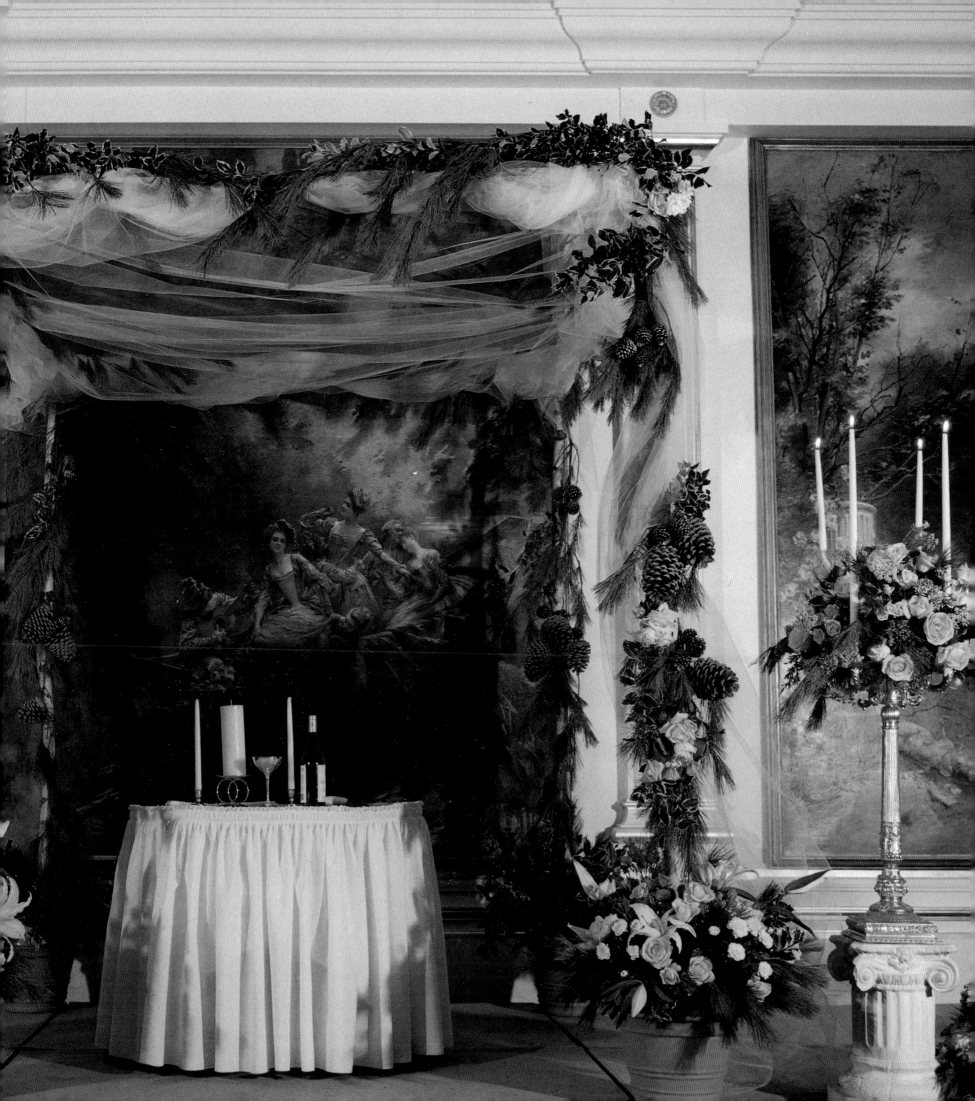

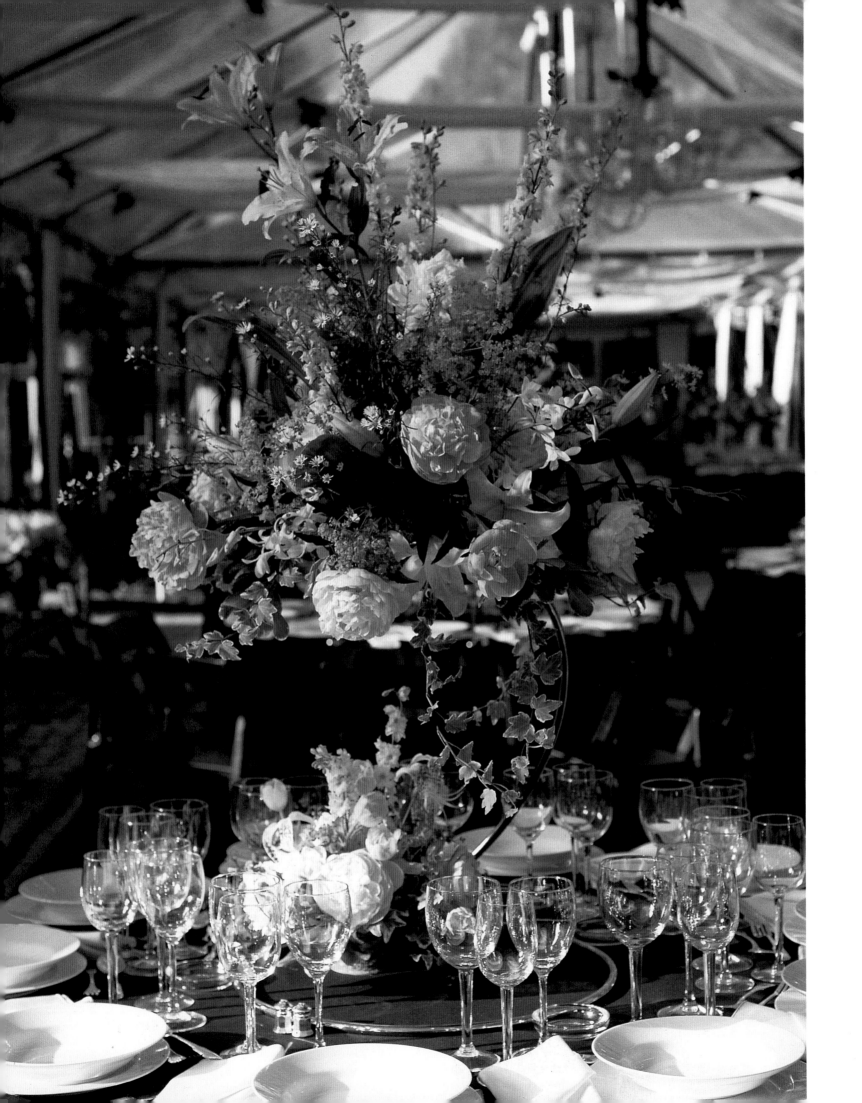

The bulk of the flowers may come from the floral wholesaler, but whenever possible do pick some of them from the garden. Foliage, branches, vines, and wildflowers gathered from the fields also can add a special touch to the wedding decor. Along with the flowers, be sure to purchase ribbons for bouquets and garlands, and be sure you obtain enough containers as well.

Cut flowers and foliage must be conditioned prior to arranging to ensure maximum freshness and vitality on the day of the wedding. It is difficult to manage a large wedding without being able to store flowers in a proper refrigerator: if there are twenty-five tables, and each centerpiece takes twenty minutes to arrange, that's a full day of work on centerpieces alone. It takes time to arrange a wedding. Without access to a floral refrigerator, buckets of flowers can be kept in a cool basement or cellar, with ice cubes to keep the water cool. Containers can be greened up in advance, since foliage usually lasts a bit longer than cut flowers do.

The goal of preparation for a wedding is to bring all of the flowers to their peak of loveliness just in time for the ceremony and reception. Immature buds of lilies need to be prompted to open in a bucket of hot water before they're placed in refrigeration. The effulgent presence of roses and peonies coaxed to their peak of openness is much more appealing than a tight bud. The sheer scale of wedding preparations gives you time to bring the flowers along to where you want them, then to retard further opening by refrigeration.

Designing of the centerpieces, garlands, and ceremony arrangements may be done in advance, but large installations of trellises and elaborate florals are often created in the place where they will be seen and enjoyed. This means arriving the day before the wedding, or that very morning, with the right quantities and kinds of conditioned flowers already organized in buckets. This kind of designing requires much preparation, but being well organized is the only way to be free to concentrate on the flowers that will do so much to make a perfect event for the bride and groom.

(Opposite) A hanging centerpiece of peonies and lilies floats above the wedding table. Photo by Devaney Stock Photos.

(Right) It takes a lot of flowers and a lot of work to decorate a wedding. Good planning and careful notes are the key, whether you make the arrangements yourself, or work with a floral professional. Here, the set-up crew arrives early to make sure that every flower is in place in time for the wedding. Flowers by Debbie Bennet. Photo by Maripat Goodwin.

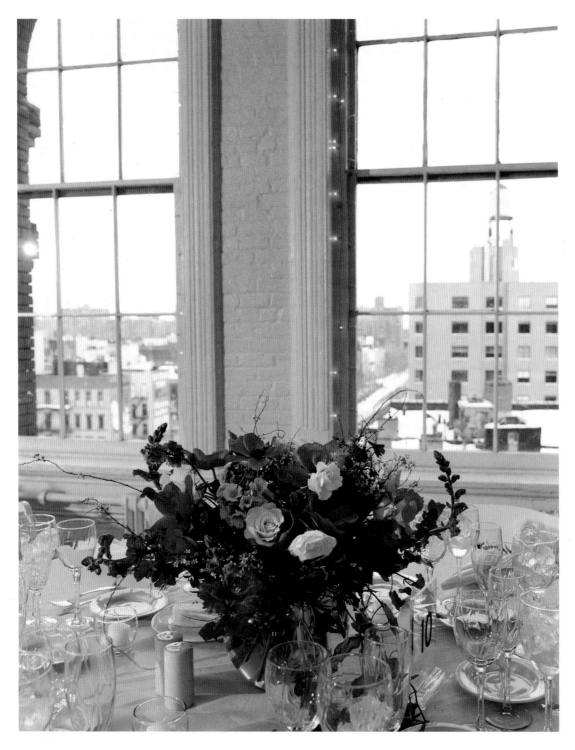

(Left) Purple anemones, phlox, snapdragons, and white roses bring a touch of the natural world to lunch against a New York window. Flowers by Christina Pfeufer. Photo by Sarah Merians.

(Below) The rustic birdhouse speaks of spring, in this whimsical wildflower arrangement. The flowers are cosmos, yarrow, coreopsis, and veronica. Photo by Peter Margonelli.

White lilies, delphinium, hydrangea, snapdragons, and yellow alstroemeria make a variety of lovely centerpieces for this stunning wedding. Flowers and photo by Lamsback Floral Decorators.

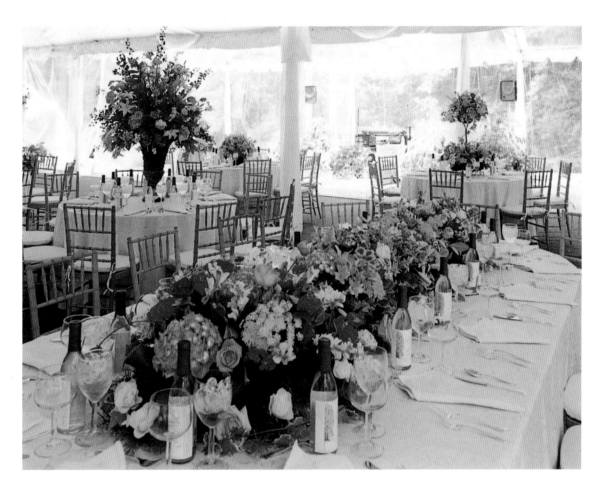

A simple garland, with informal centerpieces of hydrangea, stock, and roses, unites this deck wedding with its waterside setting. Flowers by Jennifer Houser. Photo by Christine Newman.

(Left) A papier mache swan welcomes the guests with a full load of peonies, delphinium, pink hydrangea, and le Reve lilies. Flowers and photo by Lamsback Floral Decorators.

(Above) White hydrangea, Champagne roses, and flat eucalyptus grace this tall wedding cake. Flowers and photo by Vena Lefferts.

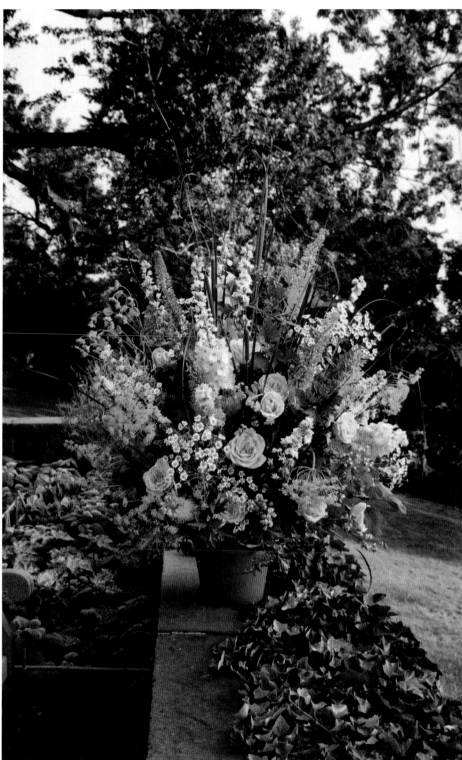

(Above) A classical urn presents this happy anniversary bouquet of sunflowers, bells of Ireland, delphinium, limonium, and roses. Photo by Christine Newman.

(Right) The bouquet on the stone wall brings the garden onto the patio. The terra cotta pot carries pink roses, yellow foxtail, pink delphinium, feverfew, white larkspur, euphorbia, miniature cattails, and yellow dill. Flowers and photo by Christina Pfeufer.

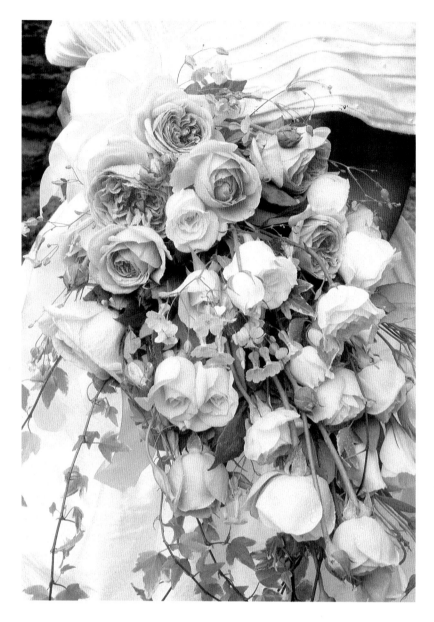

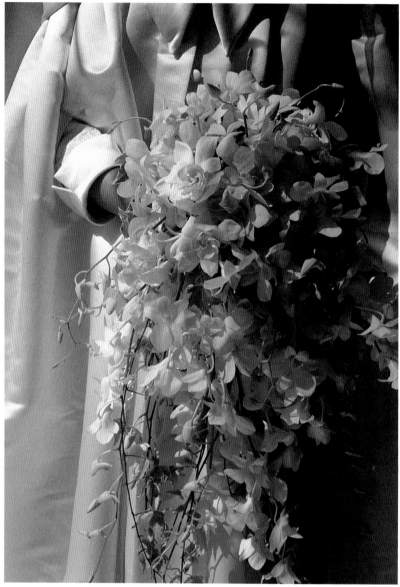

The bride carries a beautiful hand-tied Victorian cascade of Abraham Darby English roses, pink saponaria, and porcelina roses. Flowers and photo by Vena Lefferts.

(Above) For a winter wedding, the bride wears a satin coat and carries a large cascade of white dendrobium orchids and white gardenias. Flowers and photo by Vena Lefferts.

(Opposite) This sweet bridal cascade combines white sweet peas with porcelina roses. Flowers by Vena Lefferts. Photo by Georgia Sheron.

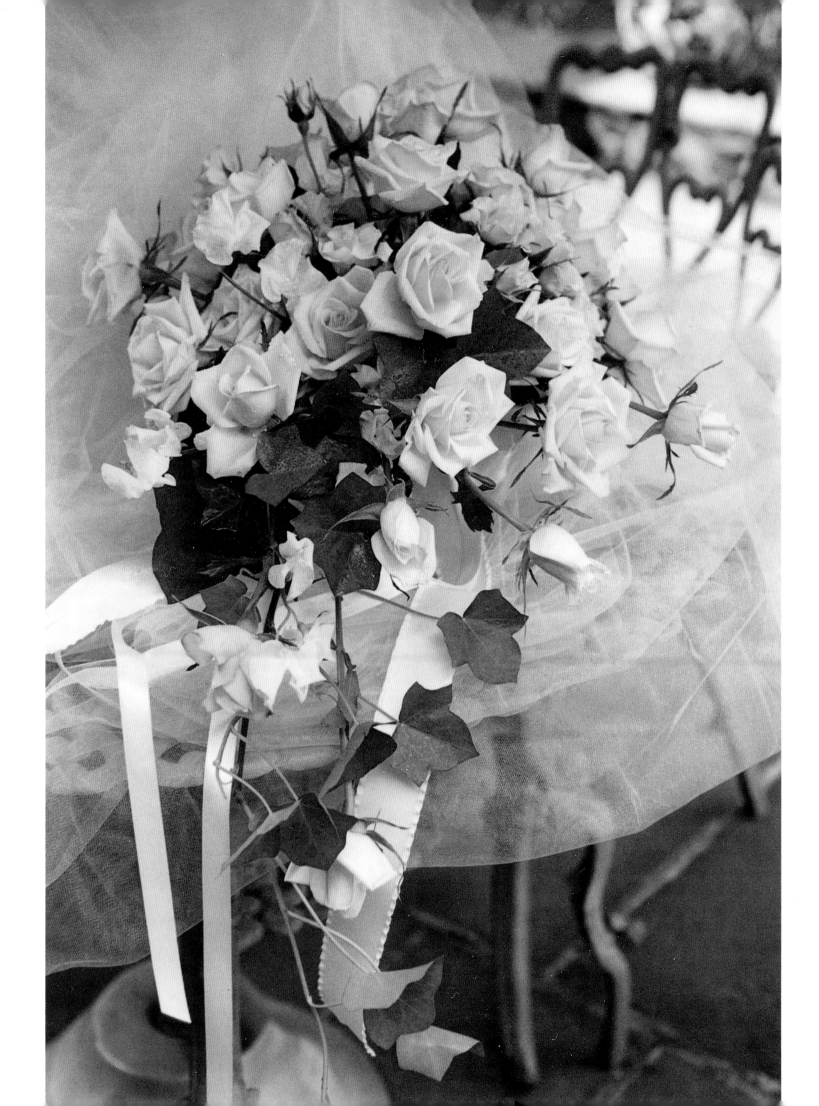

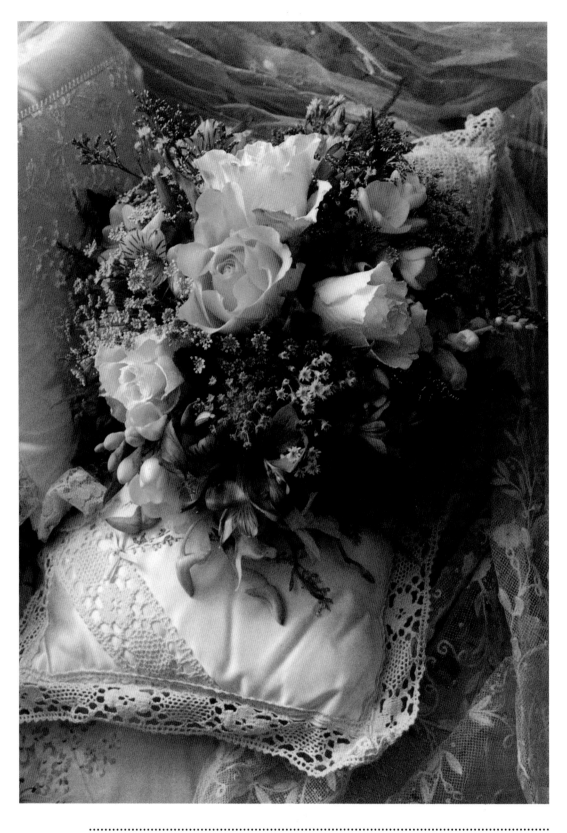

(Opposite) The bride shall have the bouquet she desires. Here (top, left), the bride carries the white bouquet, while the bridesmaids carry the colors of delphinium, black-eyed Susan, feverfew, lysimachia, and physostegia. For a starkly elegant contemporary wedding, the bride will carry a bouquet of calla lilies, eucharis, bear grass, and Ming fern (top, right). The sophisticated bouquet (bottom, left) combines phalaenopsis orchids, Casablanca lilies, dendrobium orchid sprays, and bear grass. And the colorful bouquet (bottom, right) is of pink astilbe, pink roses, lavender sweet peas, and delphinium. Photos by Iraida Icaza.

(Above) Yellow roses make a pretty bouquet for the bridesmaid. It includes Queen Anne's lace, alstroemeria, freesia, limonium, solidaster, and white dendrobium orchids. Flowers and photo by Kasha Furman.

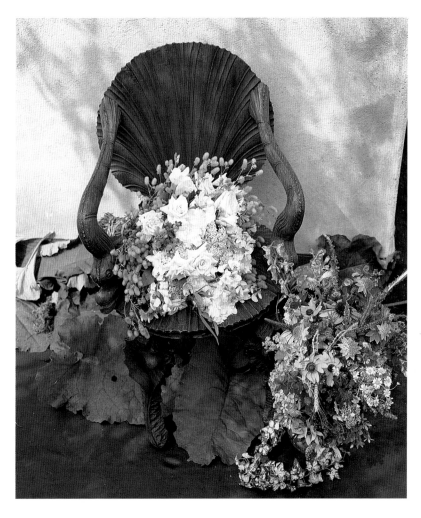 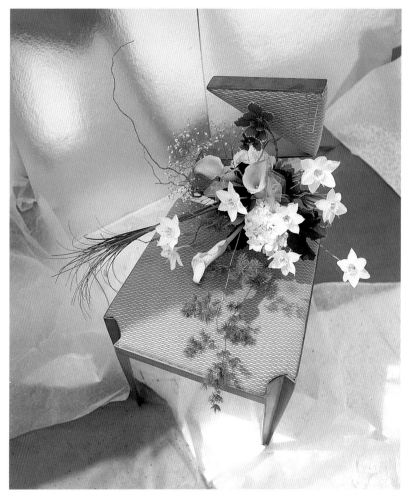

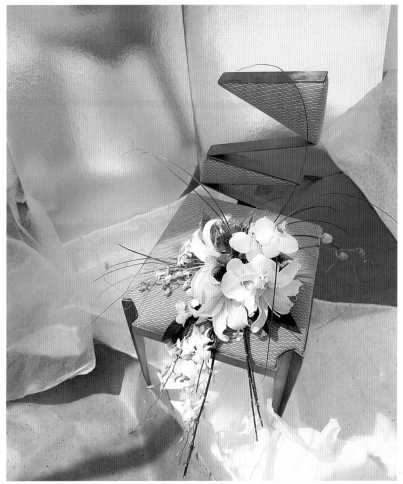 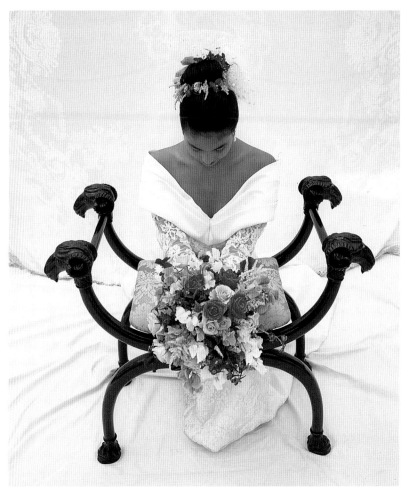

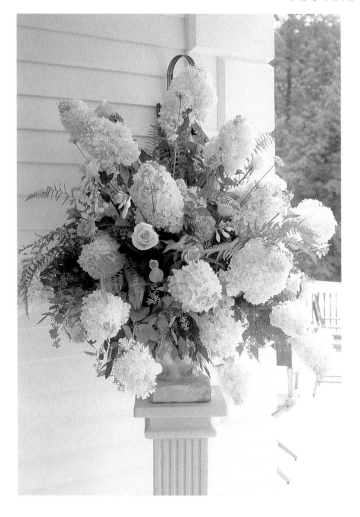

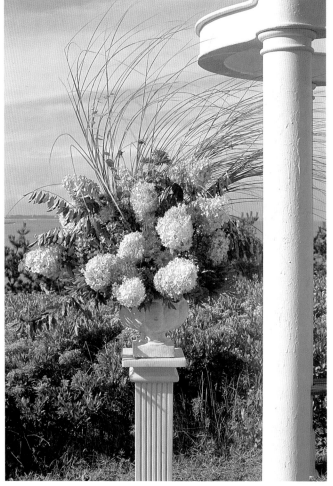

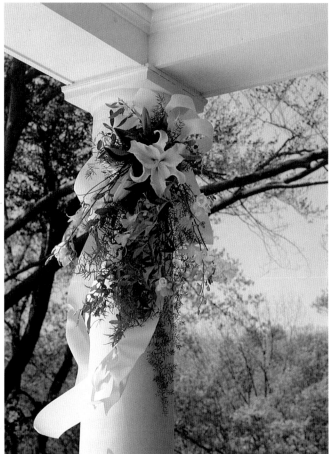

(Above, left) White hydrangeas and Osiana roses make a reception arrangement to sit atop a pedestal at an August wedding. By late September, the hydrangea have turned pink and blue, and they combine with chrysanthemums (above). A cluster of white dendrobium orchids and Casablanca lilies (left) transforms the porch column for an outdoor wedding reception. Flowers and photos by Vena Lefferts.

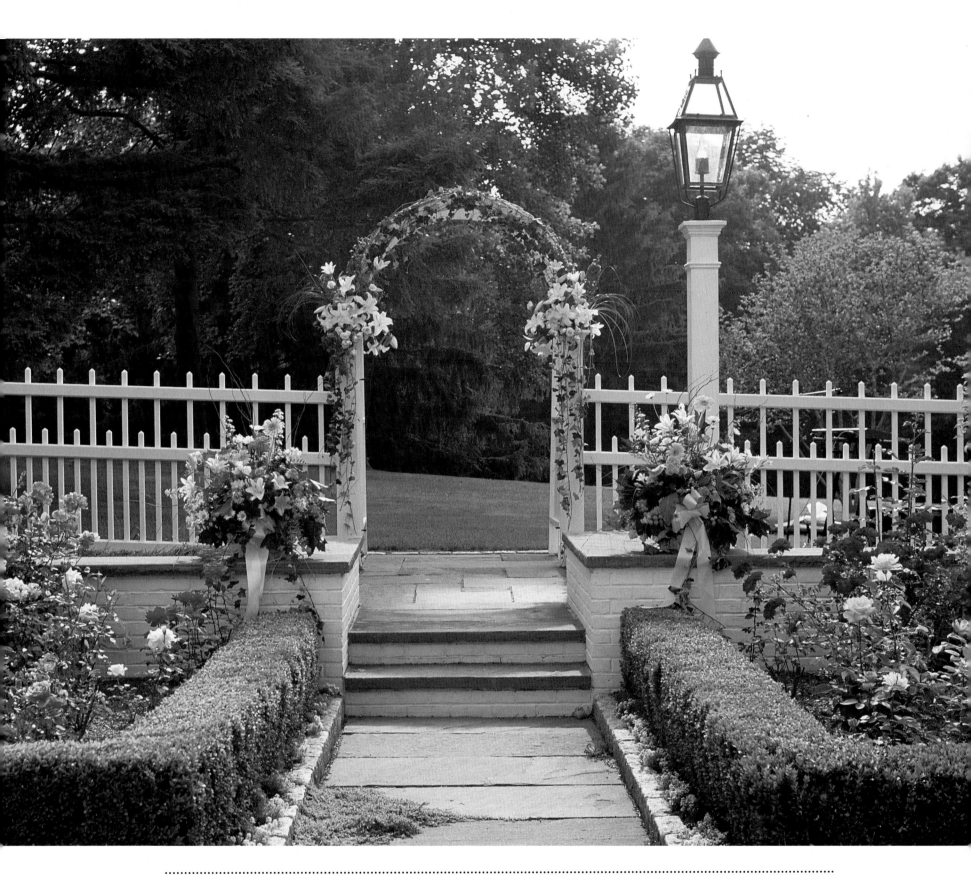

The bride and groom said their vows under this floral arch of Dutch hybrid delphinium, Osiana roses, and long vines of ivy. Flowers and photo by Vena Lefferts.

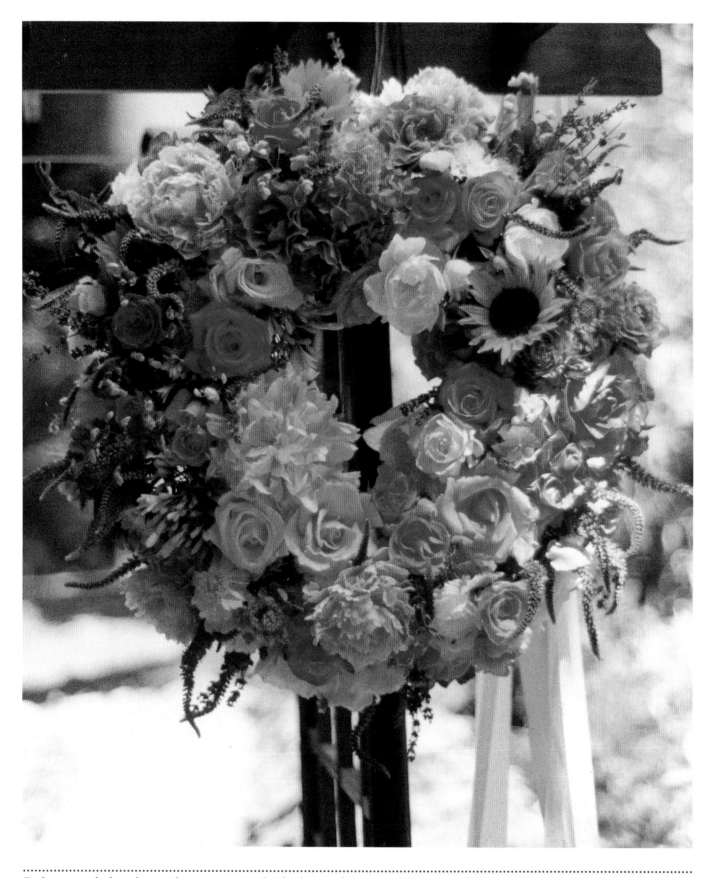

Pink peonies declare that it is late spring, time for the first outdoor party of the season. The wreath includes miniature sunflowers, scabiosa, veronica, and roses. Photo by Maureen DeFries.

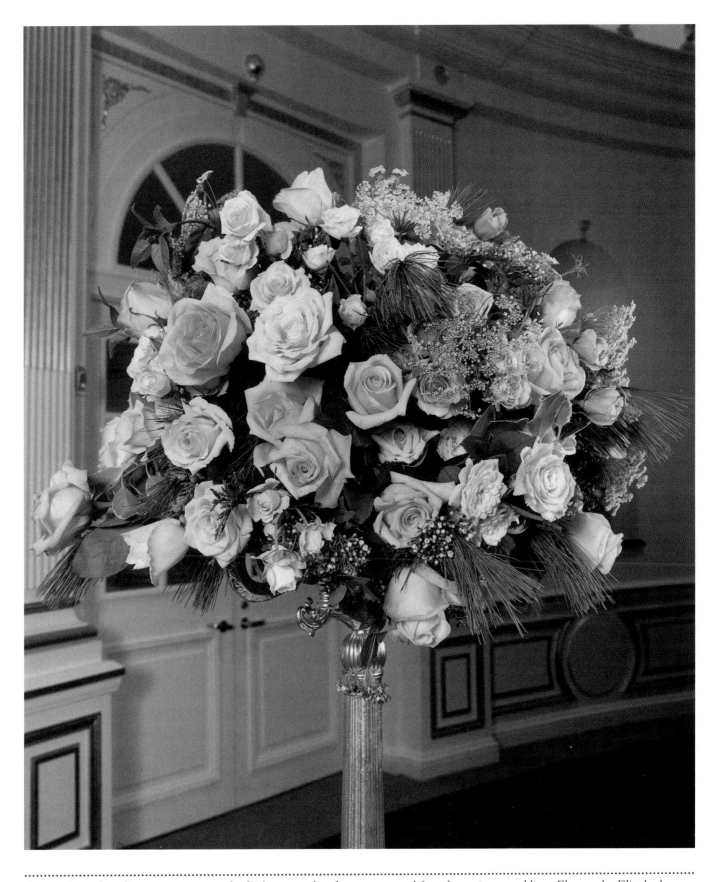

Sprigs of pine boughs punctuate a standard of many-colored roses arranged for a late winter wedding. Flowers by Elizabeth Ryan. Photo by Z. Livnat.

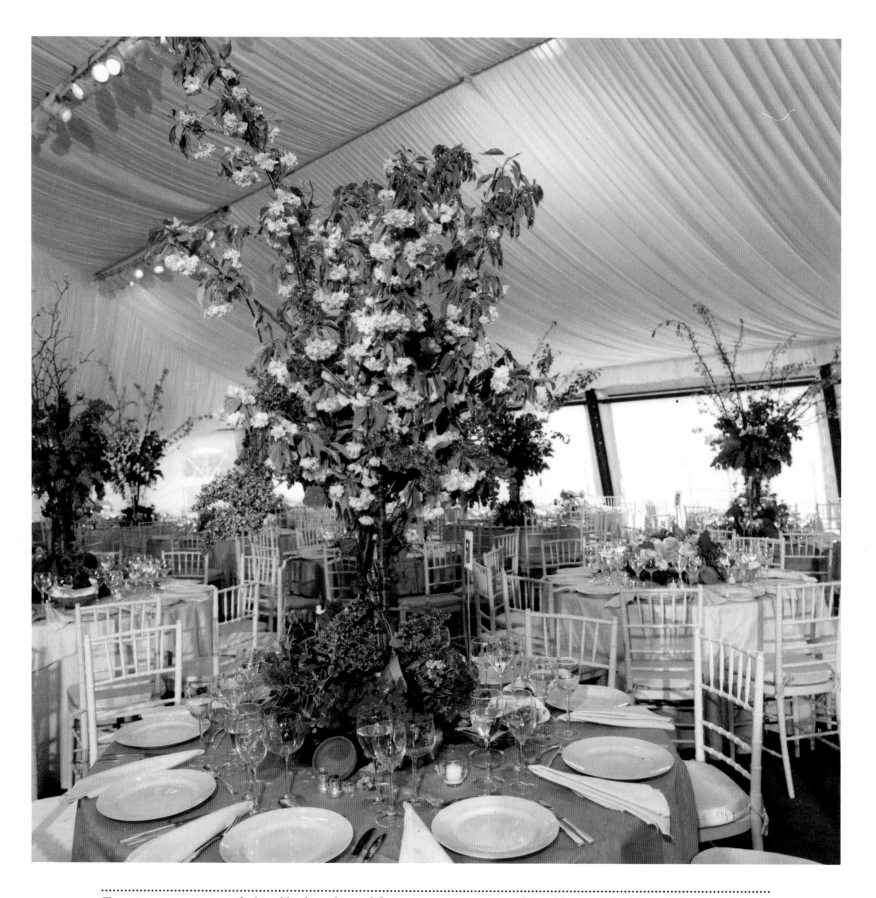

Towering centerpieces made from lilac branches and flowering trees suggest a traditional bower within the wedding tent. The design has been beautifully guided by the seasonal spring flowers. Flowers by Christina Pfeufer. Photo by Sarah Merians.

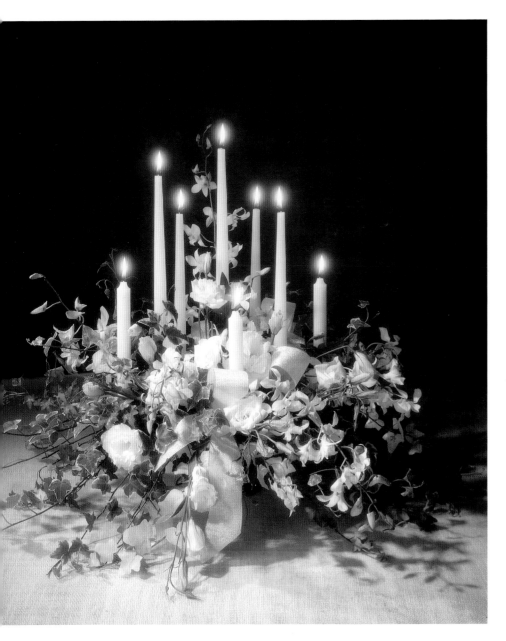

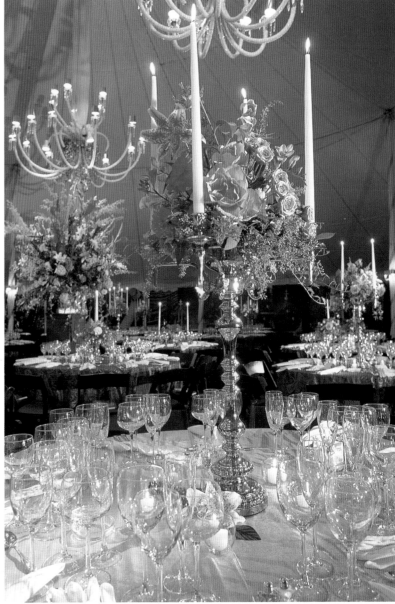

White blossoms, soft greens, and tall candles set the scene for a midwinter wedding. The designer has arranged dendrobium orchids and lisianthus with miniature ivy to radiate across the table, drawing the eye into the centerpiece. Photo by Sidney Cooper.

Festive colors put guests in a celebratory mood. Devaney Stock Photos.

(Left) A single blossom of dendrobium orchid makes a stunningly simple boutonniere. Photo by Georgia Sheron.

(Above) An elegant bouquet glistens in the sunlight. Photo by Irene Chang.

(Left) Lavender waxflowers, thistle, and white roses make an unusual boutonniere. Photo by Georgia Sheron.

(Above) Bicolor godetias and a white chrysanthemum crown a festive serving tray. Photo by Georgia Sheron.

(Opposite) A pearl-studded tulle veil with porcelina roses, white lilac, and still-green acacia is the bride's crowning glory. Flowers by Karen Frerichs. Photo by Peter Hōgg.

(Opposite) Magnolia leaves, gilded fern heads, and a single gardenia, all fixed to a paper box, make an unusual container for the wedding ring. Flowers by Elizabeth Ryan. Photo by Z. Livnat.

(Above) Here is a delightful corsage for the guest of honor at her baby shower. It is made from lavender freesia and Champagne roses, with organza and satin ribbons. Photo by Sidney Cooper.

MAKING A HOLIDAY GARLAND

Garlands are an essential part of the traditional Christmas holiday. Bringing evergreens into the house in the dark of winter gives us heart. By remaining green and fragrant when everything else lies dormant, they remind us that the light and warmth soon will return. These ancient feelings are so embedded in our culture that they cut across religious faiths—everyone responds to evergreens in winter.

You can make an evergreen garland to festoon your mantel or sideboard. The basic technique of wiring branches together can be applied to spring and summer garlands for weddings and other festivals. For the winter holidays, try some unusual greens—like sprengeri, accented with lemonleaf—for a distinctive look.

• Wind several stems of sprengeri around each other loosely.

• Add stems of lemonleaf one by one, binding them to the springeri with florist's wire.

• When the base of greens is complete, add dried or artificial materials with glue, carefully laying them into the garland. For fresh flowers use floral adhesive and if you want to keep the garland for a long time, water tubes.

• Wind the final touches of French-wired ribbon through the garland, anchoring it where necessary.

(Opposite) The focal point of this holiday table is a huge clear glass globe filled with cranberries and white tulips. Photo by Peter Hōgg.

(Right) An ivy Christmas "tree" provides a wonderful alternate to the traditional bulkier evergreen trees. This cone-shaped ivy topiary is bedecked with French wired gold lame ribbon spirals, white freesia, pomegranates, and roses. Photo by Irene Chang.

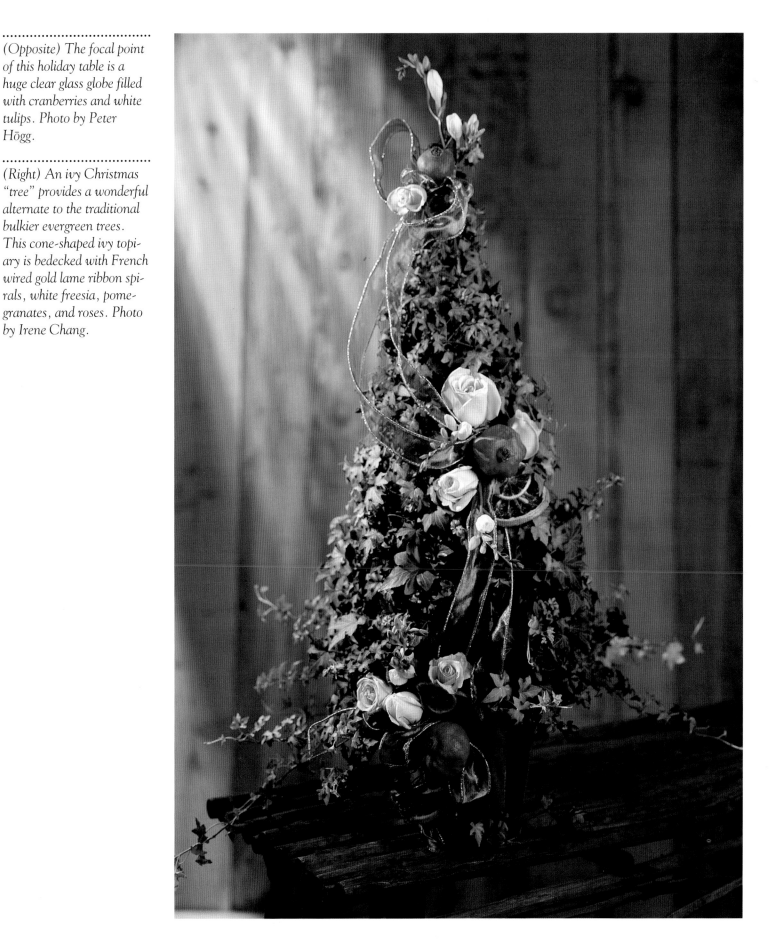

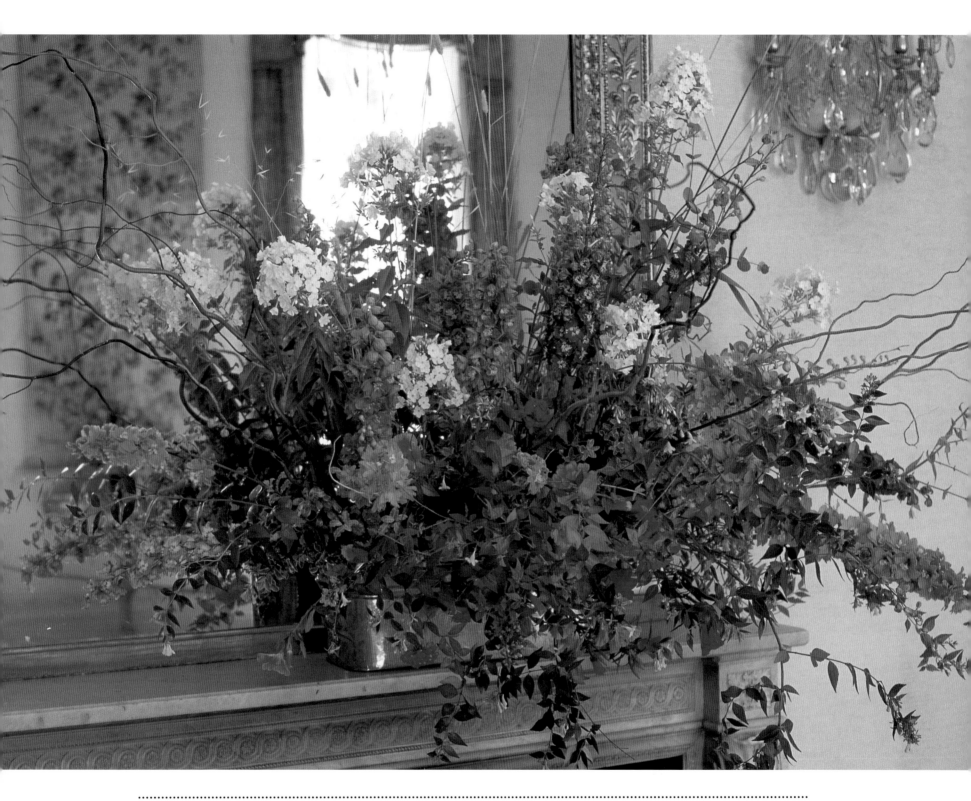

(Above) Wild foliage combine with cultivate flowers to create the atmosphere of a flower garden in the heat of summer, transforming this living room. The flowers include delphinium, curly willow, and white phlox. Photo by Peter Margonelli.

(Opposite) A lovely Italian ruscus garland with yellow roses, snapdragons, and peonies sets the scene for a spring wedding. Flowers and photos by Kasha Furman.

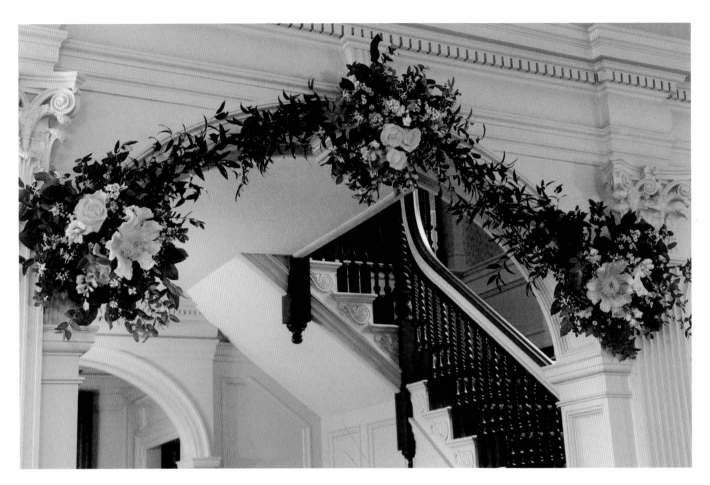

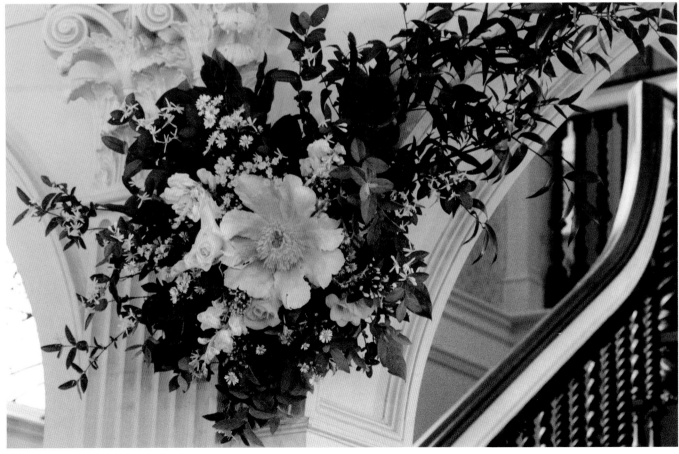

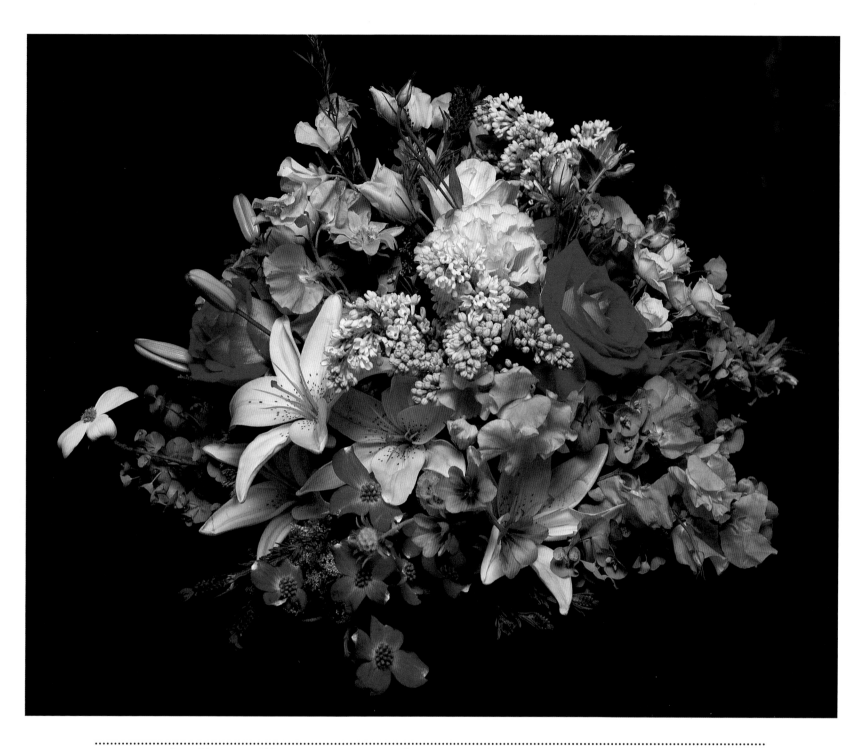

A sumptuous formal bouquet of lilies, roses, anemones, and Queen Anne's lace create a dramatic ambiance for a formal setting. Flowers by Fabrice. Photo by Z. Livnat.

A Nosegay of Statice

- Gather the flowers together in a cluster without crowding the heads. The stems are delicate, so add a few at a time to the cluster while turning it gently.
- Add galax leaves around the edges to support and protect the flowers.
- Loosely wrap an elastic or rubber band around the stems to hold them together.
- Tie a ribbon around the bouquet stems, covering the rubber band.
- Place the bouquet in a vase, or decorate a special gift with it.

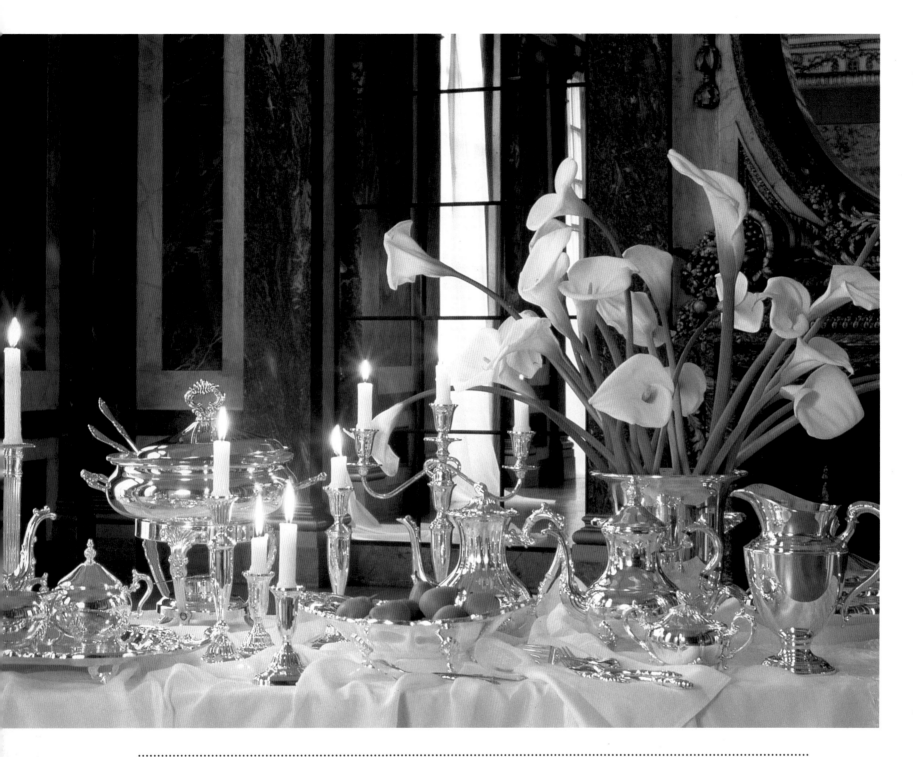

(Above) Graceful calla lilies displayed in a wine cooler set an elegant mood for this festive silver wedding anniversary. Photo by Elizabeth Heyert.

(Opposite) The table setting is elaborately elegant, and the flowers are elegantly simple: two sprays of white pharaenopsis orchids. Photo by Elizabeth Heyert.

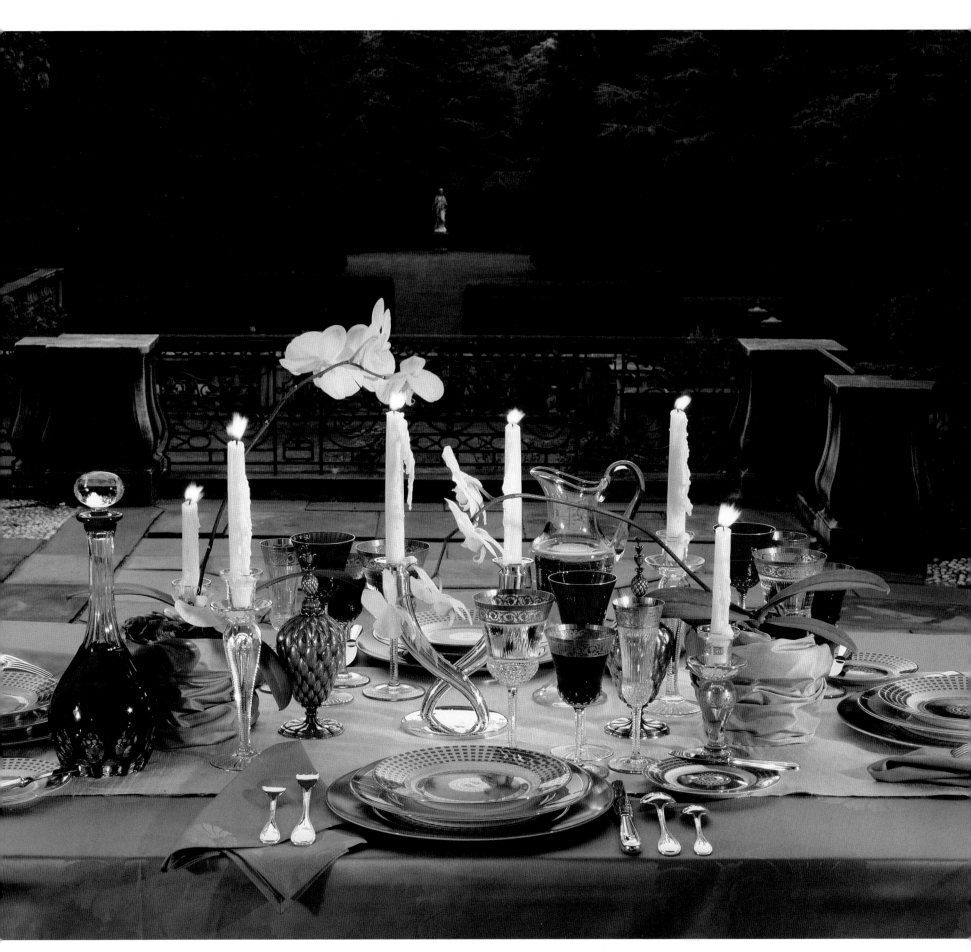

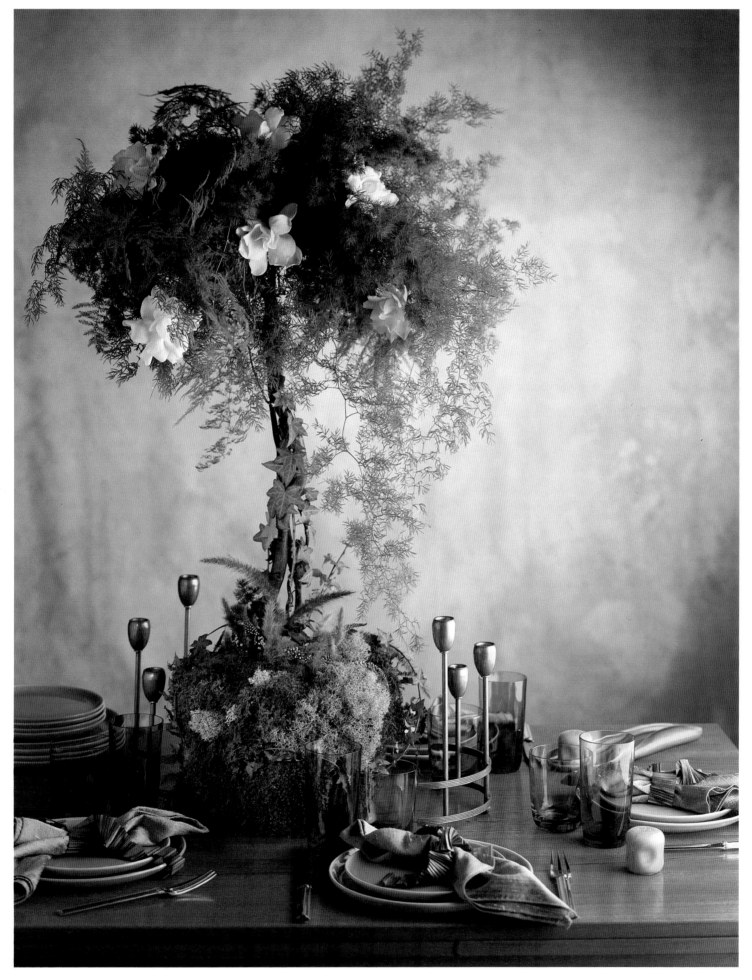

(Opposite) A few white gardenias dress up this delicate cascading plumosa fern topiary, and transform the decorative topiary into the centerpiece for a dinner party. Photo by Sidney Cooper.

(Right) Instead of a single centerpiece, the hostess has had this handsome table set with many small trumpet-shaped vases of loosely arranged gypsophilia and miniature carnations. Photo by Elizabeth Heyert.

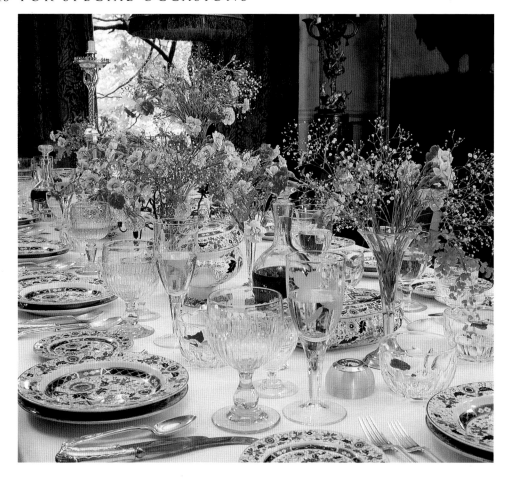

The Presidential table at the White House, set for a formal dinner, offers a simple centerpiece of colorful roses. Photo by Elizabeth Heyert.

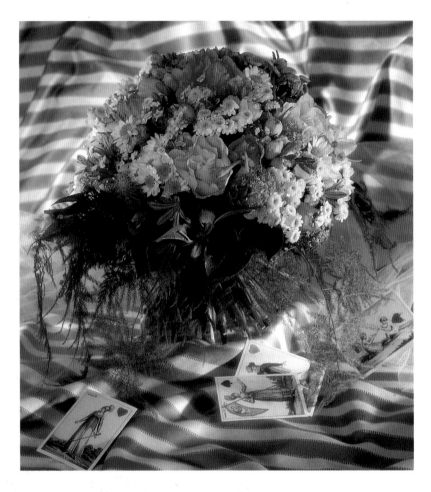

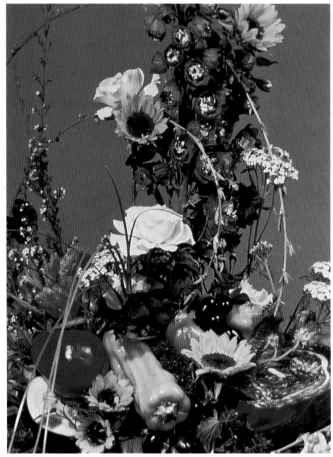

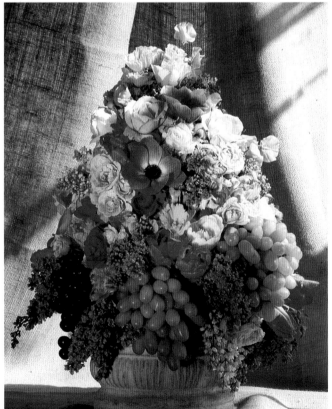

(Above, left) A decorously draped bouquet of flowers sits atop a unique set of playing cards. Photo by Sidney Cooper.

(Above) Flowers and vegetables have always been paired together. Photo: Philadelphia Horticultural Society.

(Left) Sunshine, natural burlap, fresh fruit, and flowers offer a three-dimensional still life work of art. Flowers by Oppizzi. Photo by Emily Miller.

(Opposite) The blue of the tablecloth and goblets sets the color scheme for this sumptuous setting. The arrangement features roses, lilac, goldenrod, heather, and various fruits. Photo by Sidney Cooper.

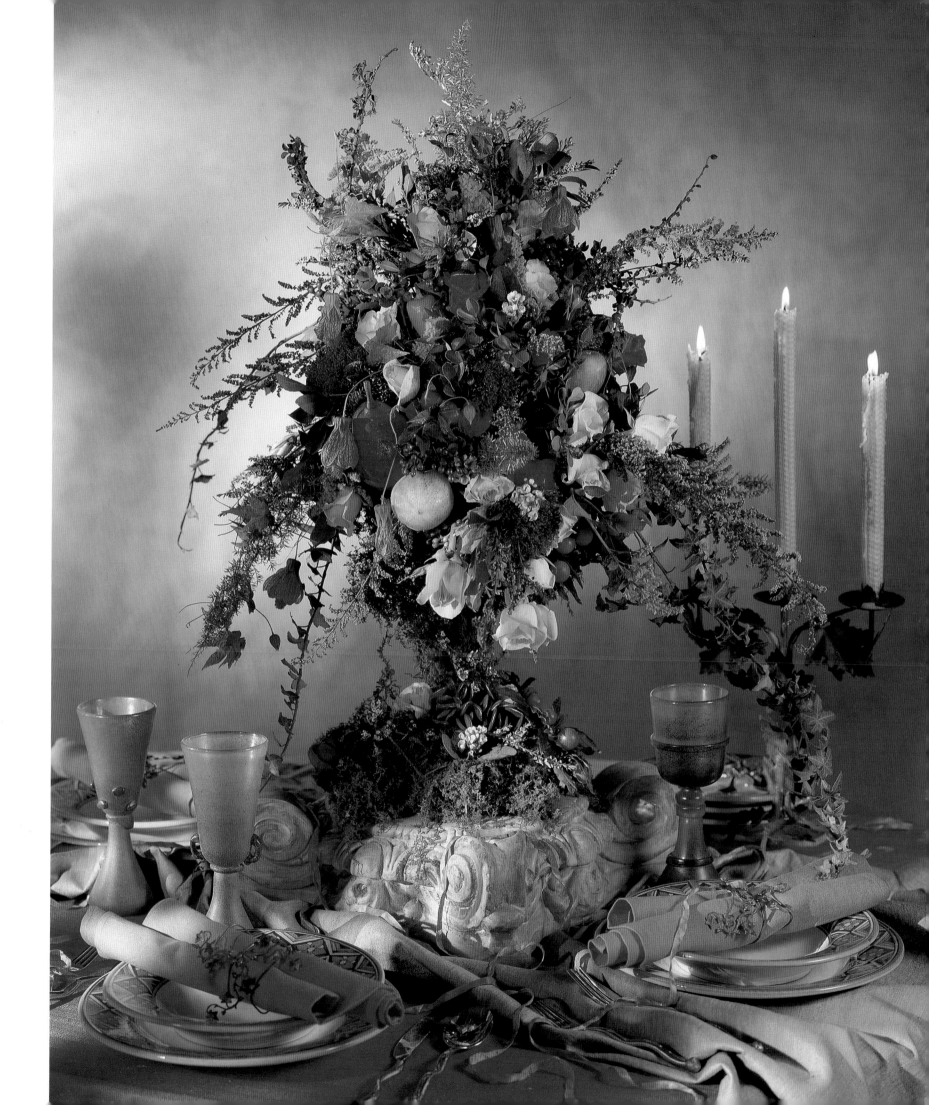

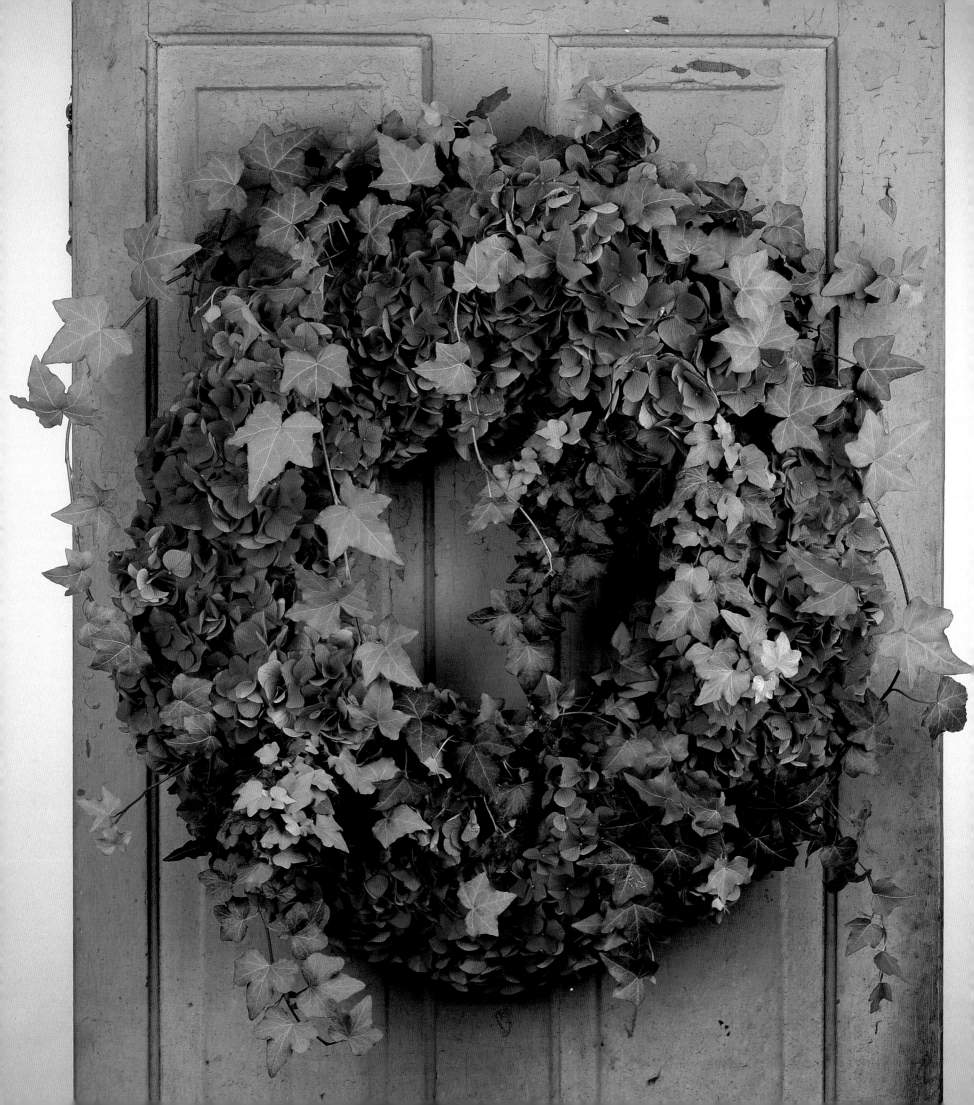

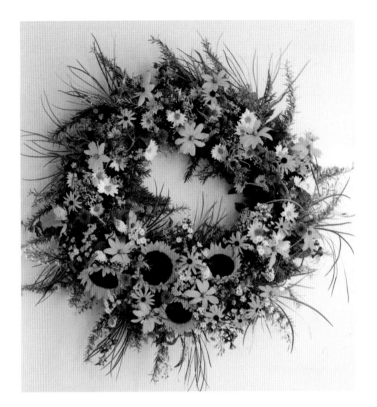

(Opposite) Hydrangeas and ivy extend a springtime greeting. Photo by Stephen Smith for Florists' Review.

(Right) Miniature sunflowers, coreopsis, blue cornflowers, asters, daisies, and gooseneck loosestrife sing a song of high summer. Photo by Georgia Sheron.

(Below) Bicolor and purple anemone, leptospermum, and wild white roses celebrate the new college graduate. Photo by Sidney Cooper.

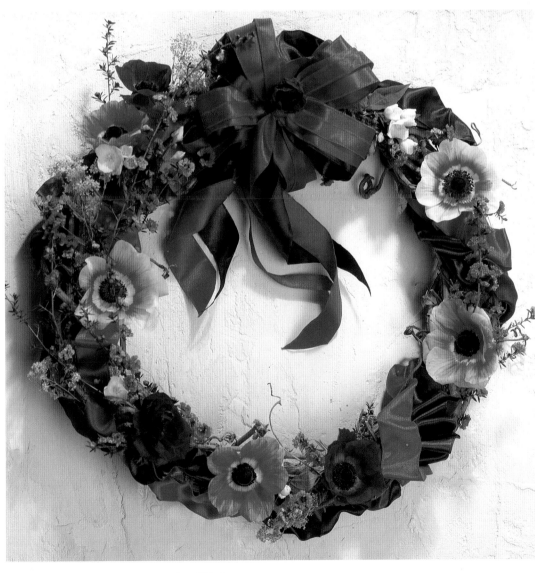

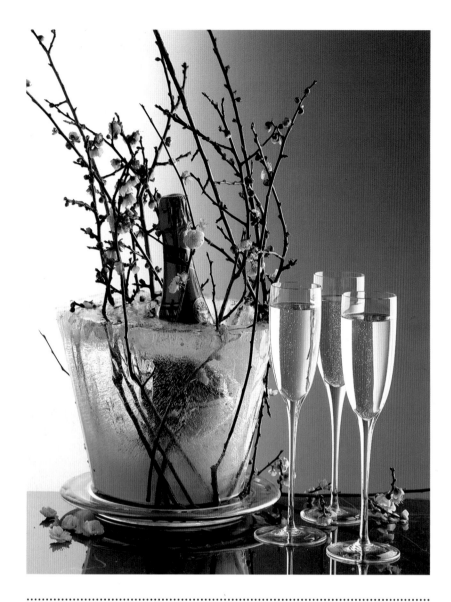

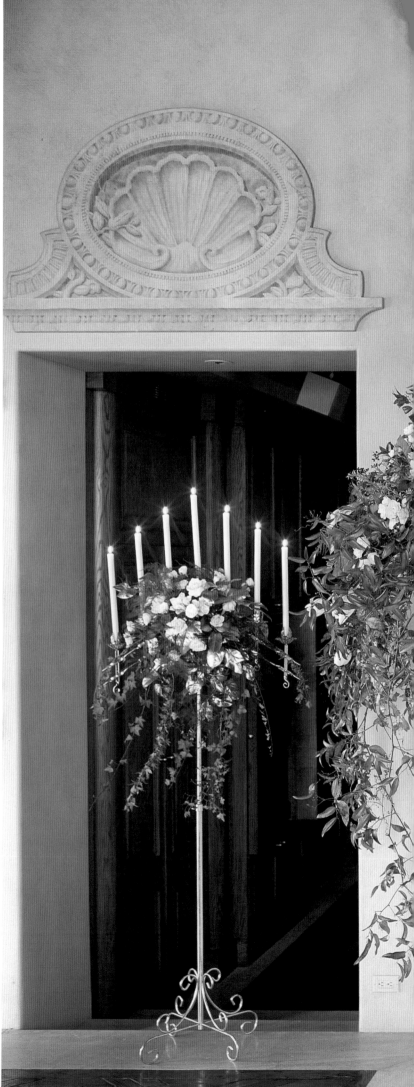

(Above) Champagne is already special, but placing forced cherry blossoms in the ice bucket creates a memorable element of surprise. Photo by Peter Hōgg.

(Right) Garlands of Osiana roses, Champagne roses, and French tulips, with flanking candelabra, transform this white marble fireplace into a suitable backdrop for the exchange of wedding vows. Flowers by Sylvia Tidwell. Photo by Grey Crawford.

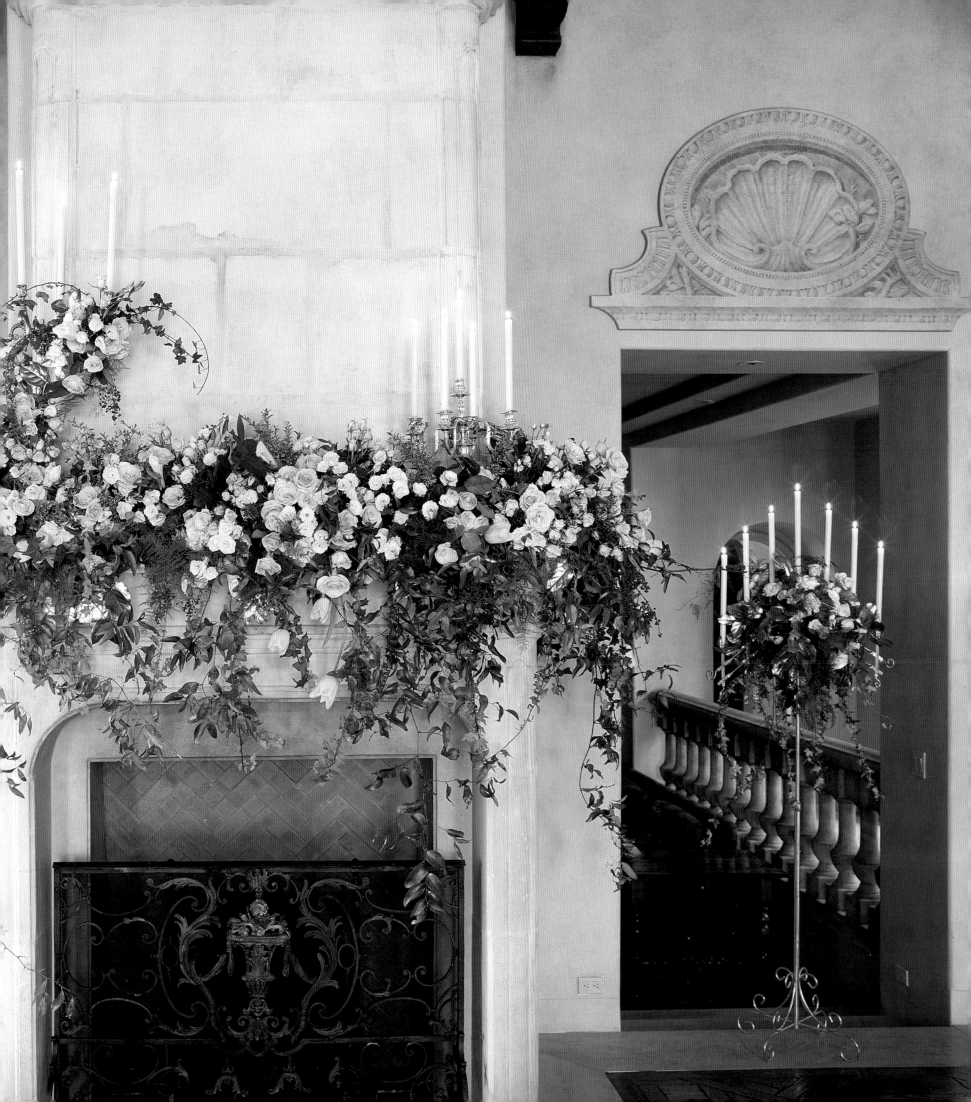

OCCASIONS FOR FLOWERS

HOLIDAYS

New Year's Day	Father's Day
Valentines Day	July 4th
Easter	Thanksgiving
May Day	Christmas
Mother's Day	Secretaries Day

PARTIES

Birthdays	Luncheons
Weddings	Bridal showers
Anniversaries	Baby showers
Reunions	Picnics
Graduations	Dinner parties
Opening receptions	Theme parties
Formal teas	Bar & Bat Mitzvahs

EVENTS

Performances	Galas
Parades	Promotion
Fund raising	

GIFTS

Hostess	Engagement
Hospital	Friendship

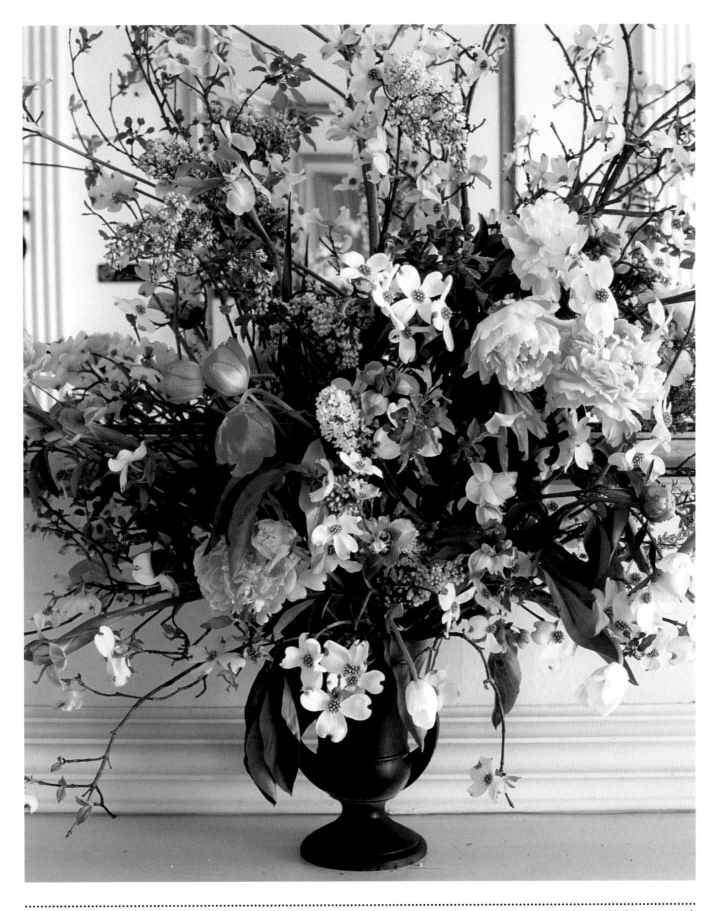

This light, airy arrangement lends an invitingly informal note to its formal vase. The arrangement, though intended for a special occasion, can bring lyrical moments to any day. Photo by Peter Margonelli.

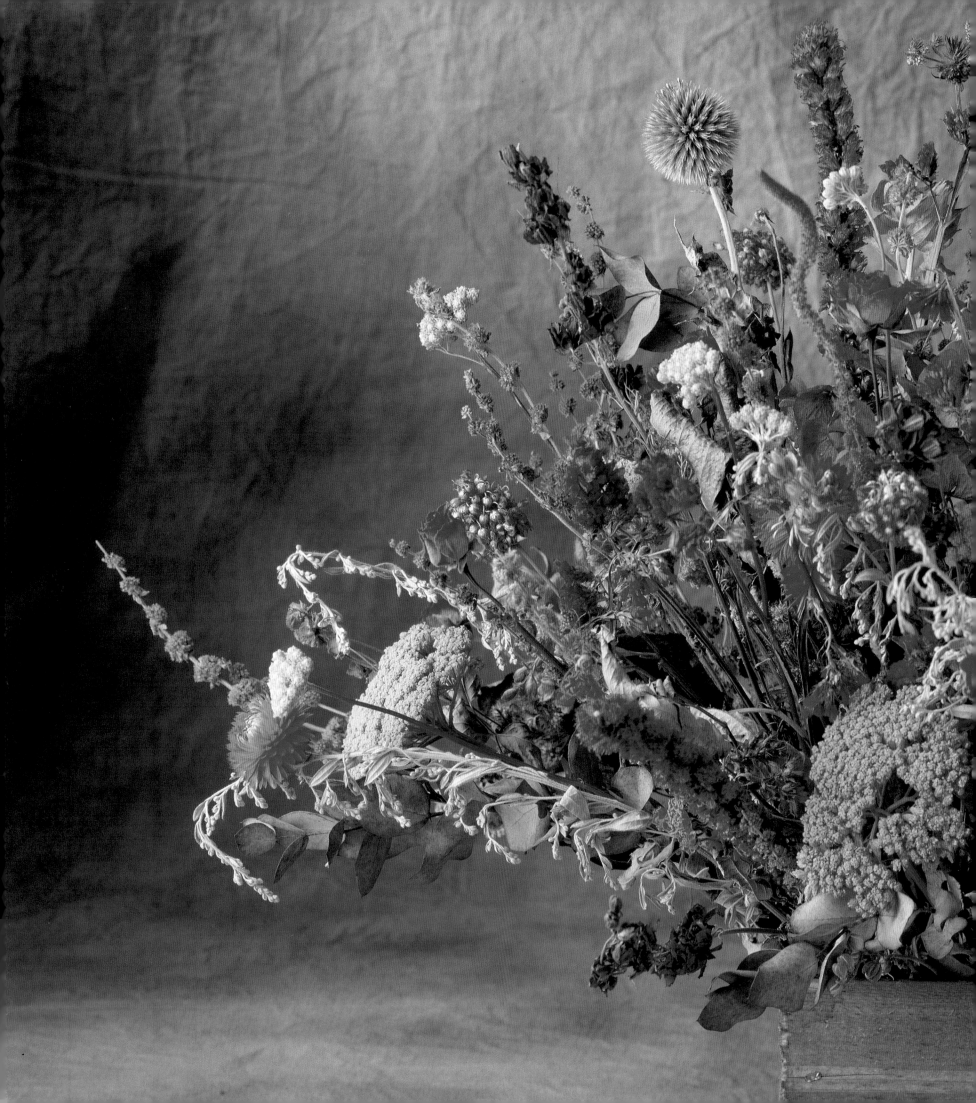

DRIED, SILK, AND CERAMIC FLOWERS

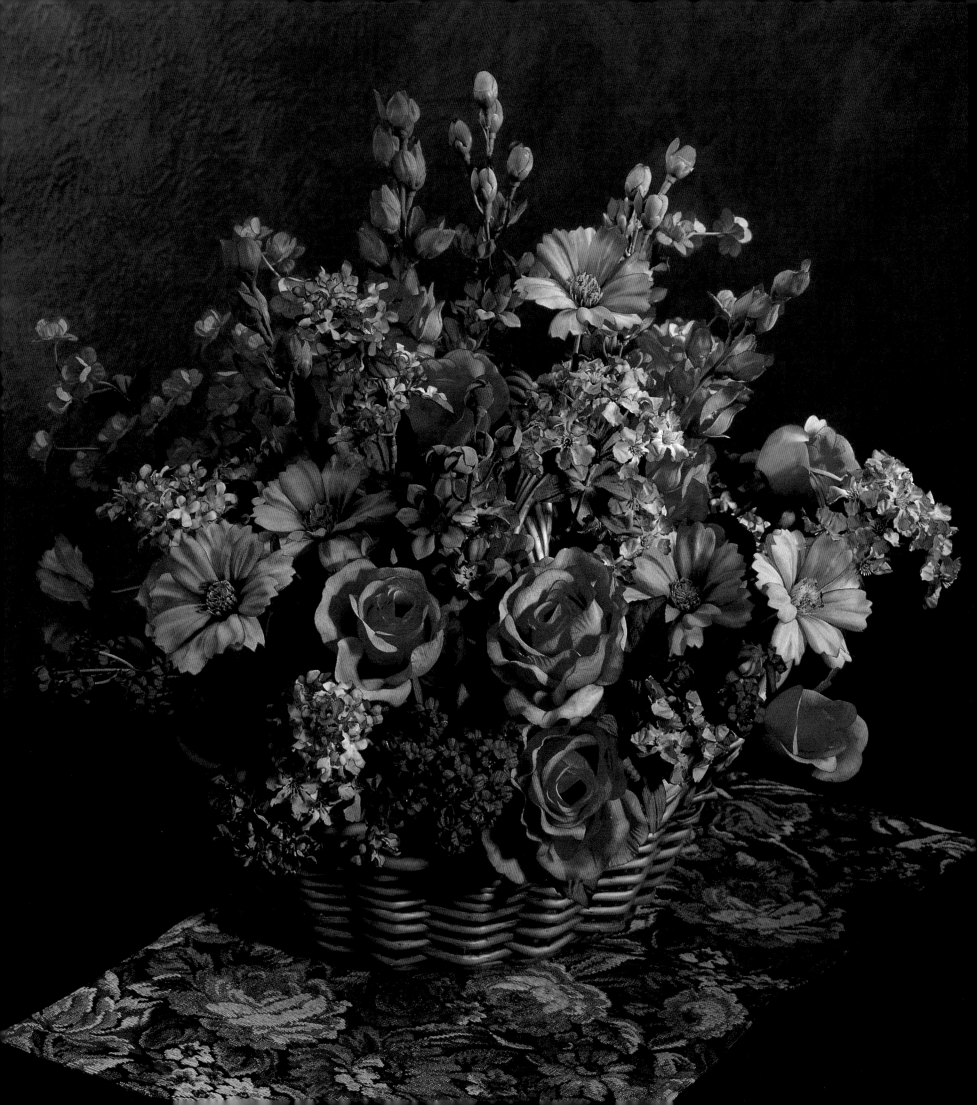

*S*ilk flowers offer an elegant alternative to real flowers. While some of the beauty of flowers lies in their transient nature, the seemingly endless shades of color that can be achieved with silk and other fiber flowers can brighten a room just as effectively as nature's own. The design requirements for faux and dried arrangements are the same as for fresh flowers: remember the context, and look for a balanced, harmonious composition.

The faded colors and papery textures of dried flowers have a nostalgic beauty and fragility that few people can resist. Though dried flowers lack the vitality of cut flowers, they have the advantage of longevity. When properly arranged and displayed, an arrangement of fine quality faux or dried flowers is an attractive accessory to almost any home style. Spanning the colder seasons, colorful faux floral designs add warmth and brightness to tabletops, walls, and corners. A contemporary room looks smart with a bunch of tall wheat or dried phragmite grasses in a ceramic vase, and a jaunty ceramic arrangement of butterfly-clad foxgloves brings a touch of whimsy to any corner of the room. Oversized baskets, filled with preserved garden flowers and dried mosses, add a touch of earthiness to a country environment. Rooms with period styling are well appointed by an antique porcelain vase of dried or silk peonies, roses, hybrid delphinium, and lemon leaves.

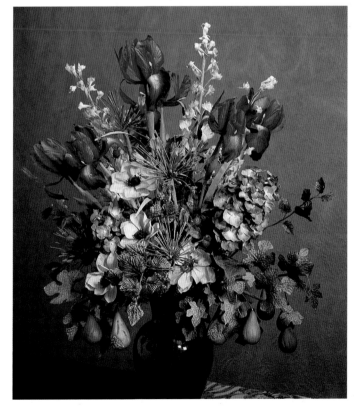

...

(Previous spread) Careful drying techniques can preserve vivid floral color, as in this arrangement of golden yarrow, globe thistle, liatris, roses, and larkspur. Photo by Maria Ferrari.

...

(Opposite) Rich silk flowers imitate autumn colors of roses, forget-me-nots, coreopsis, and scilla. Photo by Stephen Smith for Florists' Review.

...

(Right) A striking arrangement of blue-hued silk flowers in a cobalt blue vase make a dramatic statement. Included are hydrangeas, anenomes, and iris, as well as figs and blueberries. Photo by Stephen Smith for Florists' Review.

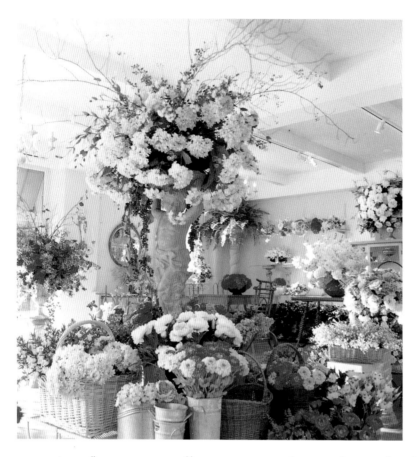

Where are the artificial flowers in this silk flower shop? Flowers by Anita Widder. Photo by Maripat Goodwin.

Good quality imitation flowers can stand alone as artistic creations. Skilled craftsmen study live flower specimens and follow the line, growth patterns, coloration, and shapes of nature to reproduce floral pieces with an astonishingly real appearance. Placed in an appropriate container, faux flowers are often mistaken for fresh flowers.

Although some artificial or "silk" flowers are constructed of polyester and other synthetic materials, with stems of wire and tape, or of plastic, the finest faux flowers are made of silk, because this material can be dyed and painted in the most subtle and complex colors. Real silk flowers generally are custom designed to order, hand-constructed and hand-wrapped, delicate and exquisite, and extraordinarily expensive.

Artists in every medium have always found inspiration in flowers. We're all familiar with floral paintings, floral motifs on fabric and wallpaper, and floral embroidery. But you can also find flowers made of blown glass, of porcelain and ceramic, of wood and paper, even of cast, cut and patinated metal. Crafts artists often regard the challenge of reproducing the delicate shapes and colors of flowers as a test of mastery. The artisan who can recreate a flower, or make a satisfying interpretation of a flower, can make virtually anything.

Paper and fabric flowers can be mixed with dried flowers and pods in an arrangement. It is more difficult to mix dried flowers with floral interpretations in other materials, because the contrast among their surface textures is too great. Arrangements of glass, porcelain, wood, and metal usually show best as complete objects on their own.

One major advantage that artificial flowers have over fresh and dried flowers is their life span. When kept out of the sunlight and dusted properly, faux flowers can last for many years. Eventually, however, sunlight fades the dyes and finally breaks down the fibers themselves. Porcelain and glass break, wood rots, metal corrodes. Like their vital originals, the most perfect imitations ultimately wither and die.

Many varieties of preserved flowers and dried foliage and herbs can be purchased from a floral boutique, craft center, nursery or garden center, and sometimes at the farmer's market. It's infinitely more fun to try preserving your own flowers. From gifts of florals that you have received,

flowers that you've grown or purchased, to roadside grasses, pods, and weeds that you pick, there is an abundance of materials available to dry. Preserving methods are many and varied, and most materials can be successfully dried in any one of several ways. It's worthwhile to experiment because each drying method will produce a different quality or look. Start with fresh, undamaged flowers and foliage, because all drying techniques magnify defects. A bedraggled stem will only get worse.

Dried arrangements should be sealed with a floral preservative, to protect them from moisture in the air. It is best to store your dried flowers and arrangements during humid seasons. Wrap them in newsprint or a brown paper bag, and place in a cardboard box in a warm, dry, room. With proper care and storage, preserved flowers can last for several years.

AIR DRYING is the oldest and easiest method for preserving flowers. Air-dried flowers retain their color and vibrancy better and tend to be less fragile than materials dried using other methods.

If picking flowers from the garden for air drying, or for treating with a desiccant, the rules are the opposite of those for gathering fresh-cut flowers. In order to start with the lowest moisture content, gather flowers and foliage in the heat of a warm day, not at early morning, and not on a rainy day. Dampness inhibits drying, turns petals brown and limp, and attracts mold and mildew.

Cut stems medium length to long. Try to capture blossoms in different stages, up until just before peaking. If the stems seem weak, it will be helpful to wire them while still fresh, or to completely replace the stems with wire wrapped in green florist's tape. Trim any unsightly foliage and loosely gather the flowers into small bunches, staggering the blossoms so they don't crush or deform one another. Bind each bunch with a rubber band, which will tighten as the stems shrink during drying. Gather foliage into small bunches, the same as blossoms.

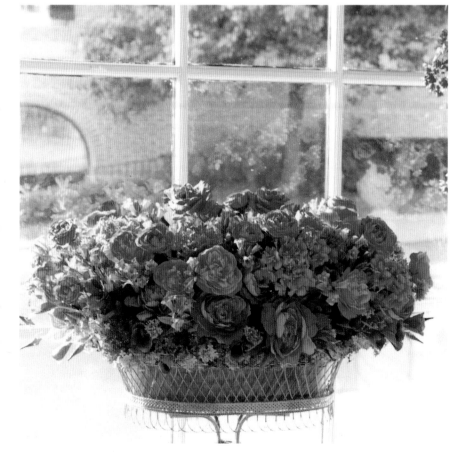

Hang the bunches, with space around them for air to circulate, in a dark and preferably very warm place. An attic can be a wonderful drying area. The exposed rafters are perfect for hanging bunches in rows. Blossoms keep more of

Bright colored silk roses in a gilded basket plant stand bask in the sunlight streaming through the window. Flowers by Anita Widder. Photo by Maripat Goodwin.

their color when they are dried quickly, at 90 to 100 degrees Fahrenheit or hotter. It's critical to avoid dampness, which rules out most basements.

Most flowers and foliage take about two weeks to dry thoroughly. Be sure to allow the stems to dry completely where they attach to the heavy head of the blossom so they will not droop when turned upright in your arrangement. Some blossoms with flat or gently rounded heads will fare better when dried upright in a vase or tall container for support, and with a small amount of water in the bottom of the vase, which moderates the pace of the process. Dill, Queen Anne's lace, yarrow, and hydrangea heads prefer this treatment.

OVEN DRYING. It's possible to dry flowers quickly in a regular oven, but it requires care to avoid burning the delicate petals. Turn on the oven light with the door closed, or set the oven temperature at 100 to 110 degrees with the door slightly ajar so moisture can escape. Some materials can be spread on regular oven racks, but some plants dry better on cookie sheets. Turn the materials every 20 minutes to assure consistent exposure, and pull them out as soon as they are dry—usually a couple of hours.

A closed car on a sunny day is another kind of oven. Carefully lodge a long tension rod between the inside structures of the car or van, and hang bunches or single stems of material from the rod. A vegetable dehydrator also works well for drying the heads of flowers, and offers a compact solution where drying space is limited.

MICROWAVING. The microwave oven can be used to speed up other drying processes, and it is possible to dry some floral species entirely by microwave. However, the process is quite unpredictable, and at its worst simply cooks the flower into a soggy mass, so it's necessary to experiment. Place the flowers on a bed of paper towels. Set the oven to its lowest power setting, and check the test flower every 30 seconds. Opening the door to see what's happening may release a burst of steam. Quit when the flower is dry, but not brittle.

POTPOURRI. When you want to dry petals and flower heads for potpourri, the oven or dehydrator methods are quick and easy. For more naturally fragrant and colorful potpourri, try the moist method: spread petals flat on paper towels or blotter paper, and turn them gently every day. When they are partially dry, layer the petals in a jar, alternating petal layers with table salt. Open the jar and stir every day for about one month. At the end of this process, mix the petals with perfume, essential oils, or spices, and add dried orris root to fix the scents.

Desiccants are drying agents that pull the moisture from the tissues of the plant materials; table salt acts as a desiccant in potpourri. Other suitable floral desiccants include fine dry sand, sil-

(Opposite) A cut crystal vase of dried roses, delphinium, and peonies extends a sweet welcome to overnight guests. Photo by Peter Margonelli.

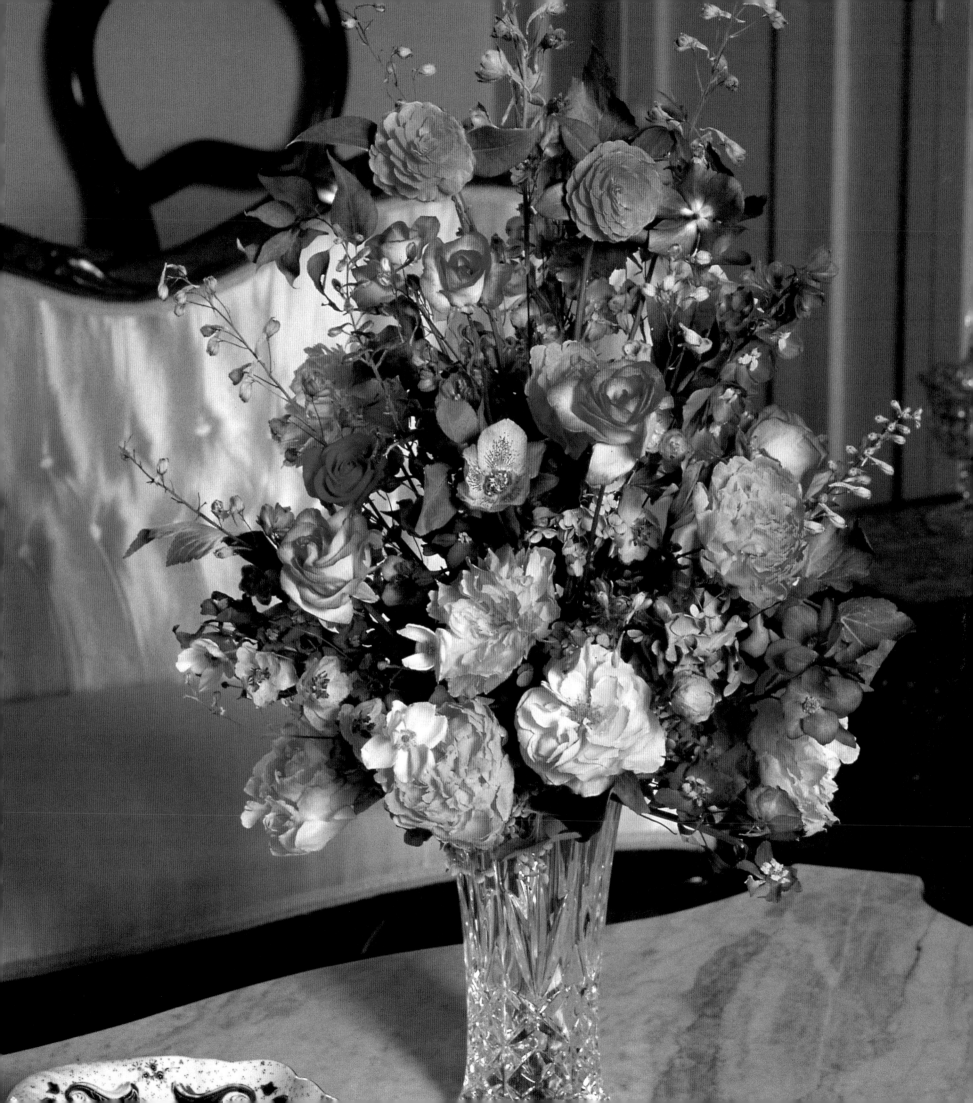

ica gel, alum (aluminum sulfate), borax, and cornmeal. The desiccant procedure is involved, but it can produce a realistically shaped flower bloom. Each combination of flower and desiccant produces different results, so it's worthwhile to experiment. For airtight, sealable containers, try Tupperware.

The procedure is to bury the flowers in the desiccant, without crushing them or deforming their shape. Cut the stems down to about an inch. Invert flat flowers, like daisies and pansies, onto an inch-thick layer of desiccant in the bottom of your container. Nestle trumpet-shaped flowers, like daffodils, and blooms with raised petals, like dahlias, upright into shallow hollows in the desiccant bed. Gently spoon or sift the desiccant around and into the blooms, taking care to fill them completely. Cover all of the plant material with desiccant, seal the container, and wait a couple of days before cracking the seal to check. Leave the flowers in the desiccant until they have the feel of dry tissue paper.

When first removing the flowers from the desiccant, the dusty results may be disappointing. But gently shake the powder off the blossoms, then use a small brush to wipe away all traces of it. You'll be amazed by the colorful, shapely flower that emerges. Alum and borax tend to clump on some flowers, so you may have to mix these powders with dry sand or silica gel. Dry the desiccant in the oven before using it again.

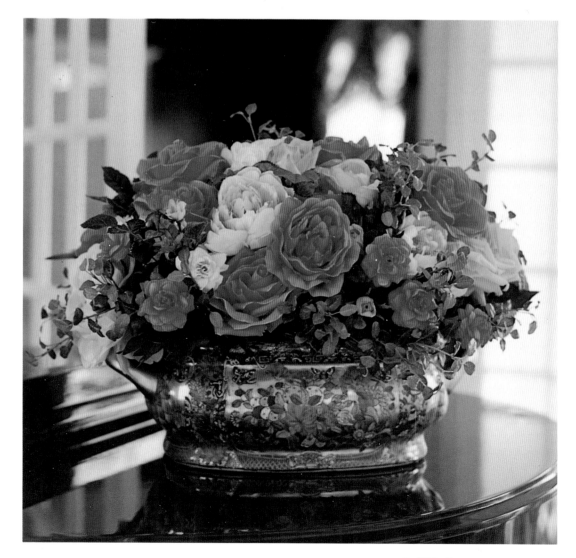

Silk roses in a Chinese tureen create a long-lasting floral presence. Flowers by Anita Widder. Photo by Maripat Goodwin.

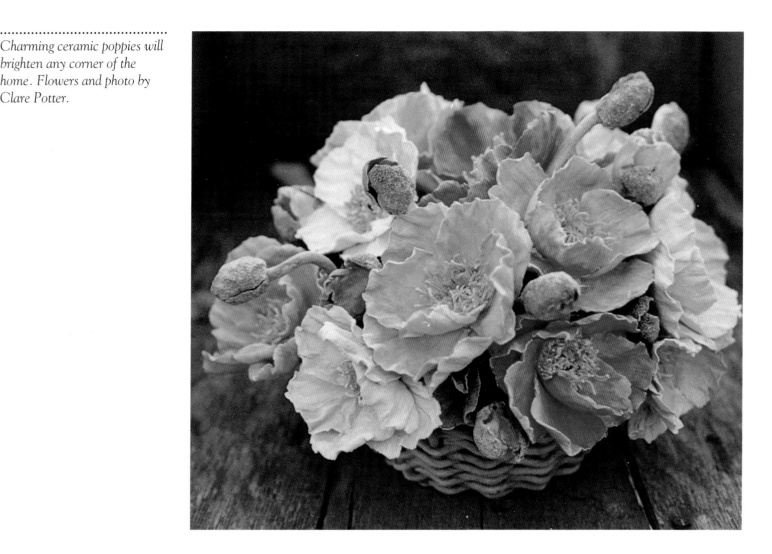

Charming ceramic poppies will brighten any corner of the home. Flowers and photo by Clare Potter.

FREEZE-DRYING. Flowers can also be preserved by freeze-drying, a service which may be offered through a local florist. Freeze-dried flowers are best stored in a sealed glass dome or shadow box, because they will reabsorb moisture very quickly in most environments. Wedding bouquets are exceptionally beautiful when preserved by freeze-drying. Keep the bouquet fresh in a refrigerator and have it delivered to the florist as soon as possible, preferably on the first business day after the wedding.

GLYCERIN. Many types of foliage and berries can be preserved with glycerin, which is available at pharmacies. Glycerin replaces water in the plant tissues, keeping them supple, relatively soft, and glossy. It affects the colors, too. The process may take several weeks.

Cut mature plant materials during the morning or evening hours, when there is a lot of water in the tissues. Condition the stems as you would for a fresh arrangement. Mix one part glycerin to two parts hot water and fill a clean container to a depth of six inches. Place the stems in the solution and leave them to drink it up. The flowers are ready when their color has completely changed and water droplets form on the face of the leaves. Wipe them dry.

Glycerin usually alters the color of foliage, turning greens to browns, golds, and rich reds.

Adding green dye to the glycerin-and-water mixture will help the leaves retain their summer appearance. Thicker leaves, like hosta or ivy, can be submerged in the solution to quicken the absorption process.

PRESSED FLOWERS are especially delicate and lovely for making note cards, for framing, or placing in a scrapbook as a remembrance of a special moment. Lay blossoms or single petals on smooth blotting paper and cover with another piece of paper. Sandwich with stiff cardboard and flatten under the weight of heavy books. Change the blotting paper after the first day or two, then leave the flowers alone in a warm, dry place for a couple of months.

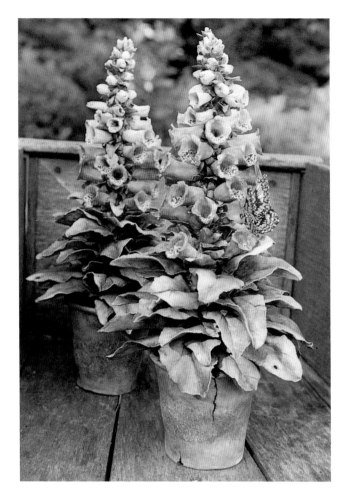

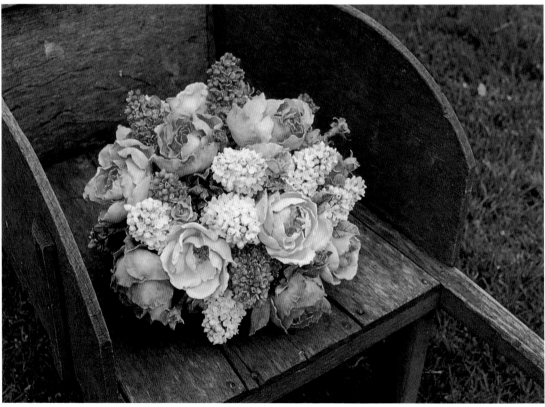

..

(Above) Whimsical ceramic floxgloves are so lifelike that they have attracted a ceramic butterfly. Flowers and photo by Clare Potter.

..

(Left) Porcelain lilacs and roses pose in a garden wheelbarrow. Flowers and photo by Clare Potter.

PAINTINGS IN THREE DIMENSIONS

Fragile in its own way, Clare Potter's delicate, luminous garden of flowers will bloom forever. To create her amazingly lifelike porcelain arrangements, Clare Potter works closely with the flowers in her own Long Island garden. She began her career as a painter, and she retains the painter's habit of looking closely at life, in order to model the light of truth.

"I try to be as true to nature as possible," Clare explains. "If there are wilted flowers in my model, I'll reproduce them as exactly as I can—blemishes and all. I try to capture the essence of the flowers, their souls, not an abstract idea of perfection. That's part of what makes my arrangements so realistic."

Potter forms the flower petals by squeezing wet porcelain clay in her fingers, making each petal as thin and feathery as she possibly can. She assembles the fragile petals, then fires the clay hard and bone-white. Ceramists usually fire the clay twice. The first, or bisque, firing transforms dusty mud into hard porcelain. The second, or glaze, firing transforms powdery coatings of chemicals into hard, shiny films of colored glass. These are the familiar strong colors and glossy textures of china cups and vases.

Potter fires her clay only once, the bisque firing. Then she paints the white clay with watery acrylics. The artist's pigment soaks into the clay, leaving a porous, textured surface that closely imitates plant tissue. "It's like water-color painting," Potter explains. "I only make the flowers I know well."

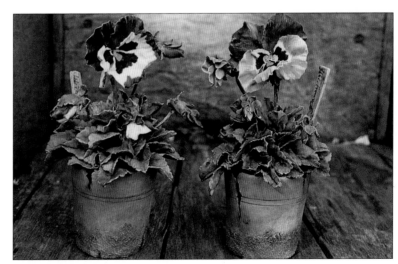

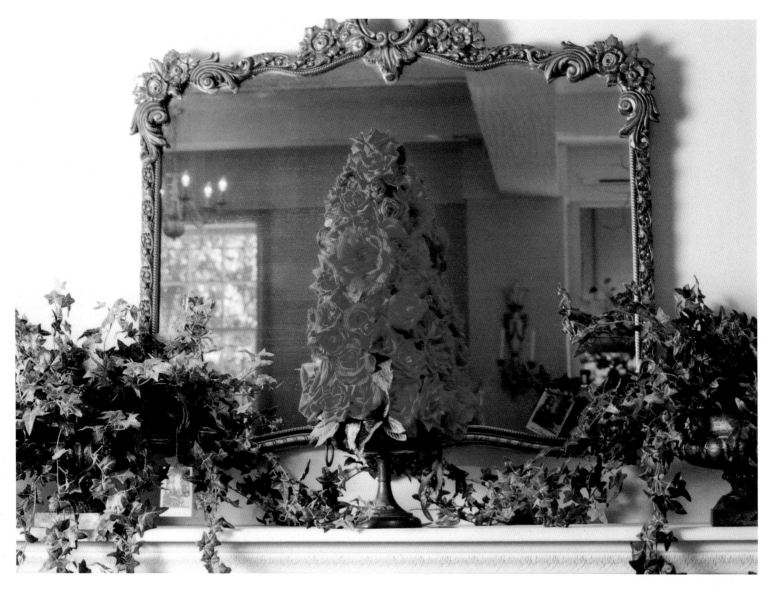

(Above) Gold gilt, glass, and silk. A perfect tree of tightly packed red roses reflects a festive atmosphere from its place of honor on the mantelpiece. Flowers by Anita Widder. Photo by Maripat Goodwin.

(Right) A ceramic pot of lily of the valley, full to over-flowing, perches in the sunlight. Flowers by Anita Widder. Photo by Maripat Goodwin.

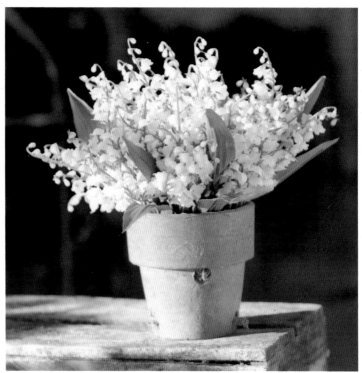

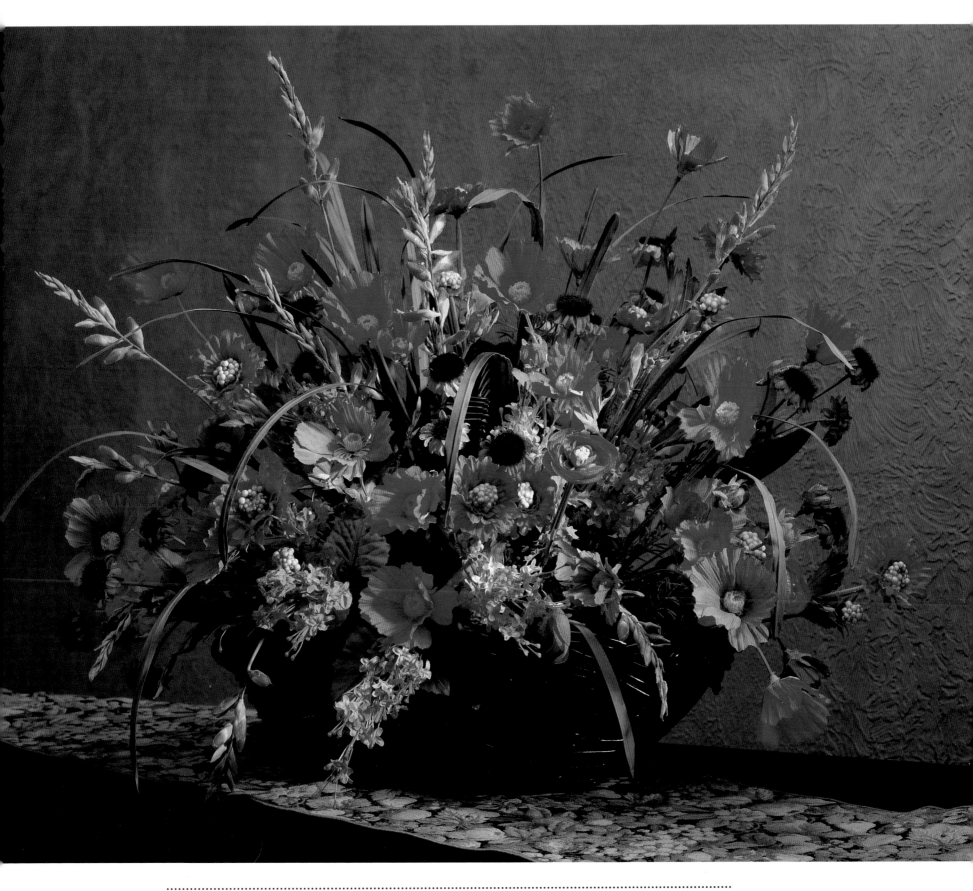

A graceful arrangement of silk anemone, snapdragon, iris, and delphinium makes a dramatic statement.
Photo by Sidney Cooper.

FLOWERS
FOR A LONG TIME

After many years as a conventional floral designer, Anita Widder now specializes in arranging silk flowers. She has developed a connoisseur's eye for what makes a great silk flower.

"It has to remind me of what's in nature," Widder says. "The colors should be hand-dyed, so they show as various shades and hues. A real rose is not solid red, and neither is a good silk rose. So you want to look for silk flowers by manufacturers who take the extra trouble. They're out there, they're just not always easy to find."

"The foliage is always a weak point," Widder adds. "Manufacturers don't pay as much attention to the leaves as they do to the blooms, so the leaves often look fake. My solution is simple: I just eliminate the leaves from my silk arrangements. I like to put a lot of flowers in a small container, so all you can see is blossoms, and I often cut the leaves off the stems, just as I would if the flowers were real."

This doesn't mean that the silk flowers have to be painstaking imitations of botanical detail. "What they have to do is create an impression or a feeling, like an Impressionist painting," Widder says. "There's a lot of room for aesthetic license."

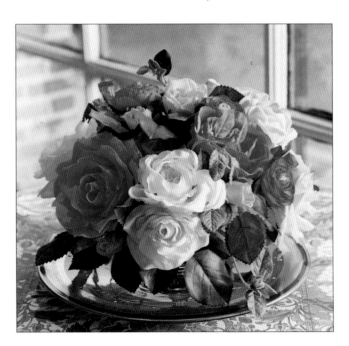

Widder says that silk flowers can be kept looking fresh and new for years, provided the owner takes the trouble to blow the dust off them. "Blow them off with a hair dryer," she says. "Do it often and the dust won't have a chance to settle into grime."

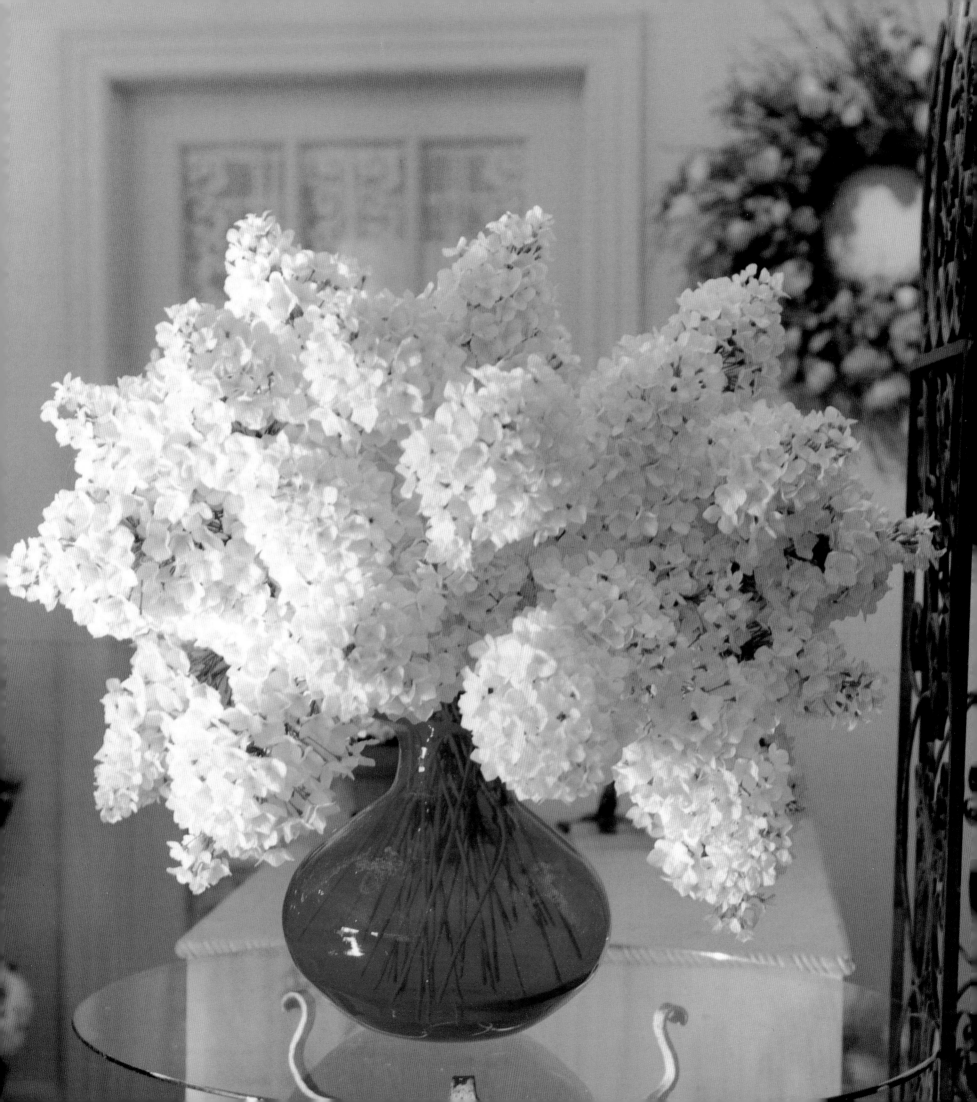

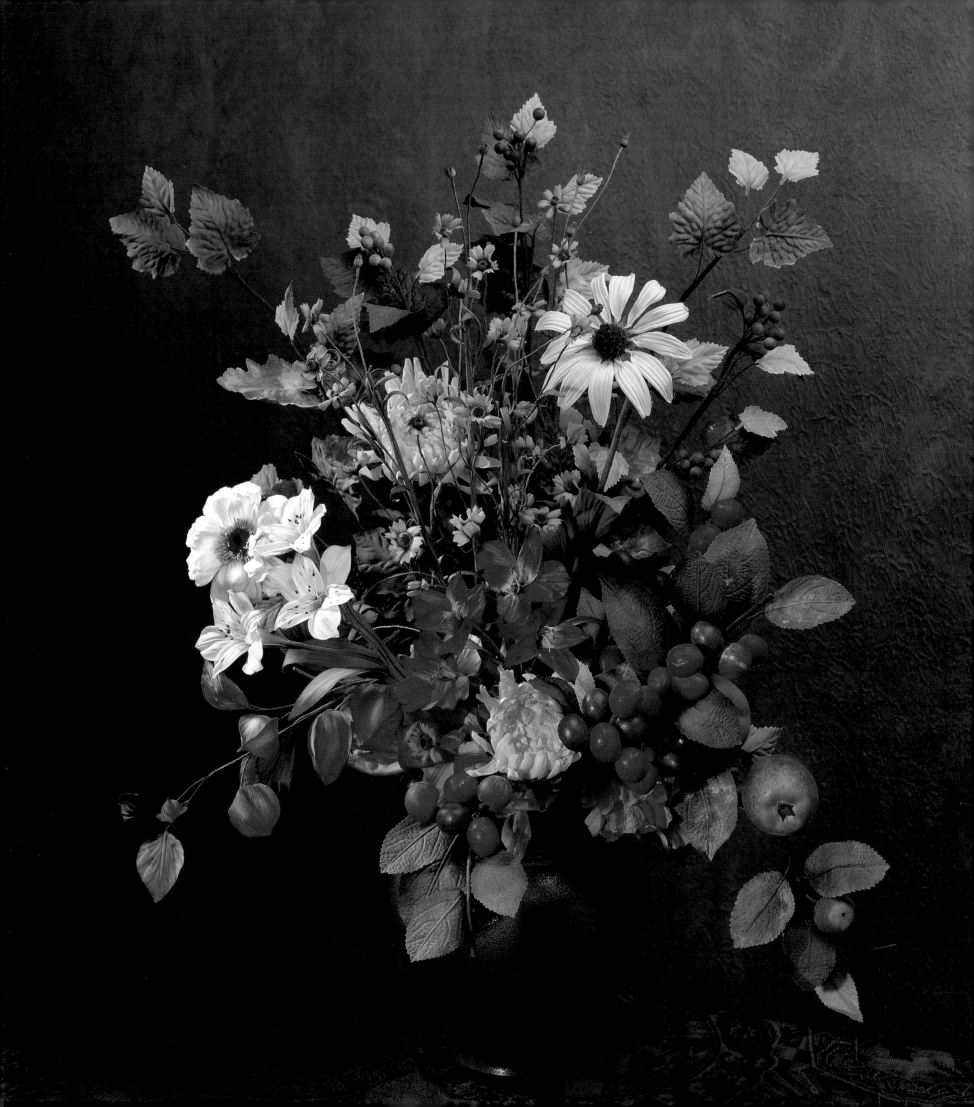

(Previous page) Colorful glass vases of opulent white lilacs made of silk are as fresh as a summer day. Flowers by Anita Widder. Photo by Maripat Goodwin.

(Opposite) A rather unpredictable arrangement including branches of fruit and a generous mix of cosmos, black-eyed Susans, and randomly placed blossoms. Photo by Stephen Smith for Florists' Review.

(Above, left) This elegant arrangement is made with organza and velvet roses mixed with lilies, silk pea pods, and hydrangeas in lovely colors of beige, brown tones, and green. Photo by Stephen Smith for Florists' Review.

(Above, right) The symmetrical composition of this "Flower Piece with Parrot" is reminiscent of the Dutch-Flemish floral still lifes. Photo by Stephen Smith for Florists' Review.

The Styrofoam foundation for this wreath is completely covered with dried moss on top of which a blue ribbon is placed. Photo by John Kelsey.

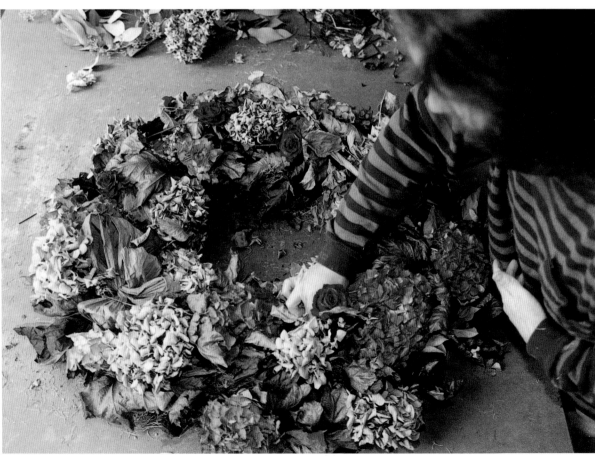

Dried hydrangeas and roses are stuck into the moss, leaving random images of ribbon visible. Wreath by Vena Lefferts. Photo by John Kelsey.

MAKE A DRIED WREATH

A wreath of dried hydrangea makes a delightful accent piece for your home. Making a wreath like the one shown here will give you the basic techniques of working with dried materials. Here's a valuable tip for beginners: don't wear a fuzzy sweater, because it will get totally covered with loose bits of dried plants.

Dried material can be very uneven in quality. It's also expensive to buy. Once you start drying your own leaves and flowers from the garden, you'll be able to try different species, and you can select the quality you want without worrying about cost.

The foundation of the wreath can be a ring of Styrofoam, straw, or twisted vines. Styrofoam is best for a wreath like this one, where the foundation will be completely covered. Twisted vines are wonderful because they can be left exposed; straw is difficult to pierce with wooden picks. As a point of reference, an 18-inch ring makes a 30-inch wreath.

WHAT TO LOOK FOR

When shopping for dried flowers, silk flowers, and faux arrangements, expect to get what you pay for. Drying requires the application of work and time to high-quality plant materials. Making silk or porcelain flowers takes good materials, artistic skill, and experience.

With faux flowers, look at the connection between flower and stem, the calyx and bract, to see whether the detail here is as convincing as the petals and stamens. See whether the petals have individual character, or have they been stamped out like cookies? Look for individuality in the leaves, and in the shape of the stems. If the detailing is stylized and not meant to be fully lifelike, is it consistent and observant, or sketchy and unrelated to the original plant?

With dried flowers, look for good quality blossoms and leaves in bunches or single stems, packaged in cellophane or paper that appears crisp and new. The condition of the packaging may be your only clue to the freshness of the dried product. Avoid materials that are crushed or broken, or that have visible mold or mildew, all signs of last season's product damaged by improper storage.

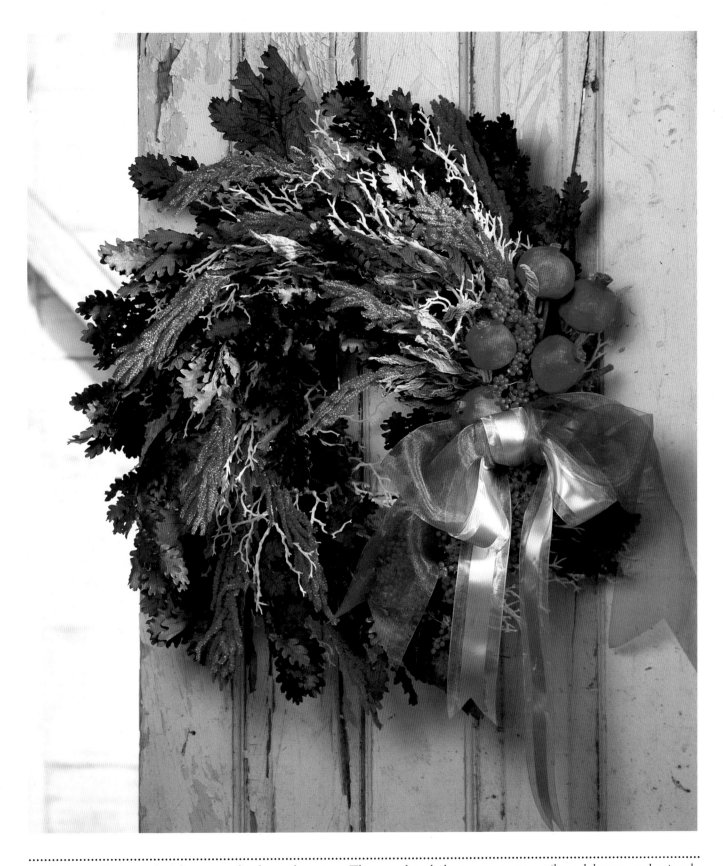

A dried wreath has a colorful presence that lasts a long time. This wreath includes pomegranates, milo, oak leaves, and painted twigs. Photo by Peter Hōgg.

A Glossary
of
Favorite
Flowers

ALLIUM

12 to 36 inches high

Rounded heads of star-shaped florets in white, violet, or pink

7 to 14 days vase life

Cut stems on diagonal, place into warm water, freshen often.

Bulb for sun. Plant in the fall for spring or summer bloom. Many species and hybrids available.

Allium aflatunense

ANEMONE

6 to 12 inches high

Rounded saucer-shaped flower in blue, white, red, pink, or purple

3 to 7 days vase life

Cut stems on diagonal, place in boiling water, avoid floral foam.

Bulb or perennial, for sun or part shade, depending on species. A. coronaria is best for cutting. Plant in full sun, in the fall in warm winter areas, in spring in the North. Soak tubers for 24 hours before planting.

Anemone coronaria

AMARANTHUS

12 to 36 inches high

Long, furry upright ropes in groups from single stem in green and crimson

7 days vase life

Remove foliage, dip stems into boiling water, transfer into deep cold water.

Annual for sun. Easy to grow from seed planted outdoors in late spring.

Amaranthus hypochondriacus

ANTHURIUM

12 to 24 inches high

Heart-shaped flower with tall central "tongue" in red, white, or pink

14 to 21 days vase life

Cut stems on diagonal, place into deep warm water, no refrigeration necessary.

Tropical which can be grown as a container plant in Northern gardens.

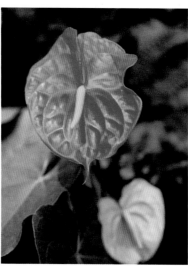

Anthurium

AMARYLLIS

24 to 36 inches high

Large lily-type blooms on hollow stem in white, pink, peach, or red

14 to 21 days vase life

Cut stem ends, fill with water, plug, put in deep warm water.

Non-hardy bulb. The familiar container plant for Christmas is Hippeastrum. Amaryllis belladonna grows in outdoor climates of warm winters and hot, dry summers. Grow in containers in cold climates. Blooms in late summer.

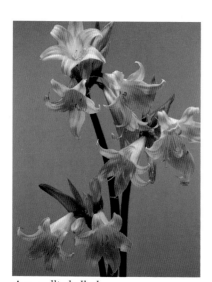

Amaryllis belladonna

APPLE AND CRABAPPLE

Tree branch

Fragrant floret clusters on branch in white, pinks, rose, or reds

7 to 10 days vase life

Cut and split or crush stems, place into deep warm water.

Hardy trees for full sun. Easily found at garden centers. Can be forced in late winter.

Malus floribunda

Information for each entry is given in the following order: flower height; shape and color; vase life; conditioning; planting information for the gardener.

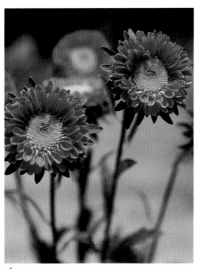

Aster

ASTER (MICHAELMAS DAISY)

24 to 36 inches high

Clusters of daisylike flowers on tall stems in white, violet, purple, or pink

7 to 10 days vase life

Cut and crush stem ends, dip into boiling water, transfer to warm water.

Annual or hardy perennial for sun. Bloom time varies, depending on species. Plant in full sun in well-drained soil.

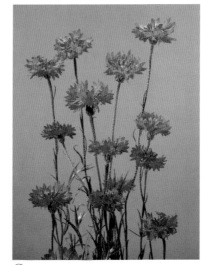

Centaurea cyanus

BACHELOR'S BUTTON

6 to 12 inches high

Many delicate petals of blue, white, pink, or mauve

7 to 10 days vase life

Cut stems on diagonal, place into deep warm water.

Annual for sun. Grow from seed sown outdoors in early spring. Performs best in cool weather. Cut off spent flowers to encourage rebloom.

Astilbe x arendsii

ASTILBE (FALSE SPIRAEA)

12 to 24 inches high

Feathery plumes on thin stems in crimson, pink, or white

3 to 7 days vase life

Split ends of stems, place into deep warm water.

Hardy perennial best suited to moist but well-drained sites in part shade.

Platycodon grandiflorus

BALLOON FLOWER

12 to 24 inches high

Many balloon-shaped flower buds in blue, pink, or white

5 to 7 days vase life

Cut stems on diagonal, place into deep warm water.

Hardy perennial for sun. Resents transplanting. Never needs dividing.

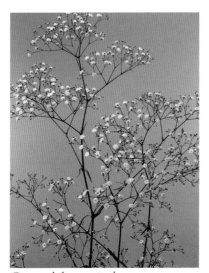

Gypsophilia paniculata

BABY'S BREATH

12 to 24 inches high

Tiny balls of feathered florets in white, pink, or pale lavender

7 to 14 days vase life

Cut stem ends, put into hot water with few drops of "Joy" dishwashing liquid to open florets.

Hardy perennial for full sun. Prefers neutral soil. Deep taproot, so difficult to transplant once established. Never needs dividing. Annual species also available.

Moluccella laevis

BELLS OF IRELAND

12 to 24 inches high

Bell-shaped floret clusters on an arched stem in lime green

7 to 10 days vase life

Cut stem ends, dip into boiling water, transfer to warm water.

Annual for sun. Good for drying. Start indoors 6 weeks before last frost, in individual peat pots. Seeds need light to germinate.

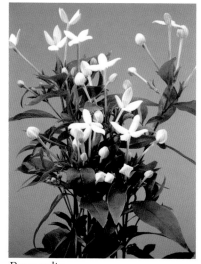

Strelitzia reginae

BIRD OF PARADISE

24 to 36 inches high

Exotic, showy birdlike flower on strong stem in blue, orange, and white

3 to 5 days vase life

Cut stems on diagonal, place into deep warm water, change water frequently.

Tropical which can be grown as container plant in the North.

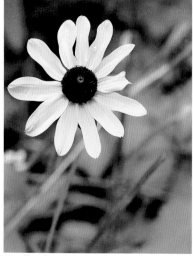

Rudbeckia hirta

BLACK-EYED SUSAN

12 to 30 inches high

Daisylike bloom on thin stem in rich yellow with brown center

7 days vase life

Cut stems, dip into boiling water, transfer to deep warm water.

Annual and perennial species for full sun. Perennials need dividing every three years. Annuals are easy from seed sown in spring.

Trachelium caerulum

BLUE LACEFLOWER

12 to 24 inches high

Feathery clusters of florets in white, blue, and purple

5 to 7 days vase life

Cut and split stems, place in deep warm water.

Annual. Grow from seed sown in early spring. Prefers cool weather.

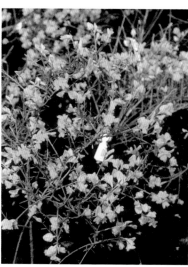

Bouvardia

BOUVARDIA

24 to 30 inches high

Rounded heads of tiny florets in white, yellow, pink, or red

3 to 7 days vase life

Cut and crush stem ends, dip into boiling water, transfer to warm water.

Tropical shrub.

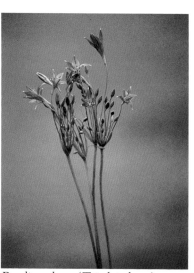

Brodiaea laxa (Triteleia laxa)

BRODIAEA

12 to 18 inches high

Clusters of florets on thin stems in medium blue or purple

7 to 10 days vase life

Cut stems on diagonal, place into deep warm water.

Hardy and non-hardy bulbs for full sun to part shade. B. laxa is the hardiest. Needs good drainage. Blooms in early summer.

Genista lydia

BROOM

12 to 24 inches high

Fragrant pea-shaped florets on thin woody stems in white, yellow, or pink

7 to 14 days vase life

Cut and split stem ends, dip into boiling water, transfer to warm water.

Hardy and non-hardy shrubs for sun. Need sandy soil, perfect drainage.

CALLA LILY

12 to 24 inches high

Folded trumpet-shaped elegant flower on thick stem in cream, yellow, or green, mini varieties in yellow, mauves, or green

5 to 7 days vase life

Cut stems on diagonal, place into deep warm water.

Tender bulb for sun. Thrives in wet areas of the garden. Grow in containers in cold-winter areas.

Zantedeschia aethiopica

CARNATION

12 to 30 inches high

Rounded, many-petalled flowers on strong stems in many colors, spicy fragrance

10 to 14 days vase life

Cut stem ends between nodes, place into deep warm water.

Many species for sun, both annual and hardy perennial. Best in neutral soil in sun. Common florist flower is difficult garden subject, but many dianthus are easy garden plants.

Dianthus caryophyllus

CAMELLIA

6 to 12 inches high

Rose-shaped bloom with glossy leaves in red, white, or pink

3 to 7 days vase life

Shake salt into each bloom, crush or split stem ends, place into deep warm water.

Non-hardy small tree for full sun or part shade. Lustrous evergreen leaves. Winter bloomer.

Camellia japonica

CATTLEYA

3 to 24 inches high

Exotic tropical flower

7 to 21 days vase life

Cut stems on diagonal, avoid wetting blooms, place into lukewarm water, keep cool and humid.

Tropical orchid. Can be grown as a container plant.

Cattleya hybrid

CAMPANULA (BELLFLOWER)

12 to 30 inches high

Bell-shaped flowers in clusters of white, lavender, blue, or pink

7 to 10 days vase life

Cut stems on diagonal, place into deep warm water.

Many species of hardy perennials for sun. Prefer well-drained, neutral, fertile soil.

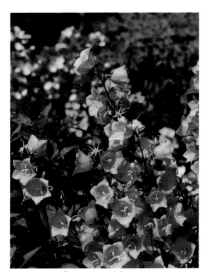

Campanula persicifolia

CELOSIA (COCKSCOMB)

12 to 18 inches high

Feathery plumes or cauliflower-draped heads in red, yellow, orange, or crimson

7 to 10 days vase life

Cut stem ends, dip into boiling water, transfer to warm water.

Annual for sun. Easy to grow from seed or bedding plants in late spring.

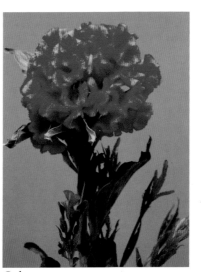

Celosia argentea v. cristata

CHINESE LANTERN

12 to 18 inches high

Lantern-shaped pods in orange

7 to 10 days vase life

Place in deep water. (Also used in dried arrangements.)

Perennial grown as an annual. Blooms first year from seed sown in spring. Color comes from ripe seed husks in the fall.

Physalis alkekengi

COLUMBINE (GRANNY'S BONNET)

12 to 30 inches high

Flowers with bonnet-shaped heads on thin stems, many colors

3 to 5 days vase life

Cut stems on diagonal, avoid wetting blooms, place into deep warm water.

Hardy but short-lived perennial for sun or part shade. Will sow babies if spent flowers are not removed.

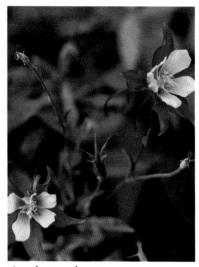

Aquilegia vulgaris

CHRYSANTHEMUM (MUM)

24 to 36 inches high

Rounded heads of many petals in many colors, many varieties

7 to 14 days vase life

Cut and crush or split stem ends, place into deep warm water, freshen water frequently.

Hardy perennial and annual species and hybrids for sun. Day-length sensitive, so avoid planting near streetlights. Pinch off side shoots to force largest-size blossoms.

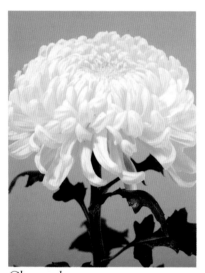

Chrysanthemum

COSMOS

12 to 24 inches high

Multipetalled flower with yellow center in white, pinks, or red

5 to 10 days vase life

Cut and crush stems ends, place into deep warm water.

Annual for sun. Easy to grow from seed sown in late spring. Needs staking or protection from wind.

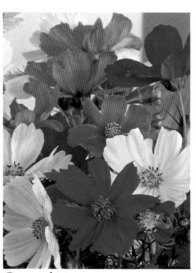

Cosmos bipinnatus

CLEMATIS

3- to 6-inch stems on tall vine

Flat petals in white, lavender, or purple followed by feathery seed head

1 to 3 days vase life

Singe stem ends over a flame or crush and dip into boiling water.

Most species and hybrids are hardy perennial vines for sun, some tolerate half shade. Pruning needs vary, so consult reliable reference. Mulch to keep roots cool.

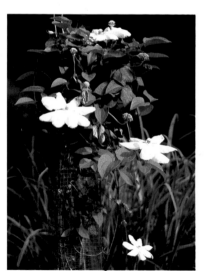

Clematis hybrid

CYMBIDIUM

3 to 24 inches high

Soft blooms along erect or drooping stems in white, yellow, green, pink, or red

7 to 21 days vase life

Cut stems on diagonal and recut every few days, avoid wetting blooms, place in lukewarm water, keep cool and humid.

Tropical orchid. Can be grown in a container.

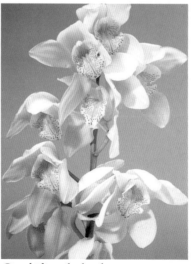

Cymbidium hybrid

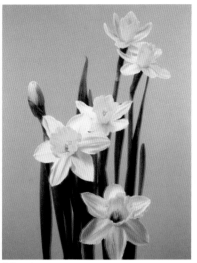

Narcissus

DAFFODIL (NARCISSUS, JONQUIL)

6 to 12 inches high

Fragrant trumpet-shaped floret clusters with a ring of petals on a hollow, sappy stem in white, yellow, orange, or bicolored

7 to 10 days vase life

Cut and split stems, place into cool water, keep cool.

Hardy bulb for sun. Plant in fall for spring bloom.

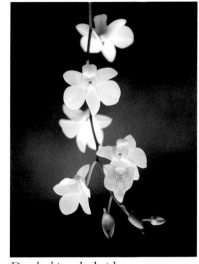

Dendrobium hybrid

DENDROBIUM

3 to 24 inches high

Stems of soft blooms, often with bright-colored fringed edges

7 to 21 days vase life

Cut stems on diagonal and recut every few days, avoid wetting blooms, place in lukewarm water, keep cool and humid.

Tropical orchid. Can be grown in a container.

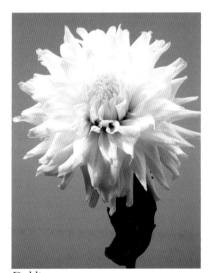

Dahlia

DAHLIA

6 to 24 inches high

Tuberous, multipetalled flower in many colors except blue

5 to 8 days vase life

Cut stem ends, dip into boiling water, transfer to cool water.

Non-hardy bulb for full sun. In northern gardens, dig tubers and winter indoors. Tall varieties need staking.

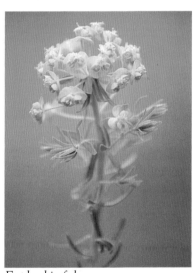

Euphorbia fulgens

EUPHORBIA

24 to 36 inches high

Clusters of florets on arched stems in cream, orange, red, or green

7 days vase life

Singe milky stem ends over a flame, transfer to warm water. Sap causes a rash in some people.

Many species of hardy and non-hardy perennials for sun or part shade and well-drained soil.

Delphinium

DELPHINIUM

24 to 36 inches high

Many florets on tall straight stem in blues, white, pink, or lavender

7 to 14 days vase life

Cut stem ends, fill with water, plug, then transfer to deep warm water.

Short-lived hardy perennial for sun, best suited to cool-summer areas. Likely to disappear in hot summers. Tall varieties require staking.

Tanacetum parthenium

FEVERFEW

8 to 18 inches high

Sprays of one-inch daisies in white or yellow. Single, double, or multiple rows of petals.

7 to 14 days vase life

Cut and split stem ends, place in deep warm water, replace water frequently.

Short-lived perennial. Flowers first year from seed, so often grown as an annual. Sow seed in early spring.

Prunus

FLOWERING CHERRY

Tree branches

Fragrant floret clusters on branch in white, pinks, rose, or reds

7 to 14 days vase life

Can force in late winter. Cut and split or crush stems, place into deep warm water.

Hardy small trees for sun. Often short lived.

Forsythia

FORSYTHIA

36 to 48 inches high

Opposite clusters of florets on bare branches in bright yellows

7 to 10 days vase life

Can force in late winter. Cut and crush or split stem ends, place into deep warm water.

Hardy shrub. Prune immediately after flowering to avoid removing next year's blooms.

Nicotiana affinis

FLOWERING TOBACCO

12 to 24 inches high

Star-shaped florets in white, pink, green, rose, purple, and crimson

5 to 7 days vase life

Cut and split stems, place into deep warm water.

Annual. Grow from seed sown in spring. Prefers lime and plenty of water in dry summers.

Digitalis purpurea

FOXGLOVE

24 to 36 inches high

Tall stem with tubular florets in white, pinks, yellow, or purple

7 to 10 days vase life

Cut stems on diagonal, place into deep warm water.

For sun or part shade. Most are biennial, although some are hardy perennials. Sow biennials in summer to bloom the following spring. Deadheading may encourage further bloom.

Myosotis alpestris

FORGET-ME-NOT

6 to 7 inches high

Tiny floret clusters on an arching stem in pale blue, white, or pink

5 to 7 days vase life

Cut and split stems, place into 2 inches of cool water, keep cool.

Biennial for sun and part shade. Sow seeds in mid- to late summer for bloom the following spring. If spent flowers allowed to remain, will self-sow.

Eremurus himalaicus

FOXTAIL LILY

24 to 60 inches high

Many small florets on tall spike in white, yellow, or orange

7 to 10 days vase life

Cut stems on diagonal, place into deep warm water.

Marginally hardy bulb for sunny, well-drained soil. Needs staking or protection from wind. Mulch heavily in cold areas.

Freesia hybrid

FREESIA

10 to 12 inches high

Trumpet-shaped florets on arched stems in many colors, fragrant

7 to 10 days vase life

Cut stems on diagonal, place into deep warm water.

Non-hardy bulb for sun. Can be grown in containers in the North for late winter bloom.

Liatris spicata

GAYFEATHER

12 to 36 inches high

Feathery florets on a sturdy stem in white, pink, or purple

7 to 10 days vase life

Cut stems and split or crush, place into deep warm water.

Hardy perennial for full sun. Can be grown from seed, but bloom is fastest from nursery plants.

Tulipa hybrid

FRENCH PARROT TULIP

12 to 16 inches high

Feathery, fringed flowers combine two or more colors on each petal, in white, ivory, yellow, orange, red, salmon, purple, or green.

5 to 7 days vase life

Cut stems on diagonal above white part, wipe off sap, place in deep, cool water, wrap in paper to straighten curved stems.

Hardy bulb. Plant in full sun in the fall for spring bloom.

Gerbera jamesonii

GERBERA

12 to 30 inches high

Large, daisy flower in white, yellow, pink, peach, red, or orange

7 to 14 days vase life

Cut stem ends, dip into boiling water, transfer to shallow water.

Non-hardy perennial. In cold-winter areas, grow as annual. Sow seeds indoors 8 weeks before last frost. Use fresh seed, which needs light to germinate.

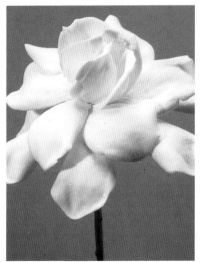

Gardenia jasminoides
(G. augusta)

GARDENIA

2 to 6 inches high

Flat blooms with fragrant layered petals in cream, glossy leaves

2 to 5 days vase life

Keep in water tube, covered in refrigerator, bruise very easily.

Non-hardy, small evergreen shrub for sun.

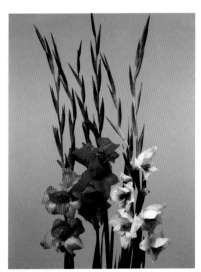

Gladiolus hybrid

GLADIOLA

24 to 40 inches high

Trumpet-shaped flowers on spikes in many colors

7 to 10 days vase life

Cut stems on diagonal, place into deep warm water.

Non-hardy bulb. Plant corms in late spring for summer bloom. Dig and store in the fall in cold-winter areas.

Echinops ritro

GLOBE THISTLE

24 to 36 inches high

Spikey, ball-shaped head in silver blue or white

7 to 14 days vase life

Cut stems on diagonal, place into deep warm water.

Hardy perennial for full sun. Cut back hard after flowering to renew foliage. Mature plants need staking. Can be dried.

Muscari armeniacum

GRAPE HYACINTH

6 to 7 inches high

Tiny bell-shaped floret clusters on a thin stem in blue or white

3 to 7 days vase life

Cut and split stems, place into 2 inches of cool water.

Hardy bulb for sun. Plant in the fall for spring bloom. Multiplies freely. Sends up foliage in the fall which lasts the winter.

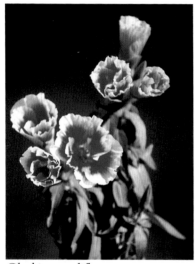

Clarkia grandiflora

GODETIA

12 to 24 inches high

Cups of paper-thin petals in white, pink, salmon, red, or violet

7 to 10 days vase life

Cut and crush stem ends, dip into boiling water, transfer to warm water.

Annual for sun. In mild areas, sow seeds in fall; in cold areas, sow in early spring. Prefers cool weather.

Erica persoluta

HEATHER

6 to 24 inches high

Tiny urn-shaped flowers on woody stems, with narrow, needlelike leaves, in shades of pink

5 days vase life

Recut and split stems.

Marginally cold-hardy small shrub. Grow in acid, sandy, well-drained soil in sun. Difficult garden plant in most of U.S.

Solidaster hybrid

GOLDENROD

12 to 36 inches high

Feathery florets in clusters on an arching stem in bright yellows

7 to 10 days vase life

Cut and crush stems, place into deep warm water.

Hardy perennial for sun or part shade, unfairly blamed for causing hay fever. (Ragweed is the real culprit.) x Solidaster is a beautiful hybrid of aster and goldenrod.

Hosta plantaginea

HOSTA

12 to 30 inches high

Lily-type florets on arched stem in white, lavender, good leaves

5 to 10 days vase life

Cut stems and split, place into deep warm water.

Hardy perennial for full or part shade. Excellent foliage plant, in shades of green, blue-green, gold, and variegated combinations.

Hyacinthus orientalis

HYACINTH

6 to 12 inches high

Trumpet-shaped fragrant florets, rounded cluster, in many colors

7 to 10 days vase life

Cut stems on diagonal, wipe ends dry, place into deep warm water.

Hardy bulb for sun, good for forcing indoors, or plant outdoors in the fall for spring bloom.

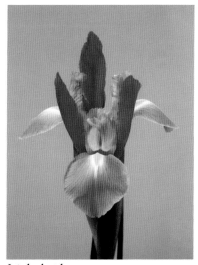

Iris hybrid

IRIS

12 to 30 inches high

Elegant thin petals, three facing up and three down in blues, purples, white, yellow, or pink

3 to 7 days vase life

Cut stems on diagonal, place into deep warm water.

Bulbs or rhizomes for sun, hardy and non-hardy. Many species available. Some suitable for wet soils, others for dry. Usually planted in late summer.

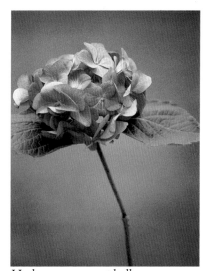

Hydrangea macrophylla

HYDRANGEA

18 to 36 inches high

Large clusters of many flat florets on woody stems in white turning to pink, blues, greens, purples, or maroons

7 to 10 days vase life

Cut stems and split, dip into boiling water, transfer to warm water, if droop then submerge heads in cool water for 3 hours.

Marginally hardy small shrub for part shade. Flower buds may not survive cold winters.

Alchemilla mollis

LADY'S MANTLE

12 to 18 inches high

Feathery yellow green sprays of tiny florets

7 to 14 days vase life

Cut stems on diagonal, place into deep warm water.

Hardy perennial for sun or part shade. Scalloped, velvety sage-green leaves capture dew drops. Self-sows. Rarely needs dividing.

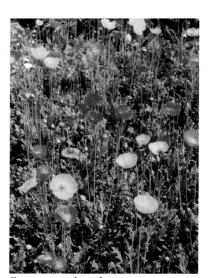

Papaver nudicaule

ICELAND POPPY

12 to 18 inches high

Like peony flower with showy center in white, yellow, peach, or red

7 days vase life

Cut and split or crush stems, place into deep warm water.

Annual or biennial for sun. Sow seeds in late summer for bloom the following spring.

Delphinium consolida

LARKSPUR

24 to 36 inches high

Delicate florets on tall straight stem in lavender, white, or pinks

7 to 14 days vase life

Cut and crush stem ends, transfer to deep warm water.

Hardy annual for sun. Difficult to transplant. Sow seeds in individual peat pots; or outdoors, in the fall in mild areas, in early spring in cold areas. Tall varieties need staking.

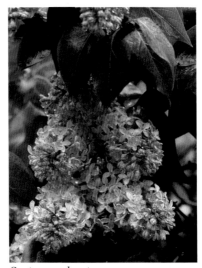

Syringa vulgaris

LILAC

12 to 36 inches high

Fragrant clusters of florets on woody stems in lavenders or white

5 to 7 days vase life

Cut and split stems, remove leaves, then place in deep, warm water.

Hardy shrub. Most species and hybrids best suited to cold-winter areas. Prune immediately after flowering, Needs sun and neutral soil.

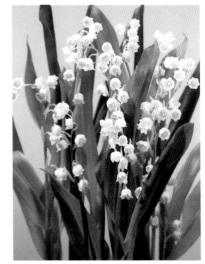

Convallaria majalis

LILY OF THE VALLEY

6 to 8 inches high

Fragrant bell-shaped florets on curved stem in white, or pale pink

3 to 7 days vase life

Cut stems on diagonal, place into deep warm water.

Hardy groundcover for shade. Suitable for northern gardens. Must be refrigerated to force bloom in warm climates.

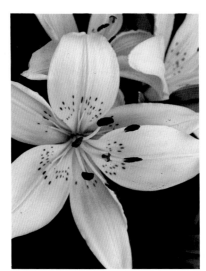

Lilium

LILY

12 to 30 inches high

Large fragrant blooms with curled petals, in many colors

7 to 21 days vase life

Cut stems and split, place into deep warm water.

Bulb for sun or part shade, well-drained soil. Many species and hybrids available, with range of hardiness. Tall varieties may need staking.

Limonium latifolium

LIMONIUM (SEA LAVENDER)

6 to 12 inches high

Fragrant tiny stiff florets on a thin stem in blue and purple

7 to 14 days vase life

Cut stems and split, place into shallow warm water.

Hardy perennial for sun, well-drained, sandy soil.

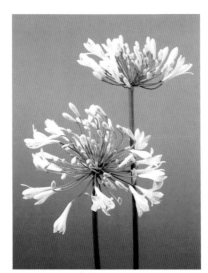

Agapanthus africanus

LILY OF THE NILE

24 to 30 inches high

Rounded heads of medium blue or white trumpet-shaped florets

7 to 10 days

Cut stems on diagonal, place into deep warm water.

Bulb for sun. Grow in containers in cold-climate gardens, overwinter indoors. Easily grown in the ground in warm-winter areas.

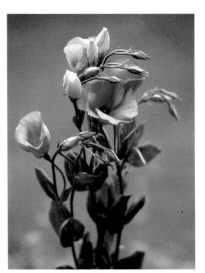

Eustoma grandiflorum

LISIANTHUS

12 to 24 inches high

Cupped delicate flowers on thin stems in bicolor, mauve, or white

7 to 10 days vase life

Cut stems on diagonal, place into deep warm water.

Annual for full sun or partial shade. Needs moist, well-drained soil. Sow seeds very early indoors.

Lysimachia clethroides

LOOSESTRIFE, GOOSENECK

12 to 24 inches high

Star-shaped floret clusters on an arched stem in white

5 to 7 days vase life

Cut and crush stems, dip into boiling water, transfer to deep warm water.

Hardy perennial. Invasive spreader for sun or part shade.

Lupinus polyphyllus

LUPINE

12 to 36 inches high

Pea-shaped floret clusters on a spike in many colors or bicolors

5 to 7 days vase life

Cut stem ends, fill with water, plug, then transfer to deep warm water.

Hardy perennial for sun or part shade. Performs most reliably in cool-summer climates.

Lythrum solicaria

LOOSESTRIFE

12 to 24 inches high

Clusters of flowers on 6- to 12-inch spikes, in bright pink, fuchsia, or purple

5 to 7 days vase life

Cut and split stems, place in deep warm water.

Hardy perennial for sun or part shade in moist, well-drained soil. Banned in many states because it has escaped to wetlands.

Chrysanthemum frutescons (Argyranthemum frutescons)

MARGUERITE DAISY

12 inches high

Delicate daisies in white, pale yellow, or light pink

7 to 14 days vase life

Cut and split stems, place in deep warm water, change water frequently.

Non-hardy perennial for sun. Can be grown as an annual bedding plant in the North. Deadhead frequently to maintain bloom.

Nigella damascena

LOVE-IN-A-MIST

6 to 18 inches high

Collared florets in white, pink, or blue

5 to 7 days vase life

Cut stems on diagonal, place into deep warm water.

Annual for sun. Easy to grow from seed sown in late winter or early spring. Will self-sow. Blooms in early summer; dislikes hot weather. Balloon-shaped seed pods are useful dried.

Acacia dealbata

MIMOSA (WATTLE)

Tree limbs

Clusters of ball-shaped yellow flowers

Cut and crush stems, dip into boiling water, put heads into plastic bag.

Non-hardy evergreen tree for warm climates.

Philadelphus x virginalis

MOCK ORANGE

10 to 24 inches high

Clusters of delicate, fragrant florets in white with yellow centers

5 to 7 days vase life

Cut and split or crush stems, place into deep warm water.

Hardy shrub for sun or part shade. Thin out one-third of stems annually after bloom for best performance.

Nerine bowdenii

NERINE (GUERNSEY LILY)

12 to 18 inches high

Lilylike floret clusters at the top of stiff stems in pinks or white

7 to 14 days vase life

Cut and split stems, place into deep warm water.

Non-hardy bulb for sun. Can be grown in containers in the North. Flowers in the fall.

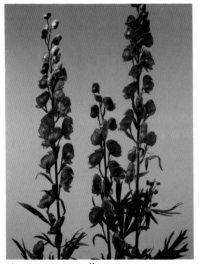

Aconitum napellum

MONKSHOOD

24 to 36 inches high

Tall spike flower with deep-purple hooded florets

7 days vase life

Cut stems on diagonal, place into deep warm water.

Hardy perennial for part shade. Late summer or fall bloomer.

Viola x wittrockiana

PANSY

6 to 8 inches high

Single blooms with velvety petals in many colors or bicolors

3 to 5 days vase life

Cut stems and place in shallow lukewarm water.

Hardy annual or biennial for sun or part shade. Seed can be sown in mid-summer to bloom in fall and the following spring; or buy bedding plants in early spring.

Crocosmia x crocosmiiflora

MONTBRETIA

12 to 24 inches high

Florets of trumpet shape on arched stem in yellow or red-orange

7 days vase life

Cut stems on diagonal, place into deep warm water.

Non-hardy bulb for sun, although some new varieties will survive winter temperatures down to -10° F.

Paeonia lactiflora

PEONY

12 to 18 inches high

Large, multipetalled, fragrant flower in white, pink, yellow, or rose

7 days vase life

Cut and split or crush stems, place into deep warm water.

Hardy, long-lived perennial for full sun. Plant rootstock only an inch below soil surface. Avoid fresh manure, which may carry botrytis, a fungus that afflicts buds. Never needs dividing.

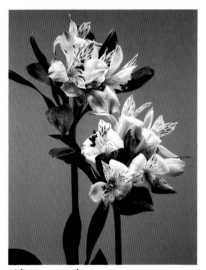

Alstromeria litgu

PERUVIAN LILY

24 to 36 inches high

Lily-type florets on long leaders with tall stem, many colors

7 to 14 days vase life

Cut stems on diagonal, place into deep warm water.

Non-hardy bulb, although new varieties survive winter temperatures to -10° F. Plant in well-drained soil in full sun.

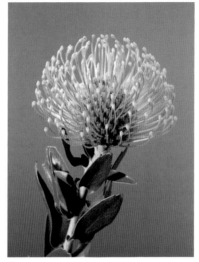

Leucospermum nutams

PINCUSHION

12 to 18 inches high

Clusters of fingerlike red or yellow flowers

7 to 14 days vase life

Cut stems straight across.

Non-hardy shrub.

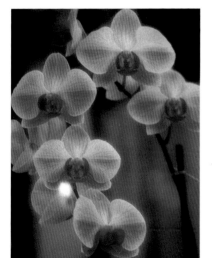

Phalaenopsis

PHALAENOPSIS

3 to 24 inches high

Usually single stems with up to 30 florets in white or pink with highlights of contrasting color

7 to 21 days vase life

Cut stems on diagonal and recut every few days.

Tropical orchid. Can be grown in a container.

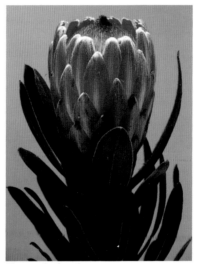

Protea hybrid

PROTEA

12 to 24 inches high

Exotic form flowers in buff, pinks, orange, reds, or bicolors

10 to 21 days vase life

Cut and split or crush stems, dip into boiling water, transfer to warm water, long-lasting flowers.

Non-hardy shrub.

Phlox paniculata

PHLOX

12 to 30 inches high

Clusters of fragrant florets in white, blue, red, and pinks

Cut above a stem joint before half of flowers are open. Condition in cold water for 8 hours.

Hardy perennial for sun. Thin out shoots in early spring for larger, stronger flowers. Snip off spent flower heads to encourage second wave of smaller flowers.

Echinacea purpurea

PURPLE CONEFLOWER

12 to 24 inches high

Multipetalled daisylike flower with orange or brown center in dark pink or white

7 to 10 days vase life

Cut stems on diagonal, place into deep warm water.

Hardy perennial for sun, well-drained soil. Deadhead to encourage repeat bloom.

Daucus carrota

QUEEN ANNE'S LACE

12 to 36 inches high

Rounded heads of tiny florets in white

3 to 7 days vase life

Blunt cut stems, place into deep warm water, avoid floral foam.

Ammi majus is an annual for sun, easy to grow from seed sown in spring. Better garden substitute for the beloved, but biennial, roadside weed.

Rosa (many varieties)

ROSE

6 to 30 inches high

Single or multipetalled elegant fragrant flowers with thorny stems, all colors but blue, many bicolors

3 to 10 days vase life

Cut stems on diagonal under water, place into deep warm water, change water frequently, submerge for 3 hours if drooped.

Plant in full sun in rich, well-drained soil, amended with compost and manure.

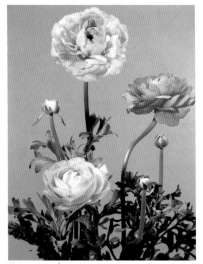

Ranunculus asiaticus

RANUNCULUS

6 to 12 inches high

Multipetalled cup-shaped flower in many colors

10 to 14 days vase life

Cut and split stems, dip into boiling water, transfer to deep warm water.

Non-hardy bulb. Suitable for forcing in containers in cold-winter areas.

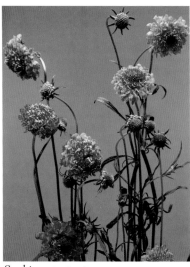

Scabios atropurpurea

SCABIOSA (PINCUSHION FLOWER)

12 to 24 inches high

Ruffle-petalled flower with lacey center in white, blue, or mauve

7 days vase life

Cut and split stems, remove leaves, place in deep warm water.

Annual for sun. Grow from seed sown in late spring. Perennial species also available.

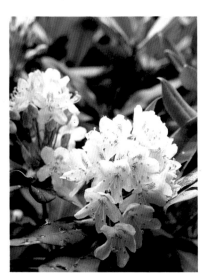

Rhododendron

RHODODENDRON

6 to 36 inches high

Trumpet-shaped florets in clusters on woody stems in white, pink, reds, or salmon

5 to 10 days vase life

Cut and split or crush stems, place into deep warm water.

Hardy shrub with broad, evergreen leaves.

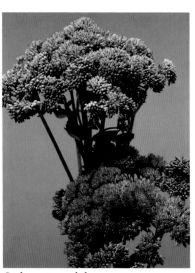

Sedum spectabile

SEDUM, STONECROP

6 to 24 inches high

Dense florets in clusters forming flat crown in mauve, red, or pink

7 days vase life

Cut stems on diagonal, place into deep warm water.

Hardy succulent-leaved perennial for sun. Many species available.

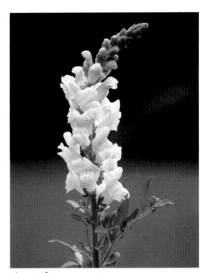

Antirrhinum majus

SNAPDRAGON

24 to 36 inches high

Tall spikes with mouth-shaped florets in white, pink, yellow, or red

7 to 10 days vase life

Cut stems under hot water or use boiling water method, place into deep warm water.

Annual. Performs best in cool weather. Sow in late winter for early spring bloom.

Limonium sinuatum

STATICE

12 to 30 inches high

Papery floret clusters in white, blue, yellow, mauve, or purple

7 to 21 days vase life

Cut stems on diagonal, place into deep warm water.

Annual for sun. Start seed indoors in individual peat pots 8 weeks before last spring frost. Prefers sandy soil and warm weather.

Spiraea

SPIRAEA

6 to 24 inches high

Lacey florets in clusters on woody stem in white, pinks, or reds

5 to 7 days vase life

Cut and crush stems, place into deep warm water.

Hardy shrubs. Many species and varieties, all with twiggy growth.

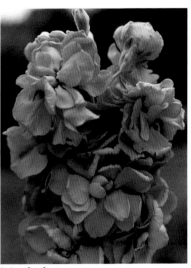

Matthiola incana

STOCK

12 to 24 inches high

Fragrant floret clusters on a stem in white, maroon, or purples

7 to 10 days vase life

Cut and split stems, remove foliage, place into deep cool water.

Annual for sun. Prefers cool weather. In mild areas, sow outdoors in fall. In cold areas, sow early indoors. Cold tolerant but not heat tolerant.

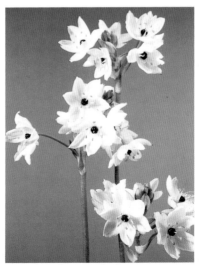

Ornithogalum umbellatum

STAR OF BETHLEHEM

12 to 24 inches high

Star-shaped florets in clusters on strong stems in white

7 to 10 days vase life

Cut stems on diagonal above white stem, place into deep warm water.

Bulb. Several species available, both hardy and non-hardy. Needs well-drained soil in sun or part shade.

Helichrysum bracteatum

STRAWFLOWER

12 inches high

Daisylike flowers with many rows of papery petals around yellow center, in white, yellow, red, or orange.

3 to 5 days vase life

Typically used dried. Hang upside down. To use fresh, split stems and place in warm water.

Tender perennial grown as annual. Start seeds indoors 6 weeks before last frost, or outdoors after last frost. Will bloom after frost.

Helianthus annuus

SUNFLOWER

24 to 60 inches high

Large daisylike flowers in rich yellow, ivory, or sunset colors with brown seeded center

7 to 10 days vase life

Cut stem ends, dip into boiling water, transfer to warm water.

Annual for sun. Sow outdoors in late spring. Branching varieties are best for cutting.

Dianthus barbatus

SWEET WILLIAM

6 to 20 inches high

Clusters of fragrant florets in white, pink, red, purple, or bicolors

7 to 10 days vase life

Cut and crush stem ends, transfer to deep warm water.

Biennial for sun. Sow in midsummer to bloom the following spring.

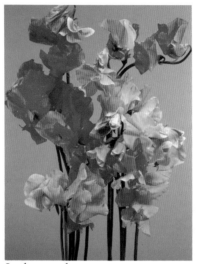

Lathyrus odoratus

SWEET PEA

6- to 12-inch stems on a vine

Fragile, pea-shaped florets on thin stems in pink, white, or lavender

5 to 8 days vase life

Cut stems on diagonal, place into 2 inches of lukewarm water.

Annual for sun. Sow seeds outdoors as early as soil can be worked. Provide trellis or netting so plants can climb. Prefers cool weather and stops blooming in summer heat. Poisonous.

Coreopsis verticillata

TICKSEED

24 to 36 inches high

Daisy-type flowers on tall stems in gold, yellow, or bicolored

7 to 14 days vase life

Cut and crush stem ends, transfer to deep warm water.

Hardy perennial. Several species available. Divide every three years.

Viola odorata

SWEET VIOLET

3 to 6 inches high

Tiny single blooms with five petals in white, blue-violet, or purples

3 to 5 days vase life

Submerge flower heads and stem in cool water for a few hours, transfer to shallow cold water, spray mist blossoms periodically.

Tender perennial for part shade. Can be grown in containers indoors in cold-winter areas.

Polianthes tuberosa

TUBEROSE

12 to 30 inches high

Fragrant trumpet-shaped florets on long stems in cream

7 to 10 days vase life

Cut and split stems, place into deep cool water.

Non-hardy bulb. Easy to grow in containers for summer bloom in cold-winter gardens.

Tulipa

TULIP

10 to 30 inches high

Elegant, chalice-shaped single or multipetalled blooms in many colors

5 to 7 days vase life

Cut stems on diagonal above white stem, wipe off sap, place into deep cool water, wrap in paper to straighten curved stems.

Hardy bulb. Plant in full sun in the fall for spring bloom. Can also be forced in containers for earlier bloom.

Chamelaucium pheliferum (Walpole)

WAXFLOWER

12 to 18 inches high

Half-inch flowers in cluster at tips of thin woody stems. Pale mauve, pink, purple, dull red, or white.

4 to 5 days vase life.

Cut and split stem ends before immersing in water.

Evergreen tropical shrub.

Mertensia virginica

VIRGINIA BLUEBELL

12 to 24 inches high

Nodding clusters of one-inch flowers in clear blue, fragrant

7 days vase life

Cut stems, transfer to deep warm water.

Hardy perennial for shade. Foliage disappears in summer. Best interplanted with ferns or hostas which will fill space after spring bloom.

Achillea filipendulina

YARROW

6 to 18 inches high

Flat heads of many florets in yellow, red, white, or peach

7 days vase life

Crush stems, place into deep warm water.

Hardy perennial for sun. Several species and hybrids. Deadhead to prolong blooming period.

Stephanotis floribunda

WAXFLOWER (MADAGASCAR JASMINE)

6 to 12 inches high

Fragrant star-shaped waxy florets in clusters in creamy white

3 to 5 days vase life

Keep covered and in refrigeration.

Tropical plant, suited for greenhouse conditions.

Zinnia elegans

ZINNIA

6 to 12 inches high

Daisylike or round many-petalled flower in many colors or bicolors

7 to 14 days vase life

Remove most foliage, cut stems, dip into deep warm water.

Annual for sun. Grow from seed sown in late spring. Prefers hot weather.

RESOURCES

FLORAL DESIGNERS

ALICE'S GARDEN
99 North Michigan
Chicago, IL 60611

ALL ABOUT FLOWERS—
KAREN BRADLEY BARLETTA
420 Mountain Road
Cheshire, CT 06410

SANDRA CLOTHIER
208 75th Street
North Bergen, NJ 07047

ANCEL FABRICE
250 E. 87th Street
New York, NY 10128

FLOWERS BY AQUINO
871 Seventh Avenue
New York, NY 10019

KASHA FURMAN
Cricket Hill Garden
670 Walnut Hill Road
Thomaston, CT 06787

SUSAN GROVES
In Full Bloom
1028 Emerson Street
Palo Alto, CA 94301

JENNIFER HOUSER
Table Art
Bridgehampton, NY 11932

MEIKO KURBOTA
6545 SW 135 Drive
Miami, FL 33156

LAMSBACK FLORAL
DECORATORS
148 Vine Street
Philadelphia, PA 19106

ELLEN O'COIN MORSE
The Trailing Vine
775 Shenipsit Lake Road
Tolland, CT 06804

ALEXIS NACCARATO
Preston Flower Market
17194 Preston Road
Dallas, TX 75248

CHRISTINA PFUEFER
Distinctive Floral Designs
143 W. 29th Street
New York, NY 10001

ELIZABETH RYAN
Floral Design
411 E. 9th Street
New York, NY 10009

PHOTOGRAPHERS

IRENE CHANG
319 South Robertson
Beverly Hills, CA 90211

SIDNEY COOPER
1427 East Fourth Street
Studio 2
Los Angeles, CA 90033

GREY CRAWFORD
1714 Lyndon Street
South Pasadena, CA 91031

LYNN DAMON
600 South Main Street
Manchester, CT 06040

MAUREEN EDWARDS DEFRIES
P.O. Box 749
Hawleyville, CT 06440

MARIA FERRARI
37 W. 20th Street
New York, NY 10011

MARIPAT GOODWIN
57 Old Highway
Southbury, CT 06488

ELIZABETH HEYERT
666 Greenwich Street
New York, NY 10014

PETER HÖGG
1221 South La Brea
Los Angeles, CA 90019

IRAIDA ICAZA
50 White Street
New York, NY 10013

KAN PHOTOGRAPHY
(represented by Watson &
Spierman Productions
524 Broadway
New York, NY 10012)

PHYLLIS KEENAN
29 William Street
Danbury, CT 06810

Z. LIVNAT
411 E. 9th Street
New York, NY 10009

PETER MARGONELLI
524 Broadway, 6th Floor
New York, NY 10003

SARAH MERIANS
101 Fifth Avenue, 5th Floor
New York, NY 10003

EMILY MILLER
124 Thompson Street
New York, NY 10012

GLORIA NERO
RD 1, Wolf Hollow Road
Andes, NY 13731

CHRISTINE NEWMAN
Persona Grata Photography
107 Sixth Street
Hoboken, NJ 07030

ZEVA OELBAUM
140 W. 22nd Street
New York, NY 10011

GEORGIA SHERON
228 Main Street
Oakville, CT 06779

TED TANAKA
6840 SW 45th Lane #8
Miami, FL 33155

NURSERIES AND MAIL-ORDER CATALOGUES

BLOSSOMS & BLOOMERS
11415 East Krueger Lane
Spokane, WA 99207

W. ATLEE BURPEE & CO.
300 Park Avenue
Warminster, PA 18974

CALYX & COROLLA
1550 Bryant Street #900
San Francisco, CA 94103

CARROLL GARDENS
P.O. Box 310
444 East Main Street
Westminster, MD 21157

THE COUNTRY GARDEN
Route 2
Box 455A
Crivitz, WI 54114

CRICKET HILL GARDENS
670 Walnut Hill Road
Thomaston, CT 06787

CROWNSVILLE NURSERY
P.O. Box 797
Crownsville, MD 21032

THE DAFFODIL MART
Route 3, Box 794
Gloucester, VA 23061

DONAROMA'S NURSERY
P.O. Box 2189
Edgartown, MA 02539

DUTCH GARDENS
P.O. Box 200
Adelphia, NJ 07710-0200

GARDEN PLACE
P.O. Box 388
Mentor, OH 44061-0388

GARDENER'S EDEN
Box 7307
San Francisco, CA 94120-7307

GURNEY'S SEED AND NURSERY
 COMPANY
110 Capital Street
Yankton, SD 57059

HEIRLOOM OLD GARDEN ROSES
24062 N.E. Riverside
St. Paul, OR 97137

HERITAGE ROSE GARDENS
16831 Mitchell Creek Drive
Fort Bragg, CA 95437

HILLSIDE GARDENS
Litchfield Road
P.O. Box 614
Norfolk, CT 06058

JACKSON & PERKINS
P. O. Box 1028
Medford, OR 97501

KLEHM NURSERY
Route 5, Box 197
Penny Road
South Barrington, IL 60010

LEXINGTON GARDENS
32 Churchill Road
Newtown, CT 06470

MILEAGER'S GARDENS
4838 Douglas Avenue
Racine, WI 53402-2498

MCCLURE & ZIMMERMAN
108 W. Winnebago
Box 368
Friesland, WI 53935

MONTROSE NURSERY
P.O. Box 957
Hillsborough, NC 27278

PARK SEED COMPANY
Cokesbury Road
Greenwood, SC 29647

JOHN SCHEEPERS, INC.
23 Tulip Drive
Bantam, CT 06750

SELECT SEEDS
180 Stickley Hill Road
Union, CT 06076

SPRING HILL NURSERIES
6523 North Galena Road
P.O. Box 1758
Peoria, IL 61656

SPRING HILL NURSERIES
110 West Elm Street
Tipp City, OH 45371

STOECKLEIN'S NURSERY
135 Critchlow Road
Renfrew, PA 16053

STOKES SEEDS, INC.
Box 548
Buffalo, NY 14240

SURRY GARDENS
P.O. Box 145
Surry, ME 04684

THOMPSON & MORGAN
P.O. Box 1308
Jackson, NJ 08527

VAN ENGELEN
23 Tulip Drive
Bantam, CT 06750

ANDRÉ VIETTE FARM AND
 NURSERY
Rte. 1, Box 16
Fishersville, VA 22939

WAYSIDE GARDENS
1 Garden Lane
Hodges, SC 29695-0001

WE-DU NURSERIES
Rte. 5, Box 724
Marion, NC 28752

WHITE FLOWER FARM
Rte. 63
P.O. Box 50
Litchfield, CT 06759-0050

GILBERT H. WILD & SON, INC.
787 Joplin Street
Sarcoxie, MO 64862-0338

WOODBURY FARM MARKET
717 Main Street South
Woodbury, CT 06798

GARDEN TOOLS
AND ACCESSORIES

COUNTRY HOME PRODUCTS
Ferry Road, Box 89
Charlotte, VT 05445

COUNTRY HOUSE FLORAL SUPPLY
Box 4086
Andover, MA 01810

DOROTHY BIDDLE FLORAL
 SUPPLY
HCOl Box 900
Greele, PA 18425

GARDEN WAY, INC,.
102nd St. & 9th Avenue
Troy, NY 12180

GARDENER'S EDEN
P.O. Box 730
San Francisco, CA 94120

GARDENER'S SUPPLY CO.
128 Intervale Road
Burlington, VT 05401

KEMP COMPANY
160 Koser Road
Lititz, PA 17543

MANTIS
1028 Street Road
Southampton, PA 18966

SMITH & HAWKEN
25 Corte Madera
Mill Valley, CA 94941
 (store)
2 Arbor Lane
P.O. Box 6900
Florence, KY 41022
 (catalogue)

ORGANIZATIONS AND
SOCIETIES

AMERICAN HORTICULTURAL
 SOCIETY
7931 E. Boulevard Drive
Alexandria, VA 22308

AMERICAN INSTITUTE OF
 FLORAL DESIGNERS
720 Light Street
Baltimore, MD 21230

ARS THE NATIONAL
 ARBORETUM
3501 New York Avenue, NE
Washington, D.C. 20002

BROOKLYN BOTANIC GARDEN
1000 Washington Avenue
Brooklyn, NY 11225

CALIFORNIA CUT FLOWER
 COMMISSION
2239 Gold Meadow Way
Gold River, CA 95670

FAIRCHILD TROPICAL GARDENS
10901 Old Cutler Road
Miami, FL 33156

GARDEN CLUB OF AMERICA
598 Madison Avenue
New York, NY 10022

HARDY PLANT SOCIETY
124 N. 181 Street
Seattle, WA 98133

LONGWOOD GARDENS
Box 501
Kennett Square, PA 19348-0501

NEW ENGLAND WILDFLOWER
 SOCIETY
Garden in the Woods
Hemenway Road
Framingham, MA 01701

NEW YORK BOTANICAL
 GARDENS
200 St. & Southern Boulevard
Bronx, NY 10458

PENNSYLVANIA HORTICULTURAL
 SOCIETY
325 Walnut Street
Philadelphia, PA 19106

PUBLICATIONS:
MAGAZINES

FINE GARDENING
P.O. Box 5506
Newtown, CT 06470

FLORISTS' REVIEW
3641 S.W. Plass
Topeka, KS 66611

FLOWERS &
12233 W. Olympic Boulevard
Los Angeles, CA 90064

PROFESSIONAL FLORAL
DESIGNER
P.O. Box 12390
Oklahoma City, OK 75157

SILK, CERAMIC, AND
DRIED FLOWERS

CLARE POTTER
P.O. Box 624
Locust Valley, NY 11560
(ceramic flowers)

SYLVIA STINSON
Winter Bouquets
8811 Postoak Road
Potomac, MD 20854
(dried flower arrangements)

ANITA WIDDER
P.O. Box 446
Locust Valley, NY 11560
(silk flower arrangements)

INDEX

PHOTO CREDITS

ADDITIONS IN TEXT

The following images were printed courtesy of *Flowers &* magazine: pages 12, 24, 25, 40, 41, 45, 63, 66 (above, left), 98, 108, 151, 158, 177 (left), 179, 181, 183, 185, 189, 194 (above, left), 195, 198, 199, 215, 223. Photo by Irene Chang: pp. 13 (inset), 20 (background), 83 (inset), 182 (inset), 183, 189 (insets); photo by Kasha Furman: pp. 20 (inset photo and flowers by), 53 (background), 189 (background and flowers by); photo by Maripat Goodwin: pp. 43 (inset), 113 (inset), 216 (inset); photo by Maria Ferrari: p. 102 (background); © *Fine Gardening* : pp. 102 (insets), 103, 106, 107; photo by Z. Livnat: p. 128 (inset); photo by Peter Margonelli: pp. 129 (inset), 252; photo by Georgia Sheron: p. 151 (inset); photo by Maureen Edwards DeFries: p. 200 (background); photo by Lynn Damon: p. 203 (inset); photo by Clare Potter: p. 213 (inset photo and flowers by); photo by John Kelsey: p. 221 (background and insets); photo by Iraida Icaza: p. 222 (background and insets). Flowers by Anita Widder: pp. 43 (inset), 113 (inset), 216 (inset); flowers by Fabrice: p. 128 (inset); flowers by All About Flowers: p. 151 (inset); flowers by Ellen O'Coin Morse: p. 203 (inset); wreath by Vena Lefferts: p. 221.

GLOSSARY

California Cut Flower Commission:
Amaranthus, Amaryllis, Anemone, Astile, Baby's Breath, Bachelor's Button, Balloon Flower, Bells of Ireland, Bird of Paradise, Bouvardia, Carnation, Cattleya, Celosia, Chrysanthemum, Chinese Lantern, Cymbidium, Daffodil, Dahlia, Freesia, French Parrot Tulip, Gardenia, Jasminoides, Gayfeather, Gerbera, Gladiola, Goldenrod, Nerine, Heather, Iris, Lily of the Valley, Marguerite Daisy, Mimosa, Monkshood, Montbretia, Peruvian Lily, Pincushion, Protea, Ranunculus, Rose, Scabiosa, Sedum, Snapdragon, Star of Bethlehem, Statice, Sunflower, Sweet Pea, Sweet William, Tulip, Waxflower, Yarrow

Maureen Edwards DeFries:
Allium, Aster, Bluebell, Brodiaea, Clematis, Dendrobium, Euphorbia, Flowering Cherry, Forget-me-not, Forsythia, Globe Thistle, Godetia, Grape Hyacinth, Lady's Mantel, Larkspur, Lilac, Limonium, Pansy, Phalaenopsis, Queen Anne's lace, Spirea, Sweet Violet

Peter Högg:
Zinnia

Vena Lefferts:
Black-Eyed Susan, Hosta, Loosestrife, Rhododendron, Tickseed

Marshall Lefferts:
Columbine

Peter Margonelli:
Phlox, Cosmos

Jerry Pavia:
Hyacinth, Feverfew

Roehrs Company:
Anthurium, Camellia, Flowering Tobacco, Foxtail Lily, Iceland Poppy, Love-in-a-Mist, Lupine, Mock Orange, Purple Coneflower, Tuberose

Georgia Sheron:
Campanula

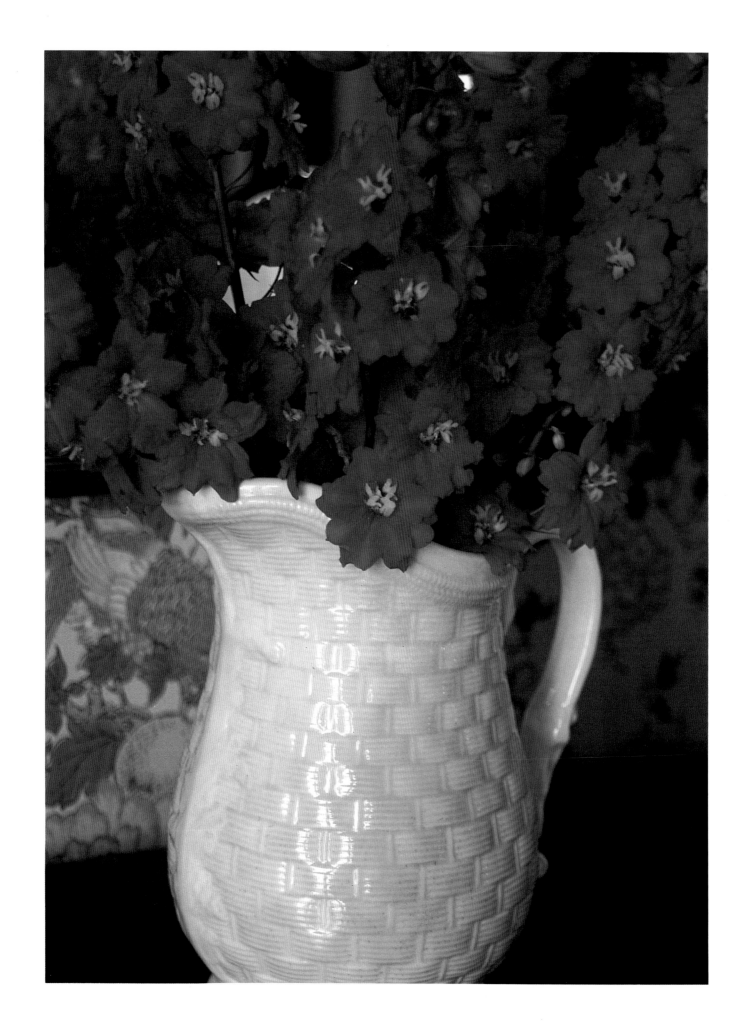